National Handicrafts and Handlooms Museum
New Delhi

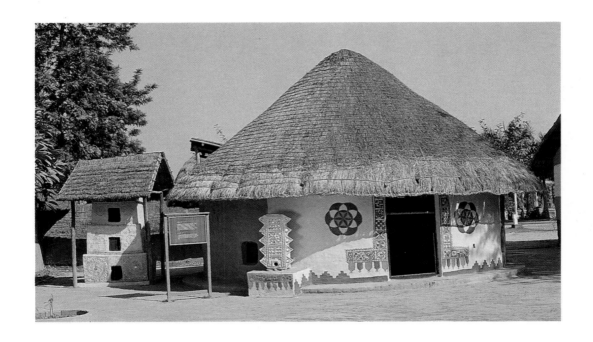

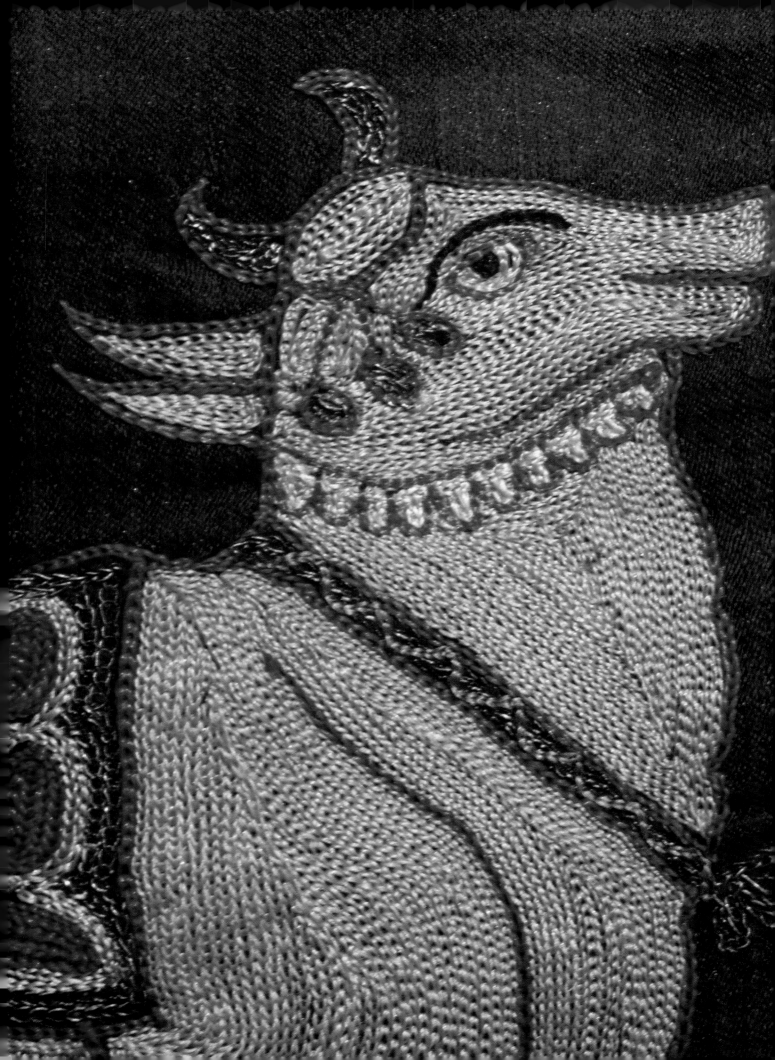

Museums of India

National Handicrafts and Handlooms Museum
New Delhi

Jyotindra Jain
Aarti Aggarwala

Photographs by
Pankaj Shah

Mapin Publishing Pvt. Ltd., Ahmedabad

First published in the United States of America in 1989 by
Grantha Corporation, Middletown, NJ 07701

by arrangement with
Mapin Publishing Pvt. Ltd.,
Chidambaram, Ahmedabad 380 013, India

Text and illustrations © 1989
National Handicrafts and Handlooms Museum, New Delhi

ISBN: 0-944142-23-0 cl
ISBN: 0-944142-27-3 pa
LC: 88-83655

Editor: Ayesha Kagal
Editorial consultant: Carmen Kagal
Designer: Dolly Sahiar

Typeset in Linotron Galliard Roman
by Fotocomp Systems, Bombay
Printed and bound in
Hong Kong

Jacket illustration:
Fertility ring (see p.43)

Page 1
Banni hut Kachchh
Village Complex of the Museum
Page 2
Detail of p.151

Contents

Acknowledgements 6

Introduction 9

Cast in a Void
Metal Forms 15

Talismans of Power
Jewels 53

Chiselled Forms
Wood, Stone, and Ivory Carving 69

Chromatic Brilliance
Printed Wood, Paper Maché, Lac-Turnery 89

Painted Myths
Traditions of Indian Folk Painting 101

Symphonic Weaves
Textile Traditions of India 131

Textural Webs
Basketry and Matting 163

Earthy Forms
Terracotta and Glazed Pottery 173

Felicitous Playthings
Dolls, Toys, Puppets and Masks 191

Appendix 210

Glossary 211

Bibliography 218

Abbrevation

A

1. Adilabad/AP
2. Agra/UP
3. Ahmedabad/GJ
4. Ajanta/MR
5. Ajmer/RJ
6. Alirajpur/MP
7. Allahabad/UP
8. Alwar/RJ
9. Amarnath/JK
10. Amritsar/PB
11. Andro/MN
12. Aranmula/KR
13. Aurangabad/MR
14. Avadh/UP
15. Azamgarh/UP

B

1. Bagh/MP
2. Bagru/RJ
3. Bahraich/UP
4. Baleshwar/OR
5. Bangalore/KN
6. Bankura/WB
7. Banni/GJ
8. Baranagar/WB
9. Bargarh/OR
10. Barpali/OR
11. Barmer/RJ
12. Baroda/GJ
13. Bassi/RJ
14. Bastar/MP
15. Bhavnagar/GJ
16. Bhilwara/RJ
17. Bhimbetka/MP
18. Bhopal/MP
19. Bhuj/GJ
20. Bhuvaneshwar/OR
21. Bidar/KN
22. Bijnore/UP
23. Bikaner/RJ
24. Bilaspur/MP
25. Birbhum/WB
26. Bisauli/UP
27. Bolangir/OR
28. Broach/GJ
29. Bundelkhand/MP
30. Burdwan/WB
31. Burhanpur/MP

C

1. Calcutta/WB
2. Cambay/GJ
3. South Canara/KN
4. Chamba/HP
5. Chandragiri/AP
6. Chanderi/MP
7. Chhatisgarh/MP
8. Chingalpet/TN
9. Chirala/AP
10. Chittorgarh/RJ
11. Chittoor/AP
12. Chhota Udaipur/GJ
13. Chhota Dongar/MP
14. Cuttack/OR

D

1. Dacca/BD
2. Darbhanga/BR
3. Deccan/MR
4. Deedarganj/BR
5. Deesa/GJ
6. Deolia/RJ
7. Dhamadka/GJ
8. Dharwar/KN
9. Dhenkanal/OR
10. Dhubri/AS

E

1. Ellora/MR

F

1. Faizabad/UP
2. Farrukhabad/UP
3. Fatehpur/UP
4. Ferozepur/PB

G

1. Ganjam/OR
2. Goalpara/AS
3. Gorakhpur/UP
4. Gwalior/MP

H

1. Harappa/PK
2. Hazaribagh/BR
3. Hoshiarpur/PB
4. Hoshangabad/MP
5. Hyderabad/AP

I

1. Indore/MP

J

1. Jagdalpur/MP
2. Jaipur/RJ
3. Jaisalmer/RJ
4. Jalna/MR
5. Jamnagar/GJ
6. Jetpur/GJ
7. Jhabua/MP
8. Jhansi/MP
9. Jodhpur/RJ

K

1. Kalahasti/AP
2. Kalibangan/RJ
3. Kalighat/WB
4. Kanauj/UP
5. Kanihama/JK
6. Kanpur/UP
7. Karimnagar/AP
8. Kashmir/JK
9. Khavda (Kutch)/GJ
10. Khammam/AP
11. Khandesh/MP
12. Khanpura/OR
13. Kodalikaruppur/TN
14. Kolar/KN
15. Konark/OR
16. Kondagaon/MP
17. Kondapalli/AP
18. Koraput/OR
19. Kota/RJ
20. Koyyalagudam/AP
21. Krishnanagar/WB
22. Kulu/HP
23. Kunkeri/MR

L

1. Ladakh/JK
2. Lothal/GJ
3. Lucknow/UP

M

1. Madras/TN
2. Madhubani/BR
3. Madurai/TN
4. Mahabalipuram/TN
5. Maheshwar/MP
6. Mainpuri/UP
7. Makrana/RJ
8. Malwa/MP
9. Mandasor/MP
10. Mandla/MP
11. Mandvi/GJ
12. Masulipatnam/AP
13. Mathura/UP
14. Medak/AP
15. Mekkekattu/KN
16. Midnapur/WB
17. Mirzapur/UP
18. Mithila/BR
19. Mohanjodaro/PK
20. Molela/RJ
21. Mundra/GJ
22. Murshidabad/WB
23. Muzaffarpur/BR
24. Mysore/KN

N

1. Nagapur/RJ
2. Nagina/UP
3. Nagore/TN
4. Nagpur/MR
5. Nasik/MR
6. Nathdwara/RJ
7. Navagarh/MP
8. Nicobar/AN
9. Nilgiri Hills/TN
10. Nirmal/AP
11. Nirona/GJ

P

1. Pahurbela/MP
2. Paithan/MR
3. Palghat/KR
4. Panchmadi/MP
5. Patan/GJ
6. Patharkatti/BR
7. Patna/BR
8. Pattamadai/TN
9. Pipad/RJ
8. Pochampalli/AP
11. Ponneri/TN
12. Pratapgarh/RJ
13. Puddukottai/TN
14. Puri/OR
15. Purulia/WB

Q

1. Quilon/KR

R

1. Raghurajpur/OR
2. Raichur/KN
3. Raigarh/MP
4. Ramanathapuram/TN
5. Ranchi/BR
6. Ratangarh/RJ
7. Ratlam/MP

S

1. Saharanpur/UP
2. Salem/TN
3. Sambalpur/OR
4. Sanchi/MP
5. Sankheda/GJ
6. Santhal Parganas/BR
7. Sawantvadi/MR
8. Shahpura/RJ
9. Shantipur/WB
10. Sheopur/MP
11. Singhbhum/BR
12. Sonepur/OR
13. Surat/GJ
14. Swamimalai/TN

T

1. Tanda/WB
2. Telangana/AP
3. Thane/MR
4. Thanjavur/TN
5. Tiruchirapalli/TN
6. Tirupati/AP
7. Trichur/KR
8. Trivandrum/KR

U

1. Udaipur/RJ
2. Udipi/KN
3. Ujjain/MP

V

1. Varanasi/UP
2. Vishnupur/WB
3. Vrindavan/UP

W

1. Warangal/AP
2. West Nimar/MP

Map of places mentioned in the text

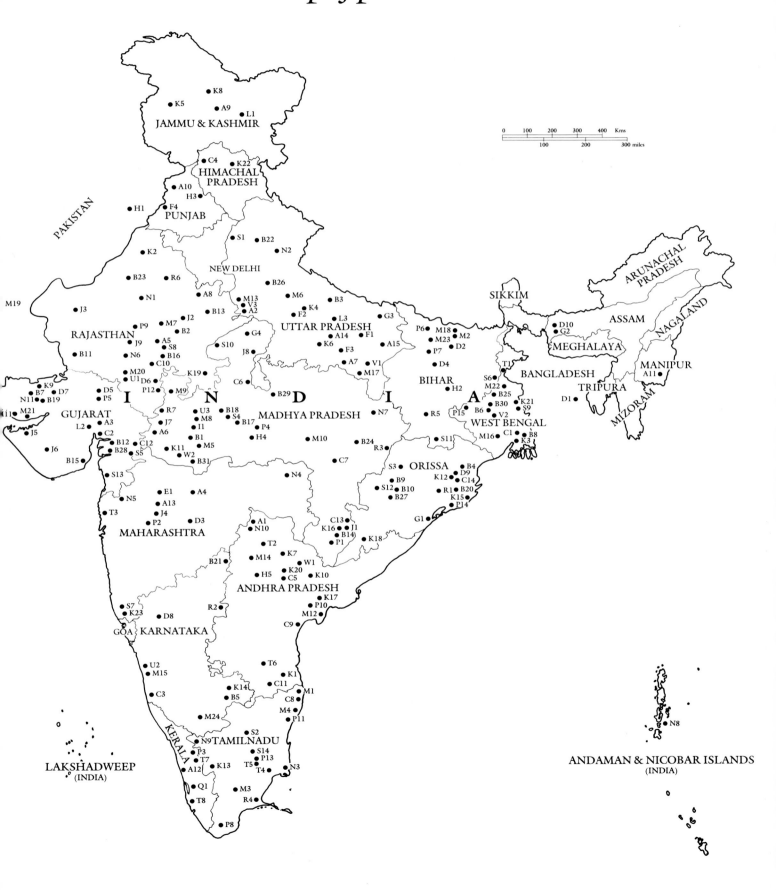

Preface

"A purple coloured bird, mighty, heroic, ancient, having no nest."
— *Rigveda*

Insights into the ancient craft traditions of India reveal the anonymous nature of creation; of direct perceptive skills and discipline as integral to the creative act, form as born of the right relationship of matter to space and energy. From this arises the supreme insight of the creator-craftsman who sees with a listening eye; who sees unending space and the tiny seed, who sees into the within of things. And so creates.

In India, however diverse the forms and multiple the objects produced by craftsmen for the use of people, the root of the creative process has always been the artisan tradition. To explore the roots of this tradition and to assess its place in the country's aesthetic and social life it is necessary to examine the norms that have moulded the craftsperson's vision and has dictated their vocabulary.

The patterns that the crafts traditions in India were to take and which were to survive for 5,000 years, appear already mature and firmly established in the cities of the Indus valley. Nomadic Aryan invasions from the north brought new elements and directions into the ways of thought, into the way of art and its vision, and into the roots of the social structure.

Panini, the first of the great grammarians in the fifth century B.C., used the word *shilpa* as a generic word to include painters, dancers, musicians, weavers, potters, tailors.

From the earliest times, the Indian mind had probed into problems of vision and into the possibilities of extending the horizon of perceptions. What made an art object was *rupa* or shape, *pramana* or proportion and *varna* or colour. Perfection of form came to be based on certain rules of measurement of length and breadth. These rules of measurement were applicable not only to architecture and sculpture but to functional objects like textiles, gold ornaments, mule chariots and weapons.

The classical craft tradition flowered around rulers and their courts and the temples built to glorify the gods. The rural or *desi* craft idiom was based on the vernacular forms of the artisan guild. Inherent in it was a total anonymity. Negating the linear movement of history, of progress, of evolution or development, it revolved around a cyclic sense of time. Agricultural magic, ritual, symbol and myth existed simultaneously as repositories of the archaic past and the existential present.

India's rural arts are the visual expression and technological processes of people living at several cultural, religious and sociological levels. They are the art of the settled village and countryside, of people with lives tuned to the rhythm of nature and its laws, and with a central concern with the earth and harvesting. They are the arts of people with memories of ancient migrations forced by war, epidemic, hunger and of live myth that make the archaic Puranic gods and legend contemporary; arts involved with household and fertility rituals, *vratas* far removed from the Vedic pantheon and observances, rites that invoke and establish the goddess, the quickened kernel of energy and power, within the hut and the village community. They are the arts of fairs and festivals, of pilgrimages, of song, dance and epic performance.

In the last five decades India has witnessed a major revolution in her social and technological environment, resulting in a challenge to craftpersons and their skills. Questions that then arise are, are craft skills relevant today? What is their place in India's economic and cultural life?

As distances between the craftperson and his patron grow and as social changes in the environment lead to a diminution of demands for local products, an institution is necessary where craft skills can come in direct contact with consumers and where a respository of fine craft objects and tools provide a reference point to the craftsperson. The National Handicrafts & Handlooms Museum will, we hope, act as a catalyst to fulfil this function.

Pupul Jayakar

Introduction

The National Handicrafts & Handlooms Museum, (Crafts Museum), New Delhi, was set up in 1956 by the All India Handicrafts Board primarily as a resource centre for the Indian handicraft and handloom traditions. The idea was not merely to create a museum of art or ethnography with a view to preservation, but to build a collection of craft specimens which would serve as source material for the revival, reproduction and development of crafts. The Museum would then be in a position to provide craftspersons with reference materials in order to re-establish weakening links with their forefathers' artistic creations.

The Museum's collection of more than 20,000 items consists of metal icons, lamps, incense burners, ritual accessories, items of everyday life, wood carvings, painted wood and pâpier mâché, dolls, toys, puppets, masks, folk and tribal paintings and sculptures, terracottas, ivories, playing cards, *bidri* work, jewellery and an entire cross-section of traditional Indian textiles. The collection truly reflects the continuing traditions of Indian craftsmanship as both old and new artefacts have been displayed side by side to demonstrate the high level of skill that has survived in India till today. The criterion of selection has never been antiquity per se rather, any piece of exquisite craftsmanship,conception, device or design has found a place here.

Over a period of 30 years, the Museum's collection has been acquired from collectors, dealers, the craftspersons themselves, as well as from actual users of craft items. Often, donations have been made by private individuals or organisations looking for a suitable "home" for their valuables. The cane and bamboo collection of the north-eastern states, put together by the National Institute of Design, Ahmedabad, for instance, is now part of the Museum's collection as will be the saris of the various states of India collected under the project "1001 Saris of India".

The Museum has also commissioned numerous master craftspersons with the intention of adding their work to its collection. For instance, Madhubani painter Ganga Devi, was asked to paint her masterpiece "Cycle of Life" between 1984 and 1986. The result of sustained encouragement has been a highly creative work, (nearly 3.6 metres long) that narrates, in evocative images, the "rites of passage" of an individual from birth to death and birth again.

The Museum, spread over an eight-acre complex, comprises three main sections: the permanent and temporary Exhibition Galleries and the Visual Store, the Village Complex, and the Craft Demonstration area. The excellently designed

building is the creation of the renowned architect Charles Correa. Placed between the simple rural huts of the Village Complex and the majestic Purana Qila, literally the "old fort" from ancient times, the building provides a harmonious mediation between the two. It does not over-power the rudimentary huts nor challenge the grand presence of the Purana Qila. In fact, it draws grace and elegance from both. The galleries, store, administrative areas, library and conservation laboratory are situated around a series of open-to-sky courtyards. Each courtyard with its *tulsi* (holy basil) shrines, *champa* trees, large storage vessel exhibits, carved wooden doors and windows and brick-paved flooring, has the charm of the traditional *havelis* of Rajasthan and Gujarat, as well as the simplicity of a contemporary building. The open walls, within and outside the building, are prominently "outlined" by terracotta-tiled roofs bearing images of monkeys, squirrels, birds, demons, lizards and spiders. The single most important feature of the building is its unique rustic ambience coupled with its modern functionality.

The Museum's Village Complex is a remnant of a temporary exhibition, on the theme of rural India, set up on the occasion of the exhibition Asia '72. Now spread over an area of six acres, the complex is an integral part of the Museum. It is made up of 14 structures representing village dwellings and courtyards from Kulu, Himachal Pradesh; Saurashtra and Banni in Gujarat; Madhubani, Bihar; Bhilwara, Rajasthan; West Bengal, Nicobar, Kashmir and tribal huts of the Adi Gallongs of Arunachal Pradesh, the Rabhas of Assam, the Ao Nagas of Nagaland, the Gadbas of Orissa, the Todas of Tamilnadu and the Gonds of Madhya Pradesh.

All the huts are built in facsimile with authentic construction materials and by villagers from the respective regions. In every hut, items of day-to-day life are displayed in order to recreate the cultural contexts in which they were actually used before they became museum pieces locked behind glass cases. Certain sections of the Village Complex have been recently converted into an open-air picture gallery. Here, mud and cow-dung plastered walls exhibit ritual and festive paintings done by tribal and village artists. These walls not only provide a fairly authentic idea of the village environment but also serve as a fresh canvas for the artists concerned to explore their creativity within the parameters of tradition and individuality.

The Village Complex has created among visitors a new awareness of and admiration for India's ancient cultural heritage. We hope it will symbolise the urgency of the need for the preservation of rural technology and traditional aesthetic values in a rapidly industrialising India.

The prime activity of the Museum is to invite craftspersons from all over India to demonstrate their craft skills in its rural environment for the benefit of visitors.

The Craft Demonstration Programme provides its visitors an opportunity to see the craftsman's creations unfold before their very eyes. Unlike assembly-line production, where the workers have little or no conception of the objects they are producing, the crafts-people possess a unified vision of their creations. The nature of the materials and techniques, the design and its execution, the socio-religious context and purpose of the creation are all ingrained in their consciousness. To watch a craftsperson at work, therefore, is like seeing the universe unfold before one.

The programme thus serves as a temporary field for observation by research scholars as well as by craftspersons themselves.

Moreover, the demonstration programme allows visiting craftspersons an opportunity to refer to the Museum's collection of artefacts and thereby revive their traditional techniques and designs which are often lost from living memory. It is for this reason that the main store is proposed to be designed as a visual store for easy access and reference to the collection.

The Museum has permanently employed two highly skilled craftsmen, hailing from traditional weaver families, to demonstrate the brocades of Varanasi, including *zari* brocade, the Baluchar and Jamdani techniques and *ikats* of Orissa, especially Sonepur. These weavers have been successful in reproducing old examples of their respective traditions selected from the Museum's collection.

The Museum regularly holds thematic workshops in certain craft techniques to provide a comparative dimension to a craft practised in different parts of the country. The metal casting workshop held in 1988, not only demonstrated the subtle differences in the *cire perdue* technique employed by metalsmiths, but also served as a forum for the improvement of casting techniques. It was discovered that while the metalsmith had a flawless creative vision, as was evident in the wax replica, it was after casting, especially among tribal metalsmiths, that the final image would lose its initial charm. The workshop, therefore, enabled craftspersons to interact with one another and learn from their mistakes.

To practise a craft as a hobby is a Western notion. As handcrafting of objects became rare in Europe due to mechanised production, the elite resorted to the practice of crafts as a hobby. In many parts of India, on the other hand, crafts have survived as a way of life. It is this aspect of crafts in India that the Educational Programme serves to highlight. The idea is to expose children to the traditional cultural heritage of India and provide them an opportunity to interact with traditional craftspeople, not only to acquaint themselves with their techniques and materials, but also to see how creative expression actually takes place.

Exposure to clay and potter's wheel, block printing and dye painting, modelling and metal casting, painting and narrating of stories, carving and inlaying in stone and wood and innumerable other media and techniques reassure Indian children that oil-painting on canvas is not the only mode of creative expression.

In addition to acquainting children with crafts, the Museum organises special Creativity Workshops. Here, a group of children is attached to a particular craftsperson, under whom they become familiar with the basic technique and materials and then use them for their own free expression. The best results are preserved for future exhibitions.

With mud plastered and thatched huts as the visiting craftsperson's workshops and brick-paved floors and stepped platforms as open-air "studios" for the children, the Museum has an ideal environment for interaction with creativity.

The Museum has a specialised reference library on traditional Indian arts, crafts, textiles and major anthropological works on Indian tribes. The library has about 10,000 books and files of such important periodicals as the *Journal of Indian Art and Industry, Lalit Kala, Roop Lekha, Marg, Rupam, Journal of Indian Folkloristics* and *American Anthropologist*.

Major systematic surveys of the arts and crafts in India were undertaken during the late 19th and early 20th centuries. The library has begun to acquire some of these rare and pioneering reports. A National Bibliography of Handicrafts and Handlooms, an exhaustive card index of themes related to the arts and crafts as well as a directory of craftspeople in India are under preparation.

A special research and documentation section studies the Museum's collection, the craftspersons and their crafts, and also undertakes field research through outside scholars. The Museum has also instituted regular monthly scholarships with a view to encouraging specialisation at higher academic levels in the field of traditional arts and crafts.

In traditional Indian society there was no sharp distinction between "art" and "craft". The Sanskrit word *shilpa*[1] refers to all forms of creative expression including skill, craft, a work of art or architecture, design, ritual, ability and ingenuity. Consequently, the word *shilpakara* denoted one engaged in *shilpa*.

The *shilpakara* or craftsman is described in the Vedas (literally, knowledge), the

sacred books of the earliest Aryan invader-immigrants, as the descendant of Vishvakarma, the maker of the universe and architect of the gods. In many parts of India, craftsmen worship their tools the day after Dipavali, the festival of lights, on the day of Vishvakarma puja[2].

The Indian craftsman perceives his creativity as a divine revelation and not merely as knowledge inherited and perfected over the years. The potters of Molela, in Rajasthan, believe that the Lord himself appeared in the dream of a blind ancestor and revealed to him the artistic representation and iconography of the equestrian deity, Dev Narayan, depicted with a serpent symbolising Lord Vishnu on a plaque done in hollow relief-work.

For the Indian craftsman, expertise lay not in conforming precisely to nature, but rather in presenting it in terms of stipulated norms of the collectivity. Many Hindu and tribal deities are represented in anthropomorphic forms with numerous arms or heads. In fact, the very character of Indian artistic manifestation is symbolic and pertains essentially to its intellectual content. A craftsman did not strive for individual appreciation. His skill and creativity were expressions of veneration and the intensity with which he carried out his sacred mission. An unknown craftsman once exclaimed, "Oh how did I make it?", when he finally viewed the product of his creation.[3]

When he produces ritual objects, the craftsman is perceived as the mediator between his patron and god. According to the Laws of Manu (Code V, 129), the craftsman is endowed with grace when he is engaged in the act of creation. His hands are said to be ritually "pure" and therefore his services essential in Vedic sacrifices.

Evidence is not lacking to prove that craftsmen organised themselves into guilds[4], or *shrenis*, with the intention of protecting their socio-economic interests, and undertook large projects on a collective basis, catering to the very specialised interests of their clients.

The function of art and craft in providing a livelihood, even today in India, is often surpassed by its more important function on major ritual events such as birth, initiation, marriage, death as well as annual and seasonal festivals. Here both the craftsman and his craft serve as significant ritual contributors in the ceremonies. On all these occasions an assortment of textiles and garments, vessels and utensils, toys, games, props and furniture is used. What is noteworthy, however, is that the same object used for mundane purposes attains a ritual value, a sacrosanctity, which then elevates the craft, and consequently its maker, to the realm of the sacred. These are, therefore, not items of "craft", made for the sole purpose of marketing; in reality, they form an integral part of the socio-religious order of traditional and contemporary village and tribal India. A simple clay or metal vessel used in everyday life attains the status of an important ritual accessory when it is used for lustrating a deity or when it contains offerings. An ordinary tribal wall painting is merely decorative until it is sanctified by the presence of the deity whence it gains potency as a ritual painting.

India's tremendous diversity in geography, climate, language and people adhering to widely different religions — the Jains and Buddhists, the Zoroastrians, the Christians, Muslims, and Hindus, who form a majority, as well as the tribal ancestor worshippers — is reflected in its varied artistic materials and forms.

The scattered dense forest belts are storehouses of ivory and different types of wood, which is ideal for the carving industry, while the north-eastern region, abundant in grasses of all types, is known for its varied techniques of basketry. Moreover, every religion has its own symbolic representations in art. The superb calligraphy and floral motifs of Islamic art is in high contrast to the numerous human and anthropomorphic forms and emblems of Hindu deities and mythical characters.

While the Vedic texts of the Aryans have been prescribing a somewhat conservative artistic paradigm for the Hindus since 1000 B.C., descendants of the so-called tribal dark-skinned Dravidians, who inhabit the remote forest areas of the Indian subcontinent, have inherited a more spontaneous and spirited artistic expression. Their myths, folklore, rituals, customs, food habits and dress, reveal timeless cultural patterns. Their highly simplified wall paintings are reminiscent of the prehistoric cave paintings of Europe and Africa. Their techniques of clay modelling and metal-casting are akin to those employed during the neolithic period of man's prehistory. Often abstract animistic forms have given way to emulating those of their Hindu neighbours, creating a distinctively folk form of a regional deity. Many invaders since the Aryans have conquered and settled in the country. The Muslims, who first came to India in the eighth century A.D., enriched the already existing culture with Islamic art and architecture in the North and the Deccan. They, in turn, absorbed and translated indigenous art forms into regal paraphernalia, with objects of jade, gold and silver fashioned after prototypes of terracotta, cane and bamboo. The later period of imperial domination, under the British, has also been incorporated in the folk artists' creative expression. English cavalry soldiers, guns, railway trains and alarm clocks are commonly represented in the *kantha* embroideries of Bengal and paintings of the tribal Rathvas and Bhils of Gujarat and Madhya Pradesh. It is from this vast framework that Indian culture has gradually burgeoned.

The following nine sections of the catalogue comprising more than 200 works of art, have been classified on the basis of an affinity between similar materials, processes, forms and functions.

Each section introduces a particular craft group in terms of its socio-historical background as well as the variety of techniques involved. It is followed by detailed descriptions of representative examples from the Museum's collection. These may represent a certain tradition, a particular technique or, simply, antiquity, exceptionality or the high level of craftsmanship.

All nine sections are nevertheless tied together with an underlying cognitive element distinctive of the socio-religious milieu of Indian culture. It is manifested in each individual item of craft in the distinctions between nature and culture, sacred and profane, collective and individual.

1. Kramrisch, 1959, p.18
2. Ibid, p.20.
3. Miller (ed.), 1983, p.56
4. Ibid, p.63

Museum objects on the whole were not
originally treasures made to be seen
in glass cases, but rather common objects
of the marketplace that could have been
bought and used by anyone.

Ananda Coomaraswamy

Cast in a void:
Metal-forms

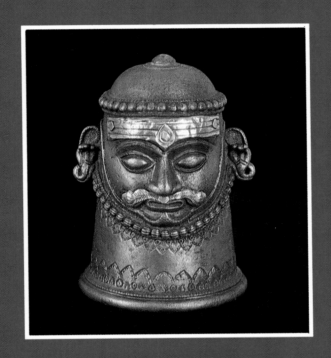

The earliest archaeological evidence of metal work in the Indian sub-continent is provided by the copper tools found at the pre-Harappan sites of Baluchistan, the Makran areas of Pakistan[1] and Kalibangan in Rajasthan, India, dating back to *c.* 3000 B.C. Several copper and more abundantly bronze[2] antiquities have also been discovered at Mohenjodaro and Harappa, including the famous figure of the so-called "dancing girl"[3] excavated at Mohenjodaro (*c.* 2500 B.C.). In fact, the Indus Valley culture is said to belong to the Bronze Age.

Literary evidence from the *Rigveda* (*c.*1000 B.C.) states that copper and bronze-smithy was a specialised science and that craftsmen were held in high esteem. Though the term *ayas* in the *Rigveda* came to mean "iron" later on, during that period it probably denoted bronze and/or copper.[4]

The 42 cm. high anthropomorphic copper-sheet figure excavated at Bisauli, Uttar Pradesh, has been assigned a date of *c.* 1000 B.C. providing us with archaeological evidence of a superbly conceptualised image belonging to the Vedic period.

Both the literature and the metal images excavated by archaeologists provide enough evidence to establish the fact that the art of bronze casting has been continuously practised in India for more than five millenia.

It is well-known that even after the advent of copper tools, stone implements continued to be used and that the basic forms of many copper tools of the Chalcolithic Age were quite similar to their prototypes in stone.[5] This process, of superimposing pre-existing forms and technologies onto new materials, is clearly observed in the fashioning of a number of metal objects by Indian craftsmen. Most domestic utensils, ritual accessories and objects of daily use, both old and new, presuppose a prototype in gourd, leaf, terracotta, leather or other objects in nature. The *lota*, the most versatile of all Indian pots, derives its basic shape from the gourd.[6] Even today, in the tribal areas of Gujarat, a gourd with a rotund belly and thin long neck is used as a *doyo* or ladle. The metal replicas of these are not only known by the same name, but also presume the same form.

In the Deccan and Malabar coast in the South, a variety of copper and brass plates faithfully imitates their plantain leaf forerunners, complete with the leaf's spine and veins.[7] Amazingly enough, the custom of eating from a leaf has continued in this region.

Among scores of other natural products, the melon, mango, pumpkin, coconut and lotus have more obviously determined the forms of many Indian artefacts in metal. The gadroon or series of convex flutings of the melon, has inspired the shapes of many pots, betel leaf and lime containers.[8] The mango, the best loved Indian fruit, has served as a prototype for the shapes of a variety of betel and lime boxes and *hukka* bases.[9] Even the shell of the coconut seems to have prompted many craftsmen to fashion containers in facsimile.[10]

In the desert regions of Western India, it is customary to use leather bottles for water and alcohol. The present day brass water bottles used by the camel riders of Jaisalmer, Kachchh and Sind are such direct adaptations of their leather precursors that even the joinery, frill work, piping and embroidery, which are natural only on soft materials like leather, are literally transferred onto the brass reconstructions.[11]

The animal kingdom has likewise been a continuous source of inspiration for Indian craftsmen. Betel boxes in the shape of elephants; nutcrackers, hairpins,

Previous Page
***Mukhalinga,* Shaivite deity in phallic form.** Brass and silver; 14 cm x 9 cm. Maharashtra. c. late 19th century. 7/179.

The worship of the *linga*, the phallic emblem of Shiva, is known from very ancient times. Stella Kramrisch explains its significance in Indian cosmology: "The propinquity in a *mukhalinga* ('face *linga*') of face and *linga*, a seemingly startling juxtaposition, is the compacted symbol of the beginning and the end of the ascent of the seed and its transubstantiation in the 'subtle body' of the yogi from the basic station of consciousness or centre of realization (*cakra*) at the root center (*muladhara*) at the base of the spine, to the highest *cakra* at the *brahmarandhra* on the top of the head. The alchemy within the 'subtle body' of the yogi has its synoptic image in the juxtaposition of face and *linga* in one sculptural shape. The *mukhalinga* presupposes yoga practice and realization, and depicts in one image its beginning and end. The method of unilocal or synchronous precipitation of several phases of a process or narrative in one picture is common knowledge in Indian art, as it is in early Christian art and elsewhere."[1]

The integration of abstract and figural, or expressive forms, is perfectly realised in this Shaivite icon. The iconographic symbols of Shiva are clear in the third eye on the forehead and the tiny curled snakes as earrings.

[1] Kramrisch, 1981, p.XVI

16

combs, foot scrubbers, *sindoor* (vermilion), and kohl containers in the form of parakeets and peacocks; lamps, locks, weight measures and a host of other items of everyday life,[12] in varying bird and animal motifs, have all been incorporated in the mind's eye of the metal worker, not so much to fix upon metal beautiful forms which gratify the senses, as to embody his thoughts and ideas with the corporeal and the tangible.

Whether it be in the worship of the sun or moon, tree or serpent, ancestors or deities, man has always considered himself as a mere mortal in the face of immortal divine forces. It is this ideal of immortality, in almost all religious world-views of India, that is manifested in the belief that objects of sacred value must be eternal and therefore may be created from non-ephemeral materials such as gold, silver, copper and bronze.

Metal icons used for everyday temple rituals, festivals and household worship all over India, are generally preferred to stone images. In South India, metal icons, especially of bronze, are believed to absorb the charged energy of the divine which is stored in the inner sanctum of a temple where the icon is installed. At festivals these icons, with the transferred energy, are carried around in procession for the common folk to take *darshan*.[13] During this period the inner shrine is not worshipped as the deity's energy or power is no longer said to reside in it.[14]

Moreover, in India, each metal is believed to possess its own alchemic and healing properties. Metals have consequently attracted more attention in the *Ayurveda* (the body of Indian medical science) than as an independent branch of chemistry. A ritual handbook from the South (around A.D. 900) states that "an image of gold gives welfare, of silver, renown, of copper, prosperity, of brass offspring."[15]

The image itself, whether of gold, silver or an alloy of several metals, is really a symbolic representation of a metaphysical concept. The famous "spirit riders" or equestrian deities of tribal India are clan ancestors of many tribes,[16] while deities like Jhitku and Mitki are *gram devatas* or village deities of the Gonds of Madhya Pradesh. Each metal image is invested with its peculiar indigenous socio-religious history and is extremely auspicious for its devotees. Similarly, Ganesha, the elephant-headed god is a familiar *lietmotif* in the creations of nearly all metalcraftsmen in India. Whether he is represented with an aureole or not, whether his iconic representation strictly adheres to the Hindu ideal or not, Ganesha is still the bestower of boons, the remover of all obstacles, and no important event in a Hindu's life will begin without invoking his blessings. Thus the icon no longer remains a mere creation in metal but is instead imbued with a sacred essence for its worshippers.

If the metal image itself is elevated to the realm of the sacred, the actual process and technique of casting the image is no less a religious experience in India. By the age-old technique of casting by the lost-wax or cire perdue[17] process, metalsmiths all over India produce a variety of icons, utensils, objects of daily use and ornaments. In this method, the form, the details of texture and surface ornamentation are entirely governed by the mode of modelling and casting.

While the technique of solid casting is predominant in the South, mainly in Tamilnadu (Swamimalai in Thanjavur, Tiruchirapalli, Madurai, Chingalpet and Salem), Bangalore and Mysore in Karnataka, Palghat in Kerala and Tirupati in Andhra Pradesh, that of "hollow" casting is largely prevalent in Central and Eastern India. As the name suggests, the lost-wax technique involves the creation of a solid or hollow (in which case an inner clay mould is required) replica of wax or a wax-like substance, of the image to be cast. The wax from this replica is melted and allowed to flow out, leaving a void to be later filled in by molten metal. Unlike reusable moulds of modern casting technology, the lost-wax method requires each metal image to be created afresh from a different mould so that no two images can ever be identical.

Significantly, modelling of the envisaged image is the stage where the craftsman's creativity is most apparent. For the metalsmith of the Kammalan[18] community of artisans in the South, who claim descent from Vishvakarma, the architect of the gods, even while the measurements, proportions, iconic details, raw materials and procedure for casting the image are clearly laid down in the *Shilpashastras*,[19] the actual transference of the image from the written word to his mind's eye and from there onto his hands, that will finally model the image in beeswax, requires the deep meditative faculties of an ascetic who is both dedicated to his task and ritually purified for it.

While the texts dictate the parameters within which every *sthapati* or traditional architect-sculptor must function, no two *Natarajas*, the dancing Shiva, made by different craftsmen, can ever have the same sculptural rendering. It is only when the craftsman internalises and becomes one with the notion of the image he is to cast that true creative expression takes place. The *Agni Purana* dictates the following prayer for every *sthapati* to recite on the night before his work commences: "O, thou Lord of all the gods, teach me in dreams how to carry out all the work I have in my mind."[20]

For the Achari craftsmen of Aranmula, Kerala, the closely guarded secret of the unusual metallic mirrors is also a divine revelation. According to a legend, the technique was revealed to Parvathi Amma of the Vishvakarma community in her dream. According to the two brothers who are solely known to possess the secret, the highly reflective surface of the metal is due to the addition of powdered herbal leaves in molten metal. The identity of the herbal leaves is still unknown.

In contrast to the traditional metalcasters of the South, the tribal metalsmith's[21] creative imagination is not dictated by canonical scriptures and instead is a spontaneous expression of a communal tradition.

The tribal metalcraftsman fashions his images in the manner of his forefathers by the same procedure of drawing out wax wires and carefully wrapping them over the inner clay core, adding here a tiny pellet, there a spiral, elsewhere a fret, chevron or lattice pattern. His creativity lies not in mere surface ornamentation but rather in his representations of nature and especially in his deviations from it.

The most crucial stage in the lost-wax technique is the metamorphosis of the wax replica into its metal image. This is done by covering the former with clay, usually mixed with rice husk, so that an impression of the wax replica may be formed on the inner wall of the clay mould. A channel is left open on this outer mould for the subsequent pouring in of molten metal. For the metalsmith, whether he is a member of the Kammalan caste or a tribal, this precarious act of the actualisation of an image inside a dark womb-like mould, in the period between the running-out of the wax form and the pouring-in of the molten metal, is one of extreme anxiety. In other art forms such as painting and stone carving, the artist is continuously in touch with his work whereas, in the cire perdue technique he loses physical contact with his creation exactly at the moment when it comes into being.

The hollow casting practised in the tribal complex of Central and Eastern India is far more archaic than the solid casting prescribed in the texts and is instead recorded only in living memory. This "tribal" complex of metal casting exists "in and around the great forest belt flanked by the Vindhyas and the Eastern Ghats, bordering Bihar, West Bengal, Orissa and Madhya Pradesh."[22] The metalsmiths, usually rather impoverished, are known as the Dhokras and Mals[23] in West Bengal, Malars in Bihar,[24] Thetari Ranas[25], Ghantrars and Sithrias[26] in Orissa, and Jharas[27] and Kasers or Gadhvas[28] in Madhya Pradesh. It is noteworthy that all the metalsmiths of these regions and several others such as the Gadulia Lohars[29] or blacksmiths of Rajasthan and Haryana have been itinerant craftsmen migrating from one region to another, in search of work.

Once made, metal utensils, ornaments and icons, last a long time and consequently the consumption in a single village would be rather low at a given time. Metalsmiths of these areas, therefore, moved from village to village, setting up their foundries in camps for a short period till they exhausted their clientele. In the process they imbibed and disseminated their knowledge of materials, tools and techniques and became deeply conscious of the cultural ethos of their clients.

In spite of their general affinity in casting by the cire perdue process, the bronzes of each region have their own individual characteristics both in form and technique. In addition to the objects of daily use such as grain-measuring bowls from Bihar, anklets from Bastar, decorative containers, lamps and incense burners from Orissa, an amazing range of images of deities, votive animal figures and mythological characters are made all over Central and Eastern India.

The Kuttia Kondhs of Ganjam and Koraput districts in Orissa are known for their bronze figurines, a description of which has been published by E. Thurston as early as 1909. This documentation has escaped the attention of almost all scholars writing on the subject in later years and therefore a full quotation will not be out of place here:

"Reference has been made above to certain brass playthings, which are carried in the bridal procession. The figures include peacocks, chameleons, cobras, crabs, horses, deer, tigers, cocks, elephants, human beings, musicians, etc. They are cast by the cire perdue process. The core of the figure is roughly shaped in clay, according to the usual practice, but, instead of laying on the wax in an even thickness, thin wax threads are first made, and arranged over the core so as to form a network, or placed in parallel lines or diagonally, according as the form of the figure or fancy of the workman dictates. The head, arms, and feet are modelled in the ordinary way. The wax threads are made by means of a bamboo tube, into the end of which a moveable brass plate is fitted. The wax, being made sufficiently soft by heat, is pressed through the perforation at the end of the tube, and comes out in the form of long threads, which must be used by the workmen before they become hard and brittle. The chief place where these figures are made is Belugunta, near Russellkonda in Ganjam."[30]

Jagdalpur, Pahur Bela, Chote Dongar, Alwaye and Kondagaon in Bastar, Madhya Pradesh, are important centres where the Gadhvas, also known as Ghasias, use beeswax for modelling votive figures of tigers, horses, boars, elephants, bullocks and a variety of deities such as Khanda Kankalini, Pillobai Mata, Hanuman and Bhairon.[31]

The Roopankar Museum of Bharat Bhavan, Bhopal, was responsible for bringing to light a whole school of bronze casting by the Jhara[32] metalsmiths of Ektal, Manora, Bargandi, Singoradongripali and Salar villages in Raigarh, Madhya Pradesh. Using *dhuvan*, a pliant vegetable gum and hand-drawn rather than press-ejected wires, the Jhara metalsmiths model remarkable figures of *dakinis* or demonesses, scenes of childbirth, erotic couples on trees, their local Karma festival, women carrying pitchers or firewood and a host of wild animals.

In Maharashtra, Khandoba,[33] an aspect of Bhairava and protector of the land, is depicted as a horse-riding deity by the metal craftsmen of the region, while in Andhra Pradesh and Tamilnadu the divinity *par excellence*, at the rural and tribal levels, is Aiyanar[34] who is also depicted in his metal image as a majestic horse-rider.

From casting to ornamentation of metalware, surface decorations are attained by the processes of punching, engraving, *repousse*, relief casting, as in plaques, inlaying and enamelling.

The tradition of embellishing the surface of one metal with that of another, usually gold and silver, was introduced into India from Persia and reached its apex under the Muslim kings from the 16th to 17th centuries A.D.

The technique of inlaying gold and silver wire on steel and iron, usually on swords, daggers and shields, is referred to as damascening. In contrast, the inlay of gold and silver wire on the blackened surface of an alloy of zinc and copper is called *bidri* after Bidar, a town of its patronage and production for nearly 300 years in the Deccan.[35]

While in true damascening a fair amount of gold or inlaying metal is required, in false damascening, or *koftgari*,[36] the previously scratched design on the surface of iron or steel is simply inlaid with gold or silver wire with the help of a hammer. The surface is heated and hammered again so that the soft gold may spread into the grooves of the design. Thus the gold or silver becomes one with the base metal producing a smooth embellished surface.

Bidri ware,[37] in contrast, is made from an alloy of zinc, copper, tin or lead which, when treated with a solution of copper sulphate, blackens the metal only temporarily. The inlay process involves sketching the design onto the surface of the object using a *kalam* or a needle-sharp implement and then engraving and chasing the design with a *cheelne-ki-kalam* or chisel. This is followed by the *chappat-kalam* or the blunt-edged chisel for precisely embedding the fine silver or gold wires, previously drawn from a *taar-patti* having holes of varying diameters, onto the surface. This technique, also called *tarkashi*, is in contrast to the *teh-nishan* or *lala* technique, where gold or silver sheets are embedded onto the surface of the alloy, previously chased and hammered into place.

Once inlaid, the surface is lightly filed or sandpapered and finally dipped into a hot solution of ammonium chloride and Bidar clay, available only in the ruins of the fortress and responsible for imparting the black colour to the metal. It is believed that no lime was used in constructing buildings in the older days and therefore the clay found there was pure and contains saltpetre. Others maintain that the Bidar clay contains gunpowder, a remnant of bygone wars in the fortress. The permanently blackened surface is then burnished with oil in order to restore and heighten the inlaid metal's soft iridescence against the dark hue of the metal.

For millenia, the Indian metalsmith has known various methods of metal working and has created forms with the vision, conception and sensitivity of a sculptor. Be it the "hollow" or "solid" method of casting by the cire perdue technique, where each object, cast from a fresh mould, has an identity of its own, or the working of metal by hammering, forging or surface ornamentation, each form has an organic naturalness, a genuine three-dimensionality, textural vividness and a timeless beauty that underlies a unique synthesis of form and function.

1. Fairservis, 1975, p. 158; 205
2. Bronze is essentially an alloy of copper and tin. In fact, "the best tools used at Harappa and Mohenjodaro were of bronze, sturdy and serviceable...." Kosambi, 1972, p.59"
3. Evidence suggests that the "dancing girl" was probably cast by the "lost-wax" method and is probably the earliest evidence of the technique in India. Reeves, 1962, p.20
4. Agrawala, 1977, p.40-41
5. Jain, 1981b
6. Ibid. p.3 ; fig. A-1, A-2, B-1, B-2
7. Ibid. p.4 fig. C-1, C-2
8. Ibid. p.4 fig. E-1, E-2
9. Ibid. p.4 fig. F-1, F-2
10. Ibid. p.4 fig. G-1, G-2
11. Ibid. p.6 fig. I-1, I-2, I-3 and Jain, 1981a., Plates 155, 156
12. Jain and Jain-Neubauer, 1978 and Jain, 1984b
13. See Eck, 1981, for a clear understanding of the concept.
14. Reeves, 1962, p.108, fn.69
15. Goudriaan, 1965, p.165
16. Kramrisch, 1968, p.52
17. See Reeves, 1962 and Mukherji, 1977; 1978, for a detailed discussion on *cire perdue* casting in Central and Eastern India.
18. Thurston, 1909, Vol.III, p.106
19. "The earliest *Shilpasastra* that describes the lost-wax process is the *Madhuchchhish-thavidhanam* as recorded in the 68th chapter of the *Manasara*, believed to have been compiled in the Gupta period." Reeves, 1962, p.29.
20. Coomaraswamy, 1948, p.43-44, fn.1
21. Here, tribes are broadly taken to be those secluded hill and forest dwelling communities who have a distinct language and have been scheduled as "tribes" under the constitution of India. Besides tribals, the metalsmiths of the central and eastern region include professional metalsmiths who make items for the use of tribals.
22. Mukherji, 1977, p.1
23. Reeves, 1962, p.42
24. Mukherji, 1977, p.1
25. Reeves, 1962, p.66-69
26. Mukherji, 1977, p.10-12
27. Khan, April 19, 1985
28. Reeves, 1962, p.81
29. For details, see Misra, 1977
30. Thurston, 1909, Vol.III p.391-392
31. Jain, unpublished manuscript
32. In conversation with J. Swaminathan, Director, Bharat Bhavan
33. For details see Sontheimer, 1983
34. Inglis, 1985, and Dumont, 1970
35. Mittal, 1986, p.45
36. Pant, 1986, p.24-31
37. See Census 1961b

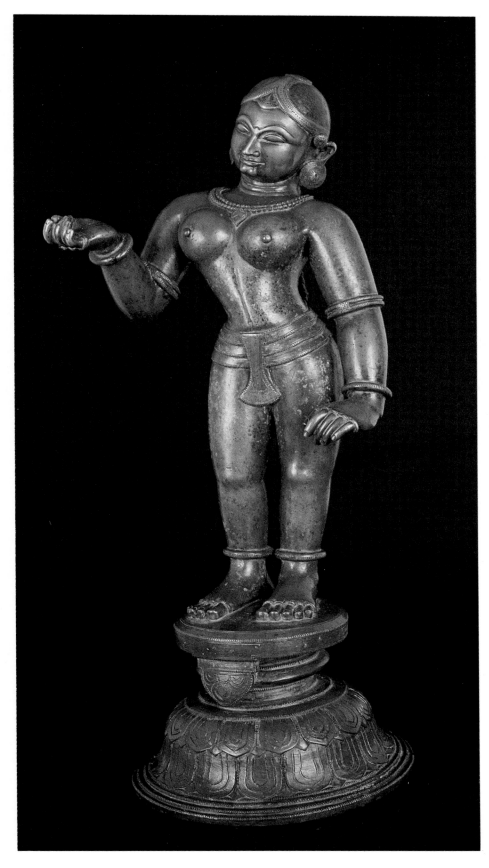

Radha, God Krishna's consort.
Bronze; 51 cm x 23 cm. Orissa, c. 18th
century. 82/6507.

Krishna, one of the incarnations of
Vishnu, is described in mythology as a
many-faceted god, a "divine and lovable
infant, mischievous shepherd boy; lover
of all the milkmaids in the herders'
camp, husband of innumerable
goddesses .., yet devoted to Radha
alone in mystic union".[1] His beloved
Radha's devotion for him has been
immortalised as the symbol of spiritual
love.

In this image, a scantily clad Radha is
shown beckoning her Lord Krishna by
a graceful gesture of the right hand.
Standing in the classical *tribhanga*
posture, where the delicate tilt of the
head, waist and knee conform to the
traditional Indian ideal of beauty, the
bronze figure truly captures the
adoration of Radha for Krishna.

[1] Kosambi, 1972, p.114

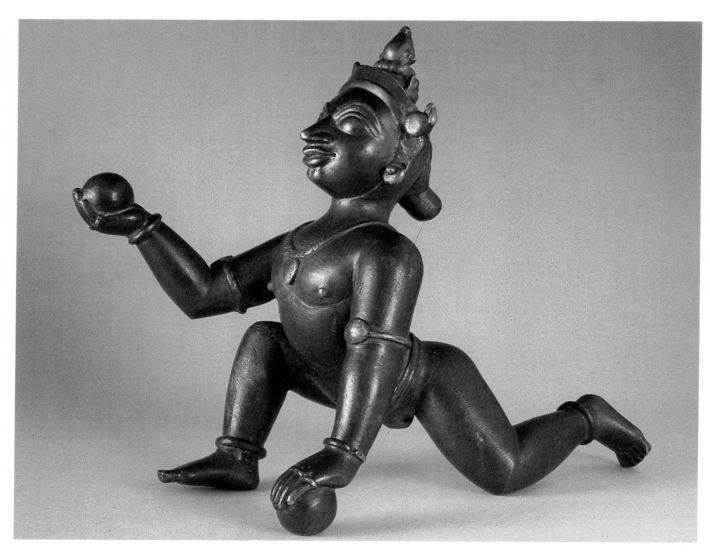

The child Krishna holding a lump of butter. Bronze; 23 cm x 22 cm. Orissa. c. 18th century. 16/220.

Having been brought up among cowherds, Krishna is renowned for his fondness for home-chu + rned butter. There are numerous references in myths and legends of him mischievously stealing butter from the houses of neighbouring cowherds. Devotional poetry of the mediaeval period, especially that of Surdas, elaborately describes how Krishna, with his cowherd companions in their amorous adventures, held up the path of young herdswomen under the pretext of demanding butter as "toll".

This is one of the three types of images of the child Krishna conceptualised in Vaishnava iconography, the other two being the child Krishna lying on a *pipal* leaf (*Ficus religiosa*) sucking his toe, and Krishna quelling the ferocious snake Kaliya.

In this bronze image Krishna is shown wearing a crown indicating his divine status even in childhood. His hairstyle with a lotus-bud-shaped bun, pointed crown, thick lips, large eyes, plump body and broad shoulders are typical features of Orissan bronzes of this period.

Opposite page, left
Krishna playing the flute. Bronze; 28 cm x 9 cm. Himachal Pradesh. c. 18th century. 84/6737.

Krishna is typically depicted and worshipped as the divine musician whose spiritual message is echoed in the enchanting notes emanating from the flute. It is said that his women companions, especially Radha, were mesmerised by the melodious call of the flute.

Tormented in Krishna's love, Radha tells her friend:

"Sweet notes from his alluring flute echo nectar from his lips.
His restless eyes glance, his head sways, earrings play at his cheeks.

My heart recalls Hari here in his love dance,
Playing seductively, laughing, mocking me".[1]

In this figure, a flute-playing Krishna is rendered in a slender, elongated folk form with an elaborate costume and a characteristic crown, typical of bronzes from the hill state of Himachal Pradesh.

[1] Miller, 1977, p.78, stanza 1

22

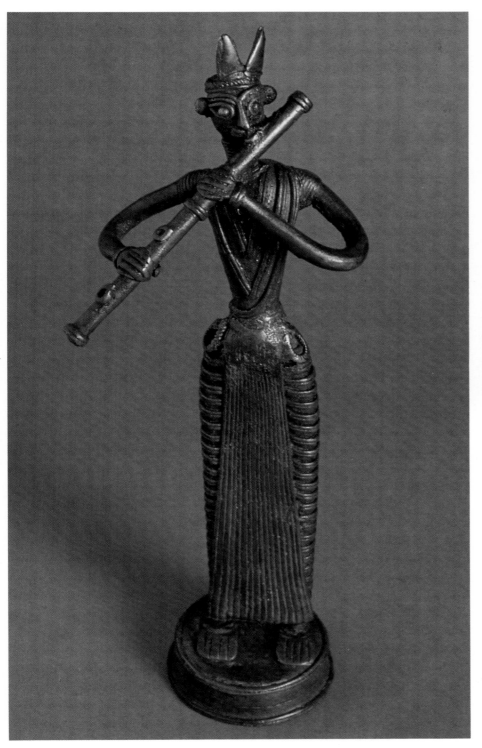

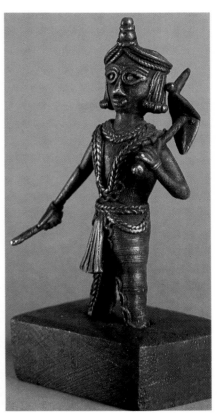

Balarama carrying a plough over his shoulders. Bronze, cast in the cire perdue technique; 17 cm x 7 cm. Eastern India, perhaps Bihar. Contemporary. 84/6719.

In some sectarian texts of Hindu mythology, Balarama, also known as Balabhadra, the white-skinned brother of Krishna, is considered to be the eighth incarnation of Vishnu while Krishna is worshipped not as an incarnation but as the deity himself. In other accounts both the brothers together form the eighth incarnation, Krishna being created from a black, and

Balarama from a white hair of Vishnu, from the wombs of Devaki and Rohini respectively. Being constant companions, the brothers were together in most of their adventures during their childhood at Ambadi.

The *Vishnu Purana* deals somewhat differently with the character of Balarama. He is known for his predilection for all sorts of liquor. A legend narrates his impudent demands after consuming too much alcohol. While strolling in the forest, the intoxicating fragrance of the flowers of the *kadamba* tree transported him into a state of inebriation. He called the river Yamuna to him so that he could bathe in her. When she refused, he got angry and threw his plough into the river and forcibly dragged her towards him. She was compelled to follow him till his anger was appeased and he finally set her free.

Iconographically Balarama is usually depicted with a drinking horn in one hand and a plough in the other which may also be hung across his shoulders.

In this image, created by the cire perdue process of metal casting, Balarama is depicted in a righteous pose with large eyes, side locks and hair tied into a conical top-knot. The breast ornamentation, in style with other figures of the region, consists of several concentric rings of necklaces and a long elaborate necklace hanging right down to the navel.

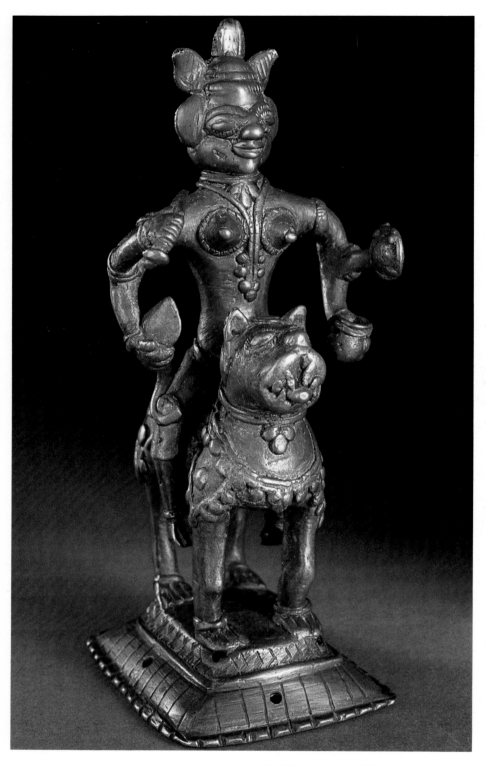

Shumbha, Nishumbha and Mahisha. As the slayer of Mahisha, or the buffalo demon, she rides a tiger (or lion) who is supposed to be a form of Shiva himself. The *Durgasatanama Stotra* of *Visvasaratantra* describes her as the "mother of gods, essence of all existence and knowledge." [2]

In iconography Durga is usually depicted astride a tiger (or lion) with four, eight or 16 arms holding various weapons.

The goddess's three-pronged crown, human facial expression, slender figure, powerful posture and rudimentary modelling of the image are some of the typical features of the folk bronzes of Himachal Pradesh.

[1] Woodroffe, 1973, p.150
[2] Ibid, pp.81-82

Opposite page, left
Mohara, mask of goddess Mujuni Devi. Bronze; 24 cm x 15 cm. Kulu region, Himachal Pradesh. c. 19th century. 7/3469.

This mask of the goddess Mujuni was actually used as a full-fledged icon in conjunction with a stuffed body dressed in a sari and decorated with flowers. During certain festivals these icons are taken out in procession around the village to sacred spots in the fields. The circumambulation of the goddess secures the boon of prosperity for the people, animals and harvest.

The face of the goddess, executed in the *repoussé* technique, is delicately conceived. Her tender smile and peaceful eyes reveal her benevolence towards her worshippers. Her many-pronged crown and elaborate ornamentation on hair, ears and neck, emphasise her divine status. Only the two snakes around her tiny breasts are reminiscent of her affinity to Lord Shiva.

Masks of this kind are known to date back to the 12th century and also to represent Lord Shiva. [1]

[1] Pal, 1975, p.86

Goddess Durga riding her vehicle, the tiger. Bronze; 16 cm x 7 cm. Himachal Pradesh. c. mid 20th century. 84/241.

Durga literally means "the one who is difficult to reach". She possesses many different forms such as Parvati or the consort of Shiva, Ambika, Bhadrakali, Vedagarbha, Devi. In the *Mahabharata* she is described as the "dark virgin, observant of the vow of chastity and giver of blessings" [1]. The Devimahatmya of the *Markandeya Purana* describes at length her noble acts of destroying the demons

Opposite page, right
Mother and child. Bronze; 23 cm x 8 cm. Southern India. c. 18th century. 7/4146.

The Indian concept of motherhood is sensitively visualised and captured in this bronze figure from South India. The divine female, divine because she seems to be holding the Vaishnava emblem of a conch shell, is carrying a suckling child. Her upright posture, proudly raised head, slender hips and slightly protruding, well-formed belly are traditional ideals of feminine beauty.

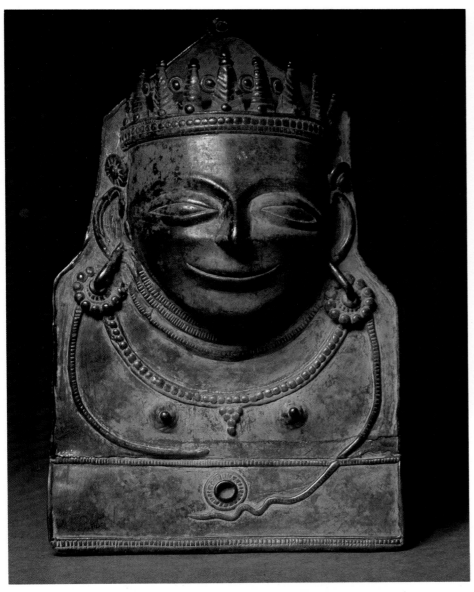

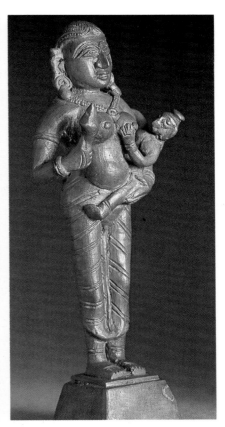

The details of the South Indian style are recognisable in the way her hair is combed, the elongated, slightly slanting eyes and the design of the lower garment.

Nandi, bull vehicle of Lord Shiva.
Bronze; 26 cm x 15 cm. South India.
c. early 20th century. 7/2564.

Nandi is the name of several of Shiva's attendants and later crystallised as the name of Shiva's favourite attendant and vehicle, the bull. The term *nandi* is derived from the Sanskrit root *nand* meaning "to rejoice" or "be pleased". It also means "the happy one". In Hindu mythology the bull, Nandi, is the embodiment of strength, power, courage and manly vigour.

A figure of Nandi, often in life size, is usually placed in the centre of the *mukhamandapa* or entrance hall of a Shiva temple, in such a way that it faces the main idol of Shiva in the *garbhagriha* or inner sanctum. It is either in a standing or, more usually, in a seated posture.

Smaller bronze images of Nandi are worshipped in domestic shrines along with other Shaivite images, or carried in procession, as in the case of this Nandi figure elaborately decorated with bells around its neck, which has small rings attached to its pedestal.

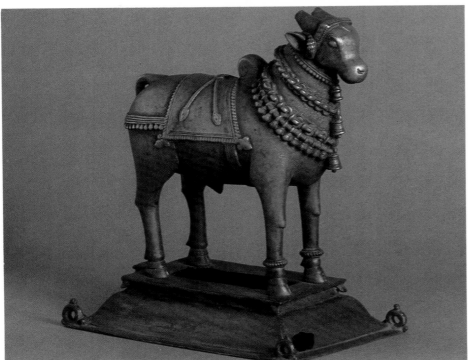

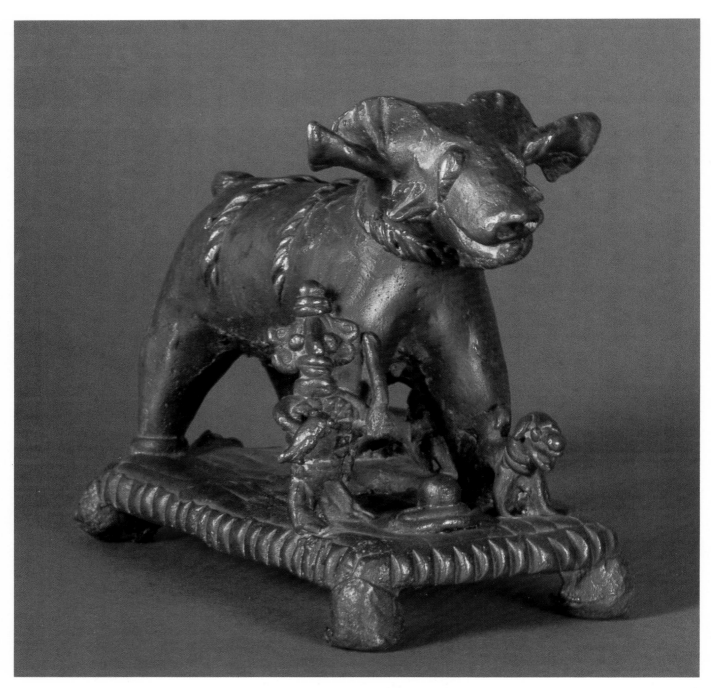

God Bhairava along with his victim the ram. Bronze; 11 cm x 7 cm. Maharashtra. c. 19th century. 7/3458.

This miniature domestic shrine consisting of a cluster of figures on a pedestal representing Bhairava are quite commonly found all over Maharashtra. Bhairava or Kal-Bhairava, the 'black-one', is associated with the dreadful aspect of Shiva, born as a result of his fury towards Brahma and Vishnu who had become extremely haughty. The moment he was born, it is believed that "Bhairava rushed towards Brahma and pinched off his fifth head which had insulted Siva." [1] Bhairava, locally known as Khandoba in Maharashtra, is usually depicted along with his consort Yogeshvari wearing a crescent moon on his plaited hair, holding a weapon, along with a

bull, dog, snake and sometimes a ram or a horse.

Here, he is shown in his folk representation, holding a weapon in his left hand and standing small beneath the looming figure of the ram. Also depicted on the pedestal is the figure of a barking dog. The disproportionately minute size of the human representation of Bhairava in comparison with the ram is an interesting feature of this icon.

[1] Mani, 1984, p.115

26

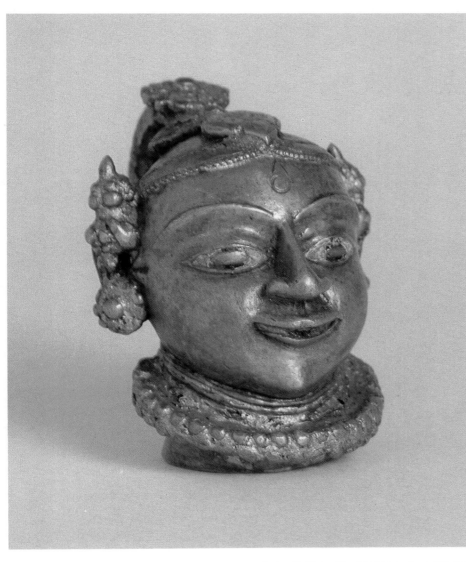

Head of goddess Gauri. Bronze; 9 cm x 7 cm. Maharashtra. Early 20th century. 5/314(2).

Gauri is another name and aspect of Parvati, the consort of Shiva. The origin of goddess Gauri is explained in a legend that goes as follows: After their marriage, Shiva and Parvati were travelling around the world. Once when Shiva called out to his consort, "Come Kali", (Kali means the "black one"), Parvati was offended and decided to leave. Brahma, the Supreme Deity, granted her a boon as a reward for her austerities and said: "Virtuous woman, from today onwards, your black complexion would change into one of the hue of a lotus petal. Because of that *'gaura'* or hue you would be called 'Gauri' " [1] meaning the "white one".

Gauri is particularly popular in Maharashtra and is worshipped during festivals by creating a body out of several plants and affixing such a brass mask on top. This mask is particularly charming with its soft feminine features, delicate lips, almond-shaped eyes, long drawn eyebrows, ornamented hairline and hair braid, looped and affixed on top of the head.

[1] Mani, 1984, p.578

Mask of Bhairava, the terrible aspect of Shiva. Brass; 30 cm x 24 cm. Maharashtra. c. 19th century. 7/5981.

Masks of Shaivite deities are commonly venerated all over the country. Such masks were usually placed inside a mobile shrine, comprising a basket, a wooden chest or attached to a stick, and carried around from house to house by itinerant mendicants for the ritual benefit of their devotees.

A cobrahood crown, Shaivite forehead mark, protruding eyes, fanning ears, large moustache and prominent canines are typical features of Bhairava[1] masks which are extremely popular in Maharashtra and Karnataka, where these are part of the broader cults of guardian deities such as *vira* (hero), *naga* (snake) and *bhuta* (spirits of deceased ancestors).

[1] See also Cat. No. I/9.

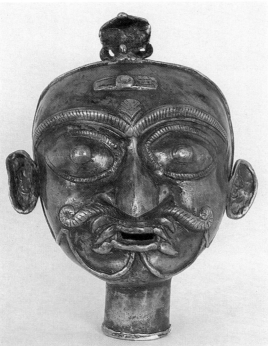

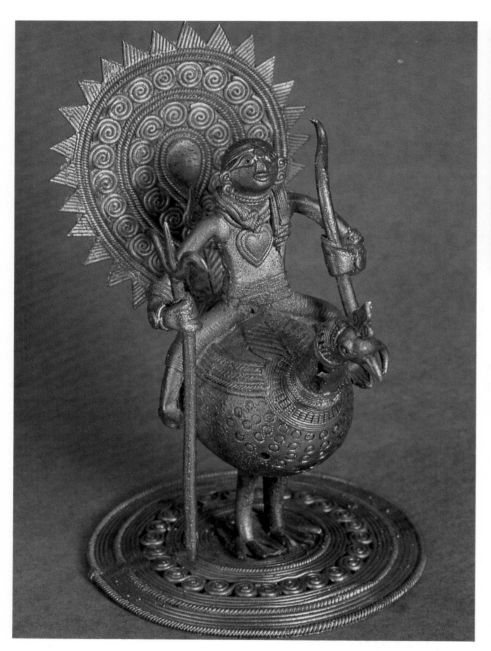

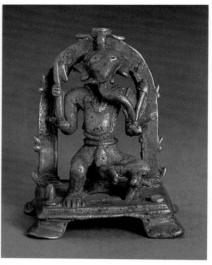

Ganesha, the elephant-headed god.
Bronze; 9 cm x 7 cm. North India.
c. early 20th century. 7/4274(9).

Ganesha occupies the most prominent
place amongst all Shaivite deities. In
South India, temples dedicated to
Ganesha are known from the sixth
century during which period such
images must also have been made.
Ganesha is usually installed at the
gateways of villages and fortresses and
at the entrance to temples, generally as
a small carving in the centre of the
lintel. He is worshipped as a deity who
removes all obstacles and is, therefore,
also called Vighneshvara (remover of
obstacles). Hence the practice of
worshipping Ganesha at the
commencement of any auspicious event.

Iconographically two types of Ganesha
idols are known: those with the
proboscis or trunk turned to the left
and those with it turned to the right.
He is usually depicted with two or four
hands, in one of them he normally has
a bowl of sweetmeats of which he is
extremely fond and is invariably
accompanied by a mouse, his vehicle.

This small idol of Ganesha is a
charming depiction of the
elephant-headed deity used for personal
worship in a household shrine. The
broad platform and the *parikrama* or
aureole complete this idol as a
miniature domestic shrine.

Opposite page
Ganesha, the elephant-headed god.
Bronze; 11 cm x 7 cm. Maharashtra.
c. early 20th century. 7/5033.

This highly imaginative figure of
Ganesha[1], seated on a throne-like
pedestal, holding the *damaru*, an
hour-glass shaped hand drum, sweets, a
weapon and a rosary, was probably
installed in a domestic shrine. The
round pellets affixed as eyes, flapping
ears, slender body, yet protruding belly,
and prominent crown are typical
features of bronzes from Maharashtra.

**Kartikeya, son of Shiva, riding a
peacock.** Bronze; 17 cm x 11 cm.
Eastern India, perhaps Bihar.
Contemporary. 7/4556.

When Shiva's newly-born son,
Subrahmanya, was found crying in the
forest, six divine Krittikas, out of pity,
breast-fed the child one after the other.
He, therefore, developed six faces and
became known as Sanmukha, meaning
"one with six faces". The Krittikas
asked Shiva whether Sanmukha was his
son, to which Shiva answered: "Let
him be your son under the name
Kartikeya...".[1]

Kartikeya is usually depicted riding his
vehicle the peacock as in this icon
where he is shown holding a trident
and bow. The peacock is ingeniously
conceived, its tail wings fanning out to
form a halo around the deity.

[1] Mani, 1984, p.748

[1] See also Cat. No. I/14

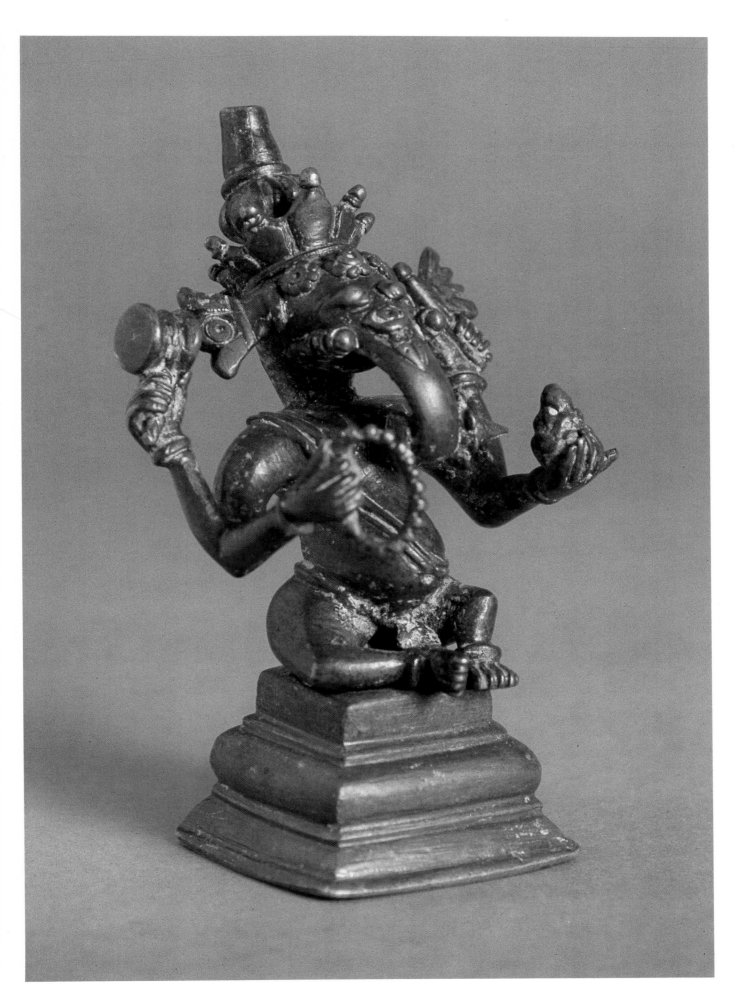

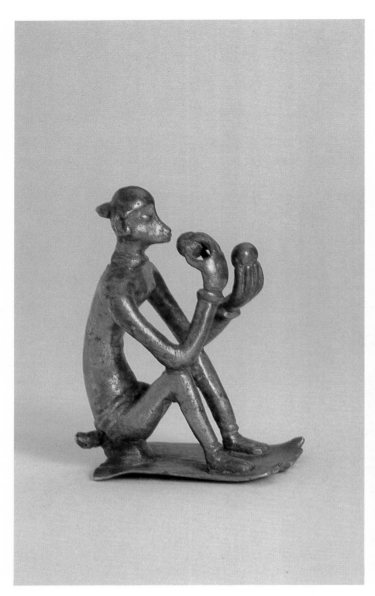

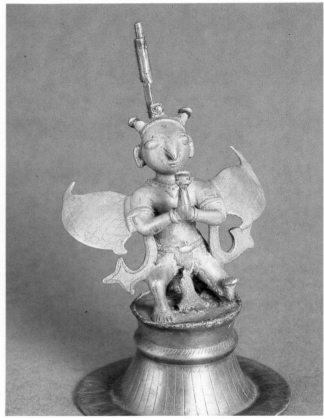

Icon of a monkey, probably Hanuman. Bronze; 11 cm x 5 cm. Rajasthan. c. early 20th century. 7/4165.

Hanuman, literally refers to "one having (large) jaws". He is the most celebrated of a host of semi-divine, monkey-like beings who were created to become allies of Rama in his war against Ravana. In fact, he figures prominently in the *Ramayana*. The possessor of supernatural powers such as flying, uprooting mountains and wielding huge rocks, Hanuman is especially worshipped for his insurmountable strength in overcoming obstacles and is also honoured for his devotion to Rama.

This icon is a pleasing representation of an anthropomorphic monkey, leisurely eating something. His slender body, long limbs and protruding jaw combined with an unusual seated posture make this image an extremely well-conceived piece of art.

Garuda, the man-eagle vehicle of Vishnu. Bronze; 21 cm x 11 cm. Himachal Pradesh. c. 17th century. 7/3467.

Garuda is considered to be the most valiant of all mythical birds. His name literally means the "devourer", perhaps because he was originally identified with the all-consuming fire of the sun's rays.[1] According to a legend in the *Mahabharata*, Garuda, shortly after his birth, frightened the gods with his brilliant lustre. Mistaken at first for Agni, he was later called "fire" and "sun" by the gods.[2]
Garuda is depicted in this icon as the divine eagle with an anthropomorphic face, a curved beak-like nose, spread out wings and shawl ends or tassels flying by his sides as though in flight. The kneeling posture and folded hands identify him as the devoted servant of his lord, Vishnu.

[1] Monier-Williams, 1976, p.348
[2] Ibid

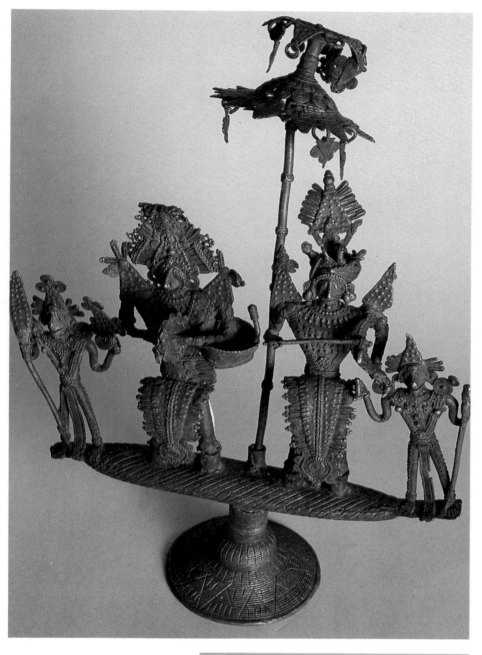

Deities with attendants. Bronze; 39 cm x 30 cm. Bastar region, Madhya Pradesh. c. 18th century. 85/6831.

This composite icon of divinities, probably that of the local goddesses Telangeen and Pardeseen[1] is cast for the use of the tribals by the Ghadva community of nomadic metal casters in the cire perdue technique. The deities have been assigned the status of a majestic pair by means of elaborate head ornaments and royal raiment. A splendid umbrella and armed guards further testify to the acquired regal character of these folk deities.

[1] In conversation with metalsmith Sukhchand Ghadva from Bastar.

Deities, probably goddess Khanda Kankalini. Bronze; 18 cm x 8 cm; 10 cm x 4 cm. Bastar, Madhya Pradesh. c. early 20th century. 85/6833, 85/6835.

Jagdalpur, Pahur Bel, Chhote Dongar, Alwaye and Kondagaon, all in Bastar district of Madhya Pradesh, are some of the important centres where Ghadva metalsmiths, also known as Ghasias, make images using the cire-perdue technique.

In addition to toys and votive figures of tigers, horses, boars, elephants and bullocks, a variety of tribal icons are also made here. Most of the mother goddesses, such as Pillobai Mata, Khanda Kankalini, Danteshvari, Banjari Mata, Pardesi Mata or Mata Devi, are depicted carrying weapons and a vessel for drinking the blood of the sacrificial victim. Male deities are usually connected with ancestor worship.

The images of the deities reproduced here look majestically powerful, radiating a certain magical charm. Stylistically the icons are marked by a simplification of form in the image of human as god. The faces, with protruding eyes, pouting lips and prominent ears, have a mythical quality about them. A semi-circular arch-like halo around the icons is really the *odhni*, or shoulder cloth, locally known as *vadhi* of the deities and testifies to their divine status.

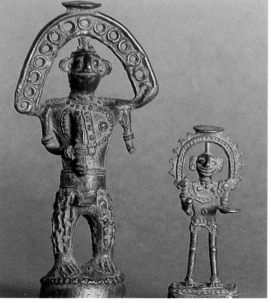

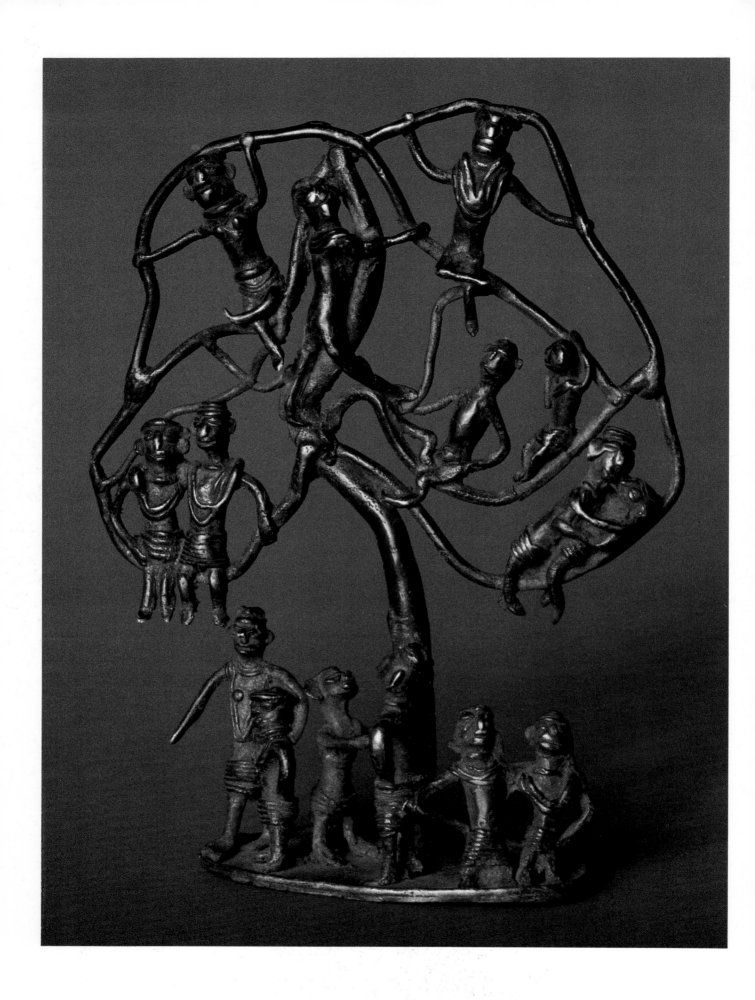

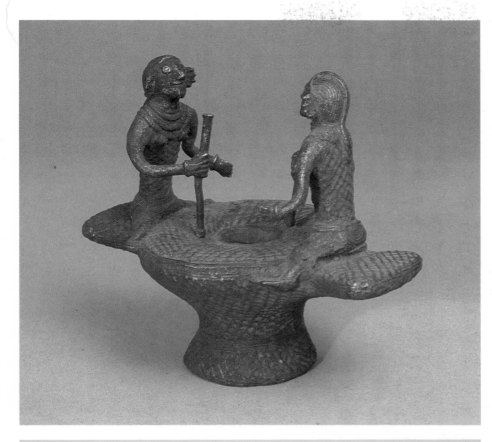

Opposite page
Karma festival. Bronze; 22 cm x 19 cm. Raigarh, Madhya Pradesh. Contemporary. 88/J/D.

The Karma festival is celebrated in the Chhattisgarh region of Madhya Pradesh by the Gond tribes. On this day, young men and women install a large branch of the Karma tree in an open ground and perform group dances around it. On this occasion many young boys and girls happen to fall in love with each other.

"O drummers, sweating in your toil, Drum to my heart's content.

Play your flute on the bank of the river. All the women have come to listen. The path is crowded with women, The women who wear all the sixteen ornaments, And dance in fourteen circles. They are playing seven tunes on the flute. Near the house they are beating the drum, in the road they are playing the fiddle.

O my beloved, they are beating the drums far away in the beautiful forest, But I cannot go with you. The echo of that drumming resounds among the hills." [1]

This depiction of the Karma festival by the Jhara metalsmiths is cast in the cire perdue or lost-wax technique.

[1] Hivale and Elwin, 1935, p.54-5, stanzas 7,8,9

Women pounding rice. Bronze; 14 cm x 15 cm x 10 cm. Kondh tribe, Orissa. c. early 20th century. FOI/CM/3.

Women pounding rice are a common sight in the villages of Orissa. While pounding, they often sing songs whose tunes match the controlled rhythm of the pestle. This mundane though highly evocative theme, the slight tilt in the postures of the women and the pestle in mid-air, are evidence of keen artistic perception on the part of the creator of this bronze.

Field guards. Bronze; 10 cm x 17 cm x 6 cm. Kondh tribe, Orissa. c. early 20th century. FOI/CM/4.

In most villages of India at night one can see farmers armed with sticks, sitting on a *charpoy* guarding their fields. The theme, the stereotypical postures of the broad-shouldered guards and the fine details of the *charpoy* make this a forceful sculpture.

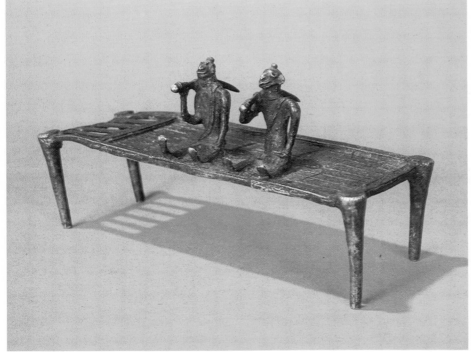

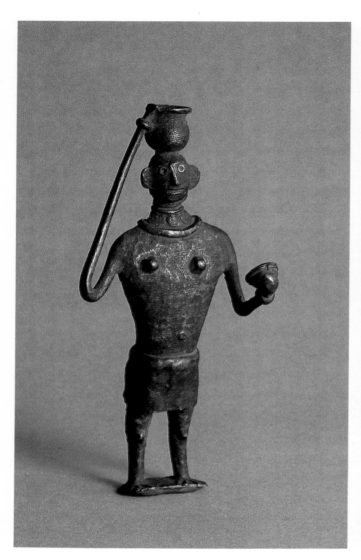

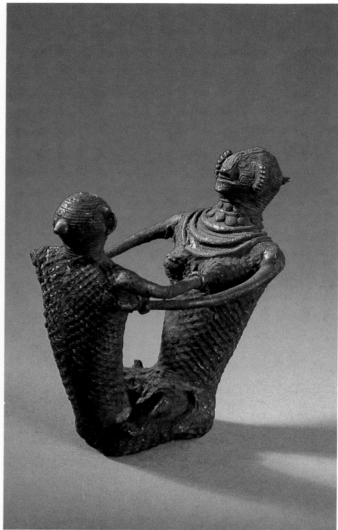

Woman fetching water. Bronze;
20 cm x 10 cm. Kondh tribe, Orissa.
c. early 20th century. FOI/CM/2.

The exceptionally long wiry arm of this
"pitcher-maid", extending right up to
the pot supported gracefully on her
head, is a subtle artistic violation of
nature. Her erect posture, heavy neck
ornaments and short, skirt-like dress[1]
portray her as a typical tribal woman of
Orissa.

[1] "Khond women wear a red or parti-coloured
skirt reaching the knee, the neck and bosom
being left bare." (Thurston, 1909, Vol.III,
p.364).

Amorous couple. Bronze; 13 cm x
9 cm. Kondh tribe, Orissa. c. early 20th
century. FOI/CM/1.

Kondh bronze figurines are carried by
the bride as playthings for the
bridegroom. In this piece, the young
bride is shown with elaborate
ornaments and hairdo. She is depicted
larger than the groom because Kondh
boys of 10 or 11 are married to girls of
15 or 16. Exaggerated torsos, short
wiry limbs, tattooed faces and erotic
gestures animate the couple.

[1] "All tattoo their faces. (Tattooing is said to be

performed, concurrently with ear-boring, when
girls are about ten years old. The tattoo marks
are said to represent the implement used in
tilling the soil for cultivation, moustache, beard
etc.)"
Thurston, 1909, Vol. III, p.364

Opposite page, top
Tiger, ithyphallic hyena, bullock.
Bronze; 12 cm x 14 cm. 14 cm x
18 cm. 5 cm x 7 cm. Kondh tribe,
Orissa. c. early 20th century. 7/7273,
87/7274, 87/7248.

Animals have varying importance in the
life of the hill and forest dwelling tribes
of India. While the tiger is dreaded
when it becomes a man-eater, it is also
worshipped by many tribes.

In Kondh lore the hyena belongs to
that category of birds and animals, such
as crows and cats, which signifies a bad
omen and brings ill-luck. Extending its
neck and raising its head skywards, a
hyena gives out a long cry which is
repeated by the entire pack, an eerie
signal of death in the vicinity. The evil
omen is apparent in the exaggerated
neck and open mouth of the hyena.

The zebu, or humped Indian bull, has
been revered in India from Harappan
times. In many tribal myths of creation,

the bull is described as the progenitor who impregnates the earth. In fact, the horns are said to contain the seeds by which the earth is germinated.

Among the Kondhs, human sacrifices were once made to the earth goddess, Tari Pennu or Bera Pennu[1] to ensure a good crop. Later, bulls were sacrificed instead. This representation of a humped bull with large horns is a classic piece of art.

[1] Thurston, 1909, Vol. III, p.372

Peacock, lizard, fish on tortoise.
Bronze; 15 cm x 18 cm. 4 cm x 12 cm. 6 cm x 10 cm. Kondh tribe, Orissa. c. early 20th century. 87/7226, 97/7271, 87/7258.

Peacocks play an important role in the life of the Kondhs because of their totemic significance. Such bronze figures of peacocks are buried near the post erected for human sacrifice at the shrine of the village deity called Zakari Pennu.[1] Moreover, peacock feathers are worn in the hair by warriors and are tied to the pole around which ritual dances take place.

Lizards are greatly dreaded by the Kondhs. They know them as

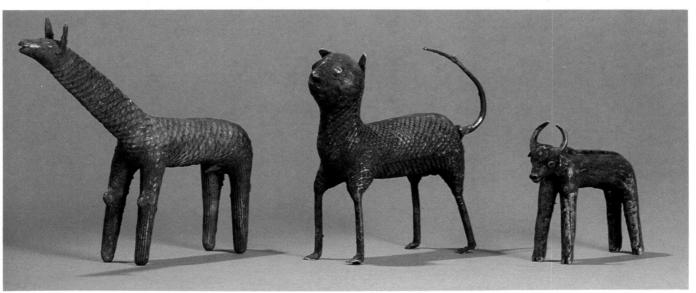

"blood-suckers" and believe they have tremendous magical significance. When a man takes an oath, a basket containing a lizard, among other objects, is placed in front of him as witness. Perhaps due to this fear of the magic associated with the lizard, the figurine here is shown with protruding eyes and broad shoulders, emanating evil powers.

This fish atop a tortoise gets a free ride on the back of the amphibian who is lying still, seemingly in eternal meditation. Such images probably derive from primeval cosmology that dwells beyond the earth in the "under-world".

[1] Thurston, 1909, Vol. III, p.374

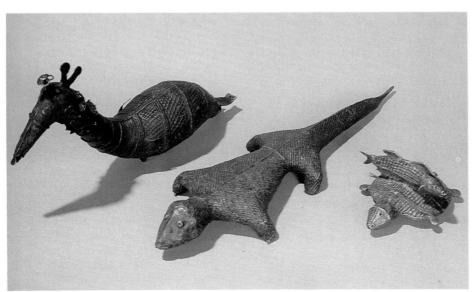

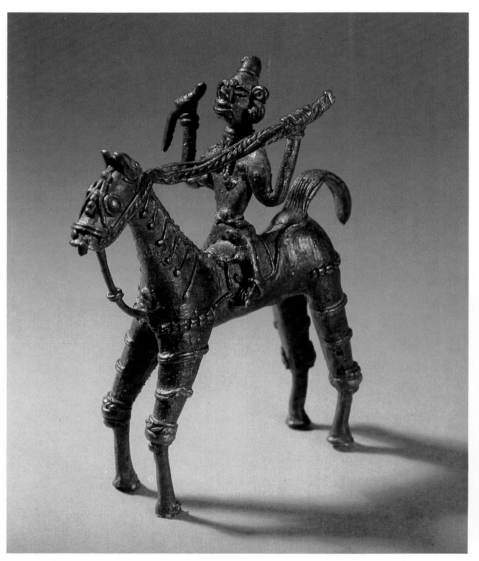

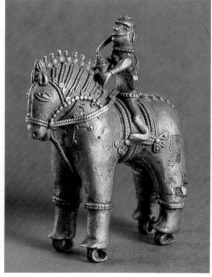

Equestrian deity Rao Dev. Bronze; 11 cm x 11 cm. Bastar, Madhya Pradesh. c. early 20th century. 7/5488.

Rao Dev is believed to be the mythical "spirit rider" and guardian deity of the village who rides his horse at night and protects the village boundaries. In fact, the people believe that lightning in the sky is really Rao Dev striking his hunter or whip.[1]

Rao Dev is considered to be the husband of Malvi Devi, a local diety lower in hierarchy than Danteshwari in Bastar. Once every year during the harvest months, all the farmers conduct a *puja*, a ceremony, in honour of Rao Dev where they sacrifice a goat, pig or hen at his shrine usually located under a bush at the frontier of a field.[2]

The extremely fine ornamentation and details of the figure, cast in the lost-wax technique by a Ghadva metalsmith, is typical of the folk metal images from the Bastar region.

[1] In conversation with Mushtak Khan.
[2] In conversation with metalsmith Sukhchand Ghadva from Bastar

Equestrian deity probably Hardaul. Bronze; 16 cm x 11 cm. Bundelkhand region, Madhya Pradesh. c. early 20th century. 7/5034.

Once upon a time there was a hero named Hardaul who was extremely close to his brother's wife, whom he respected and loved dearly as a mother. However, their relationship soon became a matter of suspicion for his elder brother who, in anger, asked his wife to prove her fidelity to him by poisoning Hardaul. When she hesitated in doing so, Hardaul insisted and eventually died proving his brother's wife innocent.[1] In his honour almost every village has a small shrine erected where such horse-riding images of Hardaul are installed either in metal, wood or stone.

Generally on wheels, as probably was the case with this figurine, the metalsmiths of this region produce a startling variety of highly ornamented figures of horse and elephant riders and chariots.

[1] In conversation with Mushtak Khan.

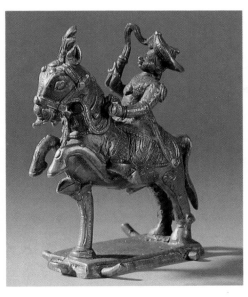

Equestrian figure. Bronze; 13 cm x 10 cm. Deccan, probably Maharashtra. c. 19th century. 7/2519 (1).

A definite sense of "slow" motion is conveyed in this highly compelling equestrian image. The horse is caught in a gallop, his mouth releasing a spontaneous neigh at the inevitable whiplash of his master who wears the characteristic turban of a Maratha warrior.

Equestrian image of Aiyanar, a local deity. Bronze; 30 cm x 24 cm. South India, perhaps Tamilnadu. c. 19th century. 7/4188.

Lord Aiyanar, the guardian deity of rural South India, is usually represented as a royal horseman armed with a sword and shield, riding around the village and field boundaries driving away evil.

"North of the Godavari, Aiyanar is practically unknown. He is also known as Hariharaputra and this name indicates his descent from the two main gods of Hinduism — Vishnu, in the guise of the celestial seductress Mohini, and Shiva." [1]

[1] Anonymous, 1984, p.109

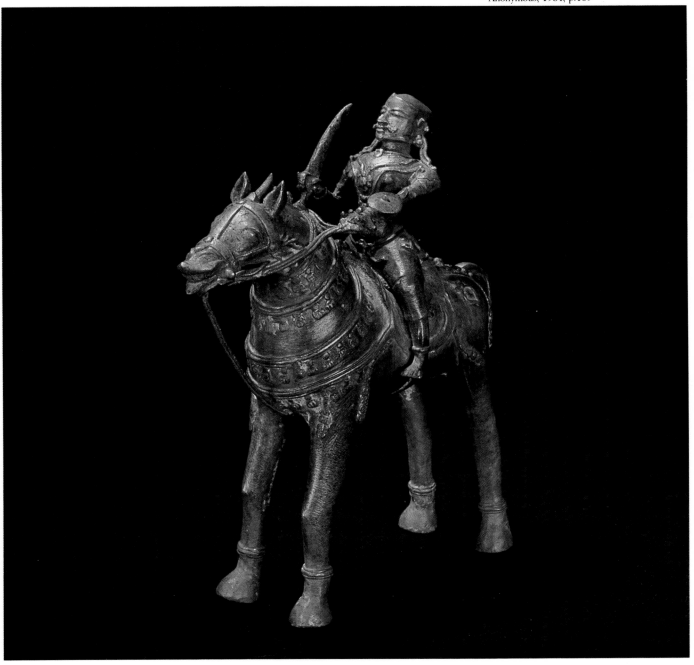

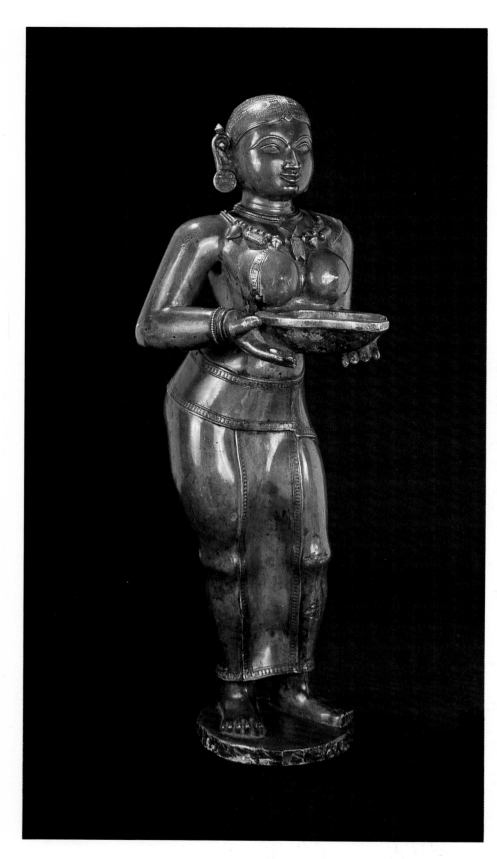

Dipalakshmi, lamp in the form of the goddess of light. Bronze; 60 cm x 22 cm. Karnataka. c. 16th century. 7/2134(4).

In addition to being a source of light, the oil lamp is an important ritual accessory in India. In fact, the more essential forms of worship among the Hindus include lamp offerings to deities.

Dipalakshmi is a lamp in the form of a celestial female, identifiable with Lakshmi, the goddess of light and wealth. Dipalakshmi is usually shown holding a lamp bowl in her hands cupped in the gesture of *anjali* or offering of the flame of "divine light" which, when lit, kindles life into this sombre bronze image.

Opposite page, top left
Hanging lamp depicting goddess Lakshmi being lustrated by elephants. Bronze; 93 cm x 21 cm. Malabar region, Kerala. c. late 18th century. 7/574(2).

Hanging lamps suspended from heavy brass chains are extremely common in South Indian homes and temples where they are venerated as sacred lamps giving divine light.

This lamp depicting Gajalakshmi, a form of goddess Lakshmi being lustrated by elephants, has a shallow basin for oil and lacks the typical "extended lip" meant for holding a cotton wick.

Other lamps common in Kerala are the many-tiered lamps with a bird or animal motif at the apex and base, the "tree" lamp with extended "branches" for lamp bowls, the famous Kathakali lamp, the *channalavattam* and the *vanchi vilakke*[1].

[1] Doctor, 1987, p.14

Opposite page, top right
Panchadipa Lakshmi, lamp in the form of the goddess of light, riding an elephant. Bronze; 24 cm x 19 cm. West Bengal. c. early 20th century. 7/6115.

In this lamp with five lamp bowls (*panchadipa*) the goddess of light, Lakshmi, is depicted riding an elephant and bearing a *kalasha*, or pitcher for oil on her head. Cast by the cire perdue or lost wax technique, the symmetrical composition of this lamp-stand together with its decorative danglers is an ideal ritual accessory for worship.

Opposite page, bottom
Matadiya, lamp stand for deity. Iron; 49 cm x 32 cm. Bastar, Madhya Pradesh. c. early 20th century. 84/6720.

The *lohars* or blacksmiths of Bastar,

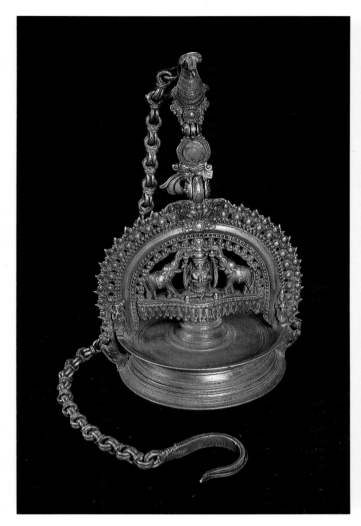

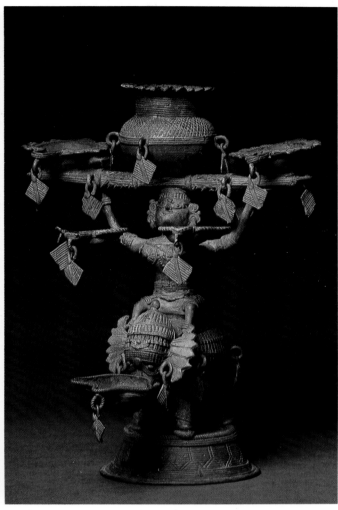

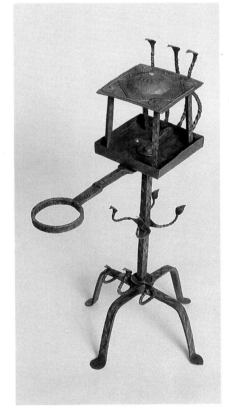

unlike those from Chattisgarh , do not consider themselves as descendants of Vishvakarma[1]. They work primarily with iron, specifically beating and hammering *loha*, or iron, into a variety of tools, lamps and other items.

This lamp-stand, with a rectangular canopied receptacle for the oil-lamp flame is embellished with numerous cobra hoods and is probably for worship in Shaivite temples or shrines.

Among the other iron lamps made by the *lohars* of Bastar a variety of lamps are bought by the tribals for use in their marriage ceremonies. The *ranakakan-diya*, where the sun and moon motif is depicted, the *supali-diya* or winnowing-tray shaped lamp, the *jhop-diya* or hanging lamp, the *khut-diya* or one that is dug in the ground and the *rath-diya* or carriage-like lamp are only a few such types. "In these stands, it will be noted, the sexual symbolism is reinforced by the decoration, the stags with upright horns and the erect hoods of cobras."[2]

[1] In conversation with Mushtak Khan
[2] Elwin, 1951, p.72

39

Incense burner of Shaivite sect.
Bronze and wood; 58 cm x 20 cm.
South India. c. early 19th century.
7/1236.

Burning of incense to ward off evil
spirits in places of worship and to keep
away insects and foul smells has been a
popular practice in India. Incense
burners are usually suspended on chains
or placed on wooden stands as in the
case of this ritual accessory.

The perforated semi-spherical lid of this
incense ball may be partially lifted for
lighting the incense. The figures of
Nandi the bull, placed at the four
cardinal points, testify that this ritual
incense burner was used by Shaivite
devotees.

Shiva-patra, **bull-headed ritual pot
for lustrating the linga or phallic
symbol of Shiva.** Copper; 21 cm x
10 cm. South India. c. early 20th
century. 7/2559.

The opening in the mouth of the bull
(the Nandi bull being the vehicle of
Shiva) is meant for the drop-by-drop
passage of ritual water or milk over the
Shiva *linga* or phallic symbol of Shiva.
The ritual vessel is hung directly above
the *linga* for purposes of lustrating,
with the bull-head facing downwards.

Opposite page
Ritual pot in the shape of a gourd.
Copper inlay on brass; 14 cm x 10 cm.
South India. c. early 19th century.
7/94.

The form of this ritual pot with
long-wide collar tapering down into a
narrower neck derives from similar
shaped gourd pots. Small copper pieces
are inlaid in a chequered pattern against
the shining brass-engraved background
in a striking contrast of colours,
symbolising the sacred confluence of
the "fair" river Ganges with the "dark"
Jamuna.

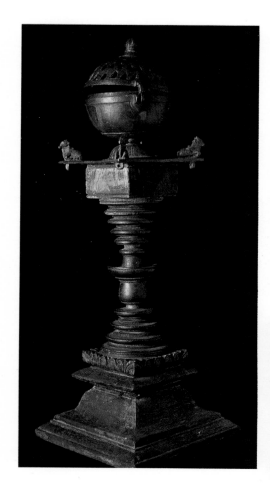

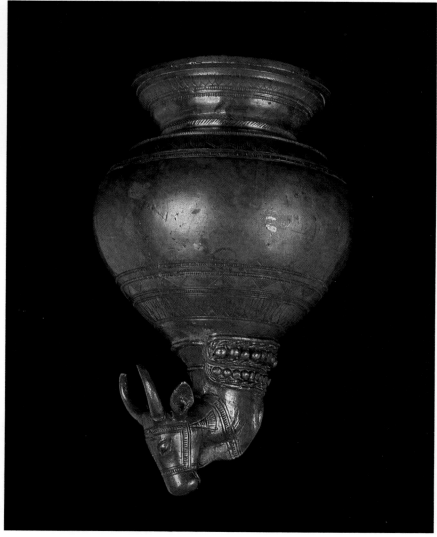

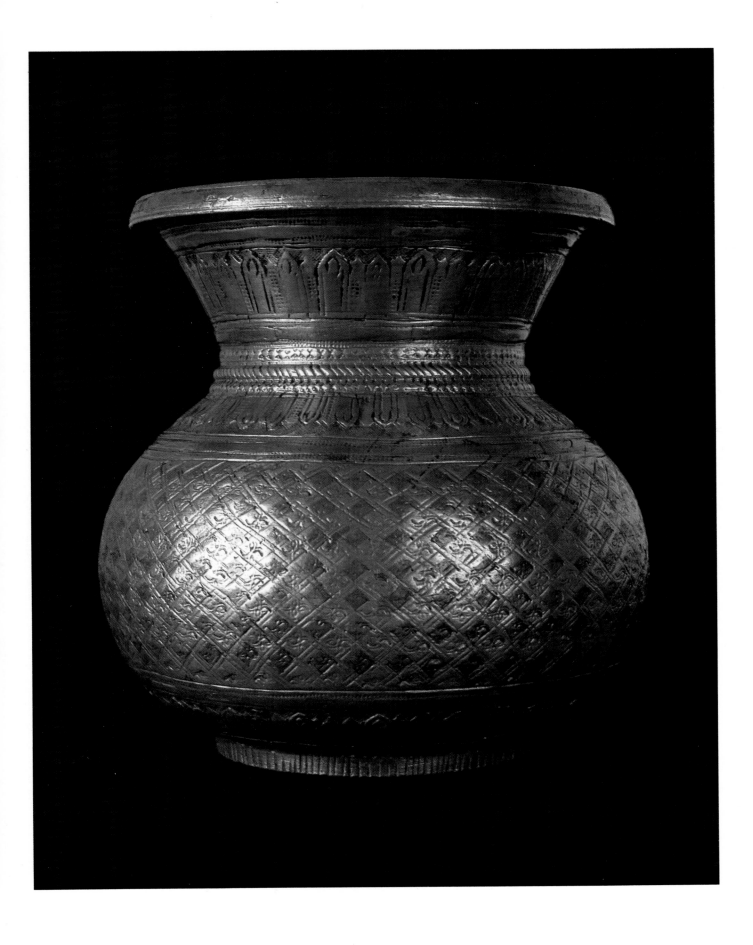

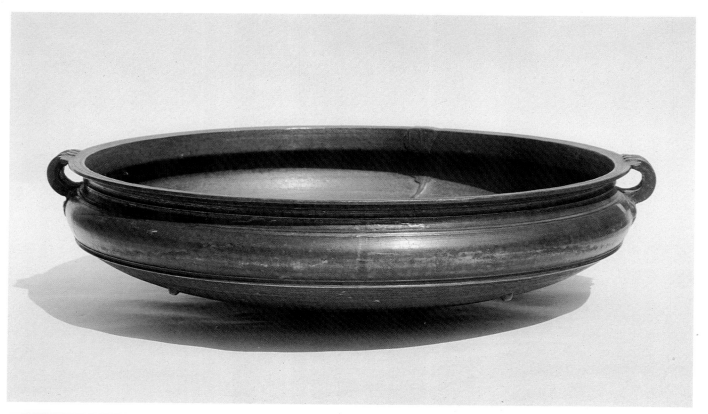

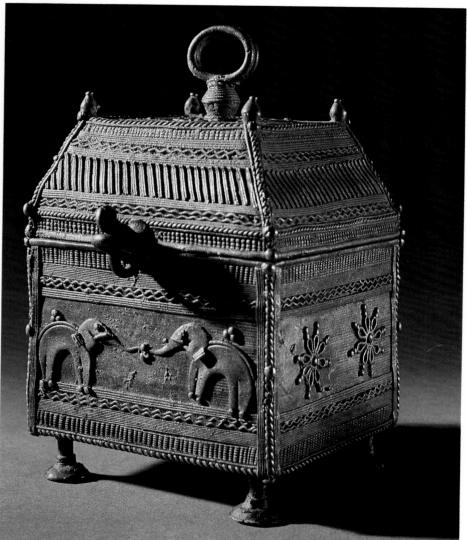

Charakku, a cauldron for cooking payasam, a ritual meal. Bronze; dia. 160 cm x height 48 cm. Palghat, Kerala. c. 17th century. RC-11/D.

The Musari community of traditional metal casters of the Kammalan caste in Kerala have perfected the complex technique of casting large utensils in one single piece, using the lost-wax process. The *charakku* and the *uruli* are the two important vessels made by the Musaris. So arduous is the process of preparing the clay mould, the wax replica and the final casting, that elaborate ritual prescriptions are observed by the Musaris for a faultless casting.

The stark earthen simplicity of the *charakku* with its smooth, unyielding spatial contours lends a resolute solemnity to its size and utility as a ritual cooking vessel.

Casket for money or ornaments. Bronze; 18 cm x 11 cm. Eastern India. c. early 20th century. 7/5428.

Cast in the lost-wax technique of metal casting, this beautiful casket embellished with fine parallel and wavy line motifs, floral designs and two elephants playing with their trunks, and a probable symbol of the goddess of wealth, Lakshmi, was possibly used for storing valuable items that needed to be locked and kept safely.

42

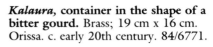

***Kalaura,* container in the shape of a bitter gourd.** Brass; 19 cm x 16 cm. Orissa. c. early 20th century. 84/6771.

The nomadic Ghantrar community of metalsmiths, generally found in the Dhenkanal district of Orissa, produce a fantastic variety of containers whose forms derive from the plant and animal kingdom. This container in the shape of a bitter gourd, locally known as a *kalaura*, is equipped with a hook for hanging by a string around the user's waist.

Fertility ring. Bronze; Inner Diameter 10 cm. Muria Tribe, Bastar, Madhya Pradesh.

Such rings depicting farmer with a pair of bullocks, a field with rich harvest, a draw-well and landlords coming to collect their share are presented to the bride at the time of marriage and are worn for seed-sowing ceremonies.

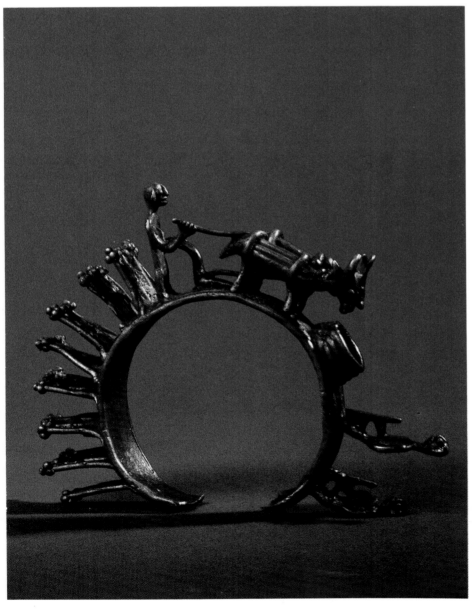

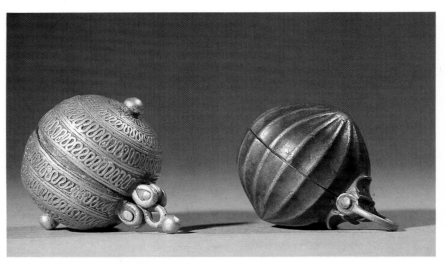

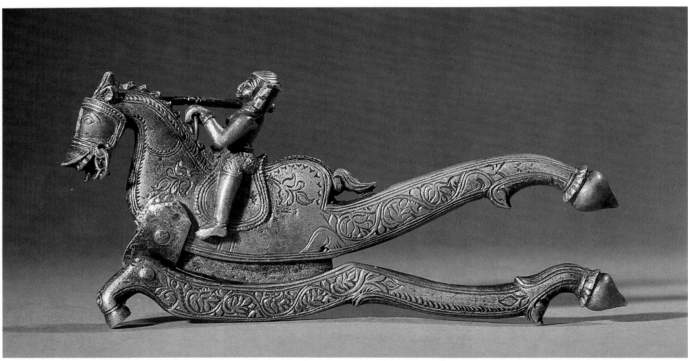

Lime containers. Brass; 5 cm x 4 cm; 5 cm x 4 cm. c. early 20th century. South India or Eastern India. 7/4154 (21); 7/4154 (20).

The culture of betel chewing[1] was probably introduced some time before or about the beginning of the Christian era in South India and then spread northwards.[2] These containers for lime are important accessories for those following this custom.

The earliest reference to the use and proportions of lime, catechu and areca nut goes back to the sixth century.

"A moderate dose of lime used with betel leaves gives good colour; an extra quantity of areca nut spoils the colour; excessive lime produces bad smell in the mouth, but an extra quantity of betel leaf, pleasant smell."[3]

Sarota, **areca nutcracker in the form of an equestrian figure.** Brass with iron blade; 16 cm x 8 cm. Deccan or South India. c. early 19th century. 7/3822.

The areca nut, slightly narcotic in character, is the fruit of the areca nut palm which grows in the vast coastal regions of India. It is consumed either with betel leaf or chewed independently.

This nut-cracker, in the form of an equestrian figure, has a sharp iron blade which, when used for chopping the nut, animates the horse into a gallop.

[1] For details see Jain, 1978
[2] There are no references to *tambula* or betel in early *Grihya Sutras.*
[3] Jain, 1978, p.87

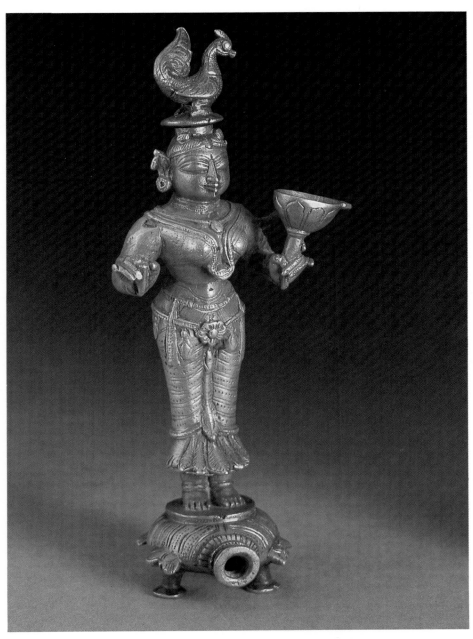

Container for eye kohl or collyrium and vermilion in the form of a *nayika* or dancer. Bronze; 20 cm x 7 cm. South India, probably Tamilnadu. c. 18th century. 7/190.

Among the characteristic items of the "beauty" culture of traditional India are the exceptionally conceived cosmetic accessories such as this female crowned with the typical South Indian swan or goose motif. She is holding a lotus-petalled *kumkum* or vermilion container, just about wide enough for the dip of a finger, and standing atop a turtle container for *surma* or eye kohl, applied with a long blunt spike that fits the head of the animal, now missing.

Container in the form of a parakeet. Bronze; 10 cm x 16 cm. South India. c. early 20th century. 7/4379.

This beautiful parakeet-shaped container is probably for *sindoor*, (vermilion) or collyrium as the opening on its back indicates.

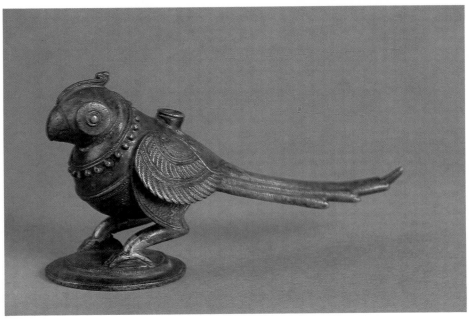

45

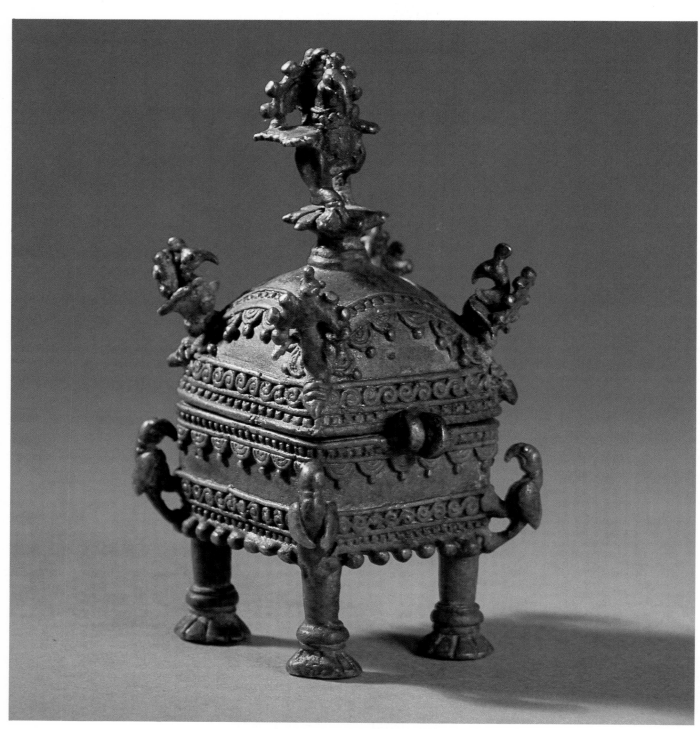

Container for valuables with dancing Ganesha at the apex. Brass; 11 cm x 5 cm. Orissa. c. 19th century. 7/5748.

The Ghantrar community of nomadic metalsmiths of Orissa create extremely decorative items of daily use such as kohl and vermillion containers, money purses, jewel caskets and betel and lime containers with the recurrent bird motif, usually parakeets or peacocks with crowns. Cast in the lost-wax technique these objects are resplendent accessories indicative of a people living very close to nature.

Opposite page
Mayur phorua, **peacock casket.** Brass; 29 cm x 24 cm. Orissa. c. early 20th century. 7/3792.

The *Mayur phorua*[1], literally "peacock-box", a creation of the nomadic Ghantrar metalsmiths of the region and cast in the lost-wax technique, is generally used to store valuables and is consequently equipped with a lock. The crowned peacocks perched on the lid are characteristic of the region.

[1] In conversation with metalsmith Dushasan Behera from Dhenkanaial, Orissa

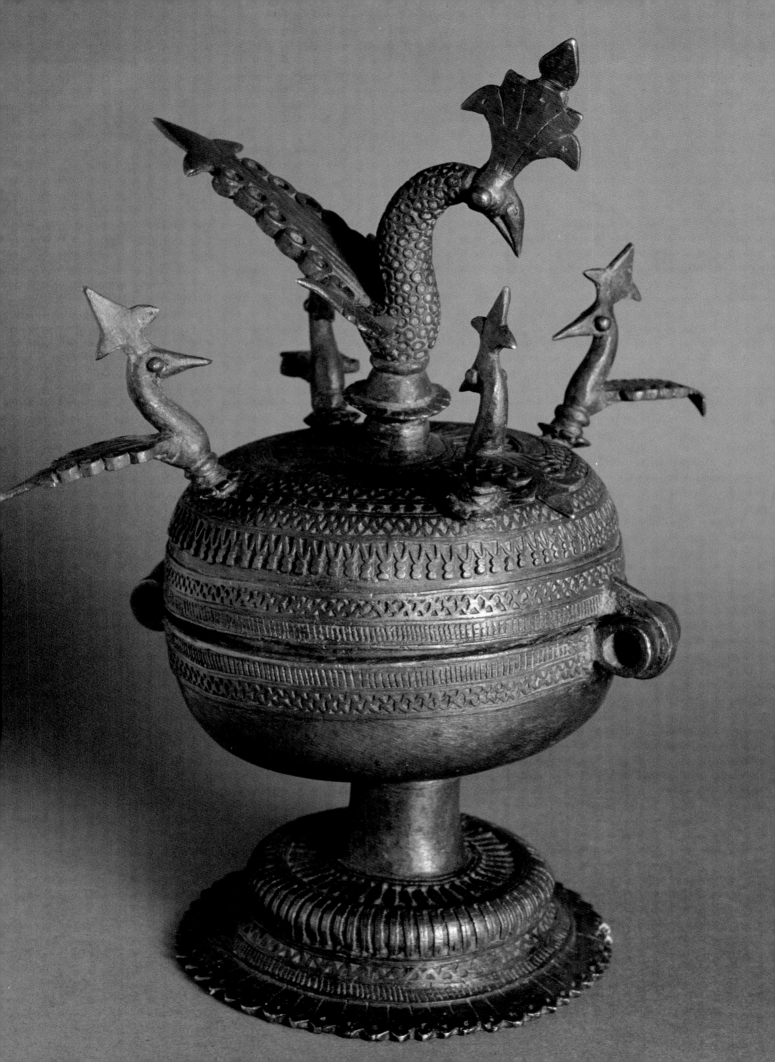

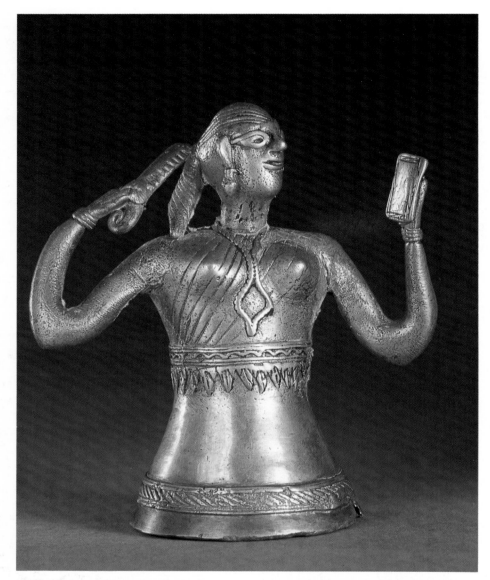

Figure of a girl combing her hair.
Bronze; 11 cm x 10 cm. West Bengal
or Bihar. c. early 19th century. 7/4289.

Indian women have been traditionally
known to spend a great deal of their
time on *shringara* or beautifying
themselves. This particular blunt
drum-like figurine, cast in the cire
perdue technique using *dhuna*, a black
wax-like substance, is shown combing
her hair with an elephant-headed comb.

Grain measure and ladle. Bronze;
height 11 cm x width 11 cm; 23 cm x
4 cm. Bastar, Madhya Pradesh. c. early
20th century. 7/4430; 7/5491.

Besides images of deities, the Ghadva
metalsmiths of Bastar produce a variety
of utilitarian items, in the cire perdue
or lost-wax method of metal casting.

The braided and matted pattern of this
grain measure, also known as *paila,
maan*, or *kudo*[1], is strongly reminiscent
of its prototype in basketry.

The ladle, locally known as an *orkha*, is
used by the tribals of Bastar and
neighbouring areas for pouring their
favourite brew of rice beer.

[1] Local names have been provided by Mushtak
Khan and metalsmith Sukhchand Ghadva, from
Bastar

48

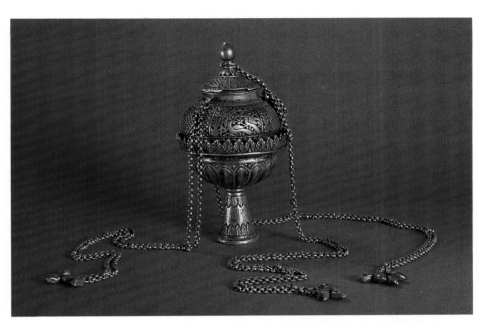

Hukka bowl for coal and tobacco.
Silver; 16 cm x 8 cm. Gujarat. c. early
19th century. 7/2931.

Leisure time, in both royal and rural
India, is characterised by smoking the
hukka which is a contraption for
smoking tobacco. It consists of a bowl,
a long flexible tube and a base
containing water that cools and filters
the smoke in the process. This silver
hukka bowl with lid is a vestibule for
burning coal in the lower clay lined
region, while the upper region is used
for burning tobacco. It is attached to
the smoking pipes with chains.

Tobacco containers. Brass-bound
wood and sheet metal; 11 cm x 19 cm;
5 cm x 18 cm; 10 cm x 22 cm. Western
India, Gujarat or Rajasthan. c. early
20th century. 84/6715; 84/6716;
84/6717.

Flat containers, with disproportionately
small lids, generally with handles or
attached to chains, are commonly used
in western India for storing tobacco
and even opium. They are integral to
the *hukka* or pipe smoking culture of
both rural and urban India.

Bidriware. Silver inlay on alloy of zinc, copper lead or tin in *bidri* technique; 22 cm x 16 cm; 15 cm x 15 cm; 17 cm x 16 cm. Deccan. c. early to late 19th century. 9/128; 9/59; 9/104.

Bidar, a small town in Karnataka, is renowned for its fascinating silver wire inlay work on the blackened surface of an alloy of zinc and copper. Highly patronised by the Mughal sovereigns, the technique was traditionally in the hands of Muslim artisans who catered primarily to the royal courts.

This spittoon, or *ugaldan*, in the shape of two bells joined back to back was, in all probability, an important accessory of courtly leisure and diplomacy, where betel-chewing and spitting were common practices. It is rendered in floral patterns in the *teh-nishan* (inlay of sheet) and *tarkashi* (inlay of wire) techniques.

The pitcher shaped *sailabchi* or wash-basin with a perforated lid, also executed in the *teh-nishan* and *tarkashi* techniques, is used for rinsing the hands of guests and other royal personages after meals.

The inverted bell-shaped *hukka* or smoking pipe base is embellished with the poppy plant cone in the *teh-nishan* and *tarkashi* forms of inlay.

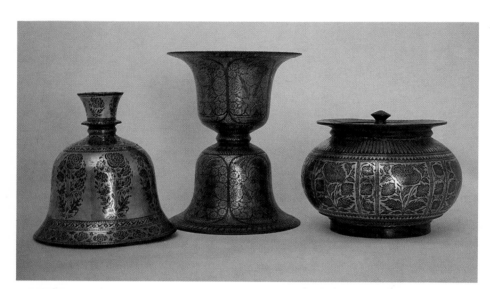

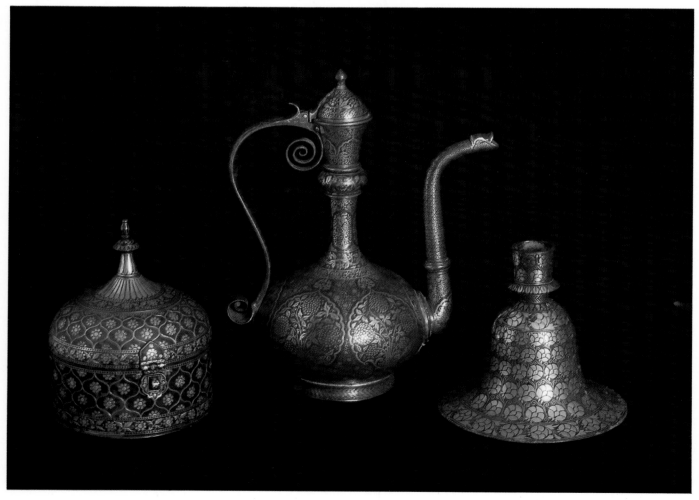

50

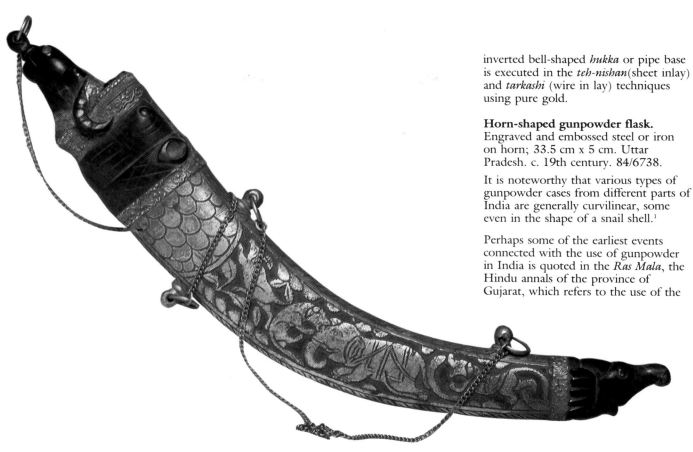

inverted bell-shaped *hukka* or pipe base is executed in the *teh-nishan*(sheet inlay) and *tarkashi* (wire in lay) techniques using pure gold.

Horn-shaped gunpowder flask.
Engraved and embossed steel or iron on horn; 33.5 cm x 5 cm. Uttar Pradesh. c. 19th century. 84/6738.

It is noteworthy that various types of gunpowder cases from different parts of India are generally curvilinear, some even in the shape of a snail shell.[1]

Perhaps some of the earliest events connected with the use of gunpowder in India is quoted in the *Ras Mala*, the Hindu annals of the province of Gujarat, which refers to the use of the substance by Muhammed Begurah against the pirates of Bulsar around A.D. 1482[2]

Probably fashioned under Muslim patronage, when the technique of decorated metal surface gained popularity, this gunpowder flask is engraved with wild animals in combat while the two ends have elephant and bull heads carved in horn. The stopper attached to a chain is also made of horn.

[1] Jain, in *Marg*, XXI, No.3, June 1978
[2] Ibid

Razors for shaving. Gold, silver and enamel on silver and iron blades; 17 cm x 2 cm. c. late 18th century. 7/4469(1), 7/4469(2), 7/4469(3).

Both men and women of the aristocracy in India laid great emphasis on personal body care. Two of these silver razor blades have exquisite handles ornamented with floral patterns in the damascening technique in gold and silver, while the other, in chevron pattern, has been executed in *meenakari* or enamel work.

Opposite page, below
Bidriware. Gold and silver inlay on alloy zinc, copper, in *bidri* technique; 31 cm x 24 cm; 18 cm x 14 cm; 17 cm x 16 cm. Deccan. c. late 18th century. 7/245; 7/571; 7/3786.

This spouted vessel or *aftaba* is executed in extremely fine gold and silver wire inlay in floral stemmed patterns bound within wavy cones. The steepled casket, a *paandaan* or betel container with latch, is embellished with single floral *butas* or motifs within a latticed or *jali* framework. The

Talismans of power:
Jewels

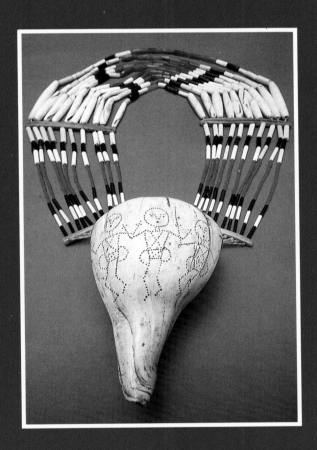

In India, jewels have been thought to possess qualities that elevate them from being mere articles of adornment. Whether it is the ephemeral fragrance of flowers, or the more permanent contiguity of beads, shells, feathers, fibres, bones, gems and metals, the effect on the human skin and body is more than just decorative.

Like amulets, jewels are believed to possess attributes that protect the wearer from evil spirits. Thus a child suffering from smallpox was made to wear a pendant engraved with the image of Sitla Devi, the deity associated with the disease, or a waistband of tiny silver beads or *bora*, "meant to resemble the smallpox pustules" in order to prevent recurrence of the attack.[1] In some places in North India a woman marrying a widower is made to wear a plate with the image of her husband's first wife, in order that the dead woman's spirit may not torment her.[2] Necklaces, bracelets, anklets, ear, nose and toe-rings worn on the extremities and orifices of the body, are believed to safeguard these parts of the wearer's body from mishap and disease.[3]

Similarly, precious stones and particularly the *nauratna har*, or necklace of "nine gems", have the potent effect of negating the ill effects of planets. "If the sun is evil, the ruby is propitious; if the moon, the diamond; if Mars, the coral..."[4] and so on.

Even beads, whether of glass or seeds of trees, have the magical potency of warding off evil. They are worn by married couples in some parts of India to prevent abortion and they are considered sacred by certain religious sects. The *rudraksha* is worn by most priests and ascetics while the Vaishnavas, in particular, prefer rosaries made from the wood of the holy basil.[5]

The significance of jewels as talismans or repositories of potent energies that shield their wearers through actual physical contact with them, is further amplified by the role they play in the principal stages in the life of a Hindu. The *Grihya Sutras* (c. 500-200 B.C.) describe the various *samskaras* or important ritual occasions such as the *namakarna* or christening of the newborn, *vidyarambha* or commencement of formal education, *upanayana* or initiation into the sacred Vedas, return from the *gurukul* or teacher's home, marriage, and finally *mritakakarma*, or rites at death, where the ceremonial wearing of a piece of jewellery is symbolic of a particular stage in life. A child's ears were pierced by the goldsmith to denote his entry into the world, while the *upanayana* ceremony was marked by the investiture of a gold thread or *yagnopavita* worn from the left shoulder across the chest to the right side. Even today in Maharashtra, a girl's marriage is marked by her husband presenting her with the *mangalasutram*, a necklace of black beads, while in Tamilnadu it is the *thali* tying ceremony that sanctifies and legalises the occasion. In fact, jewels are symbolic of the married status of a woman. In North India every married woman, whose husband is living, must wear glass bangles (usually red or green) and toe-rings or *bichhwas*. The saying *tere nath churi barqarar rahen* or "may your *nath* (nose ring) and *churi* (bangles) be preserved, (may you never become a widow)"[6] are particularly evocative of the symbolic value attached to a married woman's jewels.

On the other hand discarding one's jewels and breaking one's glass bangles are symbolic of widowhood. Among the Kondhs of Orissa, "if a woman's husband dies, she removes the beads from her neck, the metal finger-rings, ankle and wrist ornaments, and the ornament worn in the lobe of one ear... These are thrown on the chest of the corpse, before it is cremated."[7]

The death rituals of most Hindus involve placing a small piece of gold or silver wrapped in *tulsi* or sweet basil leaf in the mouth of the corpse to ward off evil as

well as ensure purity in the after-life.[8]

The Hindu laws of succession and inheritance, and especially the Mitakshara and Dayabhaga schools, clearly expounded the notion of *stridhana* or a married woman's wealth. A girl inherited from her parental home, movable property, particularly jewels, which was her sole property and could not be usurped by her husband's family. A woman was thus free to do whatever she wished with this wealth, independently of her husband. Here the reference is particularly to the eventual protection of the woman in time of need, that is if she becomes a widow, or if her husband and his family divest her of their guardianship.

Whether they are made of cowrie, bone and feathers or of precious gems and metals, jewels are responsible for endowing the wearer with a certain amount of prestige. Among the tribes of the North-East, wood or metal pendants or skulls, tally with the number of heads hunted by the warrior. The greater the number of skulls on the pendant, the greater the prestige of the Naga warrior.

Jewels, regardless of whether they are worn by the deity, *devadasi* or damsel, are symbols of supplication. They are visual codes of the relationship between the deity and her devotees, the *devadasi* and her god, the woman and her lover. In Tirupati, the image of the deity is so heavily laden with jewels and precious gems that pilgrims are asked to take *darshan*[9] with dark glasses lest the divine energy invested in the image be too powerful for them to withstand.

The sun, moon, *naga* or serpent and *lingam* or phallic symbol, motifs recurrent in the adornments worn by the *devadasis* or temple dancers of the South, are symbolic of the lifelong devotion of these women who are ritually wedded to their gods.[10] Similarly, on a young woman, jewels are wicked betrayers of a lover's plight; even as early as *c.* 100 B.C. – A.D. 250, the Tamil poet Ammuvanar of the Sangam period writes:

" Look my bangles
slip loose as he leaves
grow tight as he returns
and they give me away."[11]

Ritually, both gold and silver are accorded a high status in the hierarchy of auspicious metals, silver coming next only to gold in the highest rung. Both metals, being soft and highly ductile, are particularly suited for making delicate jewellery. Indian goldsmiths work with pure gold or *chokha*, gold alloyed with copper or *svansa* and that with silver, *phika*. Lucknow is renowned for its pure refined silver or *takya* while *rupa*, *subara* and *karawal* are varieties of alloyed silver.[12]

By means of shaping, punching, engraving, enamelling, inlaying, filigree and granulation techniques, beautiful ornaments are fashioned by gold and silversmiths in almost every corner of India. Often jewellery is fashioned by tribal metalsmiths by the age-old process of *cire perdue* casting or the lost-wax process. Each technique has its specialist craftsperson whose family has been practising the craft for over three to four generations. In fact, references to the goldsmith's craft are made in *Manusmritis* which mentions fines and punishments for bad workmanship and debasing gold.

In North India the gold or silversmith is known as the *sunar*, a name derived from the Sanskrit *suvarna kar*, or one who works in gold. In the South the occupation is dominated by the Tattans or goldsmiths of the Kammalan caste, also known as Visvagnas or Daivagnas.[13] S.M. Risley in *Tribes and Castes of Bengal*, relates the following legend regarding the *sunars*:

"In the beginning of time, when the goddess Devi was busy with the construction of mankind, a giant called Sonwa Daitya, whose body consisted entirely of gold, devoured her creations as fast as she made them. To baffle this monster the goddess created a goldsmith, furnished him with the tools of his art, and instructed him how to proceed. When the giant proposed to eat him, the

goldsmith suggested to him that if his body were polished his appearance would be vastly improved, and asked to be allowed to undertake the job. With the characteristic stupidity of his tribe the giant fell into the trap, and having had one finger polished was so pleased with the result that he agreed to be polished all over. For this purpose, like Aetes in the Greek legend of Medea, he had to be melted down, and the goldsmith, who was to get the body as his perquisite, giving the head only to Devi, took care not to put him together again. The goldsmith, however, overreached himself. Not content with his legitimate earnings, he must need steal a part of the head, and being detected in this by Devi, he and his descendants were condemned to be for ever poor."

Ever since the *sunar* is proverbially a thief. "He steals gold even from his wife's nose-ring", "the wearer has the bracelet, the *sunar* has the gold"[14] are only a few of the sayings used for the local goldsmith. The *sunars* are said to be so particular about their gold that they will even buy back the grains retrieved from the swept waste of their workshop that is washed and separated by the *niarias*, an occupational group traditionally engaged in this task.[15]

Shaping or *ghadai* is the most important process in the hand-crafting of gold and silver ornaments. Purity of metal is essential for the finest quality of work as this stage requires hammering and soldering or casting the metal into the required shape. The ornament may be solid metal or hollow. In the latter case, they are made into two halves which are either filled in with lac to make them heavy or simply soldered together hollow. For larger pieces a mould or die may also be prepared. Engraving with a sharp jewellery chisel is done after embedding the ornament on a bed of lac. The necessary openings are made with a jewellery saw. Separate pieces are either joined with locks or soldered together. The ornament, filed and polished, is then ready to be beautified with pearls, gems and enamel. While the *sadhkar* will complete the entire process from beginning to end, himself, (*sadh* in Persian refers to "hundred percent",) often the *sunar* will only prepare the basic ornament and send it to the *chatera* for engraving, to the *kundansaz* for setting it with precious stones and to the *meenakar* for enamelling.

Perhaps the earliest finds in jewellery have been excavated from Chalcolithic sites. Highly-decked terracotta figures, copper rings, beads, bangles and hairpins found here are dated between *c.* 3500 B.C. and *c.* 2000 B.C. The jewellery belonging to the Harappa and Mohenjodaro cultures, between *c.* 2700 B.C. to *c.* 1800 B.C., reveals a high degree of skill and craftsmanship. Animal motifs are common in hairpins and armlets while the *pipal* and lemon leaf are predominant motifs for ear and neck ornaments.

The jewellery of the later period is clearly reflected in the sculptures at Bharut, Sanchi, Amarnath and Orissa, influences of which are seen in later Indian jewellery both in design and craftsmanship. On the gateways of Bharhut and Sanchi, valuable jewels are seen flowing out from the numerous branches of the *kalpavriksha* trees.[16] Sanskrit literature abounds in references to ornaments. The Sanskrit word *sraj* or garland also means necklace. It is believed that the *saj* or necklace of charms and pendants of the Deccan, has its origin in this ancient word.[17] In an early Sanskrit play, *Mrichchhakatika* or *Little Clay Cart* there is a scene which describes a street of jewellers' shops, "where skillful artists are examining pearls, topazes, sapphires, beryls, rubies, lapis lazuli, coral and other jewels; some set rubies in gold; some work with gold ornaments on coloured thread, some string pearls, some grind the lapis lazuli, some pierce shells, and some cut coral."[18] The jewellery of the epic period is no less resplendent. The *chudamani*, or head ornament, given to Sita by her father Janaka, studded with many glittering gems, is said to have sparkled in her hair and enraptured her husband King Rama.[19]

Under the Muslim sovereigns, gold and silver jewellery became more and more elaborately embellished with precious stones and enamelling. The indigenous

Hindu figurative motifs were incorporated and greatly enriched with floral and geometric designs. Creepers, branches, leaves, the crescent moon and the star were only a few of the motifs that distinguished the jewellery of the Muslim period.

It was under the Mughals that Indian craftsmen mastered the technique of *kundan* work, the setting of precious and semi-precious stones within bands of highly purified soft gold. The characteristic feature of this type of setting lies in applying pieces of pure gold leaf or *kundan* in the space between the stone and its gold frame in order that the stone remains firmly set. Often *kundan* work is combined with enamelling or *meenakari*, so that a piece of jewellery has two equally beautiful surfaces, enamel at the back and *kundan* set gems in front. Today both Gujarat and Rajasthan are renowned for this work.

In Bengal, precious and semi-precious stones are set in the latticed framework of gold or silver ornaments without using a base adhesive and metallic sheet. In this type of open-setting the stone is kept in place by tightly pressing the metallic rim of the ornament around it. Often tiny claws, cast together with the ornamental framework, are used to clasp the stone in place, as is done in the *pachchikam* of Gujarat of fairly recent origin.[20]

Delhi and Jaipur are known for *meenakari*, the beautiful enamel work on gold and silver. The art involves the fusion of coloured minerals, such as cobalt oxide for blue and copper oxide for green, on the surface of the metal giving the effect of precious stone inlay work. The particular mode employed is known as *champleve* where the metal is engraved or chased in such a way as to provide depressions within which the colours can be embedded. The colours are applied in order of their hardness, those requiring more heat first and, those less, later.

Varanasi, on the other hand, is noted for its lovely glowing pink enamelling work on jewellery. Here the base is first covered with white or pink enamel upon which the colours are fused separately. When fixed, the mingling of the colours produces a wonderful effect. Gold admits a wider range of colours than any other metal and, as in *kundan* work, purity of the metal is a necessity.

Partabgarh in South Rajasthan has a very special technique called *theva*[21] in which extremely fine work in gold leaf is done on red or green glass. The pattern is first painstakingly punched out on gold leaf embedded on lac. Coloured glass of the same measurement and encased in a frame is then heated and, while still hot, the gold film is daintily slipped over the edge and pressed onto the surface of the glass. The article is reheated until a sort of fusion takes place between the two. Silver foil is placed beneath the glass to give the surface a uniform glow. From elaborate hunting scenes to intimate *rasa lilas*, intricate patterns are made on the surfaces of plates, caskets, panels and ornaments in this technique.

Cuttack, in Orissa, has long been famous for its very fine filigree wire or web work in silver. Silver wire is first drawn in varying thicknesses and pressed and twisted into different forms and shapes. First the main ribs are fixed and the interspaces are, then, filled in with the delicate tendrils of finer wires according to the design.

This requires special dexterity as the craftsman's skill lies in not causing the solder to fuse over more than the desired nodes of attachment. In Cuttack, the flower motif predominates. In addition to silver ornaments, *attardans* or rosewater sprinklers, bowls and decorative animal and bird, especially peacock, figures are some of the articles made in the filigree technique.

Motifs of the sun, moon, *naga* or serpent, especially the cobra hood and images of deities such as Mahalakshmi and Dashavatara, are predominant in the jewellery of the southern states. The *thali,* an essential component of the marriage ceremony of many communities in the South, is a gold necklace consisting of numerous emblems of which the *thali,* usually a phallic symbol, hangs in the centre. Other chains include auspicious fruit like the mango,

vegetables, leaves, lotus-buds and the *aragu-kulishan* or the summit of a temple.[22] These are usually cast in hollow or solid relief and are believed to be important receptacles of magical powers. In some areas, especially Madurai and Tiruchirapalli, there are specimens of pendants depicting the *yali* or monstrous lion, in combination with the *garuda* or mythical man-eagle. In coastal Malabar in Kerala and South Canara in Karnataka, the *thali* talismans are stiff cylindrical bars, "elaborately built up with motifs of wire, granules, or paillons of burnished sheetmetal, with a rosette and bud hanging from each bar".[23] In Kerala, the button-shaped gold embossed ear ornament or *toda*, elongates the earlobes of the wearer and the *mekka motiram* or ring is worn at the top in the ear folds. Among traditional neck ornaments, the *kasumala* is a necklace of coins, while the *nagapatam* is a string of cobra hoods.[24] Thanjavur, in Tamilnadu, is particularly known for its precious stone setting, usually rubies, in gold. Elaborate necklaces, with a central hanging pendant called the *padakkam* in various shapes such as the serpent head, swan, peacock, lotus and mango, girdles, hairbraid ornaments, hair studs and armlets are only a few ornaments made by craftsmen of the region.

The folk and tribal jewellery of India is so varied, both in materials used, which include lac, glass, shells and beads, as well as in designs and mode of wearing, that a whole book would not be enough for documenting them. Each state in India is renowned for its particular tradition in jewellery of which Kashmir, Himachal Pradesh, Gujarat, Rajasthan, and the tribal zones in the central, eastern and southern regions are renowned for ornaments in silver and a particular type of white metal, an alloy of copper or tin and pewter, that imitates silver.

1. Russel and Hira Lal, 1975, Vol. IV, p.527
2. Bhushan, n.d. p.11
3. Russel and Hira Lal, 1975, Vol. IV, p.524
4. Bhushan, n.d., p.134
5. Crooke, 1925, p.289-90
6. Bhushan, n.d., p.11
7. Thurston, 1909, Vol. III, p.396-7
8. Crooke, 1925, p.286
9. For detailed discussion, see Eck, 1981
10. For detailed discussion on the subject of *devadasis* see Marglin, 1985
11. Ramanujan, 1985, p.34
12. Bhushan, n.d., p.111
13. Thurston, 1909, Vol. III, p.113
14. Risley, 1969, p.314
15. Russel and Hira Lal, 1975, Vol. IV, p.532
16. Agrawala, 1970, p.119
17. Dongerkery, 1970, p.18
18. Schoff, 1912, p.223-24
19. Dongerkery, 1970, p.19-20
20. *Marg* publication, 1984, p.74
21. Jain-Neubauer, 1986, p.57-61
22. Bhushan, n.d., plate L
23. Mehta, 1960, p.17
24. Doctor, 1987, p.38

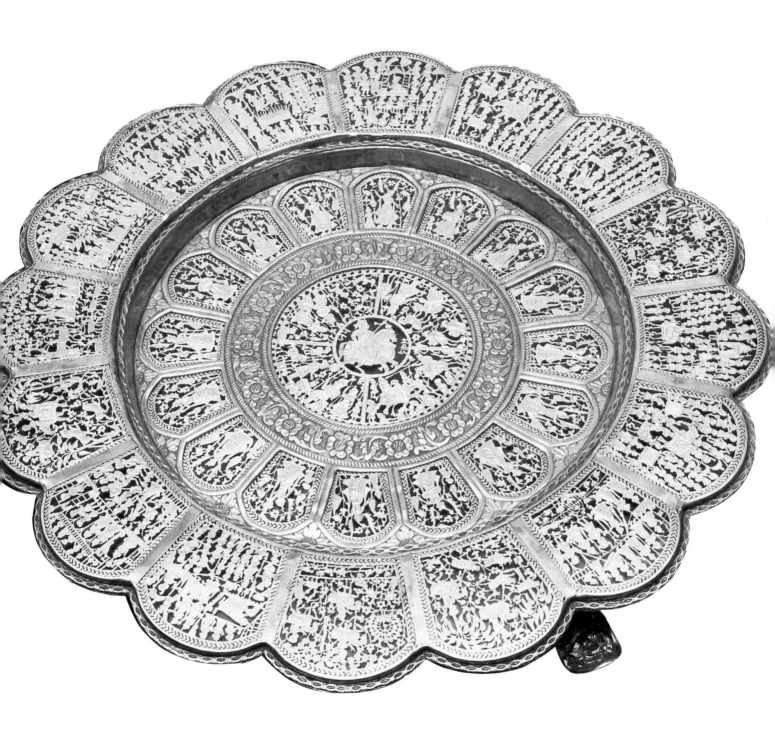

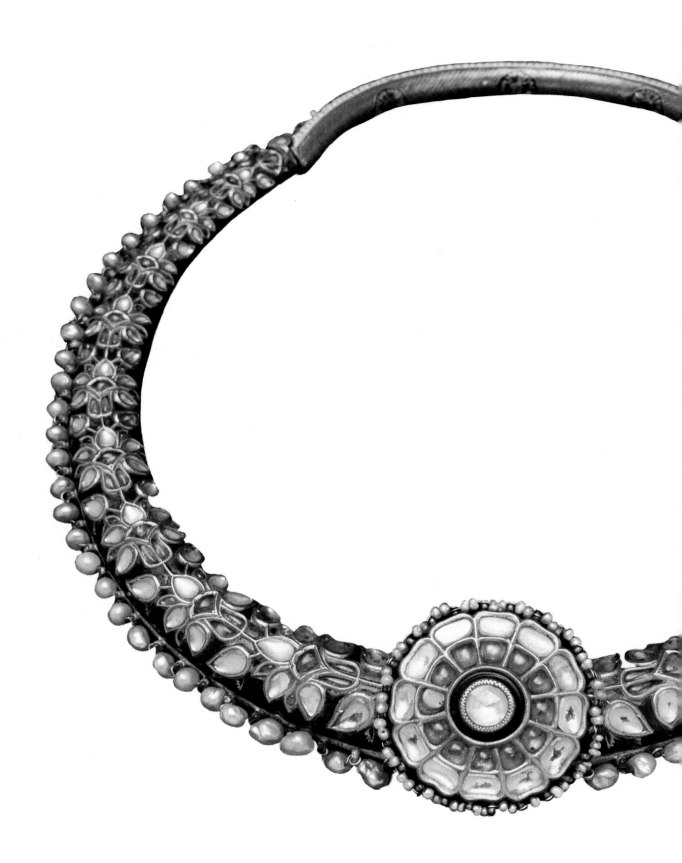

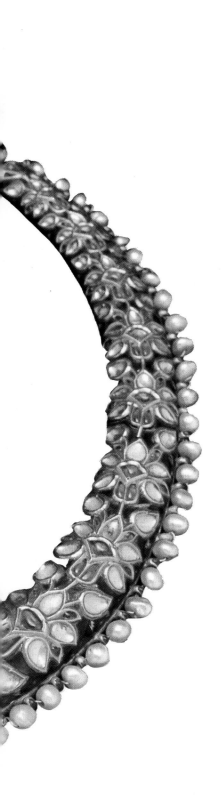

See page 59
Plate depicting scenes from local history. Gold plated silver on glass in the *theva* technique; 31 cm x 5 cm. Partabgarh, Rajasthan. Contemporary. 7/5787.

In 1561 Prince Bika of the Mewar kingdom founded his own little kingdom in Deolia. which, due to the shortage of drinking water, was moved to Partabgarh, a principality in the Chittorgarh district of South Rajasthan. Today this erstwhile kingdom would have been just another insignificant fortified town had it not been for the existence of four families of goldsmiths renowned for their inherited tradition of *theva* work for nearly 400 years. Among the numerous royal patrons, Maharavat Samant Singh (1775-1844) gave his official recognition to these families by granting them 400 *bighas* of land.

The surveyors of the crafts of India in the late 19th and early 20th centuries erroneously described the *theva* technique as enamelling. In the *theva* technique, a fine sheet of silver or gold, on which a pattern is carefully punched out, is delicately slipped onto the surface of semi-fused coloured glass, usually green or red. In this way extremely intricate work, in the manner of a miniature painting in pure gold, is done on the glass surface of snuff and jewellery boxes, ornaments, picture frames, plates, vases and perfume bottles.

In this exquisite plate the artist has created the imagery of a flower within a flower, each petal depicting historical scenes from the court, jungle or palace.

Moving centripetally, the plate has two concentric rings with the innermost core depicting the Rajput warrior king, Maharana Pratap, riding his favourite horse Chetak. The ring surrounding him is divided into four sections, each showing the king with his queen. "Other petals show him with his Minister Bhama Shah. A pitched battle between the Maharana and Salim is the theme of the next one. In this way each petal recreates a historical event in minute detail. One petal reveals a moving incident between two brothers: the Maharana's brother, Shakti Singh, deserting the army of his ally, the Mughal army, when he sees his brother in real trouble on the battlefield and helps him. The next concentric circle is a relief from the petals charged with historical events, and shows sixteen beautiful winged fairies, eight of them dancing and eight of them playing music. A final circle of petals presents an insight into the pleasures of court life: a coronation scene, a royal procession, the Raja granting an audience to his ministers, the Raja hunting, the worship of the family deity, a royal wedding, the pleasures of married life, an outing into the forest, the birth of a prince and the consequent celebrations, village life in Mewar, a scene of a battle and the installation of the pillar of victory".[1]

[1] Jain - Neubauer, 1986 p.59-61

Opposite page and below
Hansli, two-faced choker. Gold, silver, semi-precious stones, pearls and enamel; 22 cm x 19.5 cm. Jaipur, Rajasthan. c. late 18th century. 7/2928.

Under the Muslim sovereigns, Indian craftsmen excelled in the art of *meenakari* or enamelling. They also mastered the technique of *kundan*, the setting of precious and semi-precious stones within bands of gold. This rigid neck-band or *hansli*, resembling the collar-bone, is embellished with semi-precious stones in the *kundan*

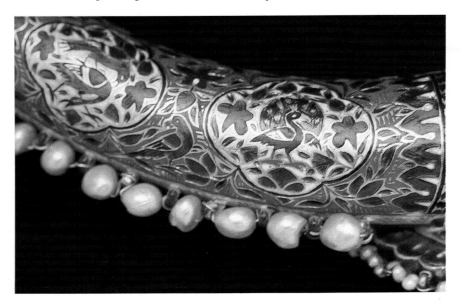

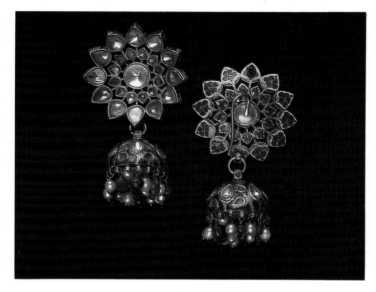

technique, while its reverse side is enriched with delicate floral enamelling, so that the ornament has two equally beautiful surfaces.

***Jhumkas,* ear ornaments with danglers.** Gold, silver, semi precious stones, pearls and enamel; 7 cm x 4 cm. Jaipur, Rajasthan. c. late 18th century. J/CCIC/215.

The leaf shaped base of each *kundan* set gem on the convex reverse side of the stud of this *jhumka* is enamelled with leaf sprigs and delicate petals to form a composite floral motif. The frontal concave side of the stud presents a colourful spectrum against the dazzling iridescence of the gems. The dangling bell-shaped pendant, that gives the ear ornaments or *jhumkas* their characteristic name, is executed in *kundan* work on a green enamel ground.

***Mangamalai,* mango necklace.** Gold, pearls, rubies and semi-precious stones; 27 cm x 4 cm. Thanjavur or Tiruchirapalli, Tamilnadu. c. 19th century. J/JG/252(2).

Sometimes known as the temple jewellery of the South, the ruby-set gold jewellery of the past was characteristically heavy and used 24 carat gold in large necklaces with

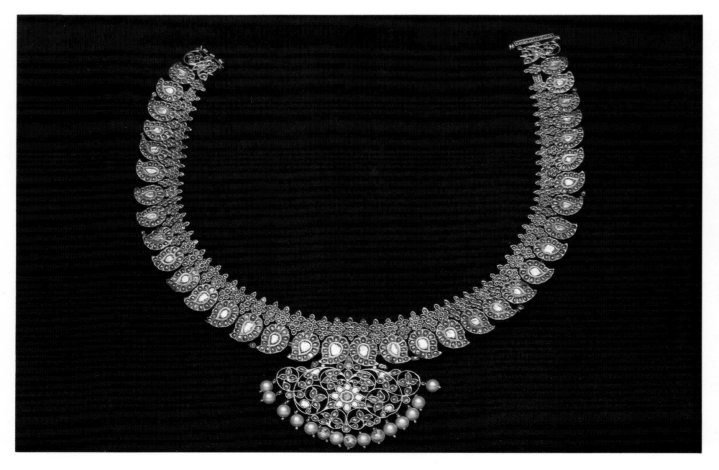

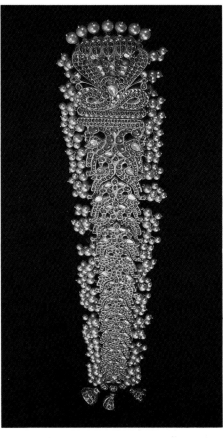

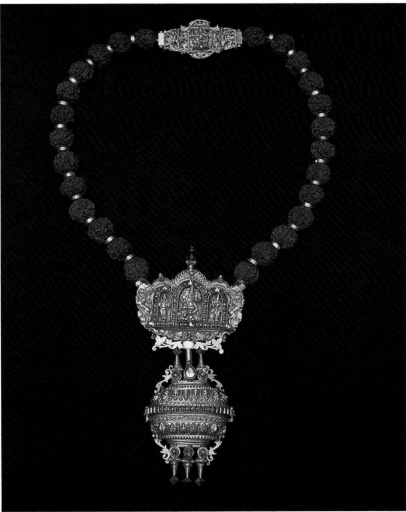

pendants and hair ornaments. This necklace is made up of a garland of mangoes, the sacred fruit of the gods and a symbol of fertility. Traditionally worn by women of well-to-do families and by *devadasis,* temple dancers, these ornaments today adorn the idols of deities installed in shrines and during important festivals when devotees appear before the deity for *darshan.*

Jadanagah, hair braid ornament.
Gold, silver pearls, precious and semi-precious stones; 55 cm x 6 cm. Thanjavur or Tiruchirapalli, Tamilnadu. c. 19th century. 7/2184.

This braid ornament or *jadanagah, jada* meaning "hair" and *naga* meaning "snake", is an important element in the *devadasi's* or temple dancer's costume whose hair must always be long and styled in a braid. It is worn in conjunction with other hair ornaments such as circular medallions, or *jada-billies,* of the sun, *surya bimbas,* or of the moon, *chandra bimbas,* worn on either side of the parting. The cobra-hood on top is symbolic of sexuality and procreation as are the peacock pairs arranged, one above the other, along the length of the ornament.

Rudraksha mala, bead necklace with casket depicting Shaivite deities.
Rudraksha beads (fruits of *Elaeocarpus ganitrus*), gold, silver, precious and semi-precious gems and lac; 42 cm x 8 cm. South India, perhaps Tamilnadu. c. late 19th century. 7/3894.

Worn generally by South Indian temple priests and *sanyasis* or ascetics, this ritual necklace is considered to be extremely sacrosanct and is reserved for sacred occasions and especially during prayer. It may not be placed on the floor and may not be worn while engaged in profane activities such as sleeping, bathing or going out from a holy place, all of which are ritually impure, and hence defiling.

The cardinal aspect of this necklace is the *kavachh,* or receptacle for the image of Shiva and his consort Gauri, in the symbolic form of two *rudraksha* beads naturally joined together to form the sacred couple, Gauri-Shankar. The interior of the casket is lined with lac for longevity while the exterior, studded with precious and semi-precious stones, depicts various deities in three arches. In the centre is Nataraja, the dancing form of Shiva trampling the body of an *asura* or demon, on his left is his wife Shivagami Sundari and on his right is his devotee, Thirugnana Sambandhan. At the extreme ends are the fiery figures of the *yali* or the mythical lion.

63

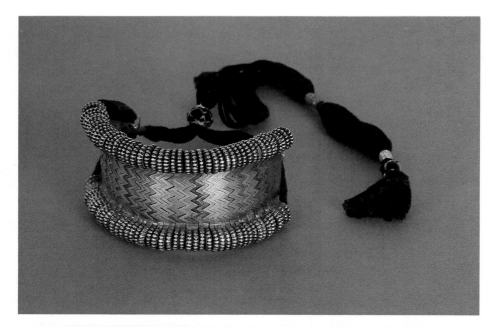

On the opposite end of the necklace is another pendant, placed at the back of the neck, depicting Shiva's son Kartikeya on his vehicle the peacock and flanked by his two wives Sreevalli, the daughter of a hunter, and Devayani, daughter of Devendra.

[1] In conversation with South Indian priest A. Sundaresa Gurukkal

Bajubandh, arm band. Silver and dyed cotton threads; 21 cm x 5.5 cm. Rajasthan. c. early 20th century. 84/6700.

The suture-like interlocking of the side rings and main zigzag pattern of this arm band, worn by the women of the Mina and Jat communities of Rajasthan, allows for a flexible curvature around the upper arm. The threads are adjusted according to the size of the wearer's arm and hence the word *bajubandh, baju* meaning "arm" and *bandh* meaning to "tie around".

[1] Wacziarg and Nath, 1987, p.111

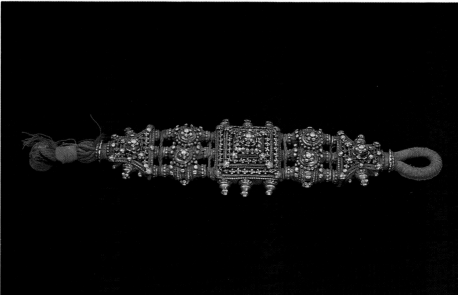

Armlet. Silver and dyed cotton threads; 28 cm x 6.5 cm. South India, perhaps Andhra Pradesh. c. early 20th century. 7/886.

Cast by the ancient cire perdue or lost-wax technique, this arm band is probably worn by the Sugali or Lambadi tribe of Andhra Pradesh. The cotton loop at one end is used to tie the ornament across the upper arm to fit tightly around it.

Hollow anklets. Silver; 19 cm x 12 cm. Rajasthan. c. early 20th century. 16/134.

Hollow anklets that jingle are usually worn by Rajasthani women, as elsewhere in India, to ward off evil spirits or even to let others know of their presence. These anklets are embellished with patterns composed of tiny beads resembling real bells. The delicate ankles that wore these ornaments must have really been tiny for the inner circumference of the anklets is barely large enough to fit a petite wrist.

Opposite page, top
Skull necklace. Silver and alloyed tin; 40 cm x 2 cm. Tribal central-eastern India, perhaps Orissa. c. early 20th century. J/D/2.

Tiny bells dangling mischievously from beneath a row of macabre skulls characterises this tribal necklace. The interlocking chain of fine craftsmanship and the hollow skulls cast in the lost wax technique pay homage to the metalsmith's primeval sense of beauty.

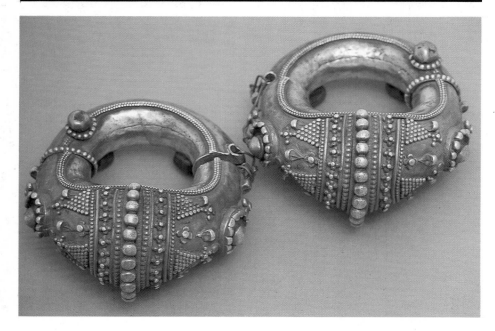

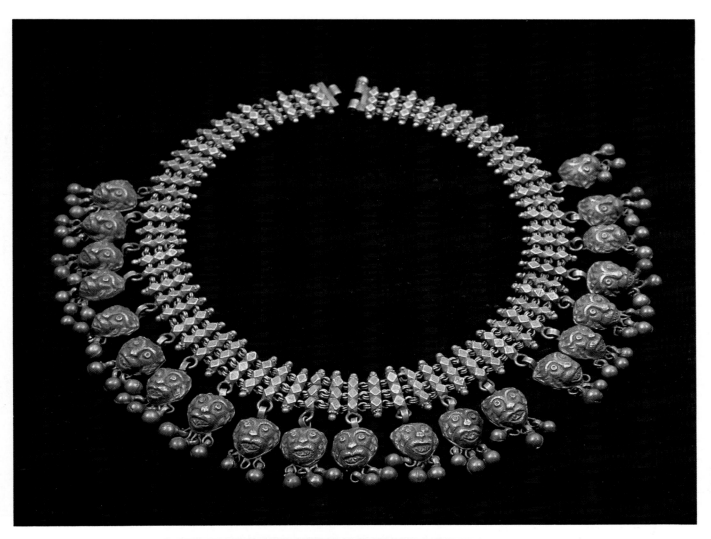

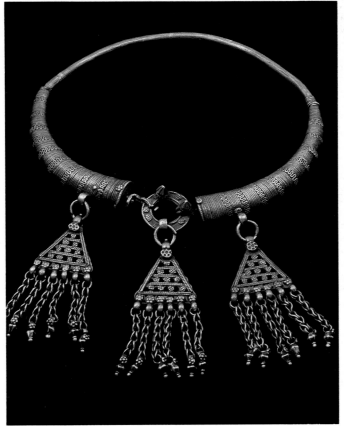

Hansli **or necklet.** Silver; 33 cm x 22 cm. Lambadi tribe, Andhra Pradesh. Contemporary. J/LS/179.

Among the Lambadis, also known as the Sugalis, this silver *hansli* or neckband is an important symbol of marriage. Of the three triangular danglers, the second and third are welded onto the neckband at the birth of two male children. "When a third is added to the family, the three *bottus* are welded together, after which no additions are made."[1] Lambadi women are distinguished by the "heavy pendants or *gujuris* fastened at the temples. This latter is an essential sign of marriage, and its absence is a sign of widowhood."[2]

[1] Thurston, 1909, Vol. IV p.220

[2] Ibid, p.219

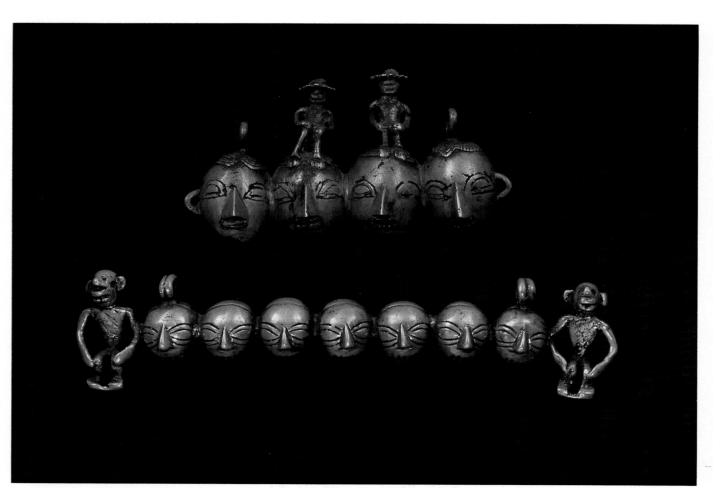

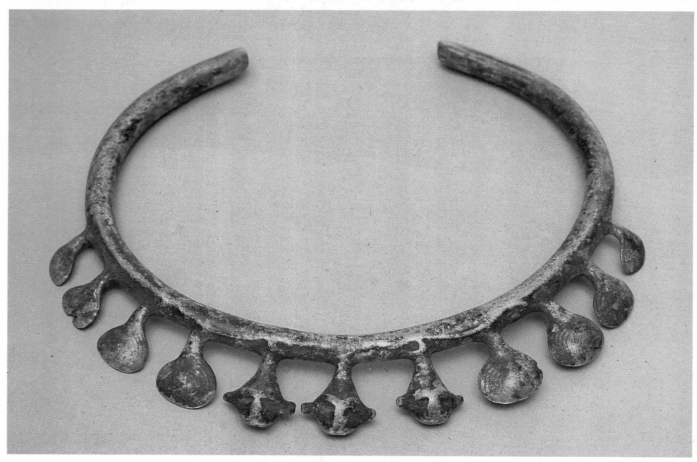

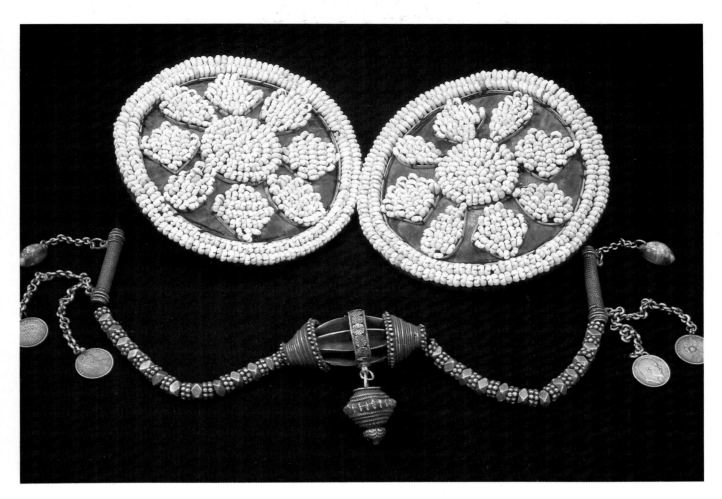

Opposite page, top
Head tally pendants. Brass; 13 cm x 7 cm. and 19.5 cm x 4.5 cm. Konyak Naga tribe, Nagaland. c. late 18th century. 85/6901, 85/6902.

Among the Konyak Nagas, miniature human heads won as trophies during war, are worn by warriors as pendants on bead necklaces symbolising the wearer's exploits on the battlefield.

The greater the number of heads on the pendants, the greater the prestige accorded to the wearer. Moreover, the heads are believed to enhance the *mio* or "spirit reservoir" of the village which is why "Naga warriors would cut off and carry away heads of dead comrades lest they fall into rival hands and thus increase the *mio* of an enemy villager."[1]

Cast by the cire perdue or lost-wax process, the metal mask pendants are chased with menacing pupil-less eyes and deathly smiles.

[1] Welch, 1985, p.77

Opposite page, bottom
Neck-band. Brass; dia 18 cm, Nagaland. c. early 20th century. 85/6858

This extremely heavy neck ornament is meant to fit passively against the collar bone, in a deliberate attempt towards restraint, symbolic of quiescent power. Cast by the cire perdue or lost-wax technique, the neck ornament is embellished with small spiral roundels that may well represent human heads. Often neck chokers are seen with skulls strung in a row around the neck, very much like the skull tallys worn by Naga warriors.

Ritual buffalo trappings. Silver, cowrie shells, black cotton thread and cloth; 130 cm x 23 cm. Nilgiri Hills, Tamilnadu, c. early 20th century. 83/6624.

The Todas who are essentially cattle breeders and dairy farmers, revere the buffalo. Although they are vegetarians they do sacrifice buffaloes, whose meat is discarded or given to their neighbours of the Kota tribe.

While there are no photographs showing the actual ceremony where a sacrificial buffalo is made to wear these trappings, it is believed that the two cowrie shell circular platters are hung on to the horns of the animal[1] while the central silver gadrooned ovoid ornament — held between two conical caps on either side — hangs from the neck by a chain made of silver beads and octahedrons.

[1] Welch, 1985, p.85

Chiselled forms:
Wood, Stone and Ivory Carving

Even in prehistory, man was familiar with the technique of carving. "All through the Upper Palaeolithic one can see the improvement and amplification of blade tools. With such tools wood and bone could be carved, shaved, engraved and punched as never before".[1]

As early as the third millenium B.C. the Indus Valley Civilisation possessed a high degree of technical expertise, as is evident both in their tools as well as their artefacts. The finely carved teeth of the ivory combs from Mohenjodaro indicate the use of a saw, while "the crisscross designs on the fish-shaped ivory-pieces could have been obtained by a thin chisel...."[2] The numerous steatite (soapstone) seals are carved with incredible pictographs, using both straight and curvilinear incisions that could only have been made by very skilled hands. The figure of the "priest" with the famous trefoil motif expertly carved on his robe is also remarkable. No less worthy is the Harappan male torso carved in red sandstone "so sensitively executed that were it not from the site one would have thought it of Gandhara or Gupta origin."[3]

While historical and archaeological evidence of earlier stone, ivory or bone carvings are innumerable, examples of wood carvings are lacking. Due to its perishable nature practically no ancient wooden artefact or monument has survived the ravages of time. Nevertheless, scholars are generally agreed that the stone carvings of the same periods provide ample clues to the character of early wood carvings.

Literary sources also testify to this. The *Ramayana,* for instance, refers to Hanuman burning down the Chaitya-Prasada shrine at Lanka. "It appears that the Chaitya-Prasada and its post were both made of wood.... It is very probable that the original form of this Chaitya with its gateway and column was of the same type as the *stupa* with gateway and column at Sanchi."[4] Moreover, scholars believe that stone or lithic carvings have their precursors in wood. This is amply illustrated by "the presence of unnecessarily large stones, by the survival of essentially wooden constructive features, by the dove-tailing and bolting together of the parts, by the production on the turning lathe of the pillars and by the absence of any knowledge in the use of cement."[5] Highly ornate and elaborate designs such as the lattice-like *jalis* or perforated window screens, lacy fringes and hanging pendants of the stone *jharokas*, or the window facades-cum-balconies of Agra and Jodhpur, are morphologically congruous in wood rather than in stone. The same seems to be true for ivory carvings in Gujarat and Rajasthan, which "followed mostly the traditional woodwork and produced some identical examples"[6]

Regardless of whether wood, stone or ivory carving came first, the similarities in design are not surprising when one considers the technique involved. Carving entails the systematic chiselling, scraping or scooping out of unwanted material from any solid — whether wood, stone or ivory. Contrary to the moulding process where metal is heated and reshaped, or the "building" process, where additional material is added, as in clay modelling, "carving," involves a "subtraction" from the original piece rather than an addition to it. The slightest error in calculation and subsequent rendering of the predetermined design onto wood, stone or ivory can lead to irretrievable loss. An extra cut or too deep an excavation can compel the artist-craftsman to abandon the work and start afresh on another block.

Indian craftsmen are particularly conscious about precision carving not only because it is expensive to replace the raw material, but also because it is considered inauspicious to constantly disturb the spirits dwelling in trees, rocks

Previous Page
See page 84

70

and even elephant tusks. Moreover, certain ritual injunctions have to be strictly adhered to in selecting and felling trees. According to the *Matsya Purana*: "The wood of bo-tree and of other milky trees should not be used for a building nor should the wood of trees inhabited by a large number of birds or one burnt up by fire, be used.... The wood of the trees broken by elephants, struck by lightning, semi-dried up or dried up of itself or those growing near a *chaitya* or sacrificial place, temple, confluence of two rivers, burial ground, well and tank should in no case be used for house building...." On the other hand, "It is very auspicious to use sandal and panasa wood for a building.... Sinsapa, Sriparni or Tinduki are auspicious in house building when only one of these is used; but the mixture is inauspicious.".[7] The *Shilpashastras* further prescribe the type of wood required for a particular image, the way in which the tree is to be felled, the season and auspicious time when this is to be done and the ritual propitiation of the resident tree spirit so that it may depart and find alternative habitation for itself.[8] Similarly, unhewn stones that are venerated may not be used for carving as they are *svayambhu* or *sui generis*.[9]

The *Brihatsamhita* clearly states that gods dwell in the root of an elephant's tusk, while the middle part and tip are abodes of demons and men respectively. An incision into any of these parts will have varying degrees of ill-effects within varying periods of time.[10]

It is interesting to note that carvers in wood and stone are usually of the same caste and occupational status. In Bengal, the guild of temple craftsmen called *sutradhars*, i.e. "those working with the string" or *sutra*, included both wood and stone carvers.[11] Similarly, the blanket term Kammalan, in South India, was given to five artisan groups which included both carpenters or *tac'chan* and stone cutters or *kal-tac'chan*.[12] In Rajasthan, the *silavats* are stone-cutters who are especially engaged in making grinding stones. The *silavats* are also called *sutradhars*.[13] Furthermore, in many areas even ivory carvers came from the same stock as wood carvers. Sir G. Watt points out a marked affinity in the designation *gudigar*, given to sandalwood carvers from Mysore, and *kondikar*, given to ivory carvers of Bengal.[14] It is also significant that the *khatis* or wood carvers/carpenters in Rajasthan are allowed to intermarry with the *silavats*.[15]

Clearly then, whether it is in wood, stone or ivory, the Indian carver-craftsman has been extremely versatile in applying his techniques and designs to various media. And even though the essential process of carving by elimination, as well as the iconography and iconometric details remain the same. The spontaneous transformation of an image from one medium to another wholly justifies the notion of a creativity within the parameters of tradition.

While the sculptures of the Mauryan period (300 B.C. – 200 B.C.), epitomised in the famed polished stone of the *chanvaradharini yakshi* at Deedarganj in Bihar, the Buddhist carvings at Bharhut and Sanchi and the rock-cut caves of Ajanta and Ellora have no present-day parallels, the subsequent Hindu and Jain and still later Islamic carvings do have their 20th century equivalents. Even today, there exists in India an undaunted, but wavering, living tradition of wood, stone and ivory carving that bears testimony to the skilled artisan of the glorious past.

A major tradition of stone carving seems to be centred around temples in India. In Puri, Orissa, the artisans who are usually, but not always, from the Karmakar community, are concentrated in Patharasahi, a locality named after the traditional occupation of its inhabitants. Using a variety of stones, ranging from soft-brittle sandstone and patchy red stone to hard granite, the craftsmen fashion replicas of the shore temples at Puri, Bhuvaneshwar and Konark, images of deities in various sizes and postures and utensils of all sorts. The granite and soapstone carving tradition around Mahabalipuram, in Tamilnadu, is equally flourishing in Salem and Pondicherry as well as in the Kolar district of Karnataka. Here, although the carriers of this tradition are the twice-born

Acharis,[16] today, the title *shilpi*, or those who work in stone,[17] is given to stone carvers regardless of their caste.

In carving an image or utensil, the stone worker must necessarily adhere to the rough outline of the sculpture sketched on the stoneblock. The friction generated due to the constant chiselling away of the unwanted material results in the tools heating up. The craftsmen, therefore, sprinkle water on the stone carving during the course of their work. Finishing is accomplished in a variety of ways from sandpapering, polishing with Multani *matti* or clay, oil and cloth.

In Gujarat and Rajasthan, the Shaivite Sompura and Adi Gaud Brahmin communities are sculptors and stoneworkers who have continued working in the Hindu and Jain tradition of temple architecture and image making. They produce a variety of items from foliage and figurative carvings on brackets and panels to spice-containers, flower-bowls and foot scrubbers.

Patharkatti in Bihar is renowned for its tradition of stone carving. Mined *in situ*, the black stone is used for making everyday utensils of which the most commonly found are the *thali*, or large plate with an upturned rim, and the traditional *kharal*, or mortar for grinding spices and medicines.

Jali, or lattice work, was traditionally used to screen the interiors of fortresses and palaces from the harsh sun while allowing the breeze to filter in through the perforations. In Agra, Alwar and Jaipur this trellis-like work is presently used for embellishing jewel caskets, window screens, panels and brackets. The play of light and shadow through the *jalis* in elaborate floral and geometric designs are reminiscent of the arches and windows of the Taj Mahal.

The inlay of colourful stones on marble and sandstone surfaces, usually in foliated motifs, is characteristic of the Mughal period, the most beautiful example of which is the somewhat lesser known Itmad-ud-Daulah's tomb near Agra. The soft bending of the leaves, the gentle sway of the stems and the delicate opening of the buds are achieved with painstaking dexterity using different shades of the same stone.

Carving and ornamentation of wood, a material which is relatively easier to work with and is available in innumerable varieties all over the country, is perhaps, the most expressive of all crafts in India. Whether it is in architecture — as in carving pillars, brackets, windows, doors — furniture, sacred images of deities or utilitarian objects from containers to combs, the vocabulary of wood carving has always been dictated by the grain of the timber employed. Thus you find the "deep under-cutting and sculpture that is possible with teak, red-wood and walnut, the low relief of *shisham* and *deodar*, the incised designs of ebony, the intricate and minute details of sandal and the barbaric boldness of *rohira, sal,* and *babul (kikar)* and other coarse grained and hard woods."[18]

Carved wooden facades and fixtures of dwellings, domestic shrines, temples, churches and palaces of Rajasthan, Gujarat, Kashmir, Kulu in Himachal Pradesh, Kumaon in Himalayan Uttar Pradesh, Maharashtra and Kerala are marked by intricate designs in sculptural relief carvings.

Scenes from the epics, particularly those from the battlefield, forest and palace, in addition to figures of deities, are recurrent themes in the wood carvings of India. Trichur and Trivandrum in Kerala are known for their models of Kathakali dancers made in teak or jack wood,[19] while Karnataka is renowned for its highly realistic relief-icon-carvings in ebony and sandalwood. Andhra Pradesh is famous for its red sanderswood Tirupati dolls carved in bulky forms with little ornamentation.[20]

The Thar desert, extending from North-Western India to South-East Pakistan, encompasses a unique cultural complex made up of Sind in Pakistan, Barmer and Jaisalmer in Rajasthan and the Rann of Kachchh in Gujarat.[21] Woodwork in this region combines sensitive shallow carving with colourful lac turnery. Occasionally, mica or mirrors are inlaid in the interstices. By employing patterns

such as interlocking circle motifs, lotus medallions, diaper, billets, chevrons, dogtooth, whorls and frets, the craftsmen of this region model chests, tables, chairs, cradles, boxes, spice-containers, opium grinders, cloth beaters, hand mirrors, bread moulds and a host of other everyday objects. The predominantly geometric character of the surface ornamentation in the woodwork of the Banni district in Kachchh and the circular floral relief design of the carving in Barmer reflect the rich artistic tradition of the area.

In Uttar Pradesh, Saharanpur is famous for its wood carving in *dudhi* or white wood and *shisham*, while Farrukhabad is well known for its extremely fine and deep floral carvings on wooden printing blocks. Nagina, in Bijnore district, is the centre of a graceful style of ebony carving traditionally done by Muslim craftsmen. Here, "tables, chairs, caskets, picture frames, walking sticks and other such articles are turned out richly chased by a delicate and crisp surface ornamentation that is purely floral...."[22] More recently the artisans have turned to producing carved combs in all shapes and sizes, often studded with ivory dots inlaid in the dark ebony surface.

Hoshiarpur, in Punjab, is known for ivory inlay in wood, while *tarkashi*, the craft of wire inlay on wood resulting in intricate, glittering designs, flourishes in Mainpuri, in Uttar Pradesh, and Jaipur in Rajasthan.

Kashmir wood carving, unlike that of the other Himalayan states, is executed in walnut wood mainly in the *pinjra* or fretsaw perforation style. Motifs derived from nature, especially the maple or *chinar* leaf, water lilies and other floral sprays are commonly depicted on wooden panels, screens and boxes.

Somewhat lesser known are the magnificent, larger than life-size, wood sculptures of the *bhuta* cult of ancestor-worship from coastal Karnataka. Carved from solid blocks of wood obtained from the jackfruit or wild-jackfruit tree, (*Artocarpus integrifolia*), these figures are images of *bhutas* or spirits of deified hero, of fierce and evil beings, of Hindu deities, of the mother goddess, of animals and the serpent spirit.[23] Sculpted in grand proportions, the human, theriomorphic and animal figures, project a strong sense of the supernatural. The carving is decisive but not sharp, naturalistic, yet not realistic. The mammoth Hulidevaru or tiger deity with its wide open mouth and sharp teeth, the Eka Shringi Nandi or single-horned bull, Nandi Raja or horse-headed guardian deity, Garuda or mythical man-eagle deity standing on a peacock, the richly adorned graceful female figure and the numerous *asava savaras* or bullock attendants and riders, are only a few of the solemn yet mysteriously unconstrained sculptures enshrined in scattered temples in Udipi district.

The wood carvings of the North-Eastern tribes are executed in a wood locally known as *kumisyng*, usually by older men, while the painting is done only by married men.[24] Carvings of human heads, a relic of bygone head-hunting practices, tigers, elephants, the auspicious hornbill and pythons are all executed in high relief on pillars and posts outside the homes of wealthy and courageous men, symbolising the prestige accorded to them in society. High relief carvings, often painted, are also done on the main pillar and outside verandah of the *morung* or young boys' dormitory. It is believed that "the tigers will make the boys ferocious, the elephants will make them strong, the hornbills will make them fertile."[25] Thus the carvings are said to have a sympathetic effect on their beholders.

The sculptures of human beings, normally smaller than life-size, are those of couples, mother and child, chieftains and warriors. Solemn expressions and decorations of cowrie shells, feathers, beads, hair and skull necklaces combined with the blunt tubular carving, give these Naga sculptures a magical, almost ominous appearance.

Among other wood-carved objects, which include utensils, rice pounding tables and musical instruments, the huge log drum is particularly noteworthy. Fashioned from a solid tree trunk that is slit in the centre, the beating drum,

generally used for festivities or for announcing war, is a resonating device made to sound by striking wooden beaters around the central slit.

The wood carvings of the tribal areas of Madhya Pradesh, Bihar, Orissa and Rajasthan include doors, window frames, "marriage-litters", memorial and wedding pillars, toy and votive zoomorphic and anthropomorphic sculptures, masks, combs, tobacco cases and pipes.

The doors of Baiga homes in Bilaspur, Madhya Pradesh, are particularly elaborately carved. Geometric relief-carved borders, usually in herringbone and star-in-shallow-square motifs, divide the door panel into square and rectangular sections within which equestrian figures, whorls, flowers and scenes from daily life are carved in low relief. "In all this carving and modelling there is naturally a great deal of simplification. Men and animals appear without anatomical detail and with little indication of clothes or ornament, as if they were in silhouette."[26] The carvings on the doors of Kuttia Kondh homes in Ganjam, Orissa, are somewhat less geometric and contained and the fish motif, executed in short incisions, is particularly recurrent.[27] A very beautiful braided pattern, carved in high relief, is seen on a chair from the Santal Parganas in Bihar.[28]

Similar geometric motifs are common on the combs carved by young tribal boys in Madhya Pradesh for their sweethearts and are symbolic of friendship and love. "Juang girls in the dormitories steal combs from the boys and it is a point of honour for the victim to react properly."[29] Besides geometric relief carvings, Muria combs usually have human and animal figures on top which can be seen from afar.[30] Juang combs, however, are generally made from bamboo and are decorated with figurative incision carvings.[31]

Wooden pillars erected in memory of socially prominent people are common in tribal India. Probably the best known are the *shedoli mundas* or pillars erected at the *shedoli* ceremony by the Korku tribals of Panchmadi in Hoshangabad, Madhya Pradesh. These are flat and paddle-shaped "tablets carved in teak with traditional representations of horsemen and men dancing, with the sun and moon at the top and generally a chevron pattern down the sides."[32] The Bison-Horn Maria funerary pillars at Bastar and those of the Saoras of Orissa are more megalithic in character.

Ivory carving in India has been an extremely prosperous craft from earlier times, especially during the Mughal and British regimes. African, Burmese and Sri Lankan ivory found its way to India though indigenous varieties from Assam, the Deccan, Mysore and Kerala were also used for carving.

Being fibrous and relatively elastic, ivory is the ideal medium for extremely fine carving. It does not tear or crack and can be easily polished due to the presence of an oily substance in its pores[33]. The ivory carvers of Bengal, especially Murshidabad; Jaipur and Delhi produced an assortment of *objets d'art* such as the *ambari hathi* or processional elephant, models of bullock carts, caskets, book covers, sandals, palanquins and frames for the European market. In Orissa, there has been a tradition of offering ivory inlaid furniture to the temple of Puri.

Miniature shrines with delicate pillars and intricate low relief floral work, caskets depicting scenes from myths and legends, and images of gods and goddesses including Christian icons and symbols has been a tradition in Kerala and Karnataka. Often caskets were so profusely perforated that the trelliswork transformed the ivory into lace.

Today, due to the ban on the product, ivory carvers are either dwindling or are turning to carving on bone or other more humble materials.

1. Fairservis, 1975, p.85
2. Dwivedi, 1976, p.31
3. Fairservis, 1975, p.285
4. Agrawala, 1970, p.133
5. Watt and Brown, 1979, p.99
6. Chandra, 1977
7. Census 1961a, p.158
8. Eck, 1981, p.52
9. Crooke, 1925, p.319
10. Dwivedi, 1976, p.23
11. Dasgupta, 1971, p.34
12. Thurston, 1909, Vol. III, p.107
13. Lohia, 1954, p.237
14. Watt and Brown, 1979, p.148
15. Sherring, 1974, Vol.III, p.58
16. Thurston, 1909, Vol.III, p.118
17. Ibid, p.113
18. Watt and Brown, 1979, p.100
19. Census 1961a, p.178-9
20. Census, 1961b, p.25
21. Jain, 1986, p.82-89
22. Watt and Brown, 1979, p.112
23. Upadhayaya, 1984
24. Census 1961f
25. Kramrisch, 1968, p.64
26. Elwin, 1951, p.100
27. Ibid, p.108
28. Ibid, p.109
29. Ibid, p.48
30. Ibid, p.51
31. Ibid, p.52-53
32. Ibid, p.95
33. Dwivedi, 1976, p.1

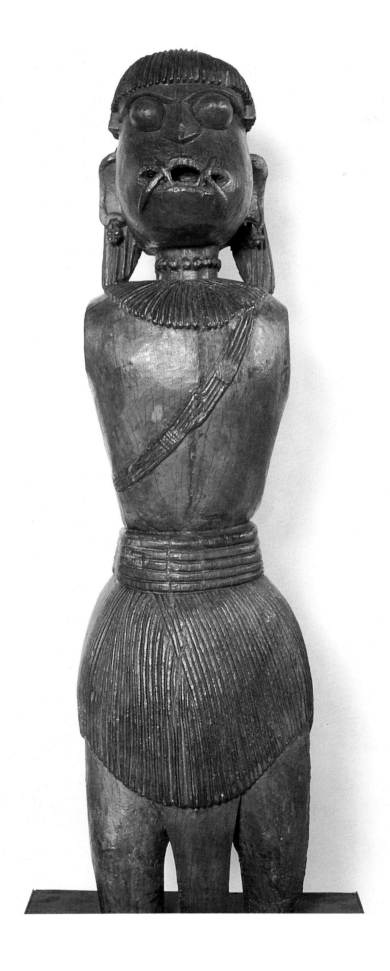

Ummalti, a ferocious *bhuta*. Carved jack wood, originally polychromed; 192 cm x 46 cm. Mekkekattu, Udipi, South Karnataka. c. late 18th century. 83/B/32.

In coastal Karnataka, especially among the fishing community, wooden figures like this are part of the *bhuta* cult of spirit worship and are propitiated in shrines or *bhutasthanas* located near a *pipal* (*Ficus religiosa*) or banyan tree. *Naga* (serpent) stones are commonly found nearby and worshipped alongside.

The *bhutas*, spirits of deified heroes, of fierce and evil beings, of Hindu deities and of animals etc., are erroneously referred to as "ghosts" or "demons" and, in fact, are really protective and benevolent in nature. Though it is true that they are extremely powerful and can even cause harm in their violent forms, they are nevertheless pacified through worship and offerings.

Bhuta aradhana or invocation of the *bhuta* spirits involves — in addition to daily worship in the form of offerings of water, flowers and the lighting of oil lamps and incense — a periodic propitiation in the form of possession rituals amidst the chanting of *paddanas* or Tulu folk narratives describing individual biographies of the *bhutas*.

This figure, from the shrine of Lord Nandikeshvara, is a classic example of sculptural mastery in wood. The extremely precise carving of the hair, necklace, waist band and short pleated skirt conveys a sense of linear continuity with only the crisscrossing of the canines to break the tension.

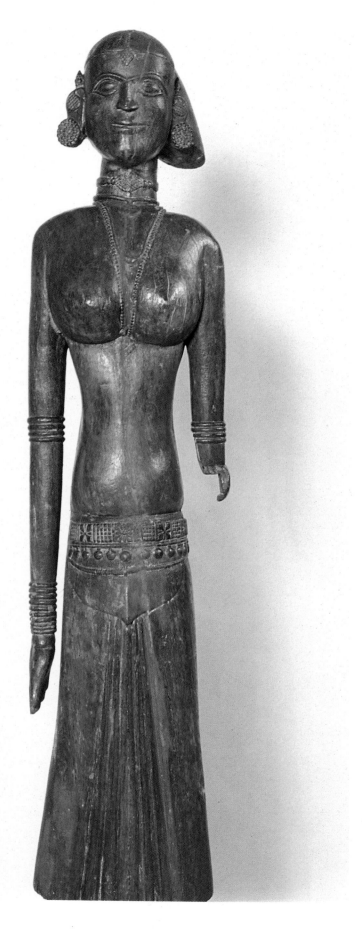

Gouramma, female *bhuta* deity.
Carved jackwood, originally
polychromed, 115 cm x 43 cm. 170 cm
x 30 cm. Mekkekattu, Udipi, South
Karnataka. c. late 18th century. 7/3963.

Among the many female *bhuta* deities
from the shrine of Mekkekattu,
Gouramma stands out as an extremely
beautiful image in terms of sculptural
quality. Probably the spirit of a once
socially prominent woman, the deity is
rendered with an amiable countenance,
elaborate coiffure, grand ornaments and
costume. She is, in most likelihood, an
attendant to Lord Nandikeshvara, the
bull deity and principal object of
worship at the Nandikeshvara
daivasthana or shrine in Mekkekattu.
The larger than life size-wood
sculptures representing the various
bhutas in their corporeal existence are
an integral part of the *bhuta* cult. They
are generally made from wood obtained
from the jack or wild-jackfruit trees.
The colours employed are natural
pigments obtained from minerals and
plants. A coating of lac is applied for
the finishing touches. Significantly,
only the eyes are left untouched for the
final ritual of *prana-pratishtha* or
"breathing-in of life", when the deity is
said to descend into the sculpture and
occupy it. The idol is covered with a
sari, or a piece of cloth, and only after a
ritual offering is performed is the
painter able to go under the cloth, fill
in the eyes, and receive his
compensation.[1]

During the invocation of the *bhuta*
spirit, the possession rituals involve a
bhuta impersonator or *patri* who acts as
a vehicle of the particular *bhuta* deity
he is personifying. It is interesting to
note that the spirit of the *bhuta* "enters
into" the physical body of the human
representation at this stage and not into
its sculptural form.

[1] Courtesy: Field notes of late H.D. Chauhan

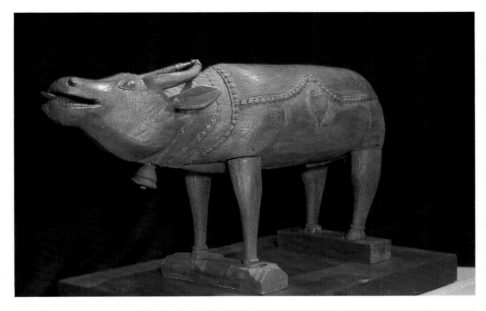

Nandikeshvara, the bull deity and vehicle of lord Shiva. Carved jackwood, originally polychromed; 115 cm x 220 cm. Mekkekattu, Udipi, South Karnataka. c. late 18th century. 83/B/52.

Nandikeshvara, the chief of the *bhuta ganas* or attendants of Shiva, is the prime deity of the shrine at Mekkekattu. According to one version of the myth, sage Jambukeshvara who was performing penance in this region employed Nandi to protect himself. Later, *bhutas* from several places were also attracted to this area and began terrorising the local villagers for a shrine for themselves. Nandikeshvara *daivasthana* was, therefore, built to appease these spiritual beings.

Nandikeshvara is represented as a bull having two horns as usual, but its head is raised upwards with an outstretched tongue. This sculpture is remarkable for its pent-up energy and realistic rendering.

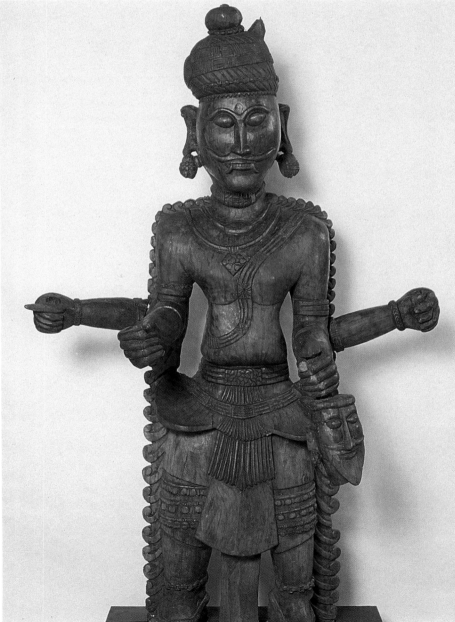

Virabhadra, a *bhuta* deity. Carved jackwood, originally polychromed; 180 cm x 117 cm. Mekkekattu, Udipi, Karnataka. c. late 18th century. RC/B/136.

Virabhadra is considered to be the favourite *gana* or attendant of Lord Shiva. It is believed that his birth was the result of Shiva's wrath when he learnt that his wife Parvati had jumped into the sacrificial fire of Daksha, the demon, and died. In anger, Shiva had fiercely struck his matted hair on the ground from which Virabhadra and Bhadrakali emerged. In mythology Virabhadra is considered to be the protector of the *devas* and destroyer of demons.[1]

In the temple at Mandarthi, Virabhadra is depicted astride a bull with a garland of skulls around his neck. In Mekkekattu, the *bhuta* is represented as a ferocious-looking male with four arms, one of which holds a single severed human head.[2] He is shown here with an elaborate hairdo that terminates in a bun tied with beads. He is also wearing the *adyana* or waist belt, *kalu kadaga* or anklets, earrings and necklace along with the usual sacred thread of the twice-born.

[1] Mani, 1984, p.859

[2] Census, 1971c

***Gadi,* toy cart.** Carved wood smeared with turmeric and oil; 14 cm x 25 cm. Kachchh, Gujarat. Contemporary. 88/2/D.

The Thar desert cultural complex, including parts of Rajasthan and Kachchh in Gujarat, produces a striking variety of wood carvings using fine chiselled patterns of the interlocking circle, whorl, diaper, billet, chevron, dogtooth and herringbone.

This *gadi,* a toy cart dragged by a string, is intricately carved with motifs typical of the area. Generally a doll is made to sit inside the cart, its legs on either sides of the pillar in front.

An intriguing aspect of this wood carving from the Banni region of Kachchh is its affinity to objects found in the Central Asian provinces of the Soviet Union. Not only is the carving similar but even the items such as bread moulds, cloth beaters, buckets, chests, spice grinders and a host of other articles have identical forms and utility.

***Vastraharana,* four panels depicting Krishna with cowherdess companions.** Pigment painted wood; 232 cm x 145 cm. Kerala. c. 19th century. F/36.

"He hugs one, he kisses another, he caresses another dark beauty...."[1] Joyful Krishna's love play in this carved panel is as evocative as is Jayadeva's poetic rendering of the young lord's amorous adventures with his cowherdess companions. Seeing them bathe, he mischievously hides their clothes and perches himself atop a tree, with his flute. Here, bashful young girls are depicted pleading with Krishna to return their clothes in a desperate attempt to protect their modesty.

[1] Miller, 1977, p.77, stanza 44

Opposite page
Goddess Kali, the terrible form of Parvati and wife of God Shiva, slaying a demon. Wood carving; 115 cm x 69 cm. Kerala. c. 18th century. 85/6897.

Surrounded by a halo of poisonous cobras and riding on the lifted palms of her female attendant, goddess Kali is shown here slaying a demon. Her enormous earrings embellished with fierce animal motifs, bulbous eyes and fangs, along with her numerous arms, represent the goddess as the feminine counterpart of one who presides over havoc and destruction.

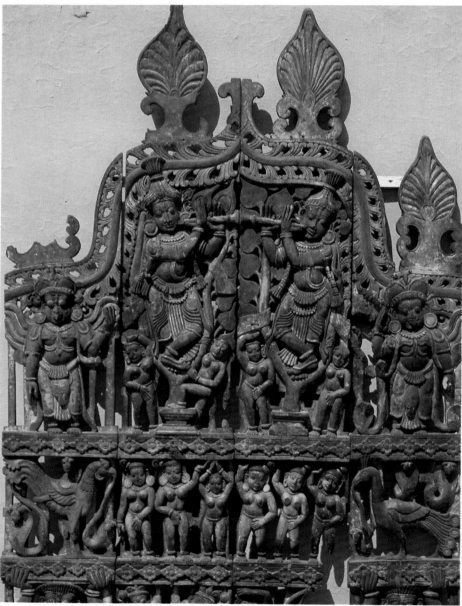

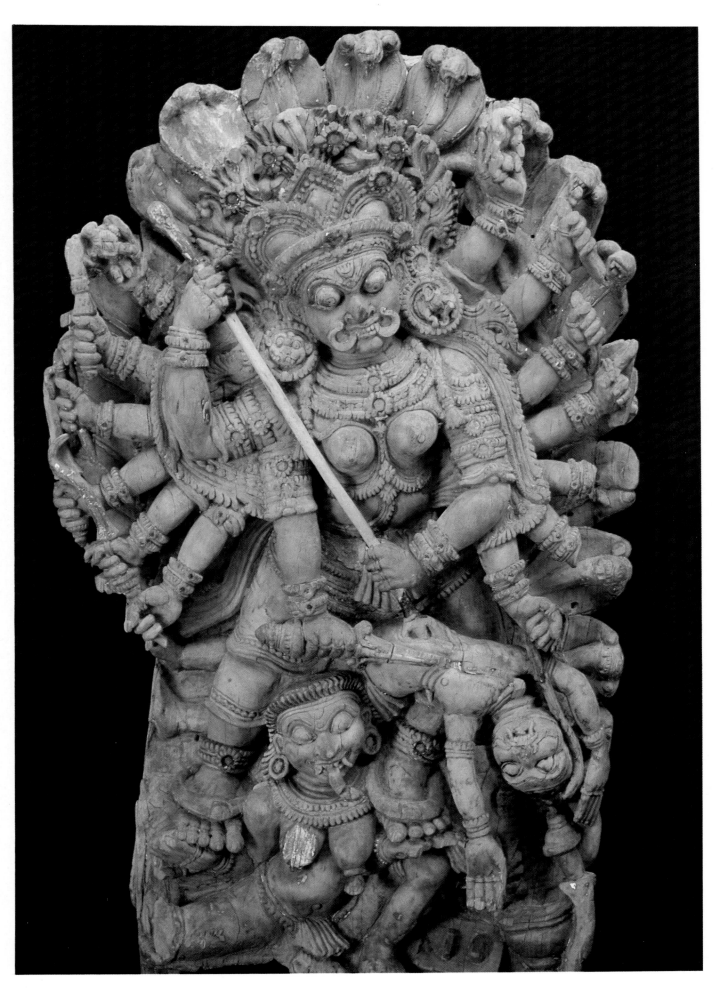

Physician examining a patient. Wood carving; 46 cm x 129 cm. Orissa. c. early 19th century. 7/5191.

An unusually "profane" theme characterises this wood panel. The skeleton figure of the patient being examined while his wife awaits anxiously is a striking contrast to the mythical themes common in Indian wood carving.

Domestic shrine of the Jain sect. Painted wood carving; 145 cm. x 141 cm. Gujarat. c. early 18th century. 5/270.

This beautiful shrine comes from an aristocratic Shvetambara Jain family and can be ranked among the finest pieces of wood carving in the region. Though Jains are an atheistic sect, they worship their "Enlightened Teachers" known as *tirthankaras*. In the uppermost horizontal panel are depicted the fourteen auspicious dreams seen by the mother of a *tirthankara*: an elephant, a bull, a lion, goddess Lakshmi, a garland, the moon, the sun, a banner, a vase, a lotus pond, an ocean of milk, a celestial palace, a heap of jewels and a smokeless fire. The panel below shows goddess Lakshmi being lustrated by elephants.

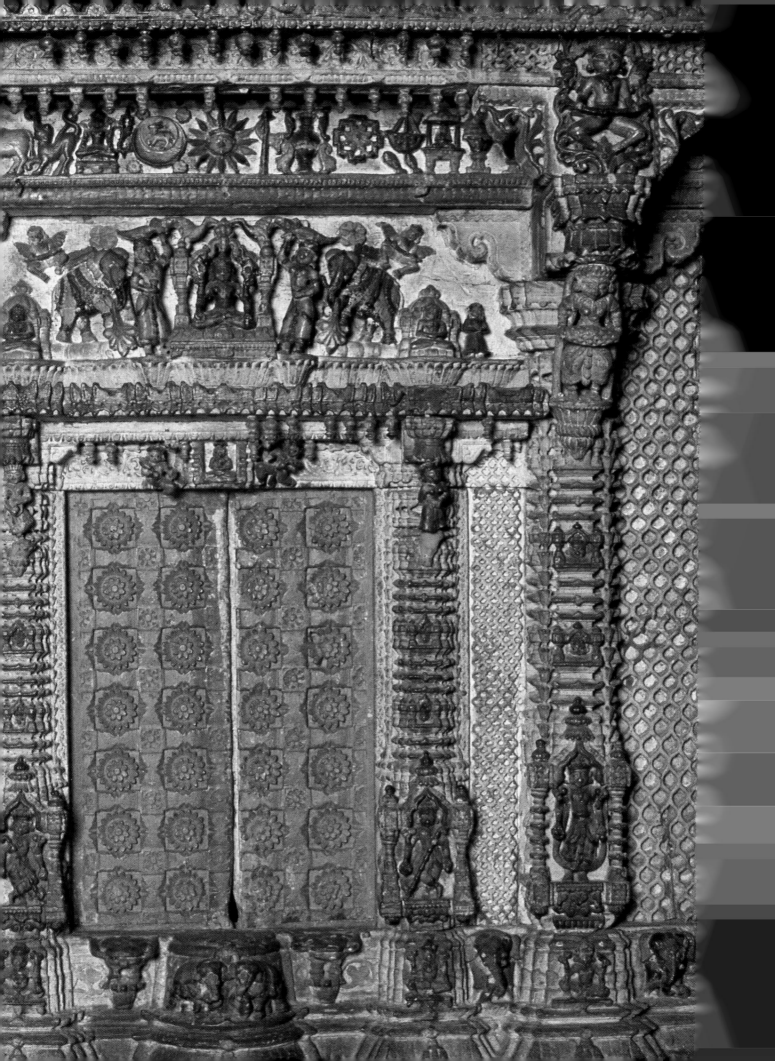

Among the many painted wooden dolls and toys popular in Nagaur, is this set of bowls fitting one into the other. These are used by Shvetambara Jain monks to beg food from householders. Generally painted orange and black, these bowls are carried, piled one inside the other, in a rope basket.

Smooth and light precisely for this purpose, the bowls have been assiduously turned on a lathe to bring out the paper-thin thickness of each piece.

This chaste jar, carved from grey soapstone, is probably a container for dried spices or fruits.

The Silavat, Usta and Bhatphode[1] communities of Jodhpur, Jaipur, Jaisalmer and Bikaner in Rajasthan practise the art of carving in locally available soft stone to produce a variety of utilitarian items such as this *hatadi* or spice container with compartments composed in the form of a lotus flower. The heavy lid, also carved in beautiful floral designs, fits neatly over the bowl container that weighs nearly five kilos.

[1] In conversation with craftsman Zahiruddin Usta from Bikaner

Reclining figure. Wood carving; 67 cm x 59 cm. Nagaland or Arunachal Pradesh. c. early 19th century. 86/7174.

Crouched figure. Carved wood and hair; 46 cm x 20 cm. Nagaland or Arunachal Pradesh. c. early 19th century. 86/7173.

Warrior. Carved wood, cowrie and hair; 85 cm x 26 cm. Nagaland or Arunachal Pradesh. c. early 19th century. 86/7114.

which the wandering spirit could inhabit, or simply placed outside the homes of valiant men as marks of prestige.

Carved from solid trunks of trees, the solemn expressions of these wood sculptures heightened by cowrie shells, beads, skull necklaces, headgear with human or animal hair, combined with the characteristic blunt tubular carving on dark wood, give these Naga figures a silent though persuasive identity.

[1] Kramrisch, 1968, p.63

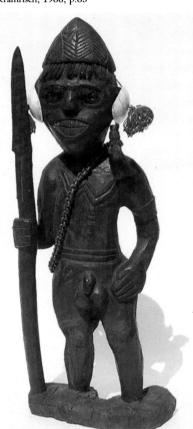

The Nagas are known as a head-hunting martial race for whom "the art of representation is... felt to be a dangerous transmutation, an act of creative magic...."[1] Not only are Naga beliefs and practices an inspiration for their art but are, in fact, truly its *raison d'etre*.

The young men's dormitory or *morung*, the guard house of the village and the chief centre of all social activities, such as the Feasts of Merit, is invariably decorated with paintings and wood carvings of the elephant, tiger, hornbill, python, human heads, the sun and the moon executed in high relief on the main pillar and upper beam. Such carvings are also found in the homes of chiefs or socially prominent men.

Human figures such as these were either used as effigies of dead warriors,

84

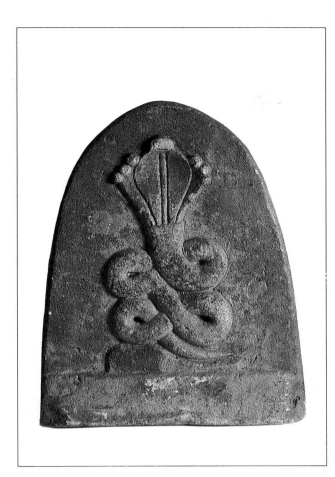

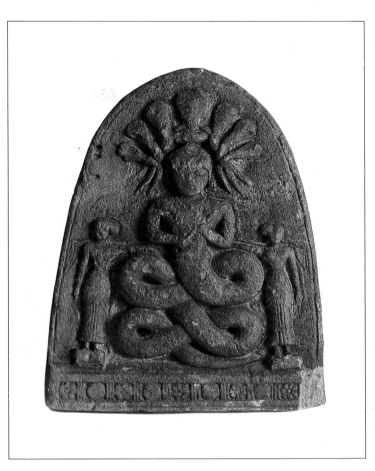

Opposite page
***Jali,* lattice work for window.** Carved
sandstone; 190 cm x 60 cm. Rajasthan.
c. late 19th century. 83/6658.

The enchanting play of light and
shadow from the *jalis* or *lattice*
windows are an integral part of the
havelis and palaces of Rajasthan. Ideal
during the hot humid Indian summer,
the *jalis* dispel the harsh rays of the sun
and allow a cool breeze to circulate in
the interiors.

Moreover, the *purdah*-conscious
Rajasthani women use the *jalis* of their
balconies and terraces to enjoy a view
of the bazaar without being seen
themselves by the public.

***Nagakalla,* votive serpent tablet.**
Carving on both sides of stone; 53 cm
x 40 cm. South India, probably
Karnataka. c. mid 19th century.
M/7/5048.

Carved stone tablets, such as this one,
are offered to "snake divinities by
women desiring children. The slabs can
be seen in groups in temple courtyards,
at the entrances of villages and towns,
near ponds (the waters of which are
supposed to be populated by nagas), or
under trees (which from immemorial
times have been associated with the
worship of serpents, since trees indicate
that there is water in the ground).
When their reliefs have been carved, the
nagakals are placed for a period of six
months in some pond, to become

imbued with the life-force of the watery
element, and then are consecrated with
a ritual and with sacred formulae...."[1]

On one side of this tablet the relief
carving depicts a female figure with
arms crossed across her breast while the
lower half of her body is that of a
coiled serpent. Probably Mudama,[2] the
serpent mother, this *naga* deity is
crowned with cobra hoods and flanked
on either sides by female attendants.
The opposite side of the slab depicts a
coiled serpent with a single majestic
hood.

[1] Zimmer, 1955, Vol.I

[2] Ibid

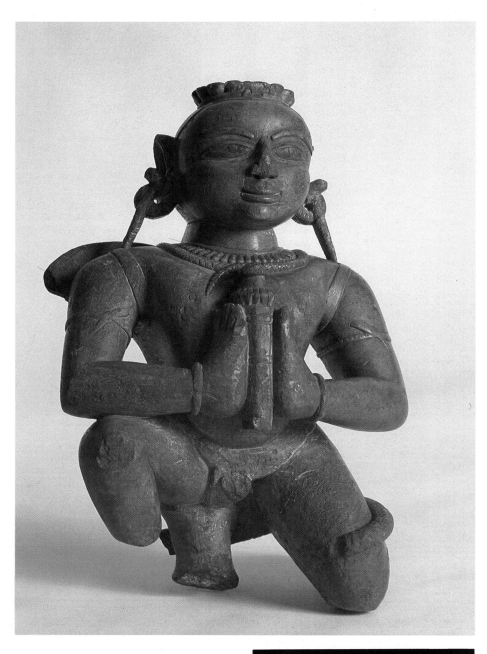

Garuda, king of birds and Vishnu's vehicle. Soft greenish grey stone; 31 cm x 21 cm. North Gujarat or western Rajasthan. c. late 19th century. F/18.

Garuda, the divine eagle and king of birds, was born to Vinata, as a result of a boon from sage Kashyapa. He emerged from an egg, his body brilliantly effulgent like the rays of the sun.

Garuda's heroic deeds enabled him to successfully retrieve the pot containing the nectar of immortality so coveted and guarded by Indra and the other *devas*. "He destroyed the wheels and the machine, and carrying the pot of nectar in his beak, rose to the sky shielding the light of the sun by his outspread wings. Mahavisnu, who became so much pleased with the tremendous achievements of Garuda asked him to choose any boon. Garuda requested Vishnu that he should be made his (Vishnu's) vehicle and rendered immortal without his tasting *amrita*," or nectar of the gods.

Having been granted both boons, Garuda became the vehicle or *vahana* of Lord Vishnu and is consequently depicted here holding a weapon with folded hands in a half-kneeling posture, as if alert for his master's command.

[1] Mani, 1984, p.282

Box with lid depicting floral motif. Inlay of semi-precious stones in marble; 17 cm x 21 cm. Agra, Uttar Pradesh. c. mid 20th century. 7/4448.

Agra, the home of the Taj Mahal, is famed for its stone inlay work on marble brought since Mughal times from the quarries at Makrana. In this technique, 'jewels' of agate, cornelian, jasper, bloodstone, lapis lazuli, malacite, Indian jade, turquoise and mother of pearl are embedded, in predominantly floral or geometric patterns, in the white marble surface.

In this technique, "Each piece has its bed prepared on the master's tracing on the surface of the slab, while it is shaped by the associated workman. As each piece is ready it is handed to the inlayer who fits it into its place with a cement of white lime. It is then covered with a small piece of glass, over which is laid a fragment of burning charcoal. When the annealing process is complete the glass is removed; and, when the whole design has been inlaid in this manner, the surface is rubbed over with a polishing powder...."[1]

This box, probably for ornaments, is embellished with floral creepers in stones of sharply contrasting colours.

[1] Mehta 1960, p.53

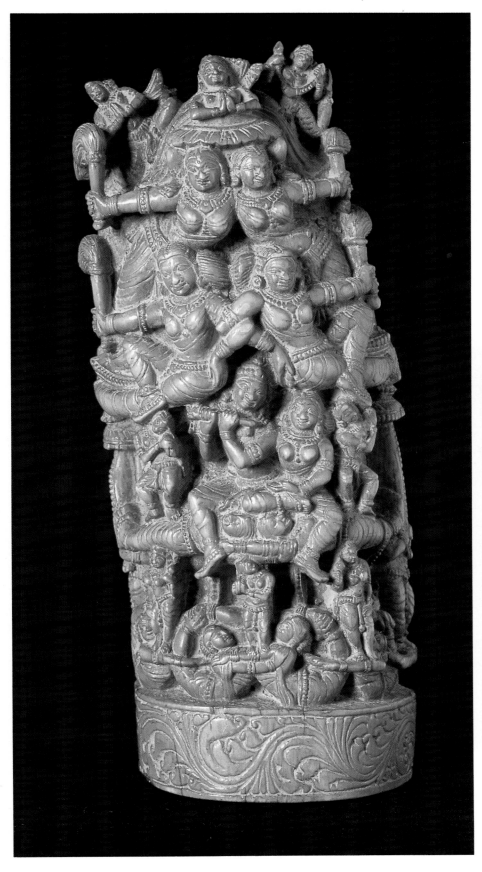

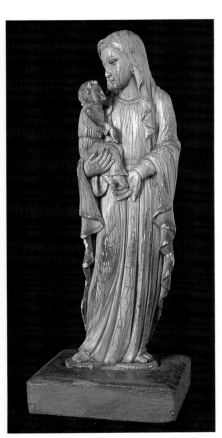

Kandarpa-ratha, **chariot of Kandarpa, the god of love.** Ivory; 21 cm x 8 cm. Orissa. c. early 20th century. 85/6864.

This composite figure carved in solid ivory is composed of numerous females forming the chariot of cupid god Kamadeva, also known as Kandarpa. Kamadeva was born of the mind of Brahma and as soon as he was born he turned to Brahma and asked *'Kamdarpayami?'.* (Whom should I make proud?), so Brahma gave him the name Kamdarpa alias Kandarpa.[1]

In the centre of the chariot Krishna is depicted playing the flute and surrounded by numerous women in amorous poses.

[1] Mani, 1984, p.384

Christian icon. Ivory; 26 cm x 12 cm; 20 cm x 6 cm. Goan or Portugese origin. *c.* 17th century. 81/6326.

The Christian influence on Indian ivory carvers is most apparent in the carvings of the 17th and 18th centuries found in the erstwhile Portuguese colony of Goa.

This Christian icon, rendered in the typical style of the era with flowing robes, svelte bodies and finely chiselled expressions, are rare examples of ivory carvings.

Chromatic Brillance:
Painted Wood, Papier Maché Lac-Turnery

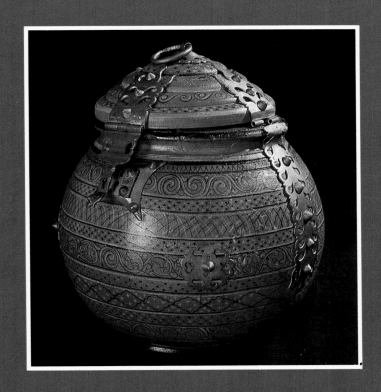

Most stone, wood, ivory and bone carvings in India have traditionally been polychromed as is amply evident in the craftsmanship of artisans today. No idol in stone, wood or ivory was ever left "naked" in sculpture. In Rajasthan, painters go to great pains in painting the clothing of the Ganagaur and Isar deities.[1] Costuming and its various accoutrements were an integral part of any image, doll or deity. Whether it is Lord Jagganath's[2] image in Puri, Orissa, or the archaic *bhuta* figures of the ancestral cult in coastal Karnataka,[3] it is only after the ritual filling in of the eyes by the painter-craftsman that the deity is said to "descend" into the painted wooden sculpture and finally occupy it. In fact, in the South, the artisan caste, Kammalan or "Kannalan denotes one who rules the eyes, or one who gives the eye."[4] In *Mediaeval Sinhalese Art*, Coomaraswamy writes: "by far the most important ceremony connected with the building and decoration of a Vihara (temple)... was the actual *netra mangalya* or eye-ceremonial." It is only after this ritual opening of the eyes that the sculpture or painting is said to be "life" imbued. Even articles of daily use such as jewellery and dowry caskets, utensils, opium containers, *hukkas*, toys, furniture and cradles are incomplete without being adorned by a kaleidoscope of colours.

Painting on flat surfaces is usually done in oil or water colours with a fine brush made from squirrel, goat or cat's hair. The painted surface is preserved by applying two to three coats of varnish that also gives it a lustrous finish.

The gloriously painted bows and arrows of Muzaffargarh in Punjab, the vivid colours of the woodwork from Jhansi and Gwalior in Madhya Pradesh, the Kathakali models painted on teak and jack wood from Trichur and Trivandrum in Kerala, the painted manuscript boxes from Bikaner in Rajasthan and Patan in Gujarat, the wooden dowry boxes depicting mythological figures, masks and toys from Raghurajpur in Orissa, and the folding mobile shrines from Puri in Orissa, and Bassi, in Rajasthan, are only a few examples of painted and varnished wood in India.

Savantvadi, in Maharashtra, is known for its painted *ganjifa* or playing card boxes depicting the *dashavatara* or ten incarnations of Vishnu. This theme is also recurrent in their ritual accessories such as the *tarang kati*, a long wooden rod with six horizontal divisions, each depicting various mythological figures including *devadasis* or temple dancers.

An extremely soft, light wood, locally called *pangara (Erythrina indica)*, is used by the *chitaris* or hereditary painters of Savantvadi, to make brightly coloured replicas of fruits and vegetables in nearly 200 different varieties. The process begins by smoothening the wooden fruit or vegetable shape with sandpaper. The cracks are then filled in by coating the surface with a paste made from boiling tamarind seed powder in water. It is left to dry and then sand-papered again. The colours are mixed in zinc oxide, gum and water and generously applied all over the wooden article with a brush. Finally, the object is given a brisk rubbing with a woollen rag to bring out its characteristic shine.

Papier maché is the technique of using pulped paper to create objects like boxes, jars, trays and bowls. In Kashmir, where the craft reached its zenith under the Muslim kings, the process involves the kneading of previously pulped paper or *burchot* with rice paste or *atiz* to produce a mixture which is subsequently applied, layer by layer, over a clay or brass mould and left to dry. The mould is then removed and a mixture of glue or *saresh* and wall plaster or *guchch* is applied onto the surface of the box with a brush and later smoothened with a rounded stone or *kurkut*. A layer of very fine tissue paper is then glued onto the surface and finally the item is sand-papered for an extremely smooth and uniform

Previous page
Nettur or **Abharanam petti, casket for ornaments.** Brass-bound and lac-painted wood; 32 cm x 22 cm. Kerala. c. early 20th century. 82/6372.

Wooden caskets, usually brass-bound with elaborate locks, hinges and beading are commonly used in Kerala to store expensive jewels and clothing. Generally used as dowry chests, some of these also have pyramidal lids on rectangular bases.

This barrel-shaped casket with lid has been hollowed out from solid wood, its surface smoothened and lac-coated on the lathe in the distinctive Kerala style. Often, such lathe-turned boxes "in a larger, slightly modified form... are used for the storage of paddy".[1]

[1] Doctor, 1987, p.11

painting surface. After applying the background colour a variety of designs is painted on the papier maché surface followed by three to four coats of varnish.

Traditionally, floral patterns such as the *gule-hazara* or "thousand-petalled flower", the *chinar* or autumn maple leaf, scenes from Mughal courts and patterns derived from the famous *jamevar* shawls, were commonly seen on jewel and bangle boxes as well as boxes for the Holy Quran, painted by Muslim craftsmen of the Kashmir valley. A sort of gesso work, i.e., raised work in gold and silver leaf, whose characteristic shine increases with time, is also practised, greatly enhancing the value of the craft.

While Kashmir is renowned the world over for its papier maché articles, Jaipur is no less famous for this craft. The technique is also known to village women in Bihar who use pulped paper, usually newsprint, mixed with glue, Multani *matti* or clay and *methi,* or fenugreek powder, to model figures of the wedding pair at marriage ceremonies, Ganesha, women weaning babies and winnowing grain, measuring bowls and storage jars. They employ little colouring material and customarily paint thick black contour lines on the greyish white background of the object.

Painting on rounded wooden surfaces, on the other hand, is achieved by a process called lac-turnery. Lac is a resin secreted by the lac insect (*Lacifer lacca*) that feeds on a variety of host trees of which the important ones are *palash* (*Butea monosperma*), *ber* (*Zizyphus mauritiana*) and *kusum* (*Schleichera oleosa*). In this technique, lac is applied onto the surface of wood using friction-generated heat created by the rotatory movement of a lathe or *kharad*.

Lacware is, often, wrongly equated with lacquer ware. While lac is an animal resin, "lacquer, on the other hand, is a vegetable oleo-resin which naturally exists in a liquid state, and is either directly applied by a brush or is thickened by ashes into a plastic material that may be moulded and, while still adhesive, can be applied to surfaces in bass-relief ornamenation. The various uses of this substance have originated with the Burmese and Siamese art that more closely resembles Japanese lacquer than Indian lac-work."[5]

Shellac or purified lac, and even lacquer, are used as bases into which mineral colour pigments are mixed and moulded into cubes of coloured lac called *battis*. The surface of the wooden object is first smoothened so that cracks and pores may be filled in. A *batti* of the required colour is pressed onto it while it revolves on the lathe. The heat generated as a consequence causes the lac to melt and spread over the wooden object. When the colour is uniformly coated all over, a rag dipped in oil of *kevda* leaves (*Pandanus odoratissimus*) dipped in groundnut oil is pressed against the turning object so as to polish the lac till it acquires a permanent shine.

Lathe-turners or *kharadi* are usually *suthars* or wood workers by caste and their title is an occupational one. In Rajasthan, they are generally Muslims who are said to have been once Rajputs[6], while in Gujarat, especially in Sankheda, they belong to the Pancholi sub-caste of Hindu *suthars*.[7]

The chief centres of plain lac ornamentation on wood, particularly that of creating striped designs in a resplendent blending of colours on objects including toys, boxes, bed-posts and cradles, are Varanasi in Uttar Pradesh, Murshidabad in Bengal, Hoshiarpur in Punjab, Jodhpur in Rajasthan, Patna in Bihar, Savantvadi in Maharashtra, Gwalior and Sheopur in Madhya Pradesh, Salem in Tamilnadu and Channapatna in Karnataka. Bed-posts, chairs, tables, cradles, cupboard handles, reels for different colour threads required for embroidery, mortars and pestles, rolling pins, ladles, jars, *attar-dans* or perfume containers, tops, yo-yos and a host of toys for children are only a few of the items made on the lathe in a variety of colours.

Often a design may be etched onto the surface of the lac-coated object so that it may give an effect of over painting with a different colour. This is achieved by coating the previously smoothened wooden surface with as many layers of

colour as desired, one on top of the other, with the background colour applied last. Then, with a fine chisel or stylus the lac-coated surface is scratched with the amount of pressure needed to bring out the colour required from the numerous layers beneath the surface. In Patna, Bihar, there is a tradition of presenting a girl with a nose-ring, a symbol of marriage, in a red lac — coated wooden box. Often, auspicious motifs like the peacock, fish, flowers and creepers are etched on the surface of these containers in black or white. The usually red *sindoordans* or vermilion containers, are also famous. Ferozepur and Hoshiarpur in Punjab and Jaipur in Rajasthan are the other well known centres of this craft which is also called "etched *nakshi*".[8]

Sankheda, in Gujarat, produces transparent lac work with tin foil painted ornamentation on wooden furniture, articles of daily use and even toys. In this technique, sheets of tinfoil are hammered along with hot *saras* or glue till the two become a homogenous mass which dissolves easily in water. This silvery pigment or *harkalai* is then used to paint floral and geometric designs on the surface of the wooden object. This is done by holding the brush immersed in *harkalai* against the object turning on the lathe. Agate stone is similarly used to bring out the silvery glow of the foil which is subsequently coated with a layer of transparent coloured lac.

1. Nath and Wacziarg, 1987, p.217
2. See for instance Eschmann, Kulke and Tripathi, 1978
3. See Census 1971c
4. Thurston, 1909, Vol. III p.106
5. Watt and Brown, 1979, p.210
6. Lohia, 1954, p.177
7. Census 1961n, p.9
8. Watt and Brown, 1979, p.214-215
9. Census, 1961n

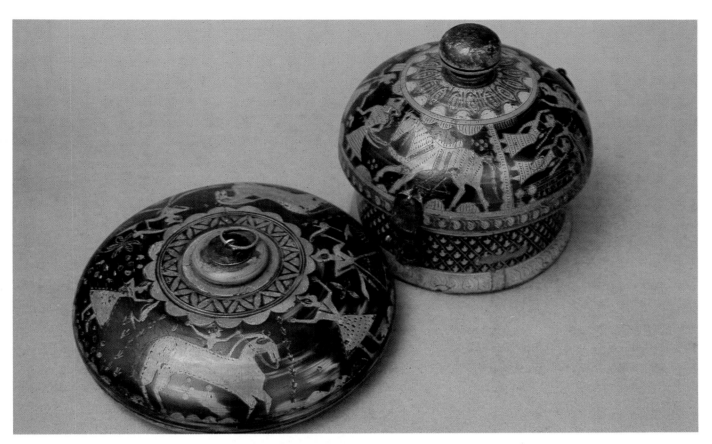

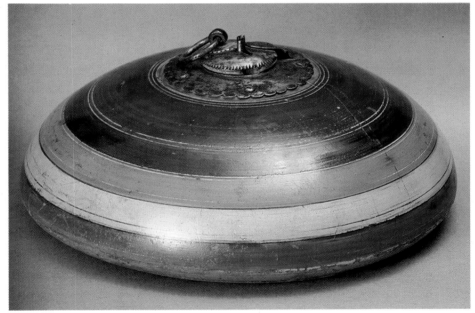

This flat disc-shaped box, an opium or tobacco container, and dowry casket in the shape of a circular hut, are embellished with hunting scenes depicting camels, horse riders and dancing human figures strongly reminiscent of the two-dimensional cave pictographs of prehistoric times. The order in which the colours have been applied, probably on the hand-lathe, are yellow, red and black. Such items, along with bowls and glasses, are generally made in Jaisalmer and Ratangarh in Rajasthan as well as other parts of the Thar desert cultural belt.

[1] Watts and Brown, 1979, p.214

Opium or tobacco container.
Lac-coated wood; 33 cm (dia).Rajasthan. c. late 19th century. 82/6444.

South Rajasthan and the Malwa region of Madhya Pradesh are highly suited for poppy cultivation. Opium extracted from the poppy plant is particularly popular among men, its hallucinogenic properties useful in both magico-religious ritual as well as in secular pastime.

This rather large, polychromed opium or tobacco container is coated with different coloured bands of lac, whose separating lines were scratched on the wood with a sharp chisel-like instrument while the object was rotated on the lathe. The glossy finish is obtained by polishing the surface with *kevda (Pandanns odoratissimus)* leaves dipped in oil.

Top
Lac-coated containers. Coloured lac and etching on wood with iron lock; 20 cm (dia); 15 cm x 16 cm (dia). Western India. c. late 19th century. 84/6432, 7/4481.

In this technique of lac-turnery, also known as "etched *nakshi*"[1] the object is coated with different coloured layers of lac (a resinous secretion of the lac insect on its host tree) one over the other, with the background colour applied last. A fine chisel is then used to scratch the design and scrape out the colours from beneath the various layers.

universal mother. It is taken for granted that the goddess is occupied in bathing all the time she remains, and ancient tradition says death was the penalty of any male intruding on these solemnities.... At length, the ablutions over, the goddess is taken up, and conveyed to the palace with the same forms and state. The Rana and his chief then unmoor their boats, and are rowed round the margin of the lake, to visit in succession the other images of the goddess, around which female groups are chanting and worshipping, as already described, with which ceremonies the evening closes, when the whole terminates with a grand display of fireworks, the finale of each of the three days dedicated to Gouri."

[1] Tod, 1957, Vol.I, p.456

Ganagor, local form of goddess Parvati, consort of god Shiva. Pigment and varnish on wood; 71 cm x 24 cm. Rajasthan. c. mid 20th century. 84/6727.

The Ganagor festival[1] in Rajasthan is celebrated by women in honour of Gouri, the goddess of abundance and consort of Shiva, by women during "the vernal equinox, when nature in these regions proximate to the tropic is in the full expanse of her charms and the matronly Gouri casts her golden mantle over the beauties of the verdant Vassanti (personification of spring)." [2]

"The meaning of Gouri is 'yellow', emblematic of the ripened harvest, when the votaries of the goddess adore her effigies, which are those of a matron painted the colour of ripe corn; and though her image is represented with only two hands, in one of which she holds the lotus... yet not unfrequently they equip her with the warlike conch, the discus, and the club, to denote that the goddess, whose gifts sustain life, is likewise accessory to the loss of it...." [3]

"The rites commence when the sun enters Aries (the opening of the Hindu year), by a deputation to a spot beyond the city, 'to bring earth for the image of Gouri'. When this is formed, a smaller one of Iswara is made, and they are placed together; a small trench is then excavated in which barley is sown; the ground is irrigated and artificial heat supplied till the grain germinates, when the females join hands and dance round it, invoking the blessings of Gouri on their husbands. The young corn is then taken up, distributed, and presented by the females to the men who wear it in their turbans." [4]

Figure of goddess Ganagor, a local form of Parvati, consort of god Shiva. Pigment painted and varnished wood; 25 cm x 7 cm. Rajasthan. c. early 20th century. F/17.

This extremely graceful figure of feminine beauty is the goddess Ganagor, also known as Gauri, Isa or Parvati, wife of Ishvara or god Shiva. Such images of the goddess are venerated along with the figure of Ishvara, her consort, during the spring festival when the images are decorated with beautiful ornaments and clothes and elaborate preparations are made to carry them in a procession to the lake in a boat to perform her royal ablutions.

"The females then form a circle around the goddess, unite hands, and with a measured step and various graceful inclinations of the body, keeping time by beating the palms at particular cadences, move round the image singing hymns, some in honour of the goddess of abundance, others on love and chivalry....The festival being entirely female, not a single male mixed in the immense groups, and even Ishwara himself, the husband of Gouri, attracts no attention, as appears from his ascetic or mendicant form begging his dole from the bounteous and

[1] Also see Cat. No. IV/4

[2] Tod, 1957, Vol. I, p.454

[3] Ibid, p.454-5

[4] Ibid, p.455

Window shutter. Pigment painting and lacquer on wood; 67 cm x 44 cm. Probably Jodhpur, Rajasthan. c. mid 20th century. 7/4217(1).

All over Rajasthan old buildings and palaces have beautifully painted window panels that depict scenes from local history and legends in the typical style of Rajasthani miniature painting.

Generally such window shutters have paintings executed on both sides so that both interiors as well as exteriors are equally well adorned.

Standing beneath a typical arch or *mehrab*, this Rajasthani woman in *lehanga*, or long skirt, delicately fanning at her feet and *odhni*, or head cloth, gracefully placed over her head, is depicted holding her son in the graceful stance of a dancer.

95

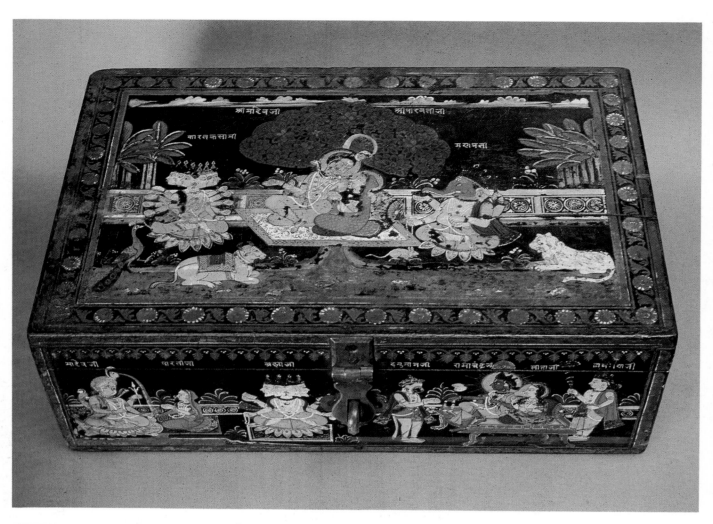

Chest. Pigment painting and varnish on wood, iron latch and quilted cotton cloth; 39 cm x 25 cm. Western India, probably Rajasthan. c. mid 19th century. 82/6433.

The interior of this wooden chest is lined with quilted cotton cloth probably for storing jewellery or important ritual accessories.

The painting, on black ground, primarily depicts a variety of Hindu deities. On the front-side panel from left to right are shown Shiva, his consort Parvati, Brahma, Hanuman, the monkey devotee of Rama, Rama, his wife Sita and brother Lakshmana. The left side panel depicts folk goddess flanked by two attendants, one of whom, the dark one, is an attendant or *gana* of Shiva.

The right side panel shows the local goddess Ronjhi attended by Shiva's *gana* on one side and a female attendant on the other. The panel at the back has Krishna playing his flute amidst cowherdess companions or *gopis* and guarded by cows.

Finally, the main top-lid panel depicts the divine couple Shiva and Parvati flanked by their two sons, the elephant-headed Ganesha and Kartikeya.

Doll, probably a *nayika* or dancer.
Pigment and varnish on wood, sawdust and tamarind seed powder; 121 cm x 55 cm. Kinnal, Karnataka. c. mid 20th century. 7/4905.

The village of Kinnal, in Raichur district of Karnataka, is known for a particular tradition of polychromed wooden figures including animals, mythological figures, dancers and mother and child.

The distinctive technique of creating a smooth painting surface on sculptures made from uneven wood involves the use of "a sticky substance prepared out of jute rags which are soaked, slivered into pieces, dried, powdered, then mixed with saw dust and tamarind seed paste..."[1] This resulting substance, known as *kitta*, is then dabbed all over the wooden sculpture by hand. The craters are filled in with tiny bits of cotton and tamarind seed paste. "Over this is applied the pebble paste which forms the base for the application of the paint."[2]

There is a certain random spontaneity in the use of bright colours by the *chitrakars* or painters of Kinnal. The rounded sculptural quality of the figure, in conformity with the South Indian ideal of beauty, the large black staring eyes and the long hair braid, meant

deliberately to drop across the arm, are definite attributes of a *nayika* or dancer.

[1] Chattopadhyay, 1975, p.117
[2] Ibid

Tray. Pigment and varnish on papier maché; 74 cm x 51 cm. Kashmir. c. early 20th century. 7/1484.

A reference to such "many angled" papier mache trays from Kashmir has been made by Sir George Watt as early as 1902. Painted with fine, delicate brush strokes in the "shawl" pattern, handkerchief or *rumal* pattern[2] and finally a variety of floral patterns in a kaleidoscope of colours, stylised serving trays were commonly produced by skilled Muslim artists whose instinctive sense of beauty is matchless in India. Today a lot of the work, traditionally done on papier maché, is being executed on wood, decreasing, not only the cost of production but also, the quality and character of the articles.

[1] Watts and Brown, 1979, p.168, pl.39, 39-A
[2] Ibid, p.167

Kuppi, **gunpowder case.** Pigment and varnish on wood and gourd; 24 cm x 36 cm. Rajasthan. c. early 20th century. 7/3090.

Gun powder cases, like this one, with a long carved spout and originally with small lid, were hung on the waist by warriors or travellers.

The subtle floral ornamentation on the "battle" accessory is a respite from the otherwise severe function of the artefact, a practice typical of Rajasthan desert art.

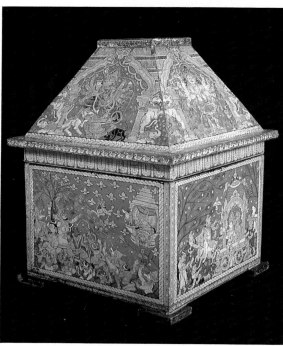

cloth, whose surface on either sides has been smoothed for over painting in the gesso technique.

Executed in vegetable pigments, one side displays a composite peacock feather motif making the fan appear like the spreading tail of a dancing peacock. The other surface is rendered in tiny floral motifs covering the entire ground.

Jautuk pedi, dowry chest. Pigment painted and lac on cloth covered wood; 77 cm x 60 cm. Orissa. Contemporary. 7/5323.

This large, temple-shaped dowry chest depicts scenes from mythology in the *pata-chitra* or cloth-board painting tradition distinctive of Orissa. The panels on the cuboid base depict scenes from the epics *Ramayana* and *Mahabharata*: Krishna and Balarama being tricked by Kansa's messenger and being warned by cowherdesses; Ravana on his *vimana*, or celestial vehicle, surveying Rama's army of soldiers; a folk tale showing lord Jagannatha with his brother Baldeva; and Krishna in the Madhuban forest with his consort Radhika.

The pyramidal lid depicts Baldeva, Mahishasuramardini, or Durga killing the demon Mahisha, lord Ganesha and Hanuman, the monkey devotee of Rama.

Hand fan. Pigment and varnish on cloth, wood and palm leaf. 84 cm x 61 cm. South India, probably Andhra Pradesh. c. early 20th century. 7/2930.

This large hand fan, in the shape of a palm leaf, has actually been made from one such leaf, only the wooden handle is separately attached. The skeletal leaf stems of a palm form the basic structure of this fan and the long interspaces are covered with treated

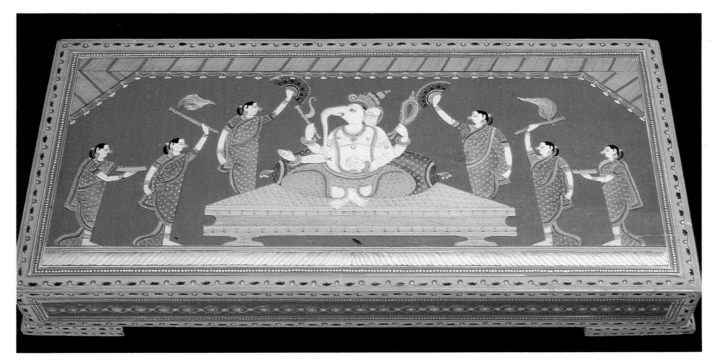

Above
Box. Polychromed and varnished wood; 7 cm x 46 cm x 23 cm. Sawantwadi, Maharashtra. Contemporary. 87/I/D.

This rectangular box, painted in the traditional style by the *chitrakars* or painters of Sawantwadi, depicts lord Ganesha being attended by female fly-whisk bearers and attendants clad in sarees worn in the Maharashtrian style.

The bright yellow and red colours, along with the floral creeper on the edges are typical of the work in the region.

Far left
Tepoy. Lac-coated and etched wood; 36 cm x 24 (dia) cm. Bihar. Contemporary. 7/2906.

The base top and stand of this wooden tepoy have been lac-coated on the lathe using heat generated friction to melt the coloured lac. The rim of the top has been etched in a delicate floral meander to bring out the underlying yellow layer beneath the surface black. Also known as "etched *nakshi*", the technique is commonly used by craftsmen on other items such as dowry boxes, jars, spice containers, dolls, toys and items of utility.

Doll, housewife sifting grain. Natural pigments on papier maché; 15 cm x 10 cm. Madhubani, Bihar. Work of Chandrakala Devi. Contemporary. VC.

Using old newsprint, *methi* or, fenugreek powder, and Multani *matti* or clay, the industrious women of Madhubani create poignant figures of Ganesha, mother and child, women engaged in household chores and containers in various shapes and sizes.

Typically, the head cloth is prominent in all female renderings such as in this doll which holds a winnowing tray, its fingers sorting grain.

Painted Myths:
Traditions of Indian Folk Painting

Man's earliest creative urge is evident in the pictographs scratched in red and yellow ochre in rock-shelters dating back to the late — Mesolithic and neolithic times. Mirzapur in Uttar Pradesh, and Bhimbetka in Madhya Pradesh, represent the earliest formidable examples of Indian painting which go back to prehistoric periods. In the later Indus Valley Civilisation, paintings on earthen pots record the state of the art in the third millenium B.C. The Buddhist frescos on the walls of the Ajanta caves in Central India were painted in earth and vegetable pigments some time during the first century B.C. to the fifth century A.D. The history of Indian painting, then, follows a route to South India where regional styles developed in temple murals that were visual narratives of myths and legends. The wall paintings on the Brihadishvara temple in Thanjavur of *c.* A.D. 1000 appear to be late survivals of the Ajanta tradition while those of the 16th century Virabhadra temple in Lepakshi, Andhra Pradesh, reflect the *kalamkari* traditions of the region. The period between the 13th and 19th centuries saw the development of various schools of miniature painting with predominantly Mughal, Persian and Rajasthani elements on the one hand and the western Indian Jain palm leaf manuscripts on the other.

The somewhat lesser-known traditions of Indian painting are the so-called "folk" paintings dating back to a period that may be referred to as "timeless". These are "living" traditions, intrinsically linked with the regional historico-cultural settings from which they arise and are ultimately nurtured by. Broadly, these may be classified into two categories: those that are executed on ritual occasions for the express purpose of "installing" a deity, and those that are essentially narrative in character. These may be executed on a wall or *bhitti-chitra*, on a canvas or *pata-chitra*, and on the floor, *dhuli-chitra*[1] or *bhumi-shobha*.[2] Moreover, even while the twin functions of Indian folk painting, i.e., magico-religious ritual and narration, may overlap, in many instances they continue to express an experience sanctified by communal tradition and hence are more than just decorative.

"Magic diagrams"[3], or auspicious symbols, outlined on the floor, in rice paste and/or coloured powder are executed by women almost all over India. The common factor leading to "this universality is the root design that always starts from the centre," and gradually builds up around it.[4] These designs are known as *kolam* in South India, *mandana* in Rajasthan, *rangoli* in Maharashtra, *sathiya* in Gujarat, *alpona* in Bengal, *aripana* in Bihar, *apna* in the western Himalayas, *chowka purna* and *sona rakhna* in Uttar Pradesh, *osa* in Orissa and *aripona* in other parts of northern India.[5] These line drawings are potent receptacles of cosmic powers that are essentially benevolent and protective in nature.

Executed during religious festivals, *vratas*, or vows taken before the deity, ceremonies associated with fertility and *samskaras* or important stages in an individual's life time such as birth, initiation and marriage, these are ephemeral symbols created afresh each time in the courtyard, threshold and other spaces in the house. In most cases, a matrix of dots or dashes is aligned in the various sacred directions to form auspicious configurations of the circle, star, rhombus and the square or *chowk* or *mandala*, (also used in tantric symbolism) which are subsequently connected by lines using a small rag or the trained finger of the woman of the house. Usually geometric and floral patterns, as well as other symbolic motifs such as the footprints of the goddess, the *naga* or snake symbol, the crescent moon, *swastika*, conch shell, lotus flower, sword, disc, *kalasha* or pot are executed in these diagrams in a similar manner all over India.

In Andhra Pradesh and Karnataka the snake, symbolising ancestor worship and fertility, is especially recurrent while in Rajasthan the "*Gangour-ka-guna* is a

Previous Page
See page 115

composition of six-petalled flowers, interlocked in a group of seven six-petalled flowers, in which all the six petals of the central flower are common to other six flowers depicted around it",[6] the composition multiplying there onwards. In Madhubani, Bihar, the *swastika aripana* consists of 41 interlinked *swastikas* and is drawn near the auspicious holy basil or *tulsi* plant during certain ritual occasions.[7] Once completed, each of these floor diagrams, invokes the sacred energies of deities and ancestors whose blessings are crucial in any ceremony or ritual occasion.

The wall paintings of many tribal communities, particularly the Saoras of Ganjam and Koraput districts in Orissa, the Rathvas and Bhilalas of Chhota Udaipur in Gujarat and nearby areas of Madhya Pradesh, the Warlis of Thane district in Maharashtra, as well as many Hindu communities of Kumaon in Uttar Pradesh and Mithila in Bihar, similarly invoke spiritual powers in the painted walls of sacred enclosures or spaces in their homes. It is only after these paintings are ritually consecrated that the mural is "ready" for the installation of the deity.

In the Kumaon region of Uttar Pradesh, no important *samskara* ceremony, nor religious festival propitiating a deity, is complete without the *jyonti*,[8] or painting of three female deities along with Ganesha, and the *pattas* depicting a particular deity, its various manifestations, symbols and co-deities. Thus, goddess Durga is worshipped during the Navaratri (nine nights) of the Dusshera festival through the *devi-ka-thapa*, painted on the wall by women of the household in yellow, green and red. Significantly, the term *thapa* is a derivation from the word *sthapana* meaning "installation".[9]

In Madhubani, Bihar, the upper-caste Kayasth women paint the walls of the nuptial chamber or *kohbar-ghar*, the verandah outside it, as well as the *gosauni-ka-ghar,* or "room of the family deity",[10] in earth and vegetable pigments in myriad sacred symbols and designs. Many of these paintings narrate myths and legends, especially scenes from the epic Ramayana. Others provide valuable glimpses of everyday life. "The commonest of these in the *gosauni-ka-ghara* are the *Harisauna puja ka citra* and the *sarovaracitra* family pool which includes different kinds of fish, turtles, etc...."[11] The paintings in the marriage chamber include the *kohbar* which represents a lotus pond and a bamboo forest[12] along with figures of various protective deities, auspicious fertility symbols such as the mango, pomegranate, parrots, peacocks and lotus, the bridal pair, the palanquin and almost anything that may be appropriate in a room where a newly-wed couple may spend their first four nights together in chastity.[13]

An essential component of the marriage ceremony of the Warli tribals of Maharashtra is the *chowk*, a diagram featuring the square, executed on the mud-plastered inner wall of the room where the wedding is to take place. The rice-paste pictograph in red ochre is initiated by four ritual lines drawn by two *sahvasinis* or women whose husbands are living. These four lines represent the four *kula devatas* or clan deities of the Warlis and essentially form the boundary area within which the Palghut devi, or goddess of fertility, is depicted with the sun and the moon. It is only after the goddess has been represented that the area outside the *chowk* is embellished with scenes from everyday life as well as other symbols of fertility, such as the horse. Once ritually installed, the deity's abode is covered with a large cloth which is unveiled during the marriage ceremonies in order that the deity may bless the newly-weds. While the marriage *chowk* may be drawn only by married women, both men and women decorate walls of their homes with scenes from the forest, hunting, harvesting, festivities of song and dance, winnowing, toddy tapping and other highly decorative scenes from daily life.[14]

The wall pictographs of the Saoras of Orissa are domestic shrines of spirits and deities. "These pictures are, in fact, the one-dimensional homes of the Dead, the heroes and the gods."[15] They are known as *ittalan* or *ittal* among the Saoras[16] and essentially represent the area, outlined within a square or rectangle, for the

inhabitation of the deity.

Not unlike Warli pictographs, *ittal* drawings are also executed in rice-paste on the red ochre background of the inner wall, although occasionally lamp-black or ashes are employed to fill in the highly simplified figures. Two triangles joined together at their apex on the vertical plane make a human figure while those joined on the horizontal axis, a horse. Here scenes from every day life are depicted too for the benefit of the spirit who is invited to reside in the *ittal* "house" in the following words: "I have made a house for you. Here are your elephants and horses. Come riding on them. Here is your tiger and your bear. Here are your birds. Come and see what a fine house I have made for you...."[17] The painting is, then, consecrated by the shaman priest who, being possessed by the particular spirit, pronounces on the accuracy of the drawing. It is only after these changes have been made and the earthen pot containing offerings hung on the *ittal* that the spirit finally enters its shrine.

Ittal icons are generally commissioned by a family suffering from the evil influence of a particular spirit. They are also meant to propitiate deities and ancestors as well as for fertility, both of the soil as well as in marriage. On every important occasion, offerings are made to the deity housed in the *ittal* pictograph which is re-touched or painted whenever necessary.

The Rathva and Bhilala tribes of Chhota Udaipur in Gujarat and its adjoining area Alirajpur in Madhya Pradesh, demarcate special areas in their homes for installing deities by means of colourful wall paintings.[18] The main wall of the verandah that divides it from the kitchen is sacred to Pithoro and all paintings related to creation myths and Pithoro's life are done on this wall. These are painted within a *chowk* or a "sacred enclosure" which is a rectangular space bound on all four sides by ornate borders. Ancestors, ghosts and minor deities as well as some features of present day life are depicted outside the sacred enclosure, on the same and other walls of the house.

Brightly painted and caparisoned horses, some gliding in the air with celestial riders, others part of a marriage procession; extramarital sex, humans copulating with animals, grinning tigers, elephants, monkeys, bullocks, spirits, deities and a variety of scenes from daily life: collecting toddy, churning butter, smoking the *hukka*, a "man shooting an arrow at an airplane", "the house of arms and ammunition" and alarm clocks are only a few glimpses of the entire worldview of the Rathvas including their mythology, cosmography and aspects of life in "this" world.

The ritual validity and authenticity of the painted myth does not depend so much upon aesthetic considerations as on the compact and complete depiction of the iconography. The final approval comes from the divinity himself when he speaks through the human mediator, the *badva,* in a trance. The *badva,* when possessed, examines the painting in detail, pointing out each character and pronouncing its name. If there is any mistake he refers to it and offers immediate rectification. After the sanction is granted, the painting is finally consecrated by the sacrifice of a goat.

In times of crisis such as failure of the harvest, disease, loss of cattle or property, the deities living in the wall painting are invoked and consulted. At the time of the invocation ceremony, the space of the verandah — where the inhabitants normally relax, smoke a *hukka*, pound grain, chat with guests or sit and drink — is converted into an area of the other world, of the cosmos, where the deities descend, receive sacrifices and converse with the family members.

In contrast to the paintings of the Rathvas of Gujarat, those in Alirajpur in Madhya Pradesh, are much simpler and archaic in their rendering. The absence of the royal procession, elaborate ornamentation and modernistic features such as the airplane and clock, combined with the rudimentary style of drawing, indicates that these paintings represent an earlier phase than the Gujarati ones.

Painting, in addition to its magico-religious function, serves as an important

medium for the expression of folklore in India. In most parts of Rajasthan,[19] the interior and exterior walls of the palaces as well as common dwellings are covered with highly ornate figures of elephants, horses, camels, scenes of royal processions, festivities, hunting parties and mythological characters and incidents. Painted on wet lime plaster in mineral colours, though in varying styles and techniques, the temples and palaces in Gujarat, Maharashtra, Orissa, Andhra Pradesh, Tamilnadu, Karnataka and Kerala, radiate in the polychromatic brilliance of their profusely painted walls.

Perhaps a more striking medium of disseminating regional folklore has been that of narrative painting or *chitrakatha*.[20] Using scrolls or panels as visual aids in the narration of myths and legends, these traditions are known to have prevailed in India since ancient times. There are references to *charan-chitra* or "mobile-paintings" in Buddhist literature. The commentary on *Samyutta Nikaya* III.151. mentions *caranam nama cittan* and explains it as: "There are Brahman heretics who, having prepared a canvas booth (*pata kotthaka*), and painting (*lekhapitva*) therein representations of all kinds of happiness and misery connected with existence in heaven or hell, take this picture and travel about (*vi caranthi*) pointing out; If you do this you will get this,..."[21] According to Coomaraswamy, *charan chitra* was the Buddhist equivalent of the better known term *Yama-pata*.[22] In Vishakhadatta's *Mudrarakshasa*, there is reference to a spy who disguised himself as a *Yama-pattika* (picture-showman of the panel of Yama, the god of death) and carried with him the painted scrolls of hell's punishments. "He habitually entered the house of his patrons, where he displayed his *Yama-cloth*, and sang songs, presumably of a religious type".[23] Bana's *Harshacharita* also mentions the *Yama pattikas* and explains that they showed pictures and gave sermons on vice and virtue, reward and punishments.[24]

Interestingly even today there exist in many parts of India, wandering picture-story tellers who carry their painted scrolls or panels to the public, narrating myths and legends wherever they go.

In Gujarat the vertical painted paper scrolls of the Garoda caste of narrators are infact direct descendants of the *Yama pattika* tradition.[25] The basis of this tradition was suggested by its literal meaning and was thus used to educate people in the matters of *karma*, reward and punishment. The present-day Gujarat scrolls amazingly depict scenes related to death, the subsequent journey to heaven or hell, and the various punishments encountered in hell.

In Rajasthan the life-stories of the great fighter hero, Pabuji Rathore and the neo-Hinduistic incarnation, Dev Narayan or Devji are painted on large rectangular canvas panels rolled and carried from village to village by their respective *bhopas* or narrator-priests. The performance involves the singing or "reading" of the painted *phad* to the accompaniment of music and dance. An important feature of the narration is the ritual oil lamp held by the assistant *bhopa* or *diyala*[26] (literally "holder of lamp"), during the course of the performance. It is believed that the deity inhabits the *phad* and consequently the painting or mobile shrine is never sold and may only be discarded by a ritual immersion in Lake Pushkar, the abode of Lord Brahma.

In the Warangal, Khammam, Adilabad, Karimnagar, Hyderabad and Medak districts of Andhra Pradesh the Nakkash caste of painters and image makers[27] use both horizontal and vertical scrolls of starched cloth for painting stories on a characteristic orange-red ground. The narrative panels depicting Puranic legends, run upto nine metres in length and are carried by specific groups of storytellers to their respective patrons in different villages. Thus the *Markandeya Purana* is narated by the Konnapalli group to the weaver caste, the *Garuda Purana* by the Yennoti and Gandachetti to the Kalali or makers of liquor, the *Shiva Purana* by the Sakalipattam to the washerman community and so on. In this manner the itinerant bards are able to protect their interests as well as cater to those of their patron clients.[28]

105

The Chitrakar or Patua community of West Bengal[29] especially in Midnapur, Murshidabad, Birbhum and Purulia districts, employ bright vegetable colours in their scroll paintings or *gundano patas*. These, unlike the Gujarat scrolls, depict a single story on the entire scroll. Each scene is bound in a floral border that separates it from the one next to it on the vertical paper panel. The religious themes painted and narrated by the *patuas* include *Ravanabadh* or the killing of Ravana, *Durgapata* and *Manasapata* or paintings related to the goddesses Durga and Manasa, *Nimaisanyas* or the exile of Chaitanya, *Lakhanashaktisheel* or powerful Laxman, *Yamashasan* or the rule of Yama, the god of death, and *Satyabirpata* or that of Muslim saint Satyabir.

In contrast to the religious *patas*, which are mainly devotional in character, the secular *patas* are satrical and are based upon the *chitrakars'* profound recognition of the contradictions in society. These scrolls, also known as *adhunik patas* or modern paintings, depict for instance, India's independence from colonial rule, or satirise the prevailing system of rationing and loss of moral values among the young. Women are portrayed as wearing dark glasses, high heels and perfume with no respect for their in-laws and instead a deep passion for the cinema! Other scrolls depict actual incidents in the past, such as a bus accident in Midnapur[30] *nari-hatya-driver-khoon*, or the murder of a taxi-driver by a woman in self-defence.

The nomadic *jadu-patuas*, literally "magic-painters", cater mainly to their Santal clientele in Singhbhum and the Santal Parganas in Bihar and adjoining areas in West Bengal. Their paintings, both scroll and rectangular, are executed in few colours usually with a pale green ground and the figures are much smaller than those of the Bengal *chitrakars*.

According to the Santals, the *jadu-patuas* possess magical powers that protect their disciples from evil, both in "this life" as well as in in the "after life". The *Chakshudana-pat* or the "eye-bestowal painting" is one carried by the *jadu-patuas* to the family of a recently deceased individual with all but the eyes painted, signifying the unincorporated wandering spirit of the dead. It is to free the spirit from this dilemma that the family must commission the "eye-bestowal" ceremony. Other themes popular among the Santals include creation myths, the geneology of the Santal tribe and legends related to mountain spirits.

In Maharashtra, the *chitrakathi*[31] performers disseminate regional folklore through their musical performances which they accompany with the showing of painted rectangular paper panels. The narrative paintings, pasted back to back and held up for the audience by means of a bamboo stick, serve as visual counterparts of the verse and prose sung in the form of a dialogue between the two narrators. Each painting illustrates a single incident and a group of such loose leaves, which together relate a single story and are kept in a cloth bundle, are known as *pothis*.

Patachitra or the icon paintings of Orissa occupy an important status among the many art forms centered around the temple of Puri. For the painted surface, the *chitrakar* community of painters utilises a gauze like fine cotton cloth, coated with a cooked solution of powdered tamarind seed, chalk and gum and subsequently smoothened.

The paintings are executed primarily in profile with highly elongated eyes within a floral border. There are few landscapes and the scenes are depicted in a foreground closely juxtaposed together. Highly stylised paintings of the Puri temple and scenes from the epics, *Ramayana* and *Mahabharata*, figure along with the predominant painting of lord Jagannath, a form of Krishna, with his older brother Balarama and sister Subhadra.

The Kalighat paintings, created by the Bengal *chitrakars* during the late 19th and early 20th centuries at the Kali temple near Calcutta, were essentially temple souvenirs for pilgrims. Their swift, black lines, flowing rhythms and abstracted

forms later took on more secular themes that attracted the European market and became known as "bazaar paintings".[32]

Thanjavur in Tamilnadu, as well as adjoining areas[33], is known for its paintings on glass and board in the gold leaf and gesso technique. The technique of painting behind a transparent glass sheet was introduced into India in the 18th century by foreign artists, "not from Europe, the original home of glass painting, but from China."[34] The process involves a reversal of the painting process. The black contour outlines as well as facial details are executed first. Gold leaf, foil and tiny sequins are, then, added to imitate gems and jewellery. The background colours which in fact cover the black lines on the working surface, are filled in last. The final painting is viewed from the opposite, non-painted surface of the glass. The solid outlines, heavy figures and bright colours of the icons and portraits painted in this technique are reminiscent of the South Indian icon paintings on wood.

Playing cards or *ganjifa*[35] and the games played with them, probably came to India with the first Mughals from Central Asia. The classic Mughal *ganjifa* with 96 cards and the standard eight suits has lent itself to Hinduisation into its 10 or 12 suited variant with the theme of *dashavatara* or the ten incarnations of Lord Vishnu.

Traditionally the cards were painted on roundels cut out from cloth, treated with lac, gum and chalk or *pata*, while ivory, tortoise shell, mother of pearl and ordinary paper were also used. Probably originating in the Deccan around the 17th century, the *dashavatara ganjifa* spread to Rajasthan, Bengal, Orissa, Madhya Pradesh, Maharashtra, Andhra Pradesh and Karnataka.

1. Kramrisch, 1968, p.65
2. Thakur, n.d., p.31
3. Kramrisch, 1968, p.65
4. Saksena, 1985, p.4
5. Kramrisch, 1968, fn.75, p.78 and Thakur, n.d., p.37
6. Saksena, 1985, 7-8
7. Thakur, n.d., p.41-42
8. Census 1961q, p.11
9. Ibid, fn.3, p.13
10. Thakur, n.d., p.59
11. Ibid, p.60
12. In conversation with Ganga Devi
13. Vequaud, 1977, p.18
14. In conversation with master-painter Jivya Soma Mashe from the Warli tribe. Also see Dalmia, 1984.
15. Elwin, 1951, p.190
16. Mahapatra, 1986, p.267
17. Elwin, 1955, p.404
18. For further details see Jain, 1984a
19. See for instance, Wacziarg and Nath, 1982
20. For detailed information see Jain, 1986b
21. Coomaraswamy, 1981, p.210
22. Ibid, p.209
23. Vishakhadatta's *Mudrarakshasa* quoted in Basham, 1957
24. Pathak, 1958, p.257
25. For more information see Jain, 1980
26. Joshi, 1976, p.31
27. Cherial, in Warangal is famous for its painted wood, sawdust and cow-dung figures of deities and animals. See Chapter IX.
28. In conversation with master-scroll painter D. Chandriah Nakkash from Warangal, Andhra Pradesh
29. Information regarding the Bengal scrolls is partly taken from Sengupta, 1973, and in conversation with some craftspersons from the area, especially Midnapur.
30. Sengupta, 1973, p.58
31. *Marg* publication, 1978
32. Archer, 1953
33. Appasamy, 1980, p.12
34. Ibid, p.3
35. Information regarding this has largely been taken from Von Leyden, in *Marg* XXXV, No.4, n.d.

Previous Page
Tribal marriage painting depicting goddess of fertility, Palghat. Rice-paste on cow dung-plastered wall; 245 cm x 245 cm. Work of Jivya Soma Mashe, Warli tribe, Thane, Maharashtra. Open display.

The unique quality of the Warli pictographs, executed on cow dung plastered walls, lies in their timelessness. Their abstract and basic forms resemble the cave paintings of pre- and protohistoric periods.

The deities are usually painted within a sacred enclosure, usually a square known as a *chowk*, around which scenes from the forest and hamlet are depicted. "Inside the square stands a figure made of two triangles with outstretched arms and legs. She is...the goddess Palghat without whom no marriage can take place. The sun, the moon, the comb, the *bashing* (wedding head-dress) form part of her wedding ensemble. On the side is a smaller square consisting of the five headed god, Panchshiriya, the male escort of the goddess." [1]

The painting is made by *sahvasinis*, or women whose husbands are living, in the homes of both the bride and groom, on a freshly-plastered wall that will be witness to all sacred rituals performed at the wedding.

[1] Dalmia, 1984, p.80

especially Ganesha, the elephant-headed god of auspicious beginnings and Lakshmi, the goddess of prosperity.

In the villages, *mandanas* are executed on freshly-plastered floor with clay and cow dung. When still wet, *khadi* or white clay and *geru*, or red clay, are used to draw these essentially geometric designs.

Sanskrit ritual handbooks often refer to the place of offering as the confluence of the two rivers, Ganga and Yamuna, probably because it is embellished with designs in sandalwood paste (off-white) and *agar*, a brownish-red natural substance. The *mandanas* of Rajasthan and the Malwa region of Madhya Pradesh, where red and white is also used, may be rooted in the same religious custom.

Individual *mandana* elements include decorative motifs like these floral medallions, creepers, chess-board patterns, carpets pairs of feet, seven flowers, chariots, drums, the lotus, seven lamps, one lamp, leaves and parrots.

Mandana, floor drawing. Pigment painting on mud and cow dung; 83 cm x 84 cm. Ujjain, Madhya Pradesh. Contemporary. Open display.

Mandana, literally means "to draw" and in Rajasthan and western Madhya Pradesh it refers to the auspicious act of floor painting. It is believed that the entrance to the home should never be without any sacred diagrams as it is presided over by various deities,

Opposite page
Tribal wall painting depicting a myth of creation. Pigments on cow dung-plastered walls; 369 cm x 158 cm. Rathva tribe, Gujarat. Open display.

In many tribal societies it is common practice to install the deity, in the form of a ritual painting, in the home. In their oral tradition the Rathva tribe, inhabiting the hilly regions of eastern Gujarat and adjoining parts of Madhya Pradesh, has preserved a creation myth narrating the story of their ancestral gods Pithoro and Babo Ind. During certain festivals, or as part of the fulfilment of a vow, the tribals paint the legend of Pithoro on the central wall of their hut in a sacred enclosure. The main theme of this painting is the marriage procession of Pithoro and Pithori, witnessed by the gods, as well as several other mythological incidents.

After the painting is completed it is consecrated by the shaman (*bhopa*) who narrates the legend of Pithoro, accompanied by loud singing and drumming. The ritual culminates in the sacrifice of goats in honour of the deity.

The iconography of the figures within the sacred enclosure is predetermined, as are the spatial configurations, the colours and the attributes of each. The paintings outside the sacred enclosure are free renderings of the painter's imagination of the world and daily life and therefore depict bicycles, aeroplanes, rifles, alarm clocks, railway engines and carriages, birds, animals, especially horses, and processional elephants.

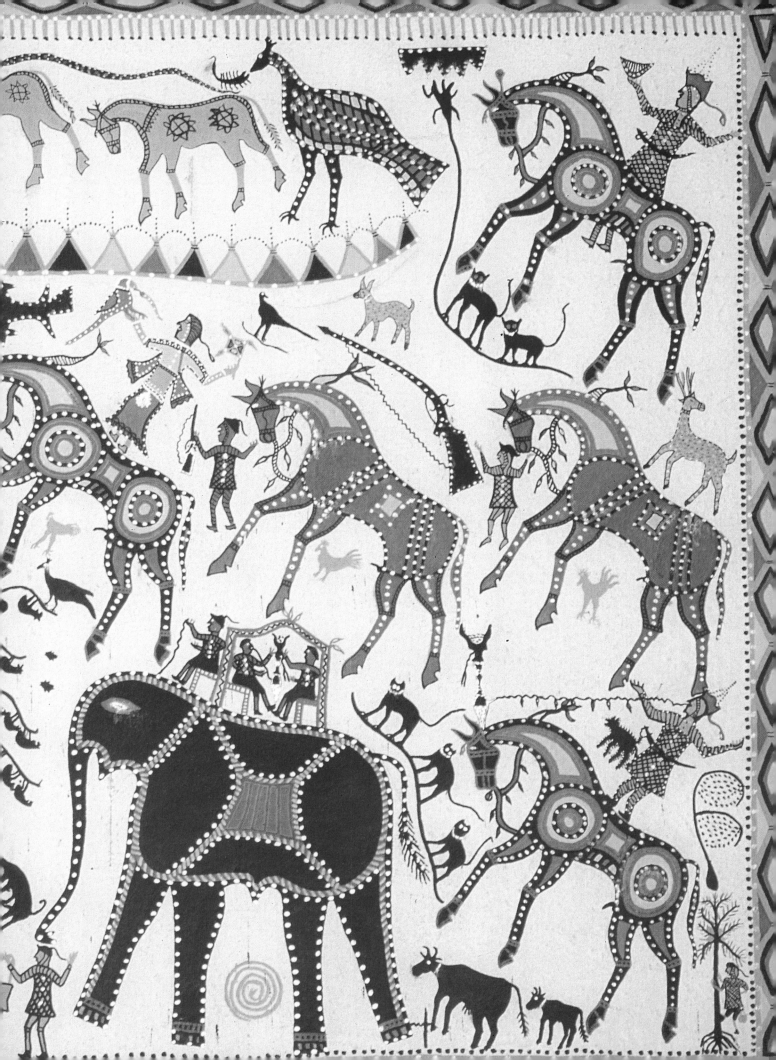

This detail depicts the elephant of the mythical king Bhoj of Malwa, Ganesha riding a horse and smoking a *hukka* (bottom right corner), the green horses of Babo Ind and the horse of Notral (top right corner) who goes to invite deities to attend Pithoro's wedding.

Shrine of Dev Narayan, a neo-Vaishnava deity. Pigment painting and terracotta on mud-plastered wall; 517 cm x 192 cm. Work of Shreelal Joshi, Bhilwara, Rajasthan. Open display.

Dev Narayan, a neo-Hindu incarnation of Vishnu, is one of the most popular deities of the Gujjar and other communities of Rajasthan. The epic story of his life — comprising hundreds of incidents from his divine birth to miraculous revelations and a series of brave battles — is painted on large horizontal cloth panels by traditional painters of the Chhipa and Joshi communities mainly settled in Bhilwara, Shahpura and Chittorgarh regions.

Less known to the world of art are the shrines of Dev Narayan where a wall is painted as in the *phad* or cloth painting depicting Dev Narayan's life story, but in place of the central painted portrait of Dev Narayan, a terracotta relief plaque of the deity, made in the village of Molela, is installed in the shrine.

Dev Narayan was born to Sadhu Mata, the wife of Savai Bhoj, who was the eldest of the 24 Bagdavat brothers. According to legend, a young widow called Leela Sevdi saw a man called Hariram Rawat carrying a lion's head in his hands. Through this vision she bore a lion-headed child called Bagh Rawat. Bagh Rawat married 12 women through whom 24 Bagdavat brothers were born. Once, in a drinking spree, the Bagdavats poured a lot of drink into the earth and some of it reached the serpent Basag in the netherworld. Basag complained to lord Vishnu, who descended to earth to destroy Savai Bhoj. Savai Bhoj's wife Sadhu, who was preparing to bathe, came to worship Vishnu in her nudity. Vishnu was so pleased with her reverence that he promised to incarnate as her son. A divine stream of water issued from the rocks of the Malasari hills and Dev Narayan appeared in a lotus floating in the stream.

Opposite page, left
detail.

Dushadh painting. Vegetable pigments on paper; 76 cm x 56 cm. Work of Chanu Devi from village Rammana, Madhubani, Bihar. Contemporary. 88/4/8.

The theme of this painting, done by a woman of the Dushadh community, is the ritual husking of rice on the chest of a selected individual during *Rahu puja*[1], a ceremony conducted by the *bhagat* or priest of the Dushadhs, as an act of thanksgiving for the successful wish fulfilment of women who desire male children or those relieved of their sufferings.

In the Hindu month of *Magh* (January-February) the ceremony begins at sunrise amidst a huge gathering inside an enclosure in the fields. The parents, paternal grandmother and father's brother of the young male child of the patron or commissioning family, wear turmeric coloured robes, while the mother and grand mother sing:

"Oh King Rahu,
our wish is fulfilled,
accept our prayer."

The painting, vividly evocative of the ritual and social life of the Dushadhs, Chamars and other castes of Bihar, is executed in subtle colours extracted from leaves, berries and the bark of particular plants. Unlike the more refined and stylised paintings of the Brahmin upper caste women of Madhubani, this painting is reminiscent of the *godna* or tattoo designs executed on the skin. The outlines, definitive yet spontaneous, are earnest renderings of a hesitant people.

[1] In conversation with Chanu Devi's husband, Rodi Paswan

Madhubani painting depicting "cycle of life", detail. Ink on paper; 322 cm x 142 cm. Work of Ganga Devi, Madhubani, Bihar, Contemporary. 84/6704.

Ganga Devi is one of the most renowned painters of the Madhubani style of painting. As an artist, she belongs to the Kayasth tradition of women painters, but tradition is not a constraint in her work. Through her unique perceptions of the world and nature around her, she depicts her paintings as personalised images connected with each other by a worldview which is very much her own.

Her capacity to transform experience into pictorial images — whether ritualistic, symbolic, iconographic or narrative — makes her a painter who seems to be "traditional" in her "modern" work and "modern" in her "traditional" work.

This large painting from which this detail is taken was executed sometime in the early '80s. It depicts the "cycle of life" as is customary in the traditional life style of Mithila from the time the child is in the womb. It includes a woman being anointed for fertility; a child inside the womb praying: "O God, relieve me from the hell"; the birth of a child; care of the mother, worship of the goddess Chatthi; visitors to see the child; the deity Chitragupta "writing" the "destiny" of the child; the ritual of the goddess Chatthi in honour of the male child; the ritual of keeping away the evil eye; purification of the body and celebration; worship of the goddess Bhagvati, while children are playing in the sun or with a parrot; a scene of eating, walking and playing; a tonsure ceremony; a child being brought to school; two girls playing being man and woman to please the god of rains; carrying a basket full of objects to celebrate the festival of brother and sister; the temple of Shiva and Parvati; worshippers approaching the temple; an engagement ceremony; a wedding ceremony; the completion of the wedding ceremony; the bride leaving for the house of the bridegroom; the bridegroom proceeding to his home after the wedding ceremony, above the palanquin on the right the newly-married bride shown as a pregnant woman; and so the continuity of the passage of life, from birth to birth.

The detail in the picture shows the bride being decorated for the ceremony.

115

Ritual painting for Maha Lakshmi Puja. Ink on paper; 66 cm x 51 cm. Kumaon region, Uttar Pradesh. c. early 19th century 7/4604.

This *pata*, or painting, is executed by the women of the household on the occasion of the festival of lights, Dipavali, for the worship of goddess Lakshmi, the deity of wealth and prosperity. It may be done on a wall in the home or on a sheet of paper as is the case here.

In the centre goddess Lakshmi is depicted with her body rendered in somewhat geometric form and her arms stretched upwards. She is flanked on either sides by female worshippers approaching her with offerings. Beneath is a lotus pond, an emblem of the goddess.

In the upper most section are anthropomorphic images of the sun and moon. The upper left corner depicts a woman worshipping the holy *tulsi* plant or sweet basil. On the right of the lotus pond is the divine couple Shiva and Parvati.

The bottom left picturises goddess Sita's *svayamvara* or betrothal while the bottom right depicts divine couples, flutist Krishna with Radhika, and Ganesha with his consort.

The extremely sensitive figurative drawing in ink and translucent colours is bound within black outlines and the figures, except for those of the main deities, are mainly in profile. Today, such ritual paintings have also begun to be printed and are used for the same purpose.

Opposite page
Chaitra-Gauri-pata, painting of goddess Gauri.Pigment painting on cotton cloth; 264 cm x 215 cm. Maharashtra. c. 19th century. 81/6291.

It is believed that on the third day of the bright half of the month of *Chaitra* (the spring month between March and April), goddess Gauri, consort of god Shiva, visits her parents for a month. This occasion is popularly celebrated by the women of Maharashtra by installing the *Chaitra-Gauri-pata* in homes and temples, in honour of the deity, amidst great festivity.

The centre of the painting depicts the divine pair, Shiva and Gauri, seated on a low platform under a domed canopy. They are flanked by Vishnu with his consort Lakshmi greeted by Garuda in *anjali mudra*, a gesture of offering (to the right), and by Brahma, who is holding a book and *mala*, a flower garland, with his consort. The three divine pairs are enclosed within a decorative steepled frame within a wavy stylised arch. The space in between is occupied by a figure of Sarasvati on the right and Ganesha on the left. In the upper corners, on each side, Balakrishna, or child Krishna, lying on a leaf and sucking his toe, is depicted between vine scrolls with playful monkeys frolicking within.

In the lower panels, Radha and Krishna are shown amidst a group of *gopis*, or cowherdesses, playing Holi, i.e. throwing coloured water on each other as part of the spring festival. This group is flanked by Garuda and Hanuman. The bottom row, conceived as the river Jamuna, depicts various scenes connected with the Krishna legend, like *Kaliyadamana*, the quelling of the snake king Kaliya.

117

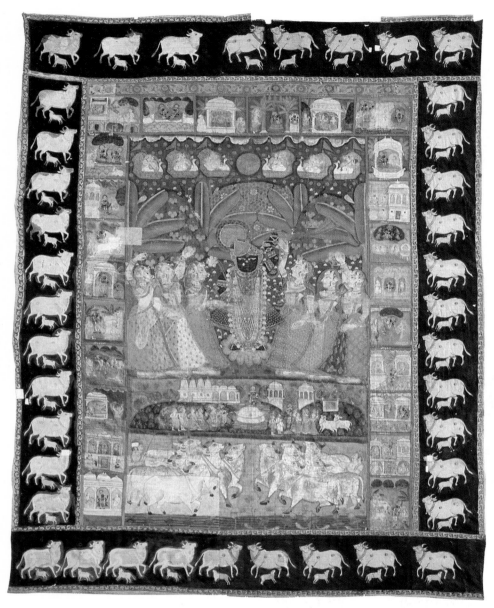

towards the main deity. Around the central portion are 24 small panels depicting various scenes from Krishna's life.

Opposite page
The child Krishna mischievously stealing butter. Pigment, gesso and gold on board; 108 cm x 78 cm. Thanjavur, Tamilnadu. c. late 18th century. 7/201(A).

Thanjavur, modern Tanjore, is famous for a rare kind of painting on glass and gesso work on board. Both these types are richly embellished with gold leaf and imitation or real gems as ornaments. The relief work of this painting is achieved by applying gesso, which is a mixture of gypsum or plaster of Paris and glue.

Here Balakrishna, or "child" Krishna, adorned with jewels and a peacock feather in his hair, is shown mischievously enjoying his stolen butter. He is seated on a gilded throne against an arched background and guarded by winged angels holding garlands. As his mother chides him with a raised finger, Krishna's hands tighten possessively on the stolen pot of butter.

Temple hanging of the Vaishnava sect depicting the festival of Sharad Purnima or autumn full moon. Pigment on cloth; 263 cm x 204 cm. Udaipur area, Rajasthan. c. early 20th century. 7/4207.

The *pichhvais* or ritual temple hangings of the Vallabacharya sect, are beautifully painted cotton cloths used as backdrops behind the main idol of Krishna in the inner shrine of the temple.

This particular painting is used for the festival of Sharad Purnima or autumn full moon. Shri Nathji, the local form of Krishna stands on a throne, of lotuses. The forested landscape of Brindavan, the groves where Krishna played as a child, is indicated by the plantain leaves and mango trees. Three *gopis*, or cowherdesses, stand on each side with raised arms as if dancing for their beloved Lord Krishna. The lower panels depict scenes of *govardhan puja* ("cow nourisher-worship") and *danalila* or Krishna demanding butter as toll, and a row of white cows looking up

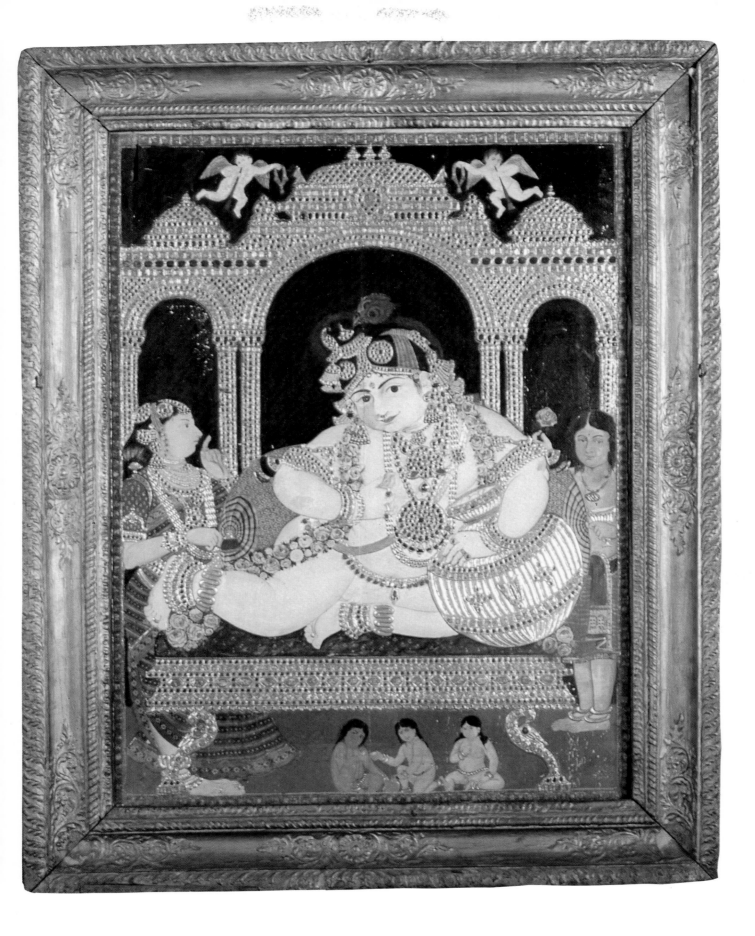

Patachitra or painting on cloth, depicting Krishna with his mother Yashoda. Natural pigments on rag board; 137 cm x 51 cm. Orissa. c. 19th century. 7/5227, 7/5228.

This painting represents the style of painting from which the later renderings of the *patachitra* tradition from Orissa evolved. Vibrant and full of naturalism, this painting depicts the loving play of child Krishna with his mother. As the arched shape of the painted cloth indicates, this piece was meant for framing the upper part of a door or providing the backdrop for an idol in a temple.

This *patachitra* is in two parts, one being the mirror reflection of the other. It depicts Yashoda lounging comfortably on a low stool, while her baby Krishna plays with her breasts. Typical features of the Orissan style are the big nose ring, prominent dangling earrings, the perfectly-shaped almond eyes and pointed nose. Parrots, set in yellowish scrolls, are in the centre, while the background of this scene is a deep red ochre.

Opposite page
Jagannatha temple at Puri. Pigment on rag board; 55 cm x 51 cm. Orissa, c. early 20th century. 7/6104.

Pilgrim paintings as souvenirs are a common tradition in India where elaborate cults develop around a shrine or temple.

The Jagannatha temple at Puri, on the coast of the Bay of Bengal, is the centre of the cult of Jagannath, the "Lord of the World". The majestic temple of Puri, depicted in this *patachitra* or painting on rag board, for the benefit of pilgrims, "was built in the 12th century A.D...probably in the last decade of the long reign of Anantavarman Codagangadeva... in order to gain religious merit and to create a lasting symbol of his own glory, he built the temple of Purushottama in Puri which was to be higher than any temple in Orissa known before." [1]

This painting conceptualises the awe-inspiring temple at Puri along with its main deities, "the Jagannath trinity which was developed in the Ganga period and consists of the juxtaposed gods Vishnu (Jagannath, Krishna) and Siva (Balabhadra, Samkarsana) together with a common Sakti (Subhadra, Katyayani)". [2]

[1] Eschmann, et. al. (eds.), 1986, p.1.

[2] Ibid, p.15

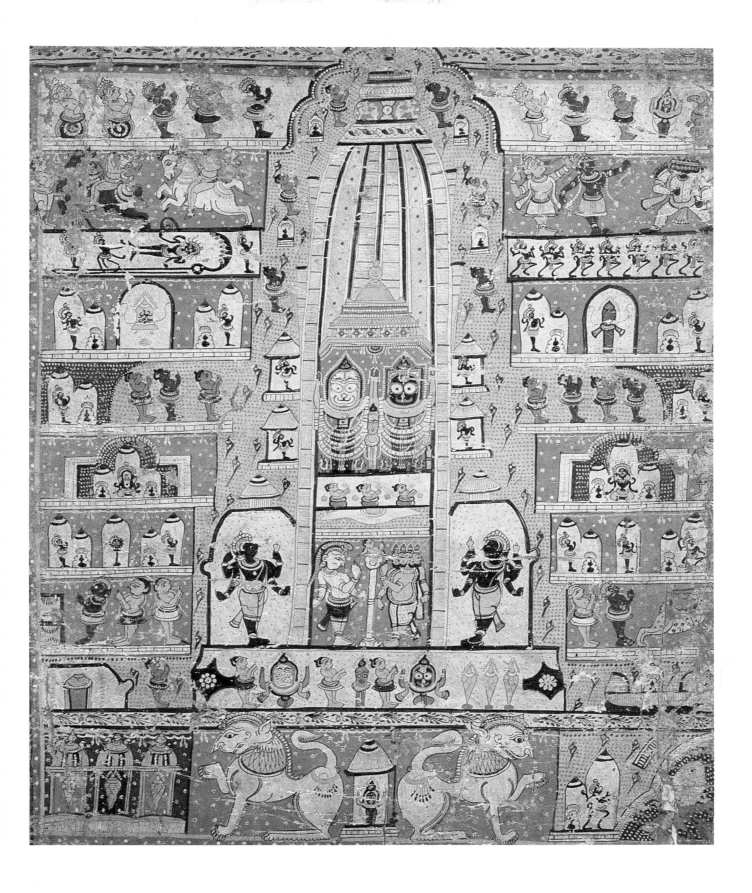

Orissa, Madhya Pradesh, Andhra Pradesh, Maharashtra and Karnataka.

This set of playing cards is painted on circular discs prepared from seasoned rag board, a typical base used for paintings in Orissa. The cards depict the Matsya, or fish incarnation and Kalki or tenth incarnation of Vishnu, a pair of *shankha*, conch shells, the emblem of Vishnu, and six axes, the symbol and weapon of Parashurama, the sixth incarnation of Vishnu.

Usually, sets of playing cards are kept in wooden boxes which are decorated with paintings similar to those on the cards.

[1] Von Leyden, in *Marg*, XXXV, No.4. n.d p.1

Ganjifa, playing cards and box.
Pigment painting on ivory; 6 cm x 4.2 cm; 11 cm x 7 cm. Rajasthan. c. 19th century. 7/4434(4); 7/4434(12) and 7/4434(97).

This set of ivory *ganjifa*[1], unlike the circular variety, is rectangular in the tradition of European playing cards, probably introduced with the coming of the European colonists after the 16th century. One of these miniature *ganjifas* depicts a royal personage on horseback, attended by a fly whisk bearer and a horse keeper leading the animal. A small kneeling figure is painted in the space above the scene in the style of miniature painting.

The second playing card of this set shows four men playing the traditional game of *chaupar*, a cross-board dice game. Ivory boxes like this one with a sliding lid, which give easy access to the cards, were used for keeping cards. This box is decorated with the figure of a royal lady sitting on a European style armchair holding a flower in one hand, while a flowering tree and two peacocks complete the charming painting.

[1] See also Cat. No.V/13

Ganjifa, playing cards. Pigment and lac on rag board; dia. 11 cm. West Bengal or Orissa. c. late 19th century. 4/395(9), 4/394(12), 4/394(26), 4/394(66).

The tradition of playing *ganjifa*, or card games, was probably introduced into India by Babur, the first of the Mughal emperors, although it is likely that the *ganjifa* must have been popular many centuries before this. Babur made the following entry in his diary: "The night we left Agra, Mir Ali the armourer was sent to Shah Hassan (Arghun) in Tatta to take him playing cards (*ganjifa*) he much liked and asked for"[1]. In addition to the eight-suited Mughal set, a 12-suited variant also developed. In the course of the Hinduisation of the game, a ten-suited set developed with the 10 incarnations of Vishnu presiding over each suit of the game. This type is most popular in Rajasthan, Bengal, Nepal,

Miniature painting depicting floral motif. Mineral pigments on paper; 30.5 cm x 16 cm. Work of Mohan Lal Soni, Jaipur, Rajasthan. Contemporary. VC.

This floral stem painted in colours derived from mineral stones, is a reproduction of master-painter Ustad Mansur's original from the court of the Mughal emperor Jehangir.

The strict adherence to naturalism, combined with the conservative use of colour, conveys a sense of beauty typical of the period. This is one of the many examples of the "living" tradition of miniature painting in India.

Painting of woman with lotus flowers. Water colours on paper; 54 cm x 38 cm. Kalighat, West Bengal. Contemporary. 7/4209.

Swift black outlines in bulky, though highly expressive, forms are characteristic of the Kalighat paintings, a tradition centred around the temple of goddess Kali at Kalighat, on the river Hooghly near Calcutta. Basically "pilgrim paintings", sold as temple souvenirs for the benefit of pilgrims, the style was highly patronised by the European colonists in India during the 19th and early 20th centuries, by the name of "bazaar paintings" from Calcutta.

By the mere manipulation of the brush stroke and the use of thick and thin black outlines, the painters of Bengal or *patuas* achieved a tremendous sense of rhythm, particularly of light and shade.

This painting, executed in pale water colours with dark outlines, depicts a woman, probably goddess Lakshmi, flanked by long stems of the lotus. At the lower left corner is the outlined figure of a bird, probably that of an owl.

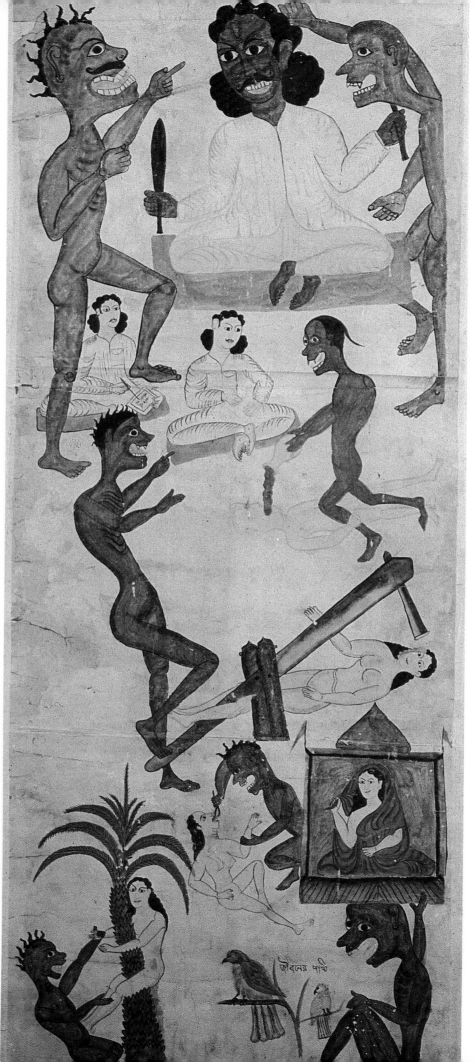

Storyteller's scroll depicting the life of Vaishnava saint Chaitanya or Nimai, as well as the various punishments in hell. Water-based pigments on paper; 435 cm x 52 cm. West Bengal. c. early 20th century. 84/6788.

Among the numerous religious *patas*, or scroll paintings, made by the itinerant *patuas* or painters of Bengal, this particular scroll depicts the life of the neo-Vaishnava saint Chaitanya or Nimai who lived from A.D. 1486-1533.

The scroll is painted in a sequence of nine panels of which only the last one is presented here. The first one shows an incarnation of Krishna standing under a tree. His six hands are due to his being a composite of Narayana, Krishna and Nimai. The two upper hands, holding a bow and arrow, belong to Narayana, the central two, playing the flute, belong to Krishna, while the lower hands belong to Nimai.

The second panel depicts three figures: the female figure to the left is Nimai's mother, Shantimata, the central one is Nimai himself, while the one on the right depicts an elderly *rishi* or ascetic.

The third panel portrays the scene where Nimai renounces the world by leaving his sleeping wife Bishnupiya (Vishnupriya), late in the night, while his deceased father, in the form of a *bhuta* or spirit, depicted as a dark black figure, looks on.

The fourth scene depicts Nimai as a saint walking in the forest. The fifth scene shows women including Shantimata, Nimai's mother, and Bishnupiya, his wife, mourning his renunciation.

The sixth panel shows the tonsure ceremony for Nimai's initiation into sainthood. The scene is of the Kantoyar Ghat, a river bank, with Nimai sitting under a *neem* tree while his hair is being shaved off by a barber. The Bengali inscription under the tree reads: *"Kantoyar (Kantuar) Ghat, Nim tala,"* which means: Kantuar river bank under the *neem* tree.

The seventh panel depicts a number of old men celebrating Nimai's *sanyas* or renunciation. The eighth panel portrays an incarnation of Krishna as half Nimai and half-Krishna, painted half yellow and half dark-blue.

The ninth and last panel shows various tortures inflicted in hell by Yama the god of death and his attendants. Since Chaitanya's lifespan is at the end of the *Tretayuga* and the beginning of *Kalayuga*, where vice and evil characters inhabit the world, the last panel in every Chaitanya scroll necessarily depicts the punishments in hell.

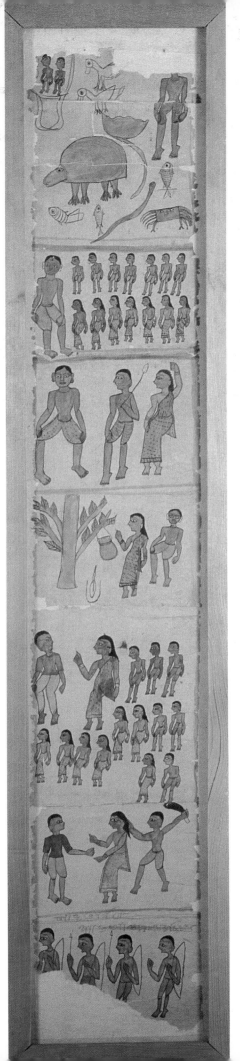

Fragment of a storyteller's scroll.
Pigment on paper; 118 cm x 20 cm.
Santal tribe, West Bengal or Bihar.
c. mid-19th century. 7/5614.

The most popular subjects for the storytellers' scrolls from the Santal region pertain to Santal legends and tribal customs, scenes from Krishna's life, memorial depictions of Santals who have recently died, legends surrounding the tiger gods Satyapir and Satyanarain, and other scenes from Hindu legends. The painters of such scrolls employ subtle colours usually on a pale brown or green ground unlike the brightly painted scrolls of the *patuas* or painters of Bengal. In addition to being storytellers, the *patuas* who paint for the tribal Santals, also perform various rituals and are therefore called *jadu-patuas* or "magic-painters".

This fragment of a storyteller's scroll depicts a series of incidents from Santal life.

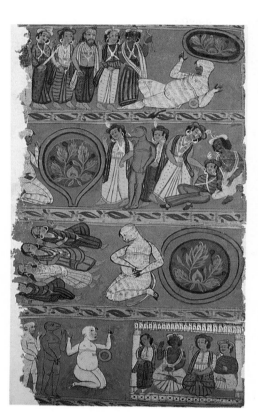

Fragment of a storyteller's scroll depicting scenes from the *Ramayana*. Pigment painting on paper; 89 cm x 50 cm. West Bengal. c. mid 19th century. 7/5610.

The panels of this fragment of a religious scroll or *pata* from Bengal depict scenes from the Ramayana. Hanuman is shown carrying the mountain of herbs (depicted as an oval filled with green plants and herbs) to Shri Rama who had asked for the *sanjivani-buti*, a life-saving herb needed for Lakshmana, who had been badly injured on the battlefield. Unable to identify the herb, Hanuman had carried the entire mountain back to his Lord.

The *patuas* of Bengal, who are also expert narrators of both religious and secular stories, are really the carriers of oral traditions to people's doorsteps. They function not only as painters and entertainers but also as prime educators in the morals of society.

Their paintings are philosophical and replete with symbolism. The unusually fair colour of Hanuman, the foetus-like herb within the womb of the mountain, and the kneeling devoted figure of Hanuman are more than mere illustrations from the epic *Ramayana*.

Chakshu-dana-pata **or "eye-bestowal panel".** Natural pigments on paper; 16 cm x 9 cm. Santal Parganas, Bihar. c. early 20th century. P/DPG/55/77/(5).

"When a man, a woman or a child dies, the *Jadu* — or *Duari-patua* appears at the house of the bereaved family with a ready-made painting of the deceased. He draws the picture of the deceased with only one omission, viz. the iris of the eye. He shows the picture to the relatives and tells them that the deceased is wandering about blindly in the Afterworld and will continue to do so until his or her eyesight is given back, for which he (the priest-painter) should be paid! So the relatives make presents of money, or some other articles of domestic use, to the *Jadu-patua*, who then puts the finishing touches to the painting by performing the act of *chakshu-dana*, or supplying the iris of the eye in the figure of the deceased!" [1]

The "floating" unincorporated soul of this deceased old woman, depicted here with a hen and a huge ring-like object, has probably been made to rest after the ritual eye-bestowal ceremony that has obviously been completed in this *pata* or painting.

[1] S.K. Ray, quoted in Sen Gupta (ed.), 1973 p.73

Detail of Garoda scroll. Water colours on paper; 279 cm x 56 cm. Gujarat. c. mid-20th century. 88/5/D.

The Garodas are a community of traditional storytellers from Gujarat who are known not only for painting and narrating legends, but also for painting horoscopes for newly born children. Unlike the *chitrakatha*, or storytelling traditions from Bengal and Rajasthan, the painted scrolls of the Garodas depict many legends in a single scroll.

The picture scrolls, known as *tipanu* in Gujarati, meaning "recording" or "remark", are usually more than 3 m long and 35 cm broad and generally depict the following scenes:

A shrine in the centre of which is a full vase topped by a coconut; two horsemen in profile representing the heroes Aklang and Niklang; four-armed Ganesha, often accompanied by his wives Riddhi and Siddhi; Shiva, usually riding his vehicle the bull Nandi, often flanked by goddesses, one of whom holds a snake, or bow and arrow, and the other a scorpion; goddess Lakshmi; the local story of Dhana Baghat; two goddesses, one riding a tiger, the other a cock (local goddess Bahuchara), killing the buffalo demon; Krishna quelling the snake king Kaliya; the Shravana episode from the *Ramayana*, depicting Dasharatha aiming his arrow at the youth carrying his blind parents seated on planks suspended from a pole slung across his shoulders; Rama and Lakshmana aiming at a two-headed deer, while Sita is sitting in a garden pavilion; two-armed Hanuman; ten-headed Ravana; the story of the truthful king Harishchandra; the game *amli-pipli* played between the Pandavas and Kauravas, wherein an over-sized figure of Bhima, with half his body in red and the other half in silver, is shaking the tree; the legend of Chelaiyyo, popular in Gujarat; Ramdev Pir of Ranuja, one of the deified heroes of Rajasthan, depicted by his footprints, his horse and his bride Netal; and finally the various punishments in hell and rewards in heaven.

The detail here depicts the game of *amli-pipli*.

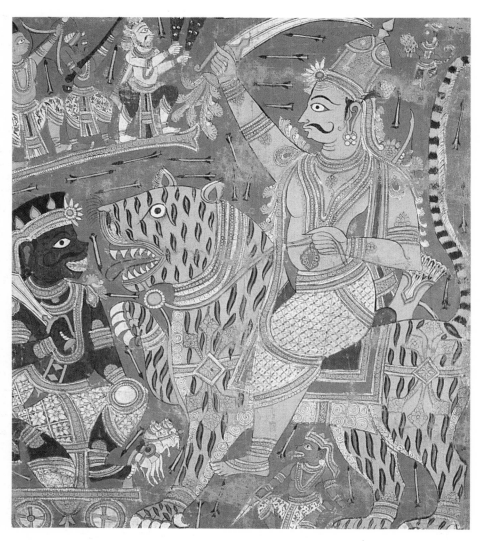

arrows signifying a battle.

Such paintings were employed as illustrations to the narration of myths and legends and were carried from village to village by itinerant storytellers.

Opposite page, top
Chitrakathi or "illustrated legend".
Natural pigments on handmade paper; 44 cm x 32 cm. Maharashtra. c. late 19th century. 7/4315.

The *Chitrakathis,* a nomadic community of storytellers, were once found all over Maharashtra and some parts of Andhra Pradesh and Karnataka. Until quite recently they would travel from village to village, unpack their *pothi* or bundle of rectangular paintings, and begin their long sessions of narrating myths and legends from the epics Ramayana and the Mahabharata and the vast "ocean" of folklore and local legends preserved in their oral tradition.

The most typical features of the *Chitrakathi* paintings are their bold and powerful drawings in thick black outlines. The human figures are shown both in profile as well as in frontal view, while the animals are mainly in profile. The faces are stereotyped with a high forehead, a prominent pointed nose, a curve for the mouth, and one for the chin, while a red line indicates the lips. The eyes are the most animated feature of these paintings for they are conceived as large white circles marked by a black dot for the pupil in the centre.

This particular piece depicts Sita, wife of Rama, who was abducted by the chief of the demons Ravana, sitting pensively in the Ashoka grove guarded by two demons holding swords and shields, while Hanuman, concealing himself in the foliage of the tree above Sita, identifies himself as Rama's messenger by dropping Rama's ring into Sita's outstretched palm.

Painted scroll depicting incidents from the *Markandeya Purana*.
Pigments on cotton cloth; 85 cm x 97 cm. Cherial, Warangal, Andhra Pradesh. c. late 19th century. 85/6903.

This fragment of an earlier horizontal scroll, painted with natural pigments on canvas, depicts local incidents from the *Markandeya Purana.* It shows Bhawana Rishi a saint and son of Markandeya Maharishi holding a sword and astride a tiger, fighting, and finally defeating the demon Kalavasenudu and his army. A small demon is shown being killed beneath the tiger's legs. This scene is framed on top by a row of three divinities in yellow, red and white, holding different weapons. The demon is approaching his enemy in a chariot drawn by two horses. The spaces in between are filled by a number of

Chitrakathi or "illustrated legend".
Natural pigments on handmade paper;
44 cm x 32 cm. Maharashtra. c. late
19th century. 7/4312(1).

Chitrakathi[1], or painted narratives of
itinerant storytellers mainly from
Pinguli, in Maharashtra, are executed in
rectangular panels, generally on both
sides. They are used as aids to narration
of legends to the accompaniment of
music and songs usually in verse. There
is no clear demarcation of foreground
or background and the figures seem to
converge and superimpose in a style
characteristic of these paintings.

This panel depicts the classic fight
between the two monkey brothers,
Sugriva and Bali, for their kingdom of
Kishkindha. According to Valmiki's
Ramayana, Sugriva entered into a treaty
with Rama, in which Rama was
supposed to kill Bali and install Sugriva
as the sole king of Kishkindha, in
return for which Sugriva was to help
rescue Sita from Lanka with his army
of monkeys.[2]

The two brothers are shown here with
both pairs of arms and legs locked
together in a typical wrestling pose.

[1] See also Cat. No. V/23

[2] Mani, 1984, p.756

Symphonic Weaves:
Textile
Traditions of
India

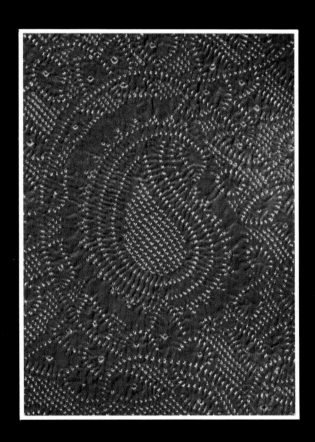

The discovery of several spindles, as well as a piece of cotton cloth stuck to a silver vase, establish beyond doubt that the spinning and weaving of cotton was known to the Harappans nearly five millenia ago.[1]

While a variety of plant fibres such as *kuhsa* or *darbha*, *kushornah*, *kshauma* (a type of linen), *umah* (flax), and *shanaha* (jute) were prominently used for weaving textiles in the early Vedic period,[2] it is only in the texts of the post-Vedic period that references to cotton begin to appear. A Buddhist text, *Bhikshuni Vinaya*, contains the following interesting reference to women spinning cotton:

"They (nuns) went up to the terrace and took cotton (*karpasam*), one of them did the selection (*cikitsitam*), the other one did the spreading (*vilopitam*), the other cleaning (*pinjitam*), the other apportioned it (*vihatam*), the other spun it (*kartitam*). Then they took the bundle of yarn and went up to a householder lady: 'O lady, (we have to you) done a favour!' (She) said: 'this is no favour to me that you honourable ones for me have cleaned (*pinjeyur*), apportioned (*lodheyur*), combed (*vikaddheyur*) or spun (*karteyur*).'"[3]

References to weaving also abound in Vedic literature. The verb for weaving is *tan*, meaning "to stretch", while the term *tantu* or yarn and *tantra* or "warp",[4] also derive from the same root. Also abundant are terms for designs and patterning, such as *bhinanta*, loose warp at the edges; *dasa* or tassels; *tusa* or woven border; and *upadhayyapurvaya*, embroidery or patchwork.[5]

The Graeco-Roman sources of Indian history, the epics, the Puranas, the classical Tamil Sangam literature, the Muslim and European accounts of India and the scores of inscriptions, sculptures, paintings, oral traditions and the surviving techniques of weaving, needlework, designs and materials provide a wealth of information on the textile history and "living traditions" of India.

The foundations of the Indian textile trade with other countries were laid some time in the second and first centuries B.C.. Kalyan, a port mentioned by Cosmas, is one from where textiles were exported. A variety of fabrics called *po-tie* ("cotton brocade" or "cotton stuff") is mentioned in authoritative Chinese works as an Indian product which was exported to China from Ho-Lo-Tan or Java.[6]

A hoard of block-printed and resist-dyed fabrics, mainly of Gujarati origin, found in the tombs of Fostat, Egypt, are the proof of large-scale Indian export of cotton textiles to Egypt from early mediaeval times. Some of the motifs were similar to those found in the 13th century Western Indian manuscript illustrations, whereas others resembled the block-printed *ajrakh* fabrics of Kachchh, Northern Gujarat and Sind and the lattice work of Islamic architecture in Gujarat.[7]

Patola, the double-*ikat* silk fabric, was a popular item of Indian export to Indonesia around the 13th century where Indian, Portuguese, Dutch and other merchants used them to barter for spices.[8] Towards the end of the 17th century, the British East India Company had begun to export silks, mixed cotton and silk, and plain cotton including very fine muslin from Bengal, Bihar and Orissa.[9] The trade in painted and printed cottons or chintz, a favourite in the European market of the time, was extensively practised between India, China, Java and the Philippines, long before the arrival of European traders.[10]

Before the introduction of mechanised means of spinning in the early 19th century, all Indian cottons and silks were hand-spun and hand-woven, a fabric now popularly known as *khadi*. Fabrics that use mill-spun yarn but which are hand-woven, on the other hand, are known as "handloom".

Previous page
See *page* 144, *below*

Cotton is the soul of the handloom industry of India today. About three million hand-operated looms — which is 90 per cent of the total handlooms in the country — are engaged in weaving fabrics of nearly[23] 23 different varieties of cotton.[11]

It appears that one of the most refined varieties of silk, known as mulberry, was probably introduced into India from China, the term for which was *chini*.[12] A legend states that the eggs of the silkworm and seeds of the mulberry tree were smuggled into India in hollow bamboo by Buddhist monks. Another story tells of a Chinese princess who smuggled the goods in her elaborate hairdo.[13] The "wild" or raw silk of India, obtained from silkworms known as the *tassar*, *muga* and *eri* as well as some other local varieties, and renowned for its textural beauty and subdued tones is, however, indigenous to India. *Tassar* worms are simply fed on any tree in the hilly tracts of the country and produce a variety of silk that is stiff in texture. The *muga* worm is reared mainly in Assam where it is fed on a species of laurel, producing a golden-hued silk. *Eri* worms feed on the leaves of the castor plant, locally known as *arundee*, and produce a silk which is rough-textured and lacks a glossy shine.[14]

The textiles of India may be roughly classified as those that involve elaborate processes prior to weaving, at the time of weaving and after the fabric is woven.

Yarn Resist

To reserve only certain predetermined areas of the warp or weft or both with tied threads in order to dye the yarn before weaving begins is a process that requires great precision and skill. This technique, by which the warp and/or weft yarn are tie dyed in such a way that the "programmed" pattern transfers, in the process of weaving, onto the finished fabric, is known as *ikat*. The main types of *ikat* include the *patola* or double-*ikat* silk of Gujarat and that of Orissa and Andhra Pradesh.

Mediaeval Gujarati literature is full of references to the *patola* of Gujarat indicating that it was a precious silk sari, the patterns of which were considered to be clear and reasonably permanent. The name *patola* probably derives from the Sanskrit *pattakula*, meaning "silk fabric".[15] Here, the weaving is done so that the elements of pattern and colour on the warp are made to juxtapose exactly with those of the weft so that the colour combination and design sequence of the predetermined pattern are kept intact. A slight irregularity in outlines creates the "flame-effect" which forms the essence of the beauty of *patola*.

It is said that *patolas* were once woven in Ahmedabad, Surat, Cambay and Patan in Gujarat, as well as in Jalna in Maharashtra and Burhanpur in Madhya Pradesh. Today, however, true *patola* is made only in Patan by a couple of Salvi families.

The ground colour runs through a range of Indian-red, emerald green and indigo-blue or dark-brown while the designs are normally executed in whites and yellows in elaborate meshes of floral and geometric repeats within which birds, beasts and even human figures are woven.

In the *ikats* of Orissa, the motif outline is not as sharp as in the *patola*. Here, in addition to the double-*ikat*, single-*ikat*, i.e., weft-*ikat* and warp-*ikat* are also common. A characteristic of the Orissan *ikat* is that some patterns in the *pallav* or end-piece and border are created simply by weaving, very often using an extra weft of plain-dyed yarn.

From the sari to yardage, the Meher community of weavers produce a large variety of *ikat* in various regions of Orissa, of which Sonepur and Bargarh are famous for their fine cotton and Cuttack for its silk and *tassar* variety. The dominant motifs are the *hamsa* or swan, *gajabandha* or elephant motif, the fish, the conch shell, *danti* or tooth pattern and *deoli* or temple pinnacle.

Andhra Pradesh has long been known for its "Asia *rumals*",[16] usually red and black in colour, with large borders. Also known as *chitti-rumals*, *chitti* meaning

"small" in Telugu, or *telia rumals*, *telia* meaning "oily", these are square kerchiefs having geometric and figurative designs such as birds, animals and flowers. Worn as turbans and *lungis* by men, they are used as *dupattas*, or shawls, and even saris by women. Executed in the *ikat* technique, locally known as *pagdu bandhu*, or tie-dyeing, these *rumals* have a characteristic oily smell and lustrous finish. This is due to the yarn being soaked in an emulsion of sweet oil and alkaline earth for several days before it is ready to be dyed. Chirala, Pochampalli, Puttapaka and Koyyalagudem were given a new lease of life in the middle of this century when these centres began to produce a variety of *ikat* fabrics in the traditional technique.

Mashru is distinguished as a textile, mainly with striped patterns in satin-weave. This is a mixed fabric with a silk warp and a cotton weft. Often, the warp yarn is tie-dyed in the single-*ikat* technique giving the fabric its characteristic lightning effect. It is believed that Muslim men were permitted to wear *mashru* cloth in lieu of pure silk which was prohibited. The traditional designs on *mashru* included the *panch patta* or "five stripes", *kala-laher* or "black-wave", *patta-patti* or "crisscross" pattern and *joda-patti* or "pairs of stripes". The fabric was also sold according to its usage: *kamkhi* meaning "for a blouse"; *gaji*, literally of a single length or yard. So coveted was the textile as an export item to Islamic countries that its trade name was *saudagiri* or one "brought by the *saudagar*," an Arabic word for "merchant". Today *mashru* is woven mainly in Patan, Surat and Mandvi in Gujarat.

Brocaded Textiles

Brocade refers to those textiles where patterns are created on the loom, i.e. in the process of weaving by transfixing or thrusting the pattern-thread between the warp. In simple weaving the weft thread passes over and under the warp thread regularly. But when brocade designs in gold, silver, silk or cotton threads are to be woven, special threads are transfixed in between by skipping the passage of the regular weft over a certain number of warp threads depending upon the pattern. This is done by using a *naksha* or design which regulates the patterning by means of pre-arranged heddles.[17]

Depending upon the nature of the patterning thread, we have cotton, silk and mixed brocades on the one hand, and *zari* or gold and silver thread brocades on the other.

Jamdani or "figured muslin", traditionally woven in Dacca, (now Dhaka in Bangladesh), West Bengal and Tanda in Faizabad, Uttar Pradesh, refers to cotton fabric brocaded with cotton and sometimes with *zari* threads. Here, two weavers work on a single loom where the design on paper, kept underneath the warp, is used as a guide in placing the cut threads, according to the design, over the warp. These are, then, interlaced into the warp with fine bamboo sticks in a zigzag manner to form the motif. This is followed by the weft thread, the process being repeated before the shuttle carrying the weft is thrown across again. Some of the traditional motifs include *chameli*, jasmine; *panna hazar*, thousand emeralds; and *gainda buti*, marigold. The most attractive design feature of the *jamdani* sari is the *konia* or "corner" with paisley motif.[18]

Himru can best be described as cotton and silk brocade where the extra silk weft, which is used for patterning, is thrown over the surface only where the actual pattern appears, the rest of the patterning thread being left to hang loosely beneath the surface of the fabric. Because of this, the material has to be lined and is ideally suited for winter. *Himru* thus differs from other mixed fabrics such as *mashru*, where the entire fabric is woven with the silk weft in a regular satin-weave. Aurangabad in Maharashtra, Surat and Ahmedabad in Gujarat, and Varanasi in Uttar Pradesh, are traditionally known for this fabric. Other mixed brocade fabrics include the *amru* silks of Varanasi, the *sangi* silks of Azamgarh, *gulbadan* silks woven all over northern India, the *mashru* of Gujarat and Decca, and the *ghatta* and *abrawan* of Uttar Pradesh.[19]

By using a loom similar to that of the *jamdani* weaver, the weavers of Baluchar, in Murshidabad district, West Bengal , are known to weave a silk-brocaded silk sari called the Baluchar *butidars* or flowered saris. The ground colour is usually in deep purple or maroon and studded with small *butis* or floral motifs usually brocaded in weft threads of beige, yellow and orange. The *anchal* or end-piece is characteristically ornamented with two or more linearly arranged elongated mango motifs around which bold figurative designs of courtly scenes, equestrian figures, peacocks and other bird and animal patterns are woven.

Maheshwar, of West Nimar district in Madhya Pradesh, produces an extremely beautiful silk and cotton mixed sari with a brocaded chequered field and a reversible border locally known as *bugdi*. The borders which contain some *zari* are known as *zari patti-bugdi*. The relatively modest borders are brocaded in the *teen-gomi Maheshwari bugdi, irkal, gol-patti, chatai, laddoo, swastika, ankh* or "eye" and flower designs.[20]

When gold and silver threads are employed with or without silk threads, in the actual weaving process, we have *zari* brocade fabrics. In these fabrics, gold wire or *kalabattu* is used in the weft or warp along with silk to create glittering patterns within the field and borders. When the *kalabattu* is so densely spread that it covers most of the surface, it is known as *kinkhab* which invariably becomes too heavy to be worn.

Varanasi in Uttar Pradesh,[21] Surat, Baroda and Ahmedabad in Gujarat, Chanderi and Maheshwar in Madhya Pradesh, Paithan in Maharashtra, Mysore in Karnataka, Kanchipuram and Thanjavur in Tamilnadu, and Murshidabad in West Bengal are traditionally renowned centres of *zari*-brocade weaving.

The village of Paithan in Maharashtra has been famous for a special kind of silk sari with borders and end-piece having silk brocaded designs rather than gold brocaded. Motifs of geese, parrots, peacocks and stylised leaves, flowers and creepers in deep tones of green, yellow, red and blue silk are brocaded against the golden background of the border and end-piece.

The tribal textiles of the North-Eastern region are produced exclusively by women, whose daily household chores include weaving *sarongs*, or women's wrap-arounds, shawls, jackets, loin cloths and *gamachas*, or towel fabric, for domestic consumption. Here too, vibrant designs are created during the process of weaving using different coloured yarns.

Broadly, the North-Eastern textiles may be divided into two categories: the textiles of the plains people, weaving on frame or fly shuttle looms such as the Bodo of Assam and the Meitheis of Manipur; and the textiles of the hill tribes in Nagaland, Mizoram, Tripura, Arunachal Pradesh, Manipur and Mikhir hills of Assam, that are woven on the "black-strap" or loin loom.[22] The predominantly geometric motifs representing birds, flowers, cat's paws, mountains, stems, leaves and stars are woven by introducing dyed yarn as weft at intervals dictated by the design. Symmetrical compositions of coloured stripes create a striking effect on shawls and *sarongs*. All over Himachal Pradesh, especially in the Chamba, Kinnaur, Mahasu and Mandi districts, textiles using cotton, wool, pasham, goat hair, merino wool and silk are woven. A variety of items such as shawls, mufflers, *dhurries*, blankets and *sarong*-like garments, such as the woollen twill weave *pattus* and *dohrus*, are woven here in geometric designs using coloured yarn. These include rectangles and squares arranged in different ways like building blocks, stripes, forks, kettles, birds, Buddhist *viharas*, crosses, zigzags, octagonals, the letters "E" and "T" in diverse combinations and the swastika.[23]

There is no doubt that India possessed a carpet-weaving industry long before the advent of any Persian influence. However, the Mughal emperors of Delhi and Agra provided great patronage to the art and raised it to lofty heights. For pile carpets Kashmir, Amritsar and Hoshiarpur in Punjab, Jaipur, Bikaner and Ajmer in Rajasthan, and Agra, Allahabad and Mirzapur in Uttar Pradesh, have

been traditionally renowned.

Using cotton in the warp and silk or wool in the weft, the acclaimed carpet weavers of Kashmir and Kulu, in Himachal Pradesh, produce a fine hand-knotted indigenous variety where the designs and motifs are predominantly Indo-Iranian, Turkish or Central Asian.

Embroidery

Embroidery, or the art of working raised designs in threads of silk, cotton, gold or silver upon the surface of woven cloth with the help of a needle, has been known in India from very early times.

Perhaps, the richest variety in Indian embroideries is found in the Kachchh and Saurashtra region of Gujarat and the Barmer and Jaisalmer regions in Rajasthan. The people here make profuse use of embroidery in their daily life, both in their garments as well as furnishings.

The Islamic pastoral communities such as the Rabaris of the Banni region in Kachchh and the Meghval leather embroiderers produce a wide range of designs in dazzling colours and intricate stitches. In Saurashtra, the once nomadic Kathis are renowned for their wall, door and window friezes, canopies, wall hangings, bullock and horse coverlets and costumes. *Heer bharat*[24] or floss silk embroidery, *ari bharat* or hook embroidery, where the thread is fed from underneath, *sooph bharat*, using counted threads of the warp and weft of the fabric in creating geometric motifs and *moti bharat* or bead embroidery are only a few of the distinct styles characteristic of the embroidery configuration of Sind.[25]

Bengal is renowned for *kantha*, or "patched cloth" embroidery in which the quilted surface is worked in running stitch with threads recycled from old saris. *Kanthas*, like the *sujni* quilts of Bihar, are filled with lively motifs of birds, animals, trees and charming conceptualisations of railway trains, airplanes, episodes from legends or daily life, in a soft rippling effect.

Karnataka is known for a special kind of embroidery called *kasuti* usually done on saris with blouses to match. From geometric motifs to figurative work, such as birds, animals, temples and plants, the embroidery is scattered over the field and concentrated on the *pallav* or end-piece. "It is done in two types of stitches, the *gavanti* line or double running stitch, and *murgi*, the zig-zag done within the darning stitch, akin to *gavanti*. In both, the two sides are neat and identical. *Negi* is the ordinary running stitch. It is used for large designs and the overall effect is of a woven design by extra weft threads."[26]

Punjab is known for its *phulkari* or "garden in bloom" embroidery, done in satin stitch over counted threads, by using floss silk on coarse madder or indigo-dyed home-spun cotton, creating a rich, floral effect.

Noor Jehan, wife of the Mughal emperor Jehangir, is said to have introduced *chikan* embroidery to Lucknow, Uttar Pradesh. Executed in white thread on white muslin, the floral motifs employ satin stitch, buttonhole stitch, darn stitch, knot stitch, netting and appliqué work in a subtle shadowy lace charm.

The coveted "Chamba *rumals*" or kerchiefs, from Chamba in Himachal Pradesh, depict mythological and court scenes using the running stitch in outline and darn stitch in fillings with silk threads on cotton. At their best, the scenes appear exactly the same on either side of the fabric.

Stem, feather and chain stitch are employed by Kashmir craftsmen to create fine motifs of the cone, almond, *chinar* or maple leaf, lotus, paisley and Mughal arches on woollen shawls.

Appliqué is the special technique, wherein pieces of cloth are cut out in varying shapes, designs and colours and sewn onto a background fabric to make a composition. While the best-known examples of the technique are found in Gujarat, Uttar Pradesh and Orissa, the *khatva* technique of Bihar is equally

worthy. Here, a complete piece of fabric is cut out in such a way that it remains intact and the entire piece is, then, attached to a background cloth of another colour. Normally canopies, tents, temples hangings and cradle covers are made in appliqué.

Dyed, Printed, Painted Fabrics

Patterns on woven textiles may also be created by means of block-printing, resist-dyeing, painting and tinsel work.

Before the development of synthetic alizarine in Europe, Indian fabrics were dyed in natural dyes extracted from indigo leaves for blue, al and turmeric roots for yellow, pomegranate skin and lac for red, iron-rust for black and so on. Dyeing was accomplished by the tie-resist method as in *bandhana* and *laheria* where the patterns are made up of innumerable dots and waves respectively.

In Rajasthan and Gujarat, both Hindu and Muslim Khatris are engaged in *bandhej*, or *tie-dyeing*, where the men do the dyeing and the women do the tying. The cloth is first washed and bleached to prepare it for absorbing the dyes. It is then folded over several times and marked with the basic design in red ochre. This is, then, sent to the *bandhani*, the woman who does the tying at short distances, along the lines of the design, deftly lifts a small portion of the fabric, using her tweezer-like nails, and tightly ties a thread around it. The more miniscule the raised fabric, the finer the *bandhana*. The tied textile is then dipped in the light colour first while the tied areas retain the original ground colour. If a second dye is required, the areas to be retained in the first dye are tied for resist and the cloth dipped in a darker dye. This process is repeated, if several colours are to be combined.

Jamnagar and Bhuj in Gujarat, and Jaipur, Jodhpur, Udaipur, Bikaner and Ajmer in Rajasthan, are among the well-known centres producing *odhnis*, saris and turbans in *bandhej*. Woollen shawls are also tie-dyed by the Khatris and worn by Rabari women. *Suhagadi* — yellow dots on chocolate brown — is worn after marriage and before a woman's first-born, while the *satbanteli* — red dots on black — is worn after her first child. The *bagida* pattern and colour combination is traditionally worn only by Harijan women.

Laheria, literally wavy, refers to the wavy pattern of a fabric processed in the tie-dyed technique. The material is rolled diagonally and certain portions "resisted" by lightly binding threads at a short distance from one another before the cloth is dyed. The shorter the distance, the greater the skill required in preventing one colour from spilling into the other. The process of dyeing is repeated until the requisite number of colours is obtained. For a chequered pattern the fabric is opened and diagonally rolled again from the opposite corner, the rest of the process remaining the same. *Laheria* turbans, *odhnis* and saris are common in Rajasthan.

When oil of safflower, castor or linseed is heated over fire for more than 12 hours and cast into cold water it produces a thick residue known as *roghan*. When this adhesive-residue is printed on cloth and subsequently dusted with coloured powder, gold or silver dust, it is known as *khari* or tinsel work. Jaipur, Sanganer and Udaipur in Rajasthan, Mandsor in Madhya Pradesh, Ahmedabad and Baroda in Gujarat, Bombay in Maharashtra and several centres in Tamilnadu and Andhra Pradesh are known for tinsel printing on *dupattas*, saris, turban cloths, banners, tent hangings, saddle and cradle cloths and book covers. The raised or encrusted work in *roghan* carried out by craftsmen of Nirona in Kachchh, Gujarat, is skillfully worked out using a stylus on one quarter of the cloth which, when folded, effectively stamps the design on the remaining parts.

Block printing in India is the chief occupation of the *chhipa*[27] or printer, derived from the Hindi word *chhapna*, "to print" while dyeing of fabrics is the traditional occupation of the *rangrez*,[28] *rang* meaning "colour" and *rez*, "to pour". Indigo dyeing, specifically, is the task of the *neelgar*, *neel* meaning "indigo".[29]

137

The main printing techniques employed are the resist-method, the alizarine method and the modern discharge process.[30] In the resist process, substances that "resist" dyeing, such as wax, gum, clay or resin, are printed or applied by brush on those areas whose colour needs to be retained. The subsequent dyeing imparts colour only on portions around the resist which is, then, washed in cold running water or de-waxed in a hot solution.

In the alizarine (the colour imparting agent traditionally found in the root of madder, *Rubia tinctorum*, technique) the cloth to be printed is first treated with various mordants which, when dipped in the dye containing alizarine, produce their characteristic colours due to the chemical reaction. Only those areas that have been printed with the mordant receive the colours.

In the discharge process, the entire fabric is first dyed in the background colour and the design is over-printed with certain chemicals which, upon reaction, erase only certain portions of the background colour, leaving it to be now treated with other colours.

Using a combination of these techniques, Indian printers, usually concentrated around rivers, wells and tanks, continue their traditional vocation in Ahmedabad, Surat, Broach, Baroda, Deesa, Rajkot, Jamnagar, Bhavnagar, Jetpur, Bhuj, Mundra, Dhamadka and Khavda in Gujarat; Sanganer, Bagru, Jodhpur, Bikaner, Barmer, Balotra, Udaipur, Ajmer, Pipad, Kota and Chittorgarh in Rajasthan; Lucknow, Kanauj, Farrukhabad, Fatehpur, Agra, Allahabad, Kanpur, Mirzapur, Varanasi, Tanda and Mathura in Uttar Pradesh; Gwalior, Ratlam, Mandasor, Indore, Ujjain and Bagh in Madhya Pradesh; Bombay, Dharwar, Nasik, Nagpur and Khandesh area in Maharashtra; Kalahasti, Chirala and Masulipatnam in Andhra Pradesh; Thanjavur, Kodalikaruppur, and Madras in Tamilnadu.

In Dhamadka village in Kachchh, the master-printer, Khatri Mohammad Siddique produces *ajrakh*[31] textiles which are characteristically printed on both sides of the cloth. *Safas* or turbans, *lungis*, shoulder cloths and shawls are printed in *ajrakh*, which is usually worn by men. Some of the basic traditional motifs, which constitute the *ajrakh* designs are *kharek* or date, *char pa ek* or "four will make one", *draksh* or grape and "*champakali* or *champa* bud.[32]

In the traditional Sanganeri prints of Rajasthan, the ground is in white or pastel shades with floral cones and sprays scattered evenly or contained within symmetrical borders. The *chhipas* of Bagru produce a variety of fabrics printed in motifs of the *gulab* or rose, *neem patti* or neem leaf, *gobi* or cauliflower, *mirchi* or chilli, *mukut* or crown, *dhaniya ki bel* or coriander sprig or creeper. Kota was traditionally known for its blue-black saris while Ajmer *butis* or floral motifs were marked by a fine black outline. Jodhpur prints were often marked by dense bands running the length of the fabric in scarlet or brick-red, orange and lemon on moss-green or indigo blue. The bedspreads and quilt covers of Kanauj, Farrukhabad and Lucknow in Uttar Pradesh, have fine paisley motifs printed close together on a white field, while those of Bagh, Madhya Pradesh, are traditionally printed in two colours, alum red and iron black. George Birdie, an English administrator writes about the "chintz" of the Coromondel coast: " In some cases the figures are printed on the cloth with wooden blocks, but all the finer *Palampores* (bedspreads) are prepared by stencilling and hand-painting".[33] In Machilipatnam, Andhra Pradesh, outlines of the designs are first block printed, resist-waxed and vegetable colours are only filled in later with a *kalam* or pen-like object. The tree of life with birds, central radiating medallions surrounded by floral *butas*, scrolling leaves, branches and creepers, stylised peacocks and parrots in a distinctly Persian style are common on the printed *kalamkaris* of Andhra Pradesh.

Kalahasti in Andhra Pradesh is the home of "true" *kalamkari*. Here, the entire work, even the design outlines, are hand-painted using the *kalam*, a bamboo stick padded with hair or cotton and tied with string on one end so as to

regulate the flow of wax and colour from it. These are temple hangings depicting scenes from the epics in a narrative style. The central portion is usually devoted to main deities, or the main theme of the mythical legend, around which various other minor scenes are organised in a series of rectangular divisions. The traditional colours used were iron black, indigo blue and madder red.

In Gujarat, *matano candarvo*[34] or "textiles for goddess worship" follow an old tradition and are made and used even today in Ahmedabad. These hand-painted and block-printed textiles are used as canopies for creating sacred enclosures around the village shrine of the goddess. Bound by ornate borders, the centre of each piece features a figure of the main goddess surrounded by subsidiary gods, goddesses, animals and mythological characters in red and black or black on yellowish white. The blocks for this cloth are made at Pethapur near Gandhinagar, while the finished product is purchased by the humble castes for the invocation ceremony of the goddess.

The pigment-painted temple hangings or *pichhavais* of the Vallabhacharya Sampradaya, a Krishna sect in Rajasthan and Gujarat, are hung behind the image of the deity. "The term *pichhavai* is a Hindi word, literally meaning 'of behind' (*pichha* – back and *vai* – of), which well describes the hanging's function."[35] In Nathdwara, Rajasthan, Sri Nathji is depicted with his *gopis* or cowherdess companions, cows, trees and creepers in deep blues and greens.

1. Chandra, 1973, p.3
2. Information presented here is derived from Rau, 1971
3. Ibid
4. Chandra, 1973, p.7
5. Rau, op.cit
6. Majumdar and Pusalkar, 1953, p.600
7. The remains of an old settlement near the site of the present day village of Dhamadka in Kachchh, are a few centuries old. Deesa in North Gujarat is another such centre. The author, J. Jain, has found blocks that have striking similarities with those at Fostat.
8. Buhler, 1980a, p.110
9. Irwin, 1957, No. II, p.38; No. III, p.65
10. Robinson, 1969, p.110
11. Rangarajan, in Jain, Vol. I, n.d., p.3
12. Chandra, 1973, p.144
13. Al-Talib, n.d., p.5
14. Watt and Brown, 1979, p.292
15. A possible derivation suggested by Prof. H.C. Bhayani of the L.D. Institute of Indology, Ahmedabad.
16. Information on these *rumals* has been taken mainly from Mittal, 1962
17. Krishna and Krishna, 1966
18. Watt and Brown, 1979, p.284
19. Ibid, p.297-8
20. Census, 1961n, p.38-9
21. For detailed information, see Krishna and Krishna, 1966
22. Shirali, 1983
23. Census, 1961l
24. The term "bharat" means "filling-in"
25. Chattopadhyay, 1971
26. Chattopadhyay, 1975, p.56
27. Russell and Hiralal, 1975, Vol.II, p.429-431
28. Ibid, Vol. IV, p.477-479
29. Ibid, Vol. II, p.429-431
30. Marg, Vol. 31,(4) 1978, p.23
31. The word *ajrakh* or *ajarakh* means "blue" in Arabic. *Azur* in German and *azure* in English are similar derivations. Significantly, traditional *ajrakh* printing only used blue and red.
32. See for more details, Varadarajan and Jain, (unpublished)
33. Watt and Brown, 1979, p.261
34. Fischer, Jain and Shah, 1978
35. Talwar and Krishna, 1979, p.11

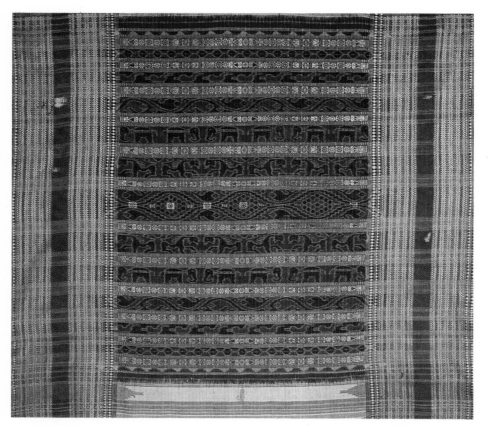

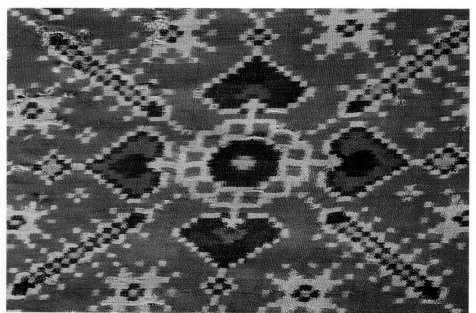

Previous Page
Mashru fabric. Mixed cotton and silk in satin weave and ikat technique; 436 cm x 71 cm. Western India. c. early 20th century. 7/243.

This type of cotton and silk mixed fabric known variously as *mashru*, *gaji* or *atlas*, is traditionally woven in Mandvi, in Kachchh, Patan, Surat and Ahmedabad, in Gujarat, as well as in the Deccan and the South.

This particular design belongs to the class of *khanjari bhat* of Gujarat, comprising fine colourful stripes intercepted by black wavy or dotted lines. This piece can be considered a masterpiece of its kind due to its warp-stripes of delicate *ikat* work in fine shades of brick-red, yellow-ochre and off-white in natural dyes. Each alternate stripe is made up of the chevron pattern in red-and-yellow and red-and-white woven in the satin weave. The zigzag or "lightning" effect of the *ikat* chevrons appears to be inspired by a twilight watery landscape.

In addition to its use for garments for both men and women, *mashru*, particularly of this design, was specially popular as material for book-binding and covers for sacred scriptures.

Above
Butadar aath-phulia, ikat sari. Ikat technique on cotton in natural dyes and tassar silk; 398 cm x 99 cm. Orissa, probably Sambalpur. c. mid 19th century. 88/A/(1).

This exquisite Orissan *ikat* sari is known as *butadar*[1] or one with tiny *butas* or motifs on the main ground or *deh* (literally meaning body).

Aath-phulia refers to the "eight" rows of woven patterns on *tassar* silk on the borders, or *dhadi*, which include the *rudraksha* seed, the *machh* or fish and the *maliphul* or floral motif. The rows of woven patterns are bound on both sides by two rows of spindle-shaped motifs locally known as *baul kadi*, the bud of a flower. All the rows are in turn bound between narrow rows of *danti*, or teeth-like motif. The steeple shaped motif along both borders is the *phoda kumbh* and the rest of the white ground is studded with woven silk motifs of the *rudraksha* and the *maliphul*.

The ornamental end piece or *muhun*, literally "face" of the sari, where the heaviest *ikat* work or *kom* is executed, is characteristically on either ends of the sari. It is sectioned into rows, the main central row having the *padam* or lotus motif. The row next to this on either side has lions facing each other, the one after, elephants, followed by fish, geese, floral motifs and finally a row of steeple-shaped *dauli* or temples.

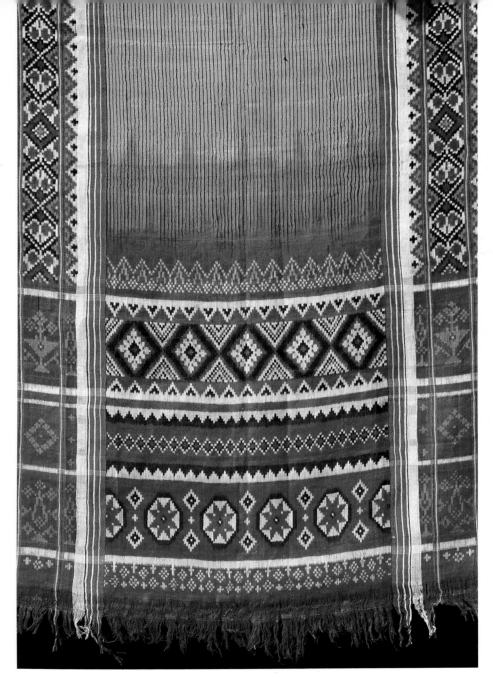

the warp and weft so as to produce a clearly-defined motif. The weavers of Patan, also popularly known as *patolawallas*, of the Salvi community, produce extremely fine patterns featuring human and animal motifs in addition to floral and geometric compositions.

The main field pattern of this particular *patola* has been woven in the *Vohra gaji* motif, comprising four *pipal*-shaped leaves placed at the corners of a diamond. The *Vohra gaji* sari, derived its name from the Vohra Muslims of Gujarat. Considering the large number of samples that are available from Gujarat and the fact that the design has not been among Gujarat's *patola* exports to Indonesia, one can surmise that this design was only regionally popular in Gujarat.

The beauty of the *patola* lies in the kaleidoscopic "flame effect" due to the intermeshing of the tie-dyed designs of the warp onto those of the weft. The most popular colour scheme traditionally employed was black, red, blue and white in natural dyes, although yellows and greens were also used.

Patola, a double ikat sari. Natural dyes on silk; 842 cm x 111 cm. Provenance uncertain. c. mid 19th century. 7/3772.

Due to the unusual length (for Gujarat) of this sari, i.e. about eight and-a-half metres, and the main field composed of a unique yellow-ochre background with fine length-wise stripes in black, it appears that this *patola* was either made in Gujarat for use in the Deccan or the South, where striped saris of this length are commonly used, or was woven in the Deccan itself. In fact, "a *patolu* fabric of this size is called *dakshini patolu*, lit. 'South Indian Patolu' " [1]. At one time Jalna, in Maharashtra, was known as an important centre of *patola* weaving in the Deccan. In Maharashtra, and certain parts of South India, "the sari is worn without any underwear and is generally more than eight yards in length to admit of its folds being carefully arranged to leave a double thickness over the upper parts of the legs" [2]

Since similar specimens are not to be found in large numbers from Gujarat, it could be assured that this type of *patola* sari was meant for use in the Deccan or the South. The only other known piece of this kind is in the Calico Museum of Textiles, Ahmedabad.

[1] Buhler, A. et. al., 1980, p.59

[2] Dar, 1969, p.91

The woven border in *tassar* silk at the *muhun* or end-piece dramatically changes into the herringbone motif that terminates, not abruptly, as in modern saris, but in a diamond at the end of each row.

The areas of red dye receive the woven design in yellowish-gold *tassar*, while the blue-black dye receives the design in silvery white *tassar*, a traditional practice still prevalent among the weavers of Orissa.

[1] In conversation with Harilal Meher, a weaver from Sambalpur, Orissa

Opposite page, below
Patola, a double-ikat sari, detail.
Natural dyes on silk; 468 cm x 115 cm. Patan, North Gujarat. c. mid 19th century. 20/5.

The *patola* sari is one where both the warp and weft yarn are tie dyed before the weaving process. The skill lies in the precise alignment of the designs on

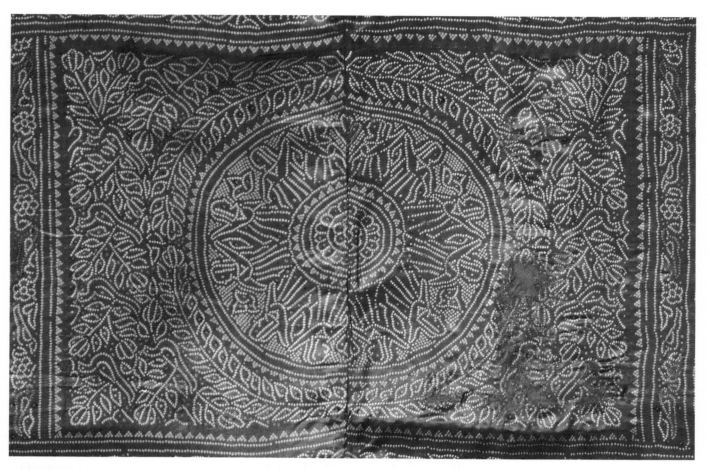

***Odhni,* veil cloth.** Tie-and-dye technique on silk; 184 cm x 168 cm. Gujarat. c. early 20th century. 7/5438.

This crimson coloured satin veil cloth, made up of two equal parts joined together in the centre, has white, yellow and occasional green tie-dyed patterns. The bands on three sides have alternate elephant and floral disc motifs. The main end-piece covering the chest (when worn) has an additional band of large floral-bunches and dancing girls. At this end, gold brocaded bands and stripes cover half the width. In the centre of the *odhni* there is a circular composition of girls performing *rasa,* a circle dance. The rest of the space of the main field is filled with foliage.

The *odhni* is used as a festive garment by the Bhansali women of western Kachchh, Gujarat. Almost an identical piece is in the collection of the Shreyas Folk Museum, Ahmedabad.

***Abho,* women's upper garment.** Tie-and-dye on silk; 113 cm x 79 cm. Kutch, Gujarat. c. early 20th century. 7/259.

Known as *abho* in Kachchh this garment has short sleeves, a round neck and slits on the shoulders. It is made up of two central rectangular pieces with two tapering panels attached on the sides. Except for the lower fringes and the sleeves, where there are black bands dotted with rows of paisley and floral creepers, the rest of the garment

is maroon coloured, with fine yellow and occasional green dots in floral and paisley patterns all over. The yoke is in the shape of a garland with a floral pendant.

The *abho* is generally worn together with a tie-and-dye *odhni* or veil cloth, *ezar* or loose trousers and *missar* or triangular head-cloth by the Memon, Sonara and Khatri women of Kutch.

Opposite page, top
***Shikargah,* or sari with "hunting scenes".** Gold and silk brocade on silk; 635 cm. 109 cm. Varanasi. c. early 19th century. M/5/102.

The superb craftsmanship of this purple or *uda* coloured gold brocade sari lies in the design which has been brocaded, not by a throw shuttle, which would lead to loose threads on the underside of the motif, but by what is known as a *kadhua jangla*. In this brocaded pattern only the outlines of the motif receive the pattern thread on the underside, so that the interstices are not covered with unnecessary loose threads. Moreover, the silk used in the weft is the untwisted variety, rarely found in saris of today, giving the sari its title *pathane ki sari*[1].

The corner or *konia* of the *anchal*, or end-piece, is characterised by the paisley motif bound on two sides by a floral creeper. The border has a row of parrots, with their heads turned back, followed by another row of elephants

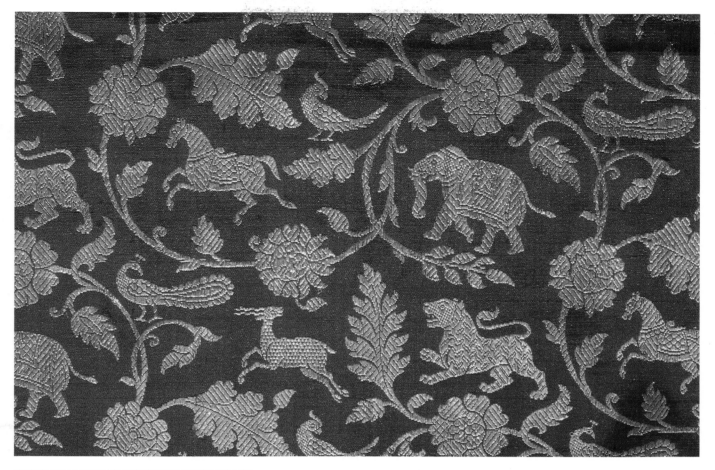

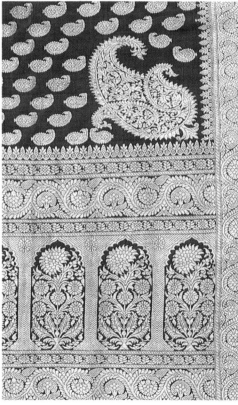

amidst foliage. An additional border, with the chevron pattern, has been sewn separately on to the border.

Unusually, the upper border has been brocaded in yellow silk to make pleating and tucking-in of the sari easier. The main body is embellished with a variety of hunting animals — the tiger, peacock, deer, elephant and parrot — bound within a floral *jangla* or mesh.

[1] In conversation with weaver M. Zafar Ali, from Varanasi

Sari. Gold brocade on silk; 474 cm x 117 cm. Varanasi. c. early 19th century. 4/487(1).

This sari, with its main ground studded with *keri* or mango *butas*, is brocaded in pure gold thread or *zari* on silk. The heavy *anchal*, or end-piece, is embellished with the *mehrabnuma buta*[1] or flowering cones bound within arched columns.

The border is characterised by floral meanders while the corner piece, or *konia*, consists of three *keris* or mango motifs, two small ones artistically composed within a large one.

The weft silk in this sari is also of the untwisted variety which makes the weaving of such a sari even more arduous than normal.

[1] In conversation with weaver M. Zafar Ali, from Varanasi

145

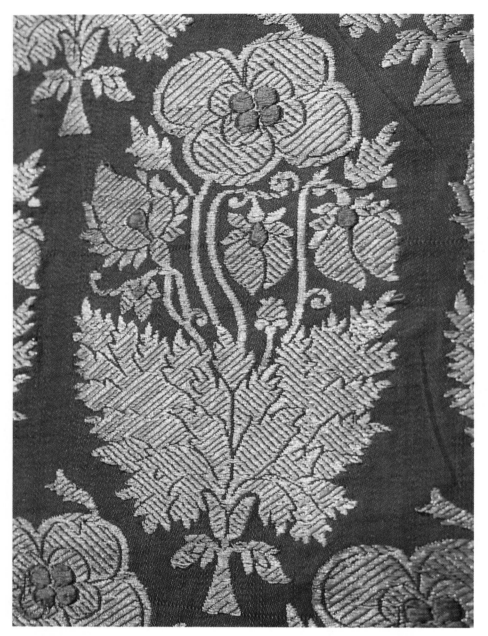

Fabric. Gold and silver brocade on silk; 438 cm x 77 cm. Varanasi. c. late 19th century. 7/3833.

This brocaded fabric for yardage, is executed in the *latifa* pattern or one with horizontal rows of *butas* or floral motifs on a deep pink background. In the upper half of each floral cone, the foliage and stems are in gold while the lower half are in silver. This confluence of silver and gold is known as *ganga-jamuna*, after the two sacred rivers whose waters are known to be pale and dark respectively. The centres of the golden flowers are in light green, in the *meenakari* or enamelling technique, so called because of its resemblance to the colourful enamelling work on gold and silver objects for which Varanasi is famous.

Shoulder-cloth. Gold brocade on silk; 340 cm x 340 cm. Mysore, Karnataka. c. early 19th century. 7/3879.

This extra-large rectangular brocaded shoulder-cloth was part of the ceremonial attire of the ruling family of Mysore. The calligraphy is the patterned repetition of a Kannada inscription "Shri Krishna Bhupati", literally meaning, "Krishna, the Lord of the Earth", a title accorded to the then ruler of Mysore. In the rich and varied range of Indian brocade tradition, this calligraphic piece, with gold patterns in a twill weave on a black silk background, stands out as a unique and highly personalised shoulder mantle.

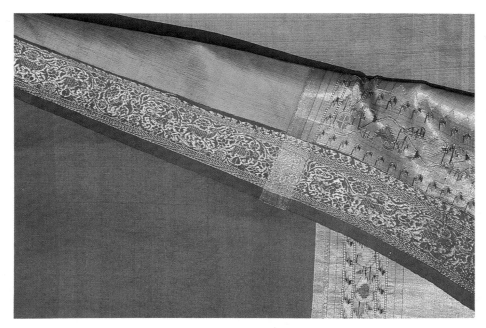

Bifacial sari. Silk brocade on gold cloth and gold brocade on silk in Paithani technique; 836 cm x 127 cm. Maharashtra. c. early 19th century. 5/219.

The village of Paithan, in Maharashtra, has long been famous for a special kind of silk sari where the border and end-piece or *pallu* is woven from gold thread while the motifs of geese, parrots and creepers are woven in dyed silk threads.

The peculiarity of this sari lies in its bifaciality, woven in green and red silk simultaneously. The two colours, one on either side, are created either by using two sets of warp threads, one in green and the other in red, with a single weft, or by using a warp of one colour and a weft of another, so that all the warp surfaces are on one side and all the weft surfaces on the other.

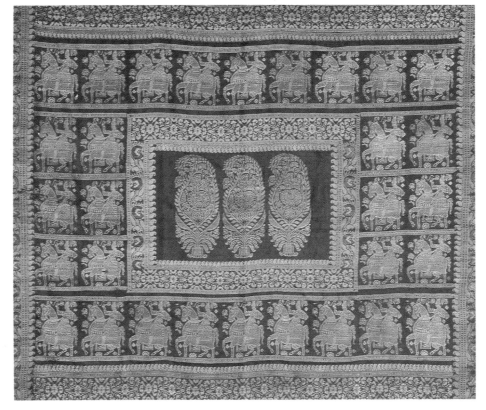

Butidar **Baluchar sari.** Silk brocade on silk in Baluchar technique; 474 cm x 113 cm. West Bengal. c. late 19th century. 7/2422.

This dark purple sari has a typical end-panel with equestrian figures surrounding the central rectangular panel that encloses three floral cones vertically placed in a row. Often, Baluchar saris, named after their town of origin, have figures of *hukka*-smoking men surrounding the rectangular panel of the end-piece.

The main field of the sari has diagonal rows of mango *butis*, or motifs, composed in off-white, green and light purple bands. The border of the sari has a fine lotus creeper in off-white and green.

The sari, brocaded in dyed silk, on a characteristically dark maroon to purple ground, gives the effect of gold and silver brocade on silk. Consequently, the sari had the advantage of being a festive sari for a much cheaper price and it was much lighter than saris with heavy gold or silver wire threads, it could be comfortably worn even in summer.

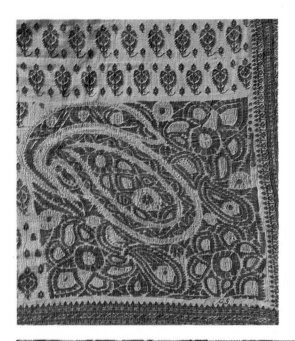

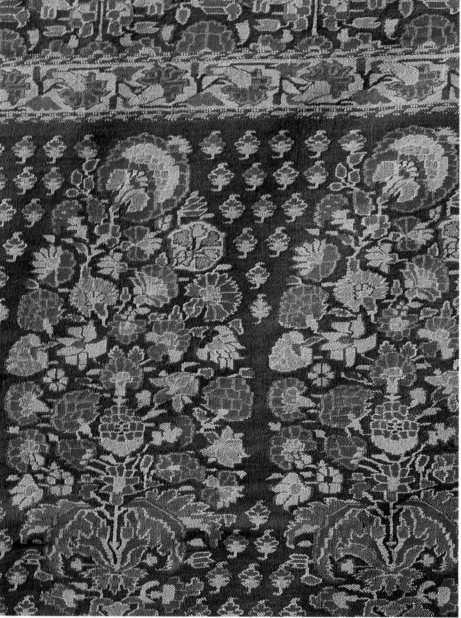

Sari. Cotton and gold brocade on cotton in jamdani technique; 508 cm x 113 cm. Dacca, Bangladesh. c. early 19th century. 7/5029.

The *jamdani* or "figured muslin" traditionally woven in Bengal and especially Dacca, now in Bangladesh, is also woven in Tanda and Avadh or Oudh in Uttar Pradesh. Perhaps the finest of fabrics, the *jamdani* technique refers to the cotton or zari brocading on extremely fine cotton fabric.

In this sari, the *anchal* or end-piece is characterised by a delicately-brocaded paisley motif at the *konia* or corner, while the main field is embellished with *butas* or floral motifs.

Shawl. Loom-woven designs in natural dyes on wool or goat fleece; 318 cm x 141 cm. Kashmir. c. early 19th century. 4/322.

The dense pattern on the indigo blue ground of this unusual shoulder mantle is visibly sectioned by long parallel lines along the length of the fabric, giving the effect of rather stiff geometric flowering stems. The *phala*[1], or end piece on either side, is adorned with floral cones or *butas* with elaborate leafy bases and a single tilted flower on the apex. The ground in between the cones or *jhal* is embellished with tiny floral sprigs in the shape of triangles. The *tanjir*, or narrow border around the cones, is that of a floral meander with bell-shaped flowers as is the lateral border or *hashiya*, around the sides of the shawl, the latter being woven on a white ground.

[1] Irwin, 1955, p.49-50

Opposite page
Shawl. Loom woven design in natural dyes on wool or goat fleece; 270 cm x 140 cm. Kashmir. c. late 18th century. 7/1285.

The *kani* shawl, a particular loom-woven shawl, as opposed to the later *amli* or embroidered variety, was once the mainstay of the economic industry in Kashmir and the village of Kanihama[1] from where the shawl probably derives its name.

The *hashiya*[2], or narrow-patterned border along the sides of this yellow ochre shawl is executed in a floral creeper on a white ground. The broad end-pieces or *phala* are embellished with flowering cones shaping out into an *ambi* or mango motif. These in turn are bound between two horizontal narrow borders, or *tanjir*, in single flower motifs within separate hexagonal white grounds.

[1] Ames, 1986, p.63
[2] Irwin, 1955, p.49-50

148

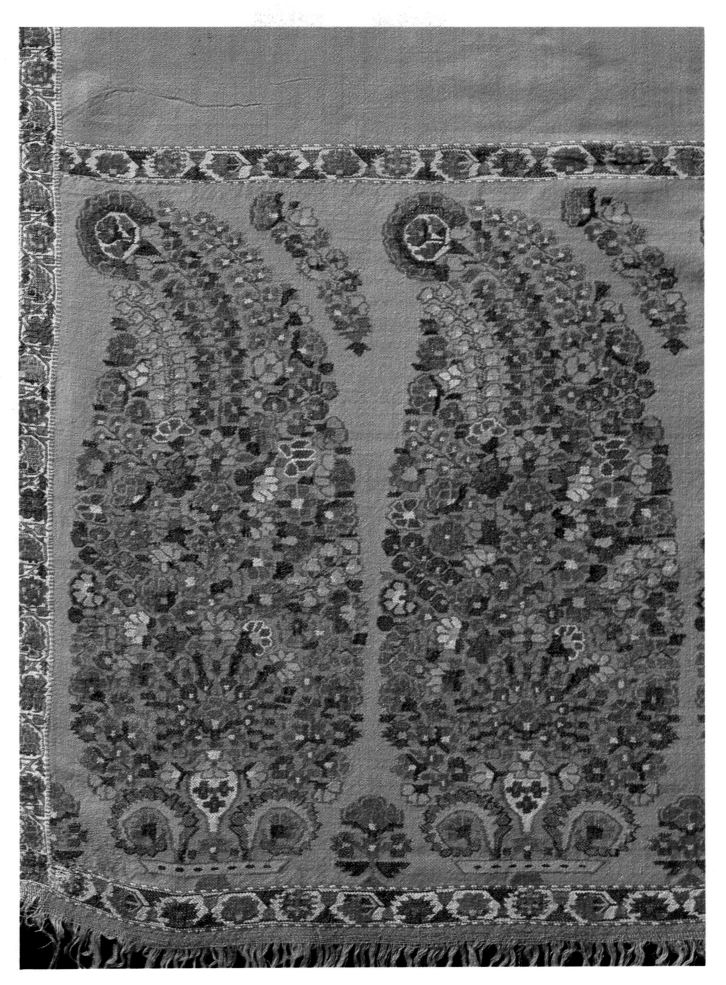

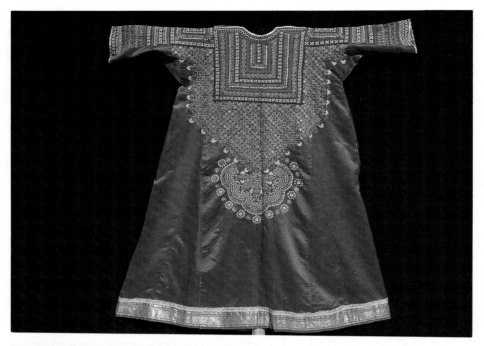

Abho, woman's upper garment. Silk embroidery with miniscule mirror discs on silk; 113 cm x 110 cm. Kachchh, Gujarat. c. mid 19th century. 85/6867.

This *abho* from Kachchh, Gujarat, is made from burgundy coloured satin and is embroidered with silk threads and minute mirror pieces in chain stitch, running stitch, button-hole stitch and interlaced stitch. The dress, with short sleeves and a high round neck, consists of two long central rectangular pieces to which two tapering side panels are attached. The embroidery on the yoke, shoulders and sleeves, comprises parallel ornate bands, while the front is embroidered with floral patterns which end in a large pendant resembling a massive garland of flowers. "The mirror pieces, which are very small, are carefully shaped as discs, petal and leaf forms integrated into all parts of the pattern in a soft shimmering effect with exquisite detail." [1]

This type of *abho* is worn together with an embroidered *ezar*, or trousers, and an *odhni*, or veil cloth by the women of the Memon community.

[1] Irwin and Hall, 1973, p.81

Phulkari, embroidered veil cloth. Floss silk embroidery on coarse cotton cloth; 288 cm x 122 cm. Punjab. c. early 20th century. M/7/4952.

Phulkaris, literally "floral work", are women's shoulder cloths or veil cloths variously known as *chadar*, *odhni* or *odhna*. The *phulkaris* differ from *bagh*, literally "garden" embroidery, in that in the latter embroidery covers the entire cloth surface,[1] inch by inch, in geometric patterns of light and shade. These embroidered textiles were given as gifts to the bride by her relatives on the occasion of her marriage.

The floss silk embroidery, mainly employing darning stitch, satin stitch, stem stitch, back stitch and running stitch was done on home-spun and hand-woven coarse cotton fabric, usually dyed red, maroon and, occasionally, black. Coarse cloth was most suitable because the most important *phulkari* stitch, namely the darning stitch, is done over a counted number of threads of the fabric.

This particular piece is unusual because the background fabric is black and the embroidery is highly individualistic. The embroidered areas in bright pink, turmeric yellow and white are divided into four lengthwise panels by three embroidered bands. Three panels are filled with two-headed arrow-like geometric motifs whereas the fourth panel has activities of everyday life including a *hukka*-smoker, men and women carrying various articles and peacocks, etc. The rendering of the figures has an innocent child-like quality.

[1] Hitkari, 1980, p.14

Opposite page
Fragment of a temple hanging of the Vaishnava sect. Fine chain stitch silk embroidery on silk; 214 cm x 145 cm. Kachchh, Gujarat, c. early 20th century. 7/1545.

This intricately embroidered fragment is a part of a larger temple hanging of one of the Vaishnava sects, depicting Lord Krishna or Shrinathji as the main deity. The present piece shows only one segment where his female devotees are depicted worshipping their Lord amidst flora and fauna. This type of embroidery was the work of professional male embroiderers belonging to the *mochi* caste or leather workers who as a result then worked in chain stitch, both on leather and on cloth, and their work was therefore also known as *mochi* embroidery.

One remarkable aspect of the technique is that by merely altering the direction of lines in chain stitch an effect of shading has been achieved. This feature, combined with the general rendering of the theme, makes it evident that these embroidered pieces were based on painted Rajasthani and Gujarati prototypes.

In Kachchh these pieces were patronised by the staunch Vaishnava community of Bhatias whose women also wore skirts, blouses and *odhnis* or veil cloths, embroidered in a similar manner.

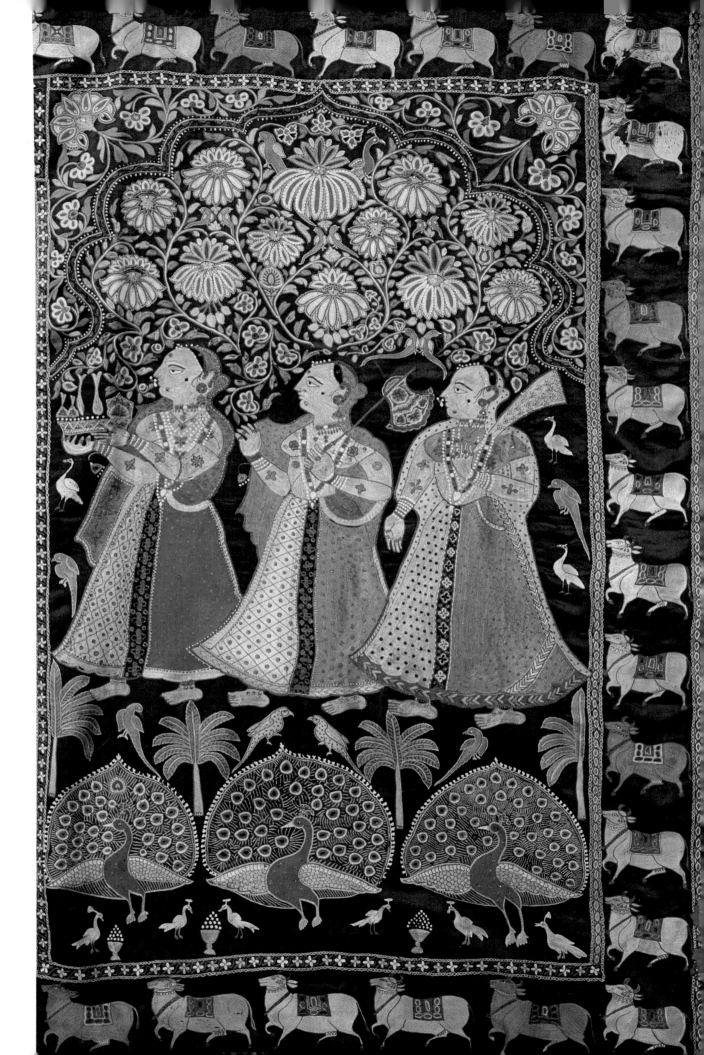

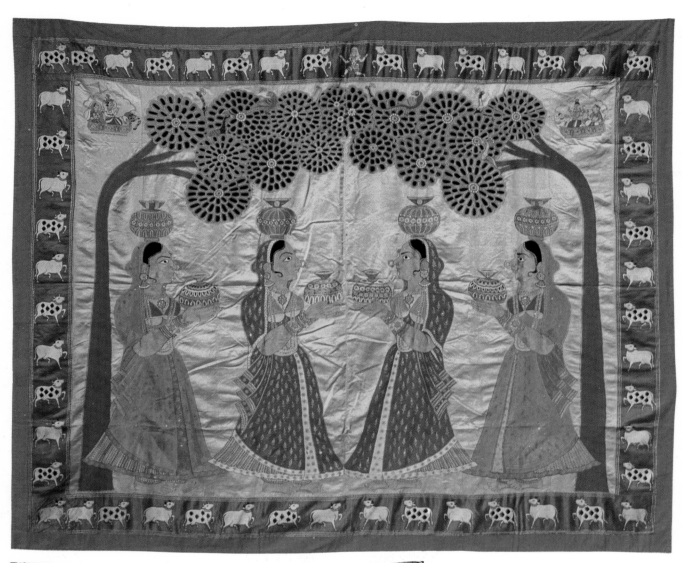

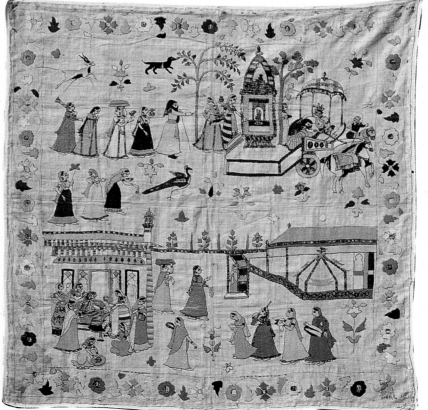

Top
Pichhvai, temple hanging of the Vaishnava sect. Fine chain stitch silk embroidery on silk; 233 cm x 195 cm. Kutch, Gujarat. c. mid-19th century. 81/6318.

In this particular Vaishnava panel, Krishna's beloved cowherdess companions are shown carrying pots of milk, yoghurt and butter and halting for a chat while passing through the forest. From other renderings of the scenes of *daanlila* or Krishna with his comrades demanding a toll of butter, it may be assumed here that the maids are almost fondly anticipating that their beloved Krishna will come and "plunder" them as a gesture of love.

The framing of the composition by a natural arch of trees, rows of cows on all four sides and *vimanas* or celestial vehicles of gods in the top corners are other remarkable details of the *pichhvai*[1]

[1] For details see Cat. No. VI/18

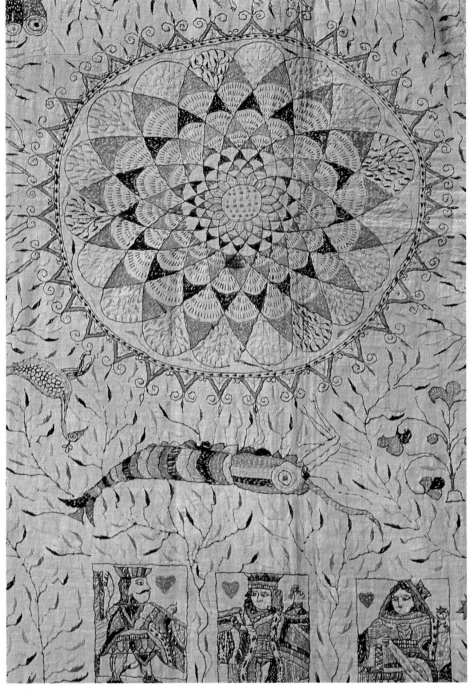

Vishnu's consort Lakshmi and Parashurama's consort Bhudevi. Rukmini, who had fallen in love with Krishna, was engaged to Shishupala by her brother Rukmi. As the sacrament of her marriage with Shishupala was about to be completed, Krishna carried away Rukmini and eventually married her.

Kantha, or "patched cloth" embroidery. Cotton threads on cotton; 168 cm x 110 cm. West Bengal. c. late 19th century. 81/6331.

Bengal is renowned for its *kantha* embroidery on patched cloth, in which the quilted surface is executed in running stitch with threads recycled from old saris.

This particular *kantha* is unique for its imagery and workmanship. Like any conventional *kantha* it has floral borders, paisley motifs in the four corners and a central lotus medallion. But the images in the main field depict a highly individualistic and sensitive world view. We have here all the symbols of 19th century Calcutta: a currency note, European-type playing cards, *sahibs* and *memsahibs*, chandeliers, medallions of Queen Victoria, memorial busts of Marwari *seths* or wealthy men, the facade of the Universal Medical Hall, side by side with scenes from Hindu mythology in which Shiva looks like a Madonna in a Christian painting, and Rama and Lakshmana appear as European boys.

The spaces between the characters and images are filled with delicately-embroidered creepers occasionally intercepted by a butterfly or a dragonfly.

The outline of all the figures is embroidered with a very fine single black thread, whose movement is so well controlled that the "drawing" appears as if done in ink.

Veil cloth. Cotton embroidery on cotton cloth in chikan technique; 278 cm x 112 cm. Lucknow, Uttar Pradesh. c. early 20th century. 7/5211.

This sheer veil cloth has alternating rows of two embroidered designs in light yellow and white, one with a heart-shaped motif, the other with a floral sprig. Each motif is surrounded by intricate scrolling plants and creepers with minute berries, flowers and foliage. The *jali* or netting is created by counting and pushing aside threads of the ground muslin.

This piece, featuring delicately embroidered motifs in white cotton threads on a white cotton ground with only a tinge of light yellow, testifies to the subtle taste of the patron and fine execution by the craftswoman.

Opposite page
Kerchief depicting scenes from god Krishna's life. Silk embroidery on cotton; 69 cm x 68 cm. Chamba, Himachal Pradesh. c. early 20th century. 7/4908.

Chamba, one of the former North-Western hill states, was renowned for its floss silk embroidery in fine darning stitch, evenly worked on both sides of unbleached cotton cloth. Incidents from history or mythology were narrated in the pictorial clarity of miniature paintings on square or rectangular pieces known as *rumals*.

This particular *rumal* depicts the theme of Rukmini's abduction by Krishna. Rukmini, Krishna's chief consort was in other incarnations Rama's consort Sita,

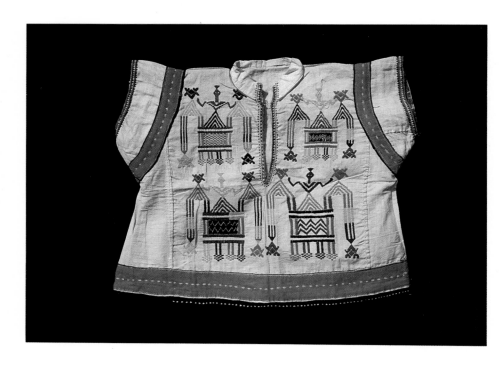

Blouse. Embroidery on cotton; 43 cm x 45 cm. Bihar c. ealy 20th century. M/7/2388.

Kashida, literally meaning "embroidery", is one of the most popular crafts practised by the women of rural Bihar.

A sleeveless blouse of this type, mainly using white cotton cloth with bands, borders and piping of red or black cloth and cotton thread embroidery in darning stitch, is typical of Bihar. The geometric stylisation of figures is achieved with the darning stitch which is done over counted threads of the ground material.

Man's robe. Zari embroidery on wool; 168 cm x 141 cm. Kashmir. c. early 20th century. 7/4235.

This majestic robe of fine green woollen cloth has a lining of red raw silk. It is embroidered all over with *kalabattun* or gold thread by a *hath-ari* or hand-operated awl. With this technique of embroidery it is possible to obtain a range of chain-stitches, employed sparsely or densely, depending upon the required design. The front and the back yoke, the

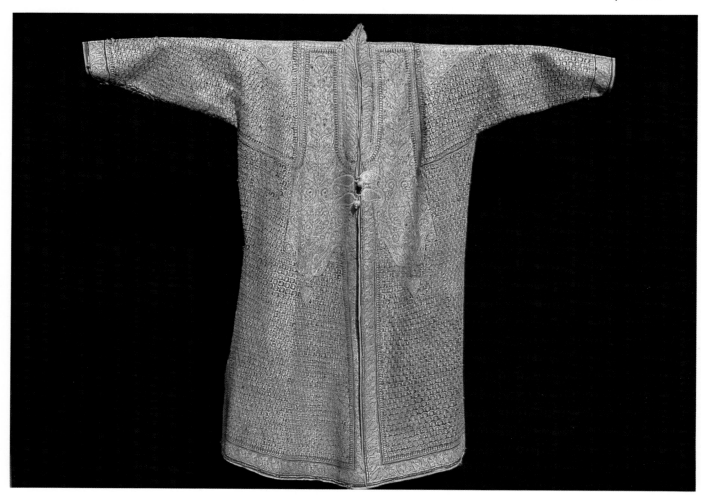

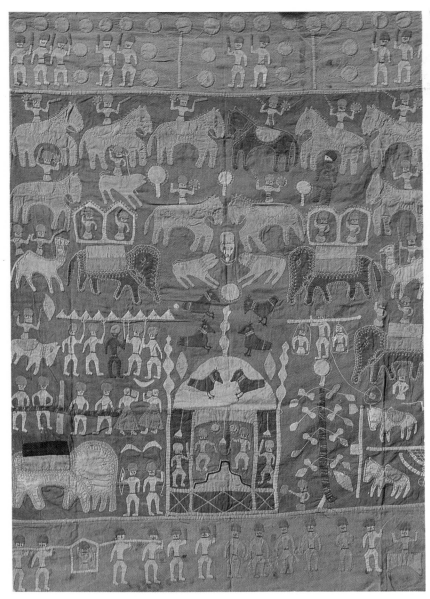

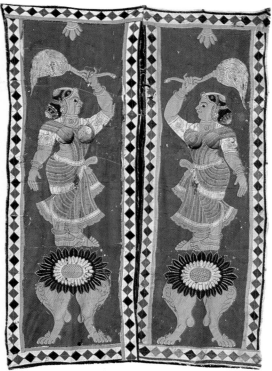

shoulder, the cuff, the border and the edges of the front opening, are densely embroidered with flowering scrolls and paisley motifs, whereas the rest of the robe is covered with a repetitive pattern of lobes, each enclosing a tiny flower. The buttons are in the form of two horizontally placed paisleys on either side which ingeniously break the continuity of the embroidered design.

Canopy. Cotton appliqué work on cotton; 142 cm x 141 cm. Bahraich, Uttar Pradesh. Contemporary. 84/6809.

This square canopy appears to be a later reproduction of similar ones offered annually at the shrine of the warrior-saint Saiyid Salar Masud, nephew of Mahmud of Ghazni at Bahraich, Uttar Pradesh.[1]

In addition to the representation of the tomb of Saiyid Salar Masud at the bottom-centre and several figures of horses, camels, elephants, tigers, birds, human beings and trees in the central field and the surrounding borders, there are also representations of scenes from Hindu mythology: Krishna and cowherds lifting Mount Govardhana, gods and demons churning the ocean, Shravana carrying his blind parents on his shoulders on a pilgrimage.

Popular *dargahs* or shrines of this type have always had devotees from all sects and therefore it is not surprising that Hindu themes are depicted on a canopy for a Muslim shrine.

[1] Kramrisch, 1968, p.100

Temple hangings. Stuffed cotton appliqué. 218 cm x 75 cm; 210 cm x 72 cm. Karnataka. c. early 20th century. 84/6802 and 84/6803.

These two vertical patchwork panels of female fly-whisk bearers were meant to be hung on either side of the image of a deity. Each figure, a mirror-image of the other, stands on a lotus in a dancing pose, holding a fly-whisk in her right hand, while the lotus rests on the legs of a lion. The figures are given some degree of three-dimensionality by stuffing cotton, or scraps of old cloth, beneath the appliqué work.

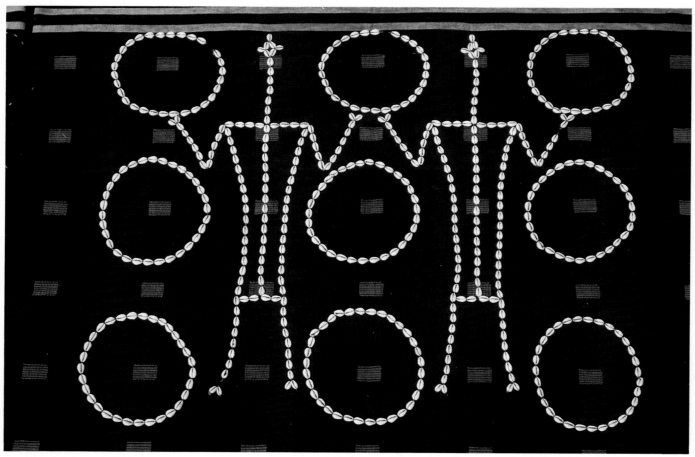

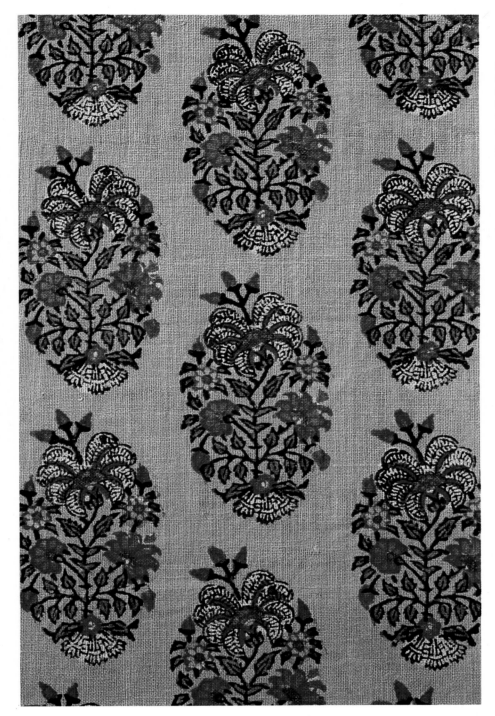

system, (*tran moti-na thansiya*), worked row-by-row, three beads being taken up at each stitch, ... The motifs are automatically conventionalised upon this geometric basis..."

Typically, in Saurashtra homes, for each structural element of architecture such as the door, window, ceiling, floor and walls, an "embroidered or appliquéd decorative piece was created. This sort of "parallel architecture" in soft, colourful material is reminiscent of the mobile tent housing of bygone days.

[1] Irwin and Hall, 1973, p.125

Opposite page, bottom
Shawl for Naga chieftain. Cowrie shell embroidery on dyed cotton; 167 cm x 113 cm. North-Eastern India. c. early 20th century. 85/6861.

This Naga shawl, adorned with circular moons of cowrie shells, is worn by privileged members of the chieftain's family as a symbol of heroic valour and economic and social status. The human figures depicted are probably symbolic of enemies slain by the wearer or members of his family.

Yardage. Block-printing on cotton in vegetable dyes. 302 cm x 84 cm. Rajasthan. c. 19th century. 19/85.

This type of block-printed and mordant and resist-dyed fine cotton yardage was used as material for women's garments and hand printed by the community of Chhipas traditionally engaged in the task.

Its pattern comprises a diaper of floral *butis*, each a graceful flowering plant with separated leaves and flowers of different colours and species — a tradition commonly seen in Mughal designs.

Opposite page, top
Toran, frieze for a door-frame. Bead embroidery; 116 cm x 71 cm. Gujarat. c. early 20th century. M/7/4473.

Torans or door-frame hangings are most commonly used in Gujarat and Rajasthan where the entrance arch to the temple is also known as a *toran* in architectural terminology.

This particular *toran* has a horizontal panel of embroidered Venetian beads depicting the goddess Lakshmi in the centre flanked on either side by animals, chariots and figures of riders. At the lower fringe of the panel there are nine pointed pendants of gold and silver brocaded cloth.

"The method of work is a tri-bead

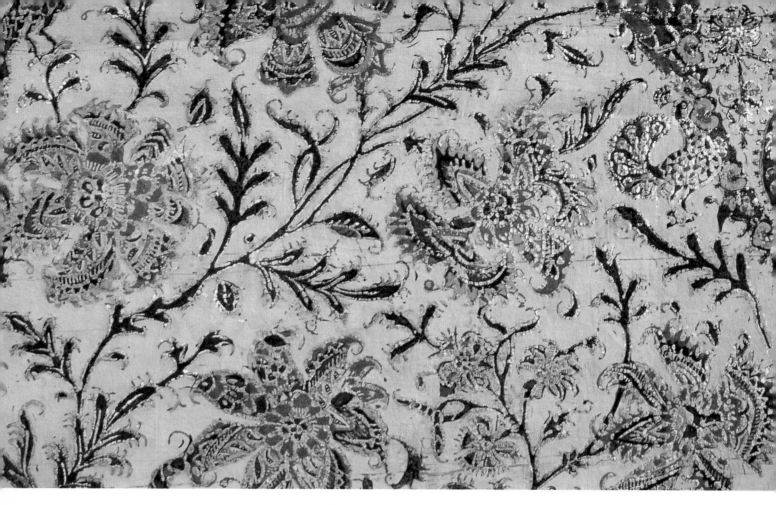

Coverlet. Printed and painted cotton; 193 cm x 187 cm. Masulipatnam, Andhra Pradesh. c. mid-19th century. 9/41.

This exceptionally fine piece of cotton textile is printed and painted with natural dyes in shades of red, blue, green and yellow. Black and red are used to outline the motifs while the entire piece is overprinted with gold.

The design is structured with a square field and broad end-panels. In the centre of the field is a medallion composed of paisley motifs, a quarter of which is repeated in each corner.

The rest of the off-white field is covered with scrolling creepers of flowers and foliage interspersed with peacocks. The border around the field has a flowering blue, yellow and off-white creeper against a deep red background. Each of the two end-panels is made up of six large ornate mango *butas* against a white background. The spaces between the *butas* is hand-painted with fragmented wave patterns in red.

The entire piece, overprinted with gold, has the effect of an early morning landscape covered with dew or that of sudden sunshine after a drizzle.

In the 18th and 19th centuries, these types of pieces were manufactured at various centres for export to Iran.

Opposite page, top
Odhni, veil cloth. Tie-and-dye technique on silk; 184 cm x 168 cm. Gujarat. c. early 20th century. 7/5438.

This transparent reddish brown veil cloth has two identical end-panels with a row of ornate floral cones in the form of mango or paisley motifs within a dense tinsel printed ground. All along the edges there are borders of meandering creepers. The centre of the main field has a large circular medallion, a quarter of which is repeated in each corner. At the four cardinal points there are four smaller medallions while the four diagonal points have four larger medallions.

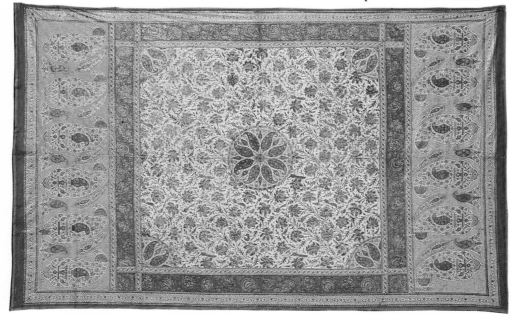

158

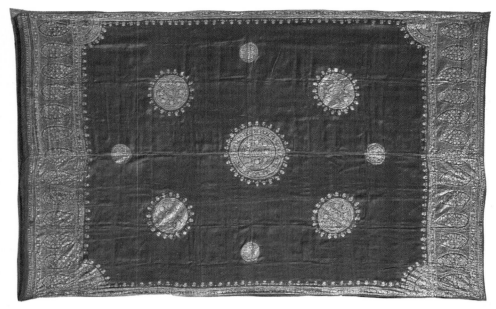

Due to the transparent quality of the fabric the shimmering gold patterns inlaid with green pigment give the illusion of free floating gold ornaments on the body of the wearer.

***Matano Chandarvo,* temple hanging for goddess worship.** Block printed and hand-painted with iron rust dye on

printed only in black, is a deviation from the standard practice of using red and black. The central rectangle depicts the local goddess Vishath with 20 arms and wielding weapons. The goddess, who receives a buffalo as her sacrifice, is shown standing on two buffalo demons whose heads have been chopped off and from where anthropomorphic heads of the demons are seen emerging.

In the spaces on the left and the right of this central rectangle there are innumerable figures of men and women, gods and goddesses, characters from myth and legend, scenes of rituals and sacrifices which include (on the left) Ganesha, Shravana of the *Ramayana* carrying his blind parents on his shoulders, the local legend of Chelaiyya where parents offer a meal cooked from their child's flesh to please god who was testing their truthfulness, Krishna quelling the snake Kaliya, the story of King Navghan who had wanted to marry one of the seven sisters (goddesses) who finally jumped into a pool of water to evade him and (on the right) goddesses such as

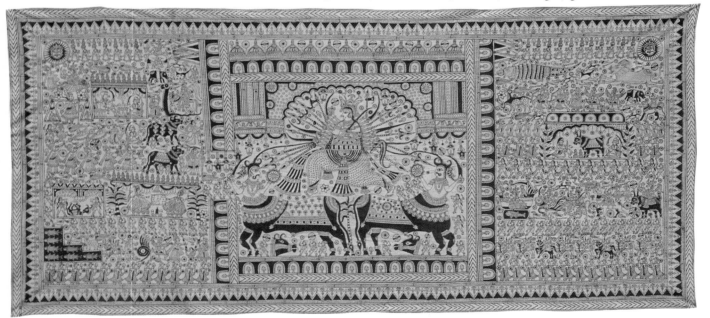

cotton; 383 cm x 181 cm. Work of Vadilal Lakshmanji Solanki, Ahmedabad, Gujarat. Contemporary. 88/A/(2).

At the time of the annual ritual of a sacrificial offering to the various local goddesses, members of the Vaghri, Ravalia, Bhangi and Dhedh communities construct an enclosure of such hangings and install it around the village shrine of the goddess. Inside this enclosure, the ritual of invocation and the goat or buffalo sacrifice is conducted.

The present piece, which is painted and

Khodiar on her crocodile, Meladi on her goat, Mommai on her camel, Hadkai on her dog, Bahuchara on her cock and a row of *bhopa* (shamans) drinking the blood of sacrificial victims.

Kalamkari, dye-painted textile depicting scenes from god Krishna's life. Natural dyes on cotton; 284 cm x 259 cm. Andhra Pradesh. c. 18th century. 7/4466.

Masulipatnam and Kalahasti, in Andhra Pradesh, are the main centres of the famous *kalamkari* or printed and painted cotton temple hangings. This piece is remarkable not only for its early date, but also for its charming outlines and subtle colours depicting the regional interpretation and rendering of the Krishna legend.

The basic iconography of this temple hanging, according to the inscriptions on the piece, is explained below. The numbers correspond to those shown in the diagram:

1: Vishnu reclining on the serpent Shesha,
2: The *kalpa* tree,
3: Kamadhenu, the wish fulfilling cow,
4: Brahma,
5: Indra,
6: Agni,
7: Yama,
8: Nairriti,
9: Varuna,
10: Vayu,
11: Kubera,
12: Isana,
13: Mounts of eight directional deities,
14: Krishna in the form of Navagunjara,
15: Arjuna worshipping Krishna,
16: Krishna with Radha,
17: Krishna with Radha and Rukmini engaged in music,
18: Krishna with cowherdesses,
19: Cowherdesses complaining to Yashoda about Krishna's mischievous acts,
20: Erotic play of Krishna,
21: Cows attracted to Krishna's flute,
22: Krishna bathing a cowherdess,
25: Krishna stealing butter,
26 and 27: Erotic play of Krishna,
28: Krishna with beloved attended by a maid holding a mirror,
29: Krishna with wives Rukmini and Satyabhama,
30 to 39: Incarnations of Vishnu, Kalki, Buddha, Balarama, Rama, Parashurama, Vamana, Narasimha, Varaha, Kurma, Matsya,
40: Isana,
41: Kubera,
42: Vayu,
43: Varuna,
44: Nairriti,
45: Yama,
46: Agni,
47: Indra,
48: Brahma,
49: Vishnu reclining on serpent Shesha with consorts Shridevi and Bhudevi,
50: Coronation of Krishna,
51: Krishna lifting the Mount Govardhana,
52: Krishna on *kadamba* tree with clothes of bathing cowherdesses,
53: Krishna quelling the serpent Kaliya,
54: Krishna emancipating the Gandharvas, Nalakobara and Manigriva, from the curse of sage Narada,
55: Offering of food and lamps to Krishna,
56: Veneration of Gajjalaswami, deity.

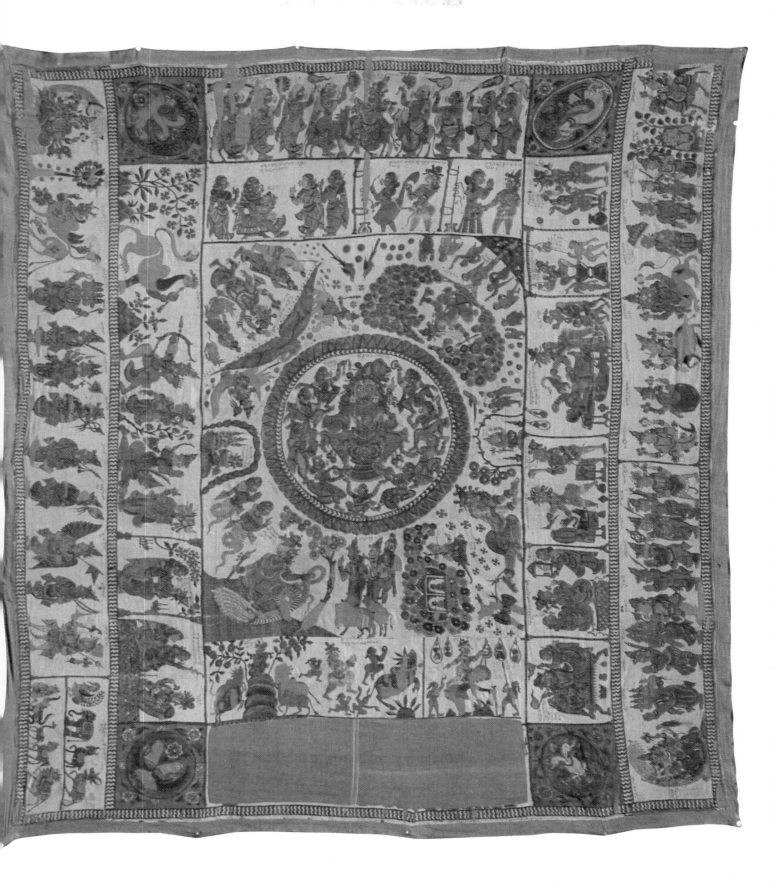

Textural Webs:
Basketry and
Matting

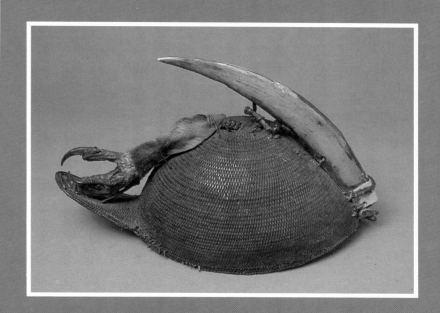

In ancient India, the crafts of both the weaver and the basket maker were considered low. "In the *Bhimasena Jataka*, the *Brahmana* archer calls the work of a weaver (*tantuvaya*) a miserable low work (*lamakakamma*). In the *Suttavibhanga* also the professions of the basket-maker, ... the weaver,... are mentioned as low."[1] The low social status of the bamboo worker is further testified in the Puranas where, as a punishment for his sins, King Vena, (*venu* in Sanskrit means bamboo) was the first low-born *nishada* and from whom the bamboo workers[2] descended.

Cane and bamboo workers of North India belong to the occupational group of the Basors or Bansphors, literally "breakers of bamboo".[3] In tribal central India the traditional basket makers cum-cultivators are known as Turi or Kisan-Turi. In fact, they are considered a sub-caste of the Birhors who slice bamboo into *sikas*[4] and worship their deity Dasha in the form of a split bamboo.[5] Other groups such as the Doms, Baigas, Dhirkars and Nayaks have also taken up the profession.

The high tensile strength of many fibres, grasses, palms, canes or rattans and bamboo splits lends these materials an elasticity that can be utilised in "weaving" baskets, mats and a host of other objects. The weave may be a tight or "closed-weave", one where the construction is relatively impervious, or an "open-weave" which is perforated to varying degrees. The weave involves the interlocking of two elements, usually the warp and the weft, in the ordinary chequerboard or grid pattern, or like a braid as in the plaited weave. Besides weaving, basketry is also made by the twilling or twining process i.e. "by weaving pliant strands about a framework of twigs or other rigid materials...."[6] Coiled or "sewn" basketry involves a thick and somewhat stiff material or a bunch of loose twigs or grasses for the basic coil and a soft flexible split or grass for "sewing" it together.

In the tribal areas of Raigarh, Sarguja, Mandla, Bastar, Bilaspur, Bundelkhund and Malwa in Madhya Pradesh, basket work is done using bamboo splits in a variety of ways.[7] Hunting accessories such as the cylindrical trap or *choria* for catching fish in flowing water, the *kumni*, used in stagnant waters, bows and arrows, and the *gophan* for shooting stones are usually made by the user himself. Articles of ritual and secular use are somewhat more elaborate and are, therefore, purchased. The *jhanpi*, a round dowry casket, with a lid that comes halfway down the lower body, is used among the Gonds, Nagesias and Kanwars as an integral part of a girl's wedding. The *dheli*, made from broad strips of bamboo, is used for storing grain, while the double-layered *dalia*, which has a tightly-matted inner layer is used for wheat flour. The *beejboni* is carried to the fields for sowing seeds, while the *phuldalia* is used for collecting the sweet-scented *mahua* flowers. Winnowing trays, frames for carrying heavy loads, muzzles for oxen, bird cages, measuring bowls and pipes for smoking tobacco are only a few of the objects made in bamboo.

In the North-Eastern states of Assam, Arunachal, Nagaland, Manipur, Meghalaya, Mizoram and Tripura, cane and bamboo are integral to sustenance. Abundantly available in the rain forests of the Himalayan foot-hills, whole bamboo and cane, sometimes reaching a height of 30 to 40 metres with a diameter of 20 to 25 centimetres, are used to construct large infrastructures of houses, bridges, gates and fences. Bamboo stems or culms with smaller diameters, along with cane, are used in whole or split form for a variety of baskets, furniture, winnowing trays, hand fans, head gear, fish traps, umbrellas and floor mats. The hollow internodes of bamboo make ideal beer-mugs, *hukkas*, pipes and musical instruments.

Previous Page
Ceremonial hat. Split bamboo or cane, horn, bird's claw and feather, 27 cm x 17 cm. Arunachal Pradesh. c. early 20th century. 86/7006.

The Apa Tani, Nishi and Mishimi tribes of Arunachal Pradesh wear a cap which snugly fits the skull. Characteristically, the head gear is woven in the technique of coiled basketry with a flap-like protrusion at the back on the base of the neck. The claw of an owl, feathers of a hawk and a bison horn painted red are embellishments proudly worn by a warrior symbolising his prowess in hunting.

Carrying baskets of the hill tribes are uniquely shaped and are easily strapped onto one's back by means of a bamboo strip worn like a band across the carrier's forehead. The Mizo basket called *paikawag*, is used by women for carrying firewood and cotton. The Adi Gallong basket or *agin* is used by men to carry rice to be sold in the market-place in Arunachal, while the Angami double-walled basket or *kophi* is given to a daughter as dowry at her wedding. All these baskets are constructed by inserting a continuous weft strip into warp strips arising from a square or circular base opening out gradually into a widening mouth. The *murdah* or low stool from Tripura is made from bamboo and cane splits. The basic structure is made by bending the bamboo into the required shape, while split cane is used to bind the structure as well as to weave the seat.[8]

The *modus operandi* in the production of cane and bamboo articles involves the cutting of whole stems with a hack-saw and slicing them into splits of various sizes using a bill-hook or *dao*. Slicing is done longitudinally along the length of the densely-packed fibres and is, therefore, a fairly smooth operation, requiring only the requisite amount of moisture in the culm. A kerosene lamp is used to heat the cane before it can be bent into shape. The weaving process is done purely by hand, occasionally using water to soften the splits.

The *patikars* (literally "makers of mats") of Midnapur in West Bengal and the Lachan and Dhubri districts of Assam make an extremely fine floor mat known as *sheetal-pati, sheetal* meaning cool and pleasant. A marshy reed locally known as *mutra* in Bengali, (*Clinogyne dichotoma*) is the chief raw material. The reed lacks knotty nodes and, therefore, one can obtain smooth long splits without aberrations from it. These splits are boiled in water for three to four hours during which they change colour to different shades of beige and brown. They are then stiffened with starch obtained from rice water and may also be dyed during this stage. Dried and smoothened, the splits are then woven in a "closed-weave" and designs are often introduced into the weave using dyed slips.

Manipur is known for its reed mat or *phak* made from the dyed yellow straw-like stem of a reed called *kauna*.[9] Women weave these mats which have a characteristic border of three to four centimetres all around.

Pattamadai, in the Tirunelveli district of Tamilnadu, is famed for its *kora* grass mats made by the Lubbai Muslim families.[10] Lengthy processes of drying, soaking, splitting and dyeing the grass are performed before they are set up on the loom which consists of the warp supported by the *mukali*, a bamboo tripod. The weft of *kora* strands is inserted in the needle-like *kuchaali* and made to pass over and under the warp of starched cotton threads according to the design, very similar to the process of weaving fabric. Water is a necessary softening agent throughout the operation. For performing their prayers, Muslims use a *kora* mat with a triangular pattern. In Kerala, the *kora* grass mat or *pantipaya* is made in Palghat district where the grass is abundant in the marshy regions and hill slopes near Chittur. Here "ordinary floor looms of the throw-shuttle variety are used. The grass forms the weft and either cotton, or a fibre made from aloe forms the warp."[11] While chemical dyes in bright colours are used today, the traditional colours from vegetable dyes were maroon and black.

The sword-shaped thorny leaves of the succulent shrub called screwpine (*Pandanus fascicularis*) are used by the enterprising women of Kerala and Tamilnadu to weave matting, usually in the twill pattern, i.e., when a single weft passes over two warp elements, for all purposes. Legend has it that screwpine was favourite among sailors who used them as sails for their ships. "In fact, there is a place near Quilon called Kadalpai (sail mat) which indicates that this was once a centre for producing the sail mats...."[12] Often two mats are sewn together to form a more cushiony one known as *mettappaya*.[13] More recently, the fibre has been used to weave table mats, handbags, boxes and even slippers, which are brightly ornamented in the floral designs of "convent embroidery".

The palm-leaf products of Manapad, Nagore and Ramanathapuram in Tamilnadu are renowned. In Manapad, the women of the local fishermen Parava community make trays and baskets "without erks", i.e. without the support of the central core of the palm leaf, as is done in other regions. "Thin strips of palm-leaves are joined together by winding over them a running strip. This band is then furled like a ribbon and fastened together by a thin strip of leaf connecting the successive layers at fixed intervals yielding, thereby, a uniform and rhythmic pattern."[14] Ramanathapuram specialises in winnowing trays or *suplis*, baskets and toys, while Nagore is known for its folding palm leaf fans, painted in bright colours reportedly brought to India from Japan.

The Darbhanga, Madhubani, Ranchi, Hazaribagh and Muzaffarpur districts of Bihar are known for their coiled basketry using a grass locally known as *sikki*, obtained from the dried stems of a succulent plant. The golden-yellow *sikki* is used to create lovely dolls, toys, caskets and baskets using the coiling technique. Before being woven, the grass is dyed in bright translucent colours and the shimmering golden grass, glowing through the paint, gives the articles their characteristic luminosity. Functional articles such as boxes for storing clothes, toilet articles, spices and dry foods, are all made in this household industry which is dominated by young girls and women. In fact, a girl's proficiency in *sikki* work is an important factor in her eligibility for marriage.

Stronger than *sikki*, but lacking the golden hue, is *moonj* grass (*Saccharum munja*) used by the Tharu tribals, mainly in Nepal, as well as the lower castes in Madhubani, to make baskets and caskets with lids of numerous varieties dyed in dark tones.[15]

Other grasses from which articles are matted and woven are leaves of the *khajur*, or date palm in Haryana and Bihar and banana, jute and coconut fibres in Tamilnadu and other Southern states.

1. Chandra, 1973, p.10
2. Russell and Hiralal, 1975, Vol. II, P.208-9
3. Ibid
4. Ibid, Vol.IV, p.588-9
5. Crooke, 1925, p.414
6. Herskovitz, 1955, p.137
7. Khan, 1986a
8. Ranjan et al., 1986, p.75
9. Shirali, 1983, p.52
10. Census, 1961d, p.4
11. Doctor, 1987, p.25
12. Chattopadhyay, 1975, p.103
13. Doctor, 1987, p.28
14. Census 1961e, p.6
15. Dhamija, 1966, p.22

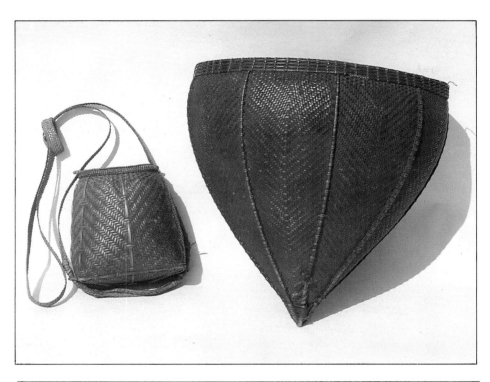

Grain baskets. Split cane and bamboo; 62 cm x 30 cm; 20 cm x 18 cm. Arunachal Pradesh. c. mid 20th century. 86/6988; VC/235.

The Nishi tribe have a distinctive carrying basket hung across the back with a head strap made of braided split cane. The baskets are primarily used to transport grain from the fields and therefore have a tight or "closed" weave structure. The conical shape with a slight bulge below the rim is characteristic of the baskets of the tribe.[1]

The seed basket of the Adi Gallongs of Arunachal, also known as the *kyayong*[2] is somewhat different. Its long straps are easily strung across the shoulders. The rectangular base and oval rim give the basket the shape of a container rather than a carrying basket. It is also used as a grain measure in addition to transporting grain from the fields.

[1] Ranjan, et. al. 1986, p.48
[2] Ibid

Fish trap and basket. Split cane and bamboo, 87 cm x 46 cm; 30 cm x 17 cm. Rabha tribe, Assam. Contemporary. VC.

Chalanis, or round tray-like traps, are used in Assam for catching fish from weed-filled ponds, while in Manipur the trap is a deep dome shaped basket with a circular rim. In Tripura, the long conical fish trap or *pollo* is open from both ends and is made from long bamboo splits.[1]

This particular fish trap of the Rabha tribe of Assam is known as the *palao* and is similar to the *sudha* and *jhakoi* of Tripura and other parts of Assam. In constructing this trap two corners of a rectangular mat are tied together to form a long handle rim very much like an open American Indian teepee. A long handle attached at the apex joint is used to hold the trap for catching fish in shallow waters.

Fish baskets are an important accessory in hunting fish. This Rabha fish basket, known as a *duku*[3], is woven from the base onwards to form a narrow opening fanning out into a broad collar, similar to a long cylindrical gourd. Generally, a rope tied from its neck is tied around the waist to carry fish back from the pond or to hang on a rack inside the home.

[1] Ranjan, et.al., 1986, p.237-248
[2] Ibid, p.244-5
[3] In conversation with craftsman Neeldhan Rabha

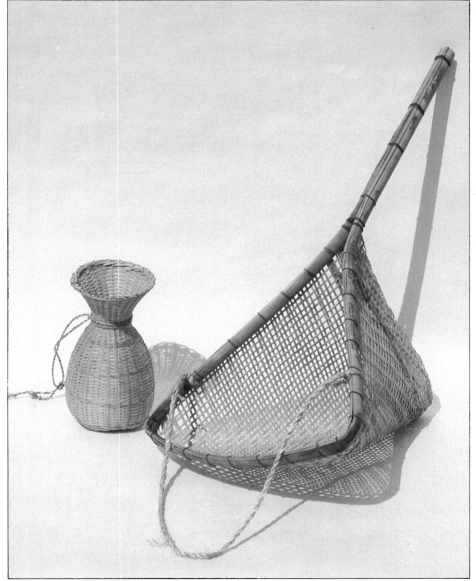

167

Ceremonial basket. Split cane and bamboo, skull, tusk and hair; 35 cm x 22 cm. Konyak and Phom tribes, Nagaland. c. early 20th century. 86/7016.

This basket, generally used as a carrying basket by men, is symbolic of the possessor's general prestige in society. The monkey skull, hair of the bear and boar tusk are trophies of a highly courageous and spirited warrior.

Ceremonial headgear. Brass, goat hair, red seeds, basketry and cotton rags; 59 cm x 39 cm. Nagaland or Arunachal Pradesh. c. 19th century. 86/7110.

Red seeds of the *Abrus precatorius* tree adorn this unusual head-dress, probably worn by the chief or prominent warrior of the tribe. The U-shaped band is meant to fit exactly below the chin[1] where it rests covering the neck in a proud display of martial glory. The matted cane or bamboo ring-like contraptions, one of which is missing, are wrist-bands of a rather "sporty" warrior. A brass disc adorns the conical cane and bamboo hat that fits neatly over the head. Feathers of the hornbill — usually arranged in a semi-circle above the head — now missing, are final touches added to the spectacular headgear.

[1] Barbier, 1986

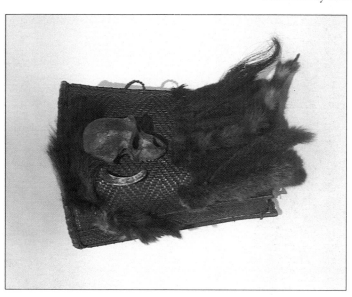

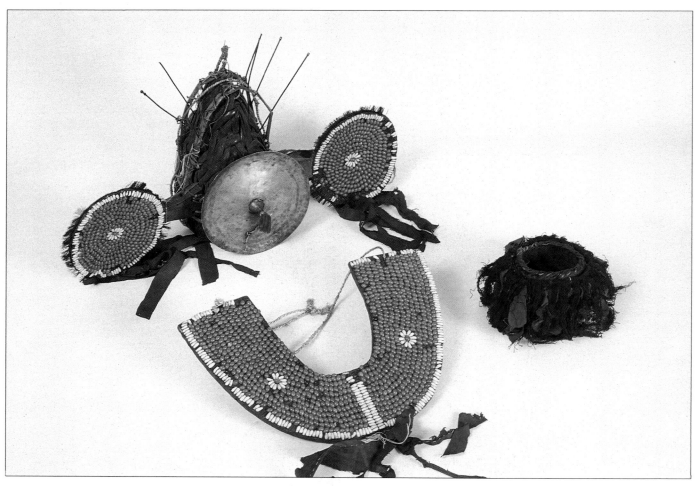

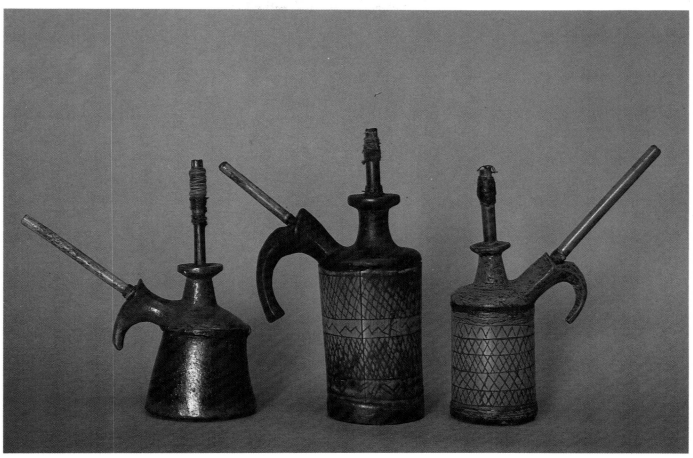

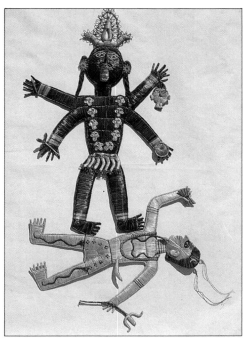

Smoking *hukkas* or pipes. Etched and pigment-painted bamboo; 17 cm; 15 cm; 13 cm. Probably Mizoram. c. early 20th century. 86/6964; 86/6965; 86/6966.

Hollow bamboo culms with a base formed at an internode, or hollow cane, are used as water containers in the ingenious construction of *hukkas* or pipes used by both men and women of the North-East. A portion of a rhizome, the underground stem of bamboo, forms the upper lid which is made so as to hold two pipes, one along the central vertical axis, and the other, diagonally, and generally longer than the first. This second pipe is used to pull in the smoke while the vertical one is used to hold a clay receptacle, now missing, containing tobacco.

In Mizoram the pipe is known as the *tuibur*, the smoking pipe of the Lushai tribe of Mizoram is known as the *vaibel*, that of the Nishi in Arunachal *hutusilli*, and that of the Apa Tani, *sudhum*[1]

[1] Ranjan, et.al. 1986, p.286-7

Goddess Kali, a form of Parvati, trampling upon the body of Shiva. Dyed sikki grass in coiled basketry; 145 cm x 77 cm. Madhubani, Bihar. Contemporary. 80/6159.

The women of Madhubani district in Bihar, are adept in creating beautiful caskets, toys in the figures of birds and animals and deities such as these, by sewing together a locally-found dried grass known as *sikki*. This grass is picked by hand directly from the fields where it grows wild and is split with one's teeth, unlike *moonj* grass (*Saccharum munja*) which requires a sharp needle. It is then dried and finally dyed in various colours. Water is an important ingredient during the coiling stage as it makes the splits more pliant.

In this figure Kali, the goddess of destruction, is depicted holding the decapitated head of a demon in addition to her dagger and bowl for drinking the blood of her victims. She is shown trampling upon the body of her consort, Shiva.

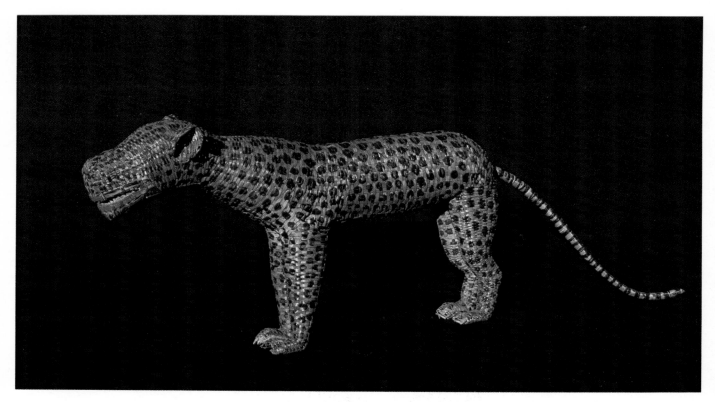

Cheetah. Pigment-painted split bamboo or cane; 137 cm x 48 cm. Probably North-Eastern India. c. mid-20th century. 7/5780.

An unusual construction in split bamboo or cane is this extremely nimble-looking cheetah, or hunting leopard, now said to be extinct in India. The long animated tail and slender body of this agile and light-footed animal truly capture the essence of the cheetah, the swiftest sprinter of the jungle.

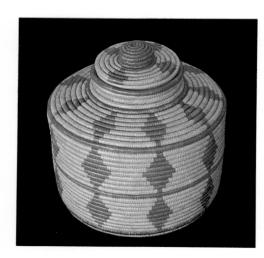

***Mandir pawnti,* temple-shaped basket with lid.** Dried *khajur* or date-palm leaves in coiled basketry technique; 33 cm x 29 cm. Bihar. c. mid 20th century. 7/3100.

Dried leaves of the *khajur* or date-palm tree are employed by women of the Harijan community to produce household items, usually storage baskets such as this *pawnti* in the shape of a temple or *mandir*. Other items they make include *dalias* or salvers used for ritual accessories, *panbatti* or *raun pawnti*, for betel, and *dhakia* or barrel-shaped grain storage baskets with lids. *Moonj (Saccharum munja)* a locally available grass, is also used for weaving such items in the coil technique of basketry.

Opposite page
***Sheetalpati,* floor matting.** Split cane; 72 cm x 60 cm. Goalpara, Assam. VC.

A special type of cane (*Clinogyne dichotoma*) locally known as *patti bent*[1] or *mutra* in Bengali, *patti due* in Assamese and *amjori* in Garo, is used to create the most beautiful floor mats in India.

Generally undyed, the natural subdued tones of the dried split cane create a phenomenal effect on the hand woven surface of the *sheetalpati*, literally, "cool matting", ideal during the sultry heat of the Indian summer. *Sheetalpati* is an important item of exchange between the families of the bride and groom and in fact seals the ties between the two.

Designs centering around the diamond, or rhomboid shape, also known as *jamdani*, are created by using naturally darker or dyed slips. The triangular pattern is known as *teen kani*, the square or rectangular as *then chek*, or just *chek*, the grid pattern is called *bielan*, rows of horizontal lines, *dusa*, and a square divided into four smaller squares with different weaves is known as the *choot jabra jamdani*. It is interesting how the *jamdani*, a famous brocaded fabric of the region, is employed in the design terminology of the *patikars* or mat-weavers of Assam.

[1] In conversation with craftsman Akhil Chandra Pal from Goalpara.

Earthy Forms:

Terracotta and Glazed Pottery

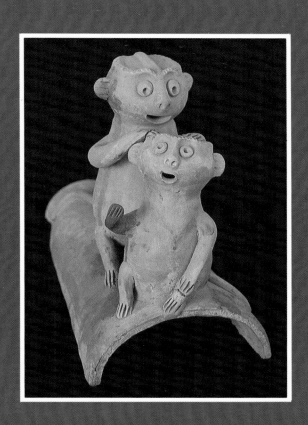

There are numerous references to earthenware, especially painted pottery and terracotta figures, in the archaeological findings of the pre-Harappan, Harappan and post-Harappan periods. The pre-Harappan pottery found at the Kalibangan site in North Rajasthan is "characterized by painted wares largely of the black on red (surface) variety. Occasional use of white as another adjunct colour occurs. The designs are largely geometric, though faunal and floral elements occur."[1] From the Harappan civilization sites of Lothal in Saurashtra, Gujarat, and Mohenjodaro in Sind, a delightful range of terracotta toys from whistles and rattles, to animal figurines and dolls has been excavated. The pottery painted black on red includes "Dish-on stand vessels (fruit stands) with narrow tapering bases, beakers, pointed base jars, handled cups, jar stands, perforated cylindrical vessels ...in addition to the variety of vases, pans, and plates...."[2] The post-Harappan sites in Punjab, Sind and the North-West frontier reveal "pedestal-footed vessels and dish lids. The latter are particularly striking, since they are handsomely painted with motifs that include human beings, plants, birds, bulls, fish, all rather stiff and formal."[3]

Nearly five millenia later, India is still rich in her terracotta and pottery traditions, many of which have their roots in prehistory. A great deal of the present day painted pottery of Kachch in Gujarat and parts of Rajasthan reveals a striking resemblance to pieces found at the sites of the Indus Valley Civilization. Patterns derived from chequered grids, rhomboid lozenges, waves and loops within parallel lines, spirals and motifs derived from flora and fauna, especially birds, are common parallels.[4] Moreover, many of the mother goddess terracotta figurines, whistles and bulls on wheels, are still produced all over India in the likeness of the objects excavated in the Harappan and later Mauryan sites.

Using techniques such as throwing on a wheel, moulding over an old pot or basket[5], modelling by hand — which is done in a variety of ways, such as coiled pottery and "slab" pottery, and a combination of the two i.e., wheel-turned and hand beaten — Indian potter-craftsmen continue to create a wide range of utensils, ritual and toy figures, relief panels and plaques.

The initial process entails processing the clay obtained from ponds and river beds. The first stage is that of removing impurities like gravel, small pebbles, twigs and roots from dried clay that is previously pounded. Depending upon the quality of clay, i.e., the extent to which it is adhesive, brittle or elastic, a variety of materials such as sand, rice-husk, ashes, cow dung and cotton wool are added to prevent the object from cracking while sun-drying and firing. The dry-mixture is then kneaded by sprinkling water and using both hands and feet to blend it thoroughly into a dough-like admixture. The clay is now ready to be turned on the wheel or modelled by hand. However, care is always taken that this mound is never directly exposed to the sun and is kept moist under a polythene sheet, jute or some such covering. The final stage is that of firing so as to fuse the siliceous material with the clay and make the utensil or object strong and durable.

The Sanskrit word for an earthen pitcher is *kumbha*, the prefix *ku* meaning earth. And, appropriately, the term given to a potter nearly all over India, derives from this with only regional variations. Thus *kumbhakara* is one who makes earthern pots as is the *kumbhara*, *kumhar*, *kumar* and even *kubha*.[6] "Words for potters in Dravidian languages also look back to the same Sanskrit derivations; *kumbara* or *kovara* in Kanarese, *kummara* or *kumrulu* in Telugu, *kusavan* or *kulalan* in Tamil, and *kusavan* or *kuyarun* in Malayalam".[7] According to popular belief, in

Previous Page
Roof tile. Terracotta; 27 cm x 20 cm. Village Barpali, Sambalpur, Orissa. Contemporary. VC.

It is believed [1] that installing birds, animals and figures of fearful ghosts and spirits on the roof of one's hut will prevent the malevolent influence of spirits from entering the house. Roof tiles like this were once very common in the villages of Sambalpur and even today one can find roofs with such bird or animal tiles. Generally, monkeys in the area who jump on roofs, break these tiles, thus making them less popular among the potters' clientele. Unbaked bird figures are nevertheless very popular, especially during the Chatia, or bird festival, when they are offered to Krishna seated on Kaliya, the serpent king, in the month of Bhadra, sometime in August-September.

[1] In conversation with Manbodh Rana, a potter from Barpali, Sambalpur

Rajasthan, Gujarat and Punjab, the potters are awarded the title of *Prajapati* or "Lord of the Universe" by Brahma himself.

Myths and legends about the origin of the potter and his craft abound all over India of which the most popular, with a few regional variants, is as follows:

Long ago, at the marriage ceremony of Shiva and Parvati, a *kumbha* (earthen pot) was urgently required. A brahmin by the name of Kulalak finally offered to produce one on condition that he was given all the tools for making it. So Lord Vishnu offered his *sudarshan chakra* (sacred discus) as a wheel. The Mount Mandar was the pivot on which the *chakra* rotated with the help of Shiva's *ghotana* or pestle for grinding *bhang* (*Cannabis sativa*). Shiva's *langota* (loin cloth) was used as an all-purpose cloth, his *kamandalu,* gourd-pot, for storing water and his sacred thread or *janeu* for separating the pot from the wheel. The *adi-kurma* or mythical tortoise was the scraper-cum-smoothener of the pot. Thus, the wedding of Shiva and Parvati took place. And, ever since, all the descendants of the Kulalak Brahmin are known as *kumbhakaras* or makers of earthern pots.

In Madhya Pradesh the two-fold division of potters, i.e., those who work on the wheel or *chakraiyas* and those who model by hand or *hathraiyas*, is said to have originated long ago when a potter used his spittle to mend the crack on his hand-modelled pot meant for a sacred *yagna* or sacrifice. Due to the ritual pollution incurred on the pot the sacrifice was unsuccessful and the gods were compelled to ask the *chakraiya* to model a new one on a wheel.[8]

For a potter, not only is his craft a divine revelation, but his tools and implements, that are "gifts" from god, are also worthy of respect and veneration. The wheel or *chak* (from Vishnu's *chakra*) and the *kiln* or *bhatti* are worshipped — in one way or another — by Hindu potter communities almost all over India.[9] Moreover, the potter himself is regarded as a "priest" by the other communities.[10] Thus in the South, the Velar potters of Madurai and Puddukotai districts in Tamilnadu, in addition to making terracotta images of deities, also "perform priestly functions at one or more temples."[11]

Many terracotta figures of animals are essentially employed as votive offerings to deities. In Chhota Udaipur, Gujarat, and its neighbour, Jhabua in Madhya Pradesh, votive figures of the horse, bullock, tiger, elephant and camel, are offered by the Bhil tribals to their deities for wish fulfilment and general well being:
"Oh! Devlimadi, Goddess Devli, I offer the horse to you.' From today, I rely on your assurance that you will do good to us."[12]

The votive animal offerings of Chhota Udaipur and Jhabua are curious as the torso — which is wheel-turned — is left hollow with a gaping hole on the frontal side of the animal image. Even the head, legs and trunk are separately wheel-turned and attached. The figures are fired and subsequently smeared with red ochre upon which white dots and stripes are applied in a simple but charming manner.

In Bankura, West Bengal, the *Manasa jhard* or shrine of the snake goddess Manasa is worshipped as protection against snakes while ritual figures of the horse, elephant and tiger are commonly bought by the villagers and offered to forest spirits to protect them from wild animals.

In Tamilnadu they are offered to Lord Aiyanar who is believed to cure an ailing animal if he is offered a clay image of it. For the well-being of an older woman, the image of goddess Kali is offered whereas for a man, that of god Munishvaran. The larger than life size painted terracotta horses with riders and bullocks as well as figures of men and women of the cult of Aiyanar are made hollow, coil by coil in sections separately fired and subsequently assembled. As early as 1909, E. Thurston refers to these "Horses made of clay, hollow and painted red and other colours, (which) are set up in the fields to drive away demons, or in thanksgiving for recovery from sickness or any piece of good luck.

175

The villagers erect these horses in honour of the popular deity Aiyanar, the guardian deity of the fields, who is a renowned huntsman, and is believed... (to visit)... the village at night, to mount the horses, and ride down the demons."[13] The ornate bells and other embellishments on the Aiyanar horses and bullocks are characteristic of the regional cult.

In Darbhanga, Bihar, votive painted terracotta horse-riders or *ghora-kalashas* are offered at shrines known as *brahmasthanas* of the twice-born Brahmin castes and *salheshsthanas* of the Harijan Dusadhs.[14]

The ritual horse and elephant riders of Darbhanga, as well as secular toys such as the pitcher-maid, woman carrying a fish on her head, mother and child, birds and animals, are all modelled partly on the wheel and partly by hand. They are brightly painted in blue, green, red, pink, yellow, black and white in lively strokes. The fish and parrot motif are predominant on pitchers both for household use as well as those used by mendicants.

In Molela, clay mixed with donkey dung is used to prepare hand modelled hollow relief plaques of the neo-Vaishnava deity, Dev Narayan, with his characteristic snake symbol, the folk hero Pabuji, Ganesha, Bhairava, Durga and a host of other deities. Figures of the Ganagaur diety and her consort Isar, tigers with wide open mouths — both wheel-turned in parts and painted in bright yellow and orange — are some of the other creations of the potters of Molela.

The votive figures of Guleria Bazaar in Gorakhpur, Uttar Pradesh, are washed with a liquid known as *kabeez* before they are fired, giving the highly ornate horses, elephants and divine figures their characteristic earthy lustre. Fringe hangings of tiny clay bells are attached to these objects with wire or thread. According to a myth the enraged deity speaks through the *sokha* or shaman and can only be appeased if an elephant or horse from Guleria Bazaar is offered to her.

Goalpara in Assam; Birbhum, Bankura and Midnapur in West Bengal; Bolangir, Sambalpur and Ganjam in Orissa; and Bastar, Jhabua, Sarguja, Raigarh, Bilaspur, Bundelkhand and the Malwa region in Madhya Pradesh produce a startling range of votive terracotta figures, ritual and secular utility objects and toys for children.

The painted pottery of the Kachch region of Gujarat is of an exceptionally mellow charm. Pots, jars, lamps and almost all kinds of kitchen utensils are turned on the wheel and later hand modelled and beaten with a wooden spatula and stone anvil. Utensils with a long or short neck, double rimmed or single rimmed collar, inwardly or outwardly bent, and with concave or convex body shapes of all kinds are created for a variety of specialised purposes. The *lotadi*, pot, is used for milk and curd, the *tapeli*, pan, for cooking vegetables and the *kalasha*, pot, for storing water. Red ochre, white and black are the three standard colours used to paint composite border patterns of the *chaukhat* or grid, *vel* or creeper, *laher* or wave, *vichhi* or scorpion and *guli* or flower. Subsequent firing makes these colours, white or black on red ground, or black and red on white, permanent and water-proof.

In Chairan, Shangmai and Thongjao villages of Thoubal district and village Andro in Imphal (East), Manipur, women potters practise a unique hand-modelling technique, probably dating back to even earlier than neolithic times before the invention of the wheel. In this process, the potter begins with a "slab" or band of clay mixed with sand, that is folded into a cylinder to which a base is added. This is then placed on the *lepshum*, a cylindrical platform, usually the trunk of a tree, as high as the potter's knee. A piece of thick wet cloth or *phunanphadi* is wrapped around the open rim while the craftswoman, holding it with both hands, circumambulates in the manner of the wheel till the collar is smoothly formed. It is only after this stage that she beats the pot with a wooden beater or *phuzei* using a stone anvil till it expands into shape with the requisite thickness of the walls.

Often the oar-shaped beater is carved on one side with shallow crisscross or linear patterns which give the pots their characteristic embossed or basketry look. When semi-dry, the surface of plain pots, water filters, vases, incense burners, lamps and *hukka* bases are tediously burnished with *kangkhil*, the seed of a wild creeper, giving them their characteristic varnished appearance. Firing turns the shining black clay, believed to contain traces of iron, into a splendid lustrous orange. For a completely black finish the object is smoked in a sealed vessel.

Nizamabad in Azamgarh, Uttar Pradesh, is renowned for its "black" pottery where terracotta *martabans* or jars, *surahis* or long-necked and spouted vessels, lamps and containers for oil, betel leaves and even ink are imparted with a lustrous black colour. Before firing, the pottery is washed with a slip or *kabeez*, a mixture of "yellow earth (a form of fuller's earth) known as *piari mitti*, of powdered mango bark and of *sajji mitti*, or crude carbonate of soda."[15] The surface is then burnished with mustard oil after which a sharp twig is used for *nakkashi* or etching floral sprays and creepers on the surface of the unbaked clay pot. It is then subjected to "smoke" firing which results in its characteristic black shine. The grooves of the design are subsequently filled in by hand with a fine silvery powder or *bukani*, a mixture of lead, zinc, and mercury which when washed with water and polished radiates a silvery hue against the black background of the terracotta.

In many parts of India, there is a tradition of coating terracotta utensils and figures with lac. This may be done with coloured lac as in toys, especially those of Baleshwar, in Orissa,[16] or by using plain lac to provide an impervious inner layer to vessels. In Chhota Udaipur, Gujarat, Bhil women coat the inner layer of their pot-moulded elliptical utensils with lac after firing. Both the lac as well as the utensil must be sufficiently heated before a smooth coating can be applied.

The roof tiles of Raigarh and Sarguja in Madhya Pradesh and Sambalpur in Orissa are crowned with chirping birds, frolicking monkeys, lizards, turtles, bears, demons and demonesses. So enchanting are these hand-modelled tiles on the roofs of thatched huts, that the owners compete with each other for the most beautifully-tiled roof.

In the Kachch and Saurashtra regions of Gujarat the pastoral Rabaris, the agricultural Kanbis and Mers, the Meghvals, leather workers and several pastoral communities of Banni district, traditionally decorate their dwellings with elaborate clay relief work.[17] The exterior mud plastered walls of their homes, cupboards, as well as the barrel-shaped clay containers with narrow bases and rounded mouths for storing grain known as *kothi- kothalas*, are embellished with tiny mirror pieces within relief triangles, sundials, rectangles, squares, crosses, figures of peacocks, flowers and even human beings in very elementary linear forms.

A similar practice is common in the Madhubani district of Bihar and the Mandla district of Madhya Pradesh. In Mandla, the Gond, Pardhan and Baiga tribal dwellings are made to come alive with clay relief work which uses a mixture of clay, cow dung and paddy husk. *Chowk* or the auspicious square, flowers, the swastika, figures of animals, usually the cow, and deities are commonly found on grain storage jars and exterior walls which are left unpainted, unlike in Gujarat where they are whitewashed. In Sarguja district the verandahs and windows of Rajwar homes are decorated with clay-covered bamboo *jalis* or lattice work, interspersed with unbaked clay and straw figures of animals and human beings. These are painted in mellow tones, usually red ochre, lamp black and lime-white along with the natural yellow ochre of the unbaked clay.

In Punjab and Haryana there exists a tradition of clay wall relief in appliqué. Tiny stars, chevrons, rings and figures of birds in painted unbaked clay are used to create highly simplified images of the goddess Sanjhi on cow dung plastered walls during fertility rituals and agricultural ceremonies.[18]

An unusual tradition of carved terracotta plaques and panels that narrate myths and legends, has existed in the Bankura, Burdwan and Birbhum districts of West Bengal. Entire temples of terracotta, built sometime during the 17th, 18th and 19th centuries, have been executed in this style whose origin may be traced to the "wooden *rathas* or the stone carvings of relief panels profusely used as embellishments on the stupa gates or on the exterior walls of stone temples...."[19] The technique of "carving", rather than modelling these panels, involves the scooping out of unwanted clay around the previously-inscribed design on the plain surface of the tile. This is done before firing when it is semi-dry, so that only a sharp-edged knife is required.

In Krishnanagar, Bengal,[20] miniature terracotta models, depicting various scenes from Bengali life, are executed in the "Company School" style of the late 18th and 19th century in which the realistic rendering of facial features and costumes is an integral part of the art. Musicians, farmers, mendicants, snake-charmers, women involved in various domestic chores and scenes from the marketplace were favourite subjects of European patrons.

According to many historians, glazed pottery, unlike terracotta, came to India via Persia as a result of the great Mongol Chengiz Khan's conquests who, "after his conquest in China in A.D. 1212., brought back with him a Chinese wife, and through her the Chinese art of glazing pottery."[21] In 1398 the invader Timur took Indian craftsmen to Samarkand where they worked on the tomb of Emperor Gur-Amir and imbibed Persian designs and the magnificent art of blue and white tiles and pottery of China or *bleu de chine* as it is known.[22] According to the Archaeological Survey of India "glazed tiles first appeared in Delhi in the Tughlak monuments dated between A.D 1321-1414. These are of Turkish inspiration".[23]

The art and technique of "blue" ceramics were brought to Jaipur, Rajasthan, by the Rajput king Man Singh I (1550-1614) and later flourished under the patronage of his great grandson Maharaja Sawai Jai Singh II. Following a decline in the craft which continued for more than a century, Maharaja Sawai Ram Singh II (1835-1880) revived the craft and established a School of Art in Jaipur.[24]

In the blue pottery technique the articles are made from a mould using a mixture of feldspar, Multani *matti* or clay, edible gum and glass. The smoothened milky-white surface of the moulded object is then painted with mineral colours, cobalt oxide for blue and copper oxide for green, in order of their hardness. The surface is subsequently glazed and fired to reveal the rich turquoise blue and pale green of the floral and geometric designs on jars, vases and containers of all shapes and sizes.

1. Fairservis, 1975, p.183.
2. Ibid, p.287
3. Ibid, p.353
4. Saraswati, 1978, p.105
5. Herskovitz, 1955, p.139
6. Saraswati, 1978, p.46
7. Ibid, p.46
8. In conversation with Mushtak Khan
9. Saraswati, 1978, p.85-6
10. For North Indian examples see Ibid, p.82-3
11. Inglis, 1985, p.94
12. Shah, Ex. Cat., 1985a, p.29.
13. Thurston, 1909, Vol IV, p.192
14. Census, 1971b, p.9-10.
15. Watt and Brown, 1979, p.85-86
16. For more information see Chapter IX
17. Jain, 1981a, p.54, 91, 116
18. Kramrisch, 1968, plate 28 and Jayakar, 1981, p.262-3
19. Dasgupta, 1971, p.35
20. Sengupta, 1973, p.24-9
21. Watt and Brown, 1979, p.84
22. Nath, 1986, p.34
23. Ibid, p.35-6
24. Ibid

Bowl. Lac-coated terracotta; dia.
45 cm. Rathva tribe, Chhota Udaipur,
Gujarat. Contemporary. 83/6379.

The women of the Rathva tribe of
Chhota Udaipur produce beautiful
terracotta utensils, not on the wheel but
by moulding them on broken pots. A
mixture of clay and rice-husk is kneaded
together and hand-formed into a slab
that is placed over the convex bottom
of an old pot. Once dry it is removed
to form a concave vessel that is fired
and, while still hot, coated from the
inside with a piece of natural lac. The
reddish brown lac must be uniformly
spread for a smooth inner surface that
shines, almost like glazed pottery,
against the plain red ochre exterior.

***Dhabu* or *ghumat*, dome-shaped lamp
receptacle for a deity.** Monochromed
terracotta; 49 cm x 29 cm; Gujarat.
Contemporary. 5/95(20).

In the tribal areas of Gujarat, especially
Chhota Udaipur and the adjoining
areas of Madhya Pradesh such as
Jhabua, there is a tradition of offering
votive animal terracottas to the spirits
and deities of the village and forest.
Every cluster of horses, camels, bullocks
or tigers must have an offering of a
dhabu or *ghumat*, as they are called by
the Bhils and Rathvas, such as this
temple-like shrine, to hold an oil lamp
in honour of the deity to which the
votive offerings are made.

There are numerous sanctuaries in
Gujarat where one can find hundreds of
such shrines grouped together beneath
trees, bespeaking past offerings to
resident spirits and deities.

Unlike the *dhabus* of Chhota Udaipur
and Jhabua, which are generally
wheel-turned in part and rather modest
in appearance, this *dhabu* is more
ornate and in fact is hand-beaten with
the help of a stone anvil. Figures of
birds and humans are probably
invitations to the spirits of the dead to
come and reside in the shrine.

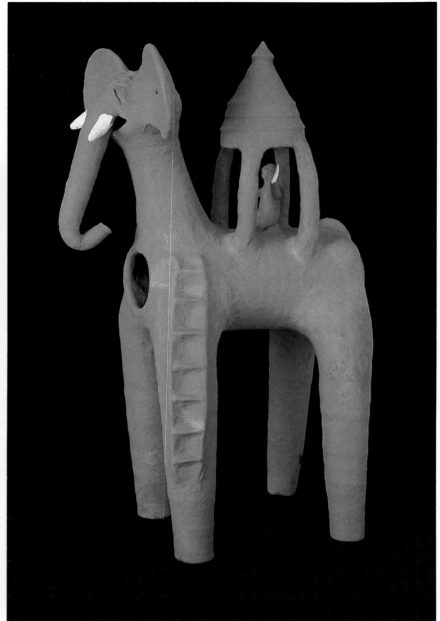

Votive animal figures. Red ochre washed terracotta; 68 cm x 44 cm; 70 cm x 46 cm; 69 cm x 32 cm. Jhabua, Madhya Pradesh. Contemporary VC.

The Jhabua district in Madhya Pradesh borders Chhota Udaipur in Gujarat. In both these areas the tribal population of the Bhils, Bhilalas, Rathvas, Nayaks and Dhanuks, have a tradition of offering votive animal figures,[1] along with a *dhabu* (see caption previous) to the various deities residing in shrines located on the frontiers of fields and divisions between plots.

Every year, during the Dusshera festival the entire village gets together and commissions a huge horse, along with a *dhabu* for the oil lamp, which are offered together with bowls of grain at the main *daivasthana* or village shrine for the general well-being and prosperity of the village.[2]

The characteristic modelling technique employed by both the Chhota Udaipur and Jhabua *kumhars* or potters, is such that the main body is wheel-turned, very much like an elongated jar, as are the tube like limbs and the curiously shaped head, while the rest of the embellishments are hand-modelled. The not-so-subtle gaping hole in the frontal side of the animal's body, a natural anomaly and consequence of the wheel, is an indication of the creative license exercised by the potters of this region.

[1] Khan, 1986f

[2] In conversation with Mushtak Khan

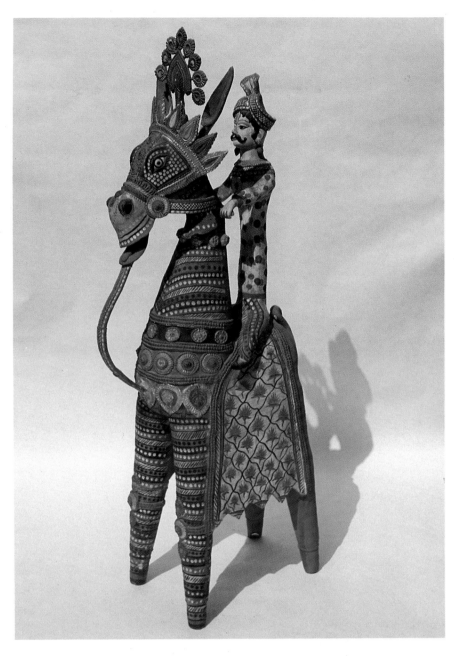

Among the Dushadhs, the terracotta horse rider is offered to Sailesh, a mythical hero who lived in Rajaji-ki-phulwari in the terrai region of Nepal. Generally, these figures are offered by devotees upon wish-fulfilment. "One instance of a visit to Salheshsthan for making votive offerings was furnished by Uchit Dusadh of Katharwari. Once his brother was accused of being involved in illicit traffic in women. Uchit knew that his brother was innocent. He, therefore, took a vow that if his brother was honourably acquitted, he would offer a *ghora-kalash* (horse-rider) to Salheshsthan and also would attend the fair at Rajaji-ki-Phulwari near Jainagar." [1]

Other figures found at the *Salheshsthan* are Motiram, Sailesh's brother, his two bodyguards mounted on horses and the two *malins* or flower girls, Kushma and Dona.

[1] ·Census 1971b. p.15

Following page
Vessels. Hand-modelled terracotta; max. 40 cm x 32 cm.; min. 19 cm x 18 cm. Thongjao, Manipur. Contemporary. VC.

Goddess Panthoibi[1] wife of Anadi Bhagwan, as she is known in Thongjao and Chairan, or Leima Leinaitabi in the Shangmai and Andro villages of Manipur, is said to have taught the women of Manipur the sacred art of hand-modelled pottery.
The women potters model the pots in the 'slab' technique where a band of clay is rolled to form a cylinder to which a base is attached. The collar is formed by circumambulating a wooden stool or *lepshum* in the manner of a wheel. The rest of the pot is beaten into shape with the aid of a wooden beater and a stone anvil. When asked why they prefer not to use the wheel to model their pots, the women generally reply that the wheel makes them dizzy!

So important is goddess Panthoibi for the woman potter of Manipur that before every firing, offerings of flowers, incense and water are made to her along with a solemn prayer to protect her pots from cracking.
Moreover, there are songs that highlight the special relationship between the Manipuri woman-potter and her clay that is described as being "harder than iron, not melting in water":

You my love,
come. Come with me.
We — all of us —
desire you
Walk ahead,
as I walk with you.[1] continued p.184

Ghora-kalash, **votive equestrian figure.** Polychromed terracotta; 145 cm x 21 cm. Darbhanga, Bihar. Contemporary. 81/6224.

Ritual terracottas such as this horse-rider are offered in two types of sacred spots in Darbhanga: *brahmasthan* and *salheshsthan* , associated with the upper caste Hindus and humble Dushadhs respectively.

For upper caste Hindus the terracotta horse rider is the embodiment of Brahmji, a Brahmin youth who died unmarried and whose disturbed soul is wandering around in search of a home. The equestrian terracotta serves as a receptacle for the unincorporated soul of this youth who in turn protects the village from evil influences and harm. These votive figures are offered at the *brahmasthan*, where offerings are made to them in the form of flowers, vermilion and sweetmeats.

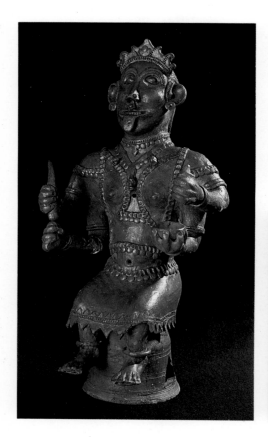

The philosophy of the people of Manipur is amply illustrated in the metaphoric ballad that refers to how a bird, even if it returns to its own tree, will never recognise the branch it had perched upon earlier. Similarly, pottery shards will always remain separate and different from mother earth, from which they have originated even when they return to it. The essential contradictions of life and death are inherent in the songs of the potter women of Manipur.

The unusual shapes of these vessels, so elegantly modelled, could never have been turned on a wheel. The orange-black tongues of fire on the glossy surface of these pots are profound symbols of nature's contribution to aesthetic sensitivity.

Another legend [2] tells of how an ancestor of the Kakatiya dynasty, an ardent devotee of goddess Danteshvari, was ordered to hold her *vastra*, or cover cloth, and follow her over an area which would thereby become his kingdom and later be ruled by his successors. Despite her warning not to look back, the king did so and the goddess disappeared before his eyes. He nevertheless built a temple in her honour and henceforth his state became known as *vastra*, meaning "cloth", believed to be the original name of Bastar.

[1] In conversation with Mushtak Khan
[2] A.I.H.B., 1969b

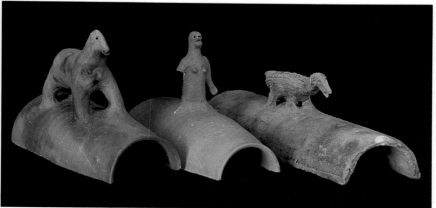

[1] In conversation with potter Neelmanidevi and her husband Shyam Jai Singh

[2] Free translation from Manipuri to Hindi, by Shyam Jai Singh and from Hindi into English by Pria Devi.

Danteshvarimai, a deity. Slip washed terracotta; 63 cm x 29 cm. Bastar, Madhya Pradesh. Contemporary. T/HMSS/340.

The main shrine of Danteshvarimai, the primary deity in Bastar, is located at Dantevara by the river Indravati near Jagdalpur. According to a legend the then ruling king went to Warangal, in Andhra Pradesh, where he requested the deity to protect his state and reside in it. She agreed on condition that he would lead the way and did not turn back to look at her as her jingling anklets would have to be enough for him to know that she was following him. However, while crossing the Indravati, sand filled her anklets. Not hearing the bells, the king looked back to find that the deity had disappeared. He therefore installed a shrine in honour of Telangeen or the goddess from Telangana.[1]

Roof tiles. Terracotta; 32 cm x 12 cm; 22 cm x 15 cm. Navagarh, Sarguja, Madhya Pradesh. Contemporary. VC.

The tradition of decorative roof tiles in Sarguja,[1] Madhya Pradesh, is not only a status symbol of the best "dressed" roof, but is also auspicious. Clay birds attract more birds or *chirai chun mun* which is considered very propitious as is amply attested by the many tribal wood carvings and pictographs of bird motifs atop roofs, especially common among the Saoras of Orissa. Moreover, in Sarguja, an elephant roof tile is an important symbol during a man's wedding and is placed on the roof after the ceremony.

[1] In conversation with Mushtak Khan

184

Male and female votive figures.
Polychromed terracotta; 45 cm x
30 cm; 48 cm x 28 cm. Puddukottai,
Tamilnadu. c. mid 20th century.
13/167(1); 13/167(2).

Figures like these, of men or *manitham*,
women or *penmani* and children or
mazdalai, are commonly offered to
Aiyanar, a folk deity worshipped in
many parts of Tamilnadu. These votive
figures are found clustered in
sanctuaries,[1] usually in the forest and
village boundaries as well as along the
inner wall of the temple of Aiyanar.
Upon wish-fulfilment — usually for the
birth of a child or the health of one's
parents or spouse — the devotee
promises to offer the deity such figures,
made upon request by the Velar
community of potters who also perform
priestly functions in the temple of

temple. When a married couple is
anxious to have female offspring, they
take a vow to offer figures of the seven
virgins, who are represented all seated
in a row. If a male or female recovers
from cholera, smallpox or other severe
illness, a figure of the corresponding
sex is offered. A childless woman makes
a vow to offer up the figure of a baby,
if she brings forth offspring. Figures of
animals — cattle, sheep, horses, etc. —
are offered at the temple when they
recover from sickness, or are recovered
after they have been stolen."[3]

Made hollow, using the coil technique
with a mixture of clay and rice husk,
these figures, the men with shapely
moustaches and women wearing the
sacred *kumkum* or vermilion mark on
the forehead, are painted in white lime,
coal black, turmeric and red ochre after

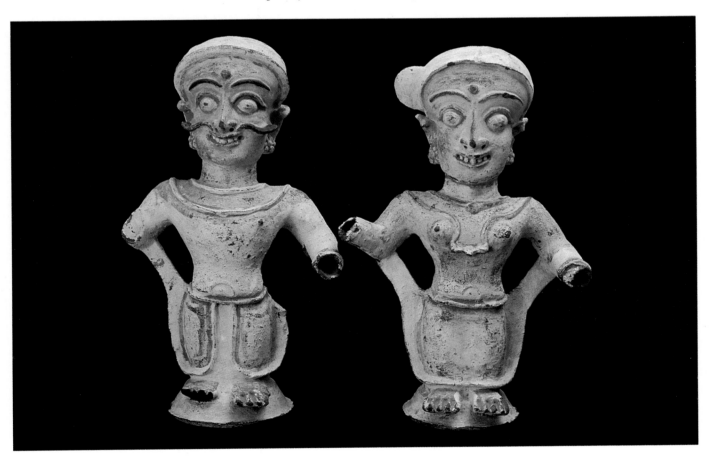

Aiyanar. Usually men visit such
sanctuaries as the women are not
advised to go to areas presided over by
mischievous spirits such as Veeran and
Kateri.[2]

As early as 1909, E. Thurston wrote:
"Painted hollow clay images are made
by special families of Kusavans (Tamil
potters) known as pujari, who, for the
privilege of making them, have to pay
an annual fee to the headman, who
spends it on a festival at the caste

being fired; "The pupils of the eyes of
the figures are not painted in till they
are taken to the temple, where offerings
of fruit, rice, etc., are first made."[4]

[1] See plates I, II and IV in Kramrisch, 1968

[2] In conversation with Arumugha, a potter of the
 Velar community from Puddukottai, Tamilnadu

[3] Thurston, 1909, Vol. IV, p. 191-2

[4] Ibid, p.192

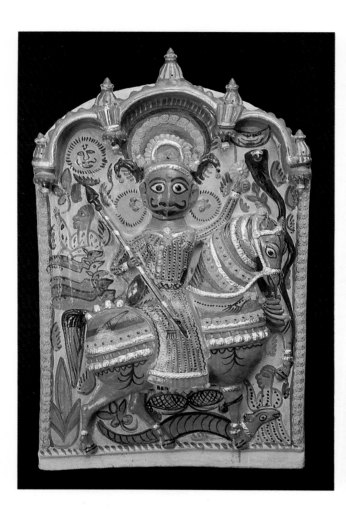

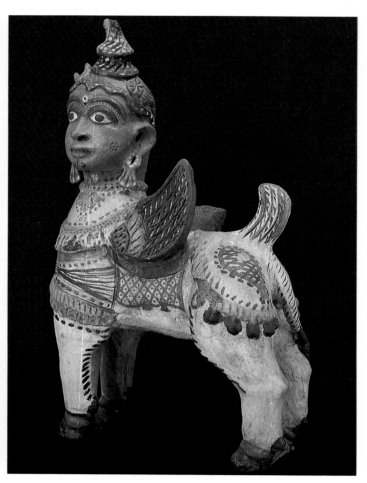

Shrine of neo-Vaishnava deity, Dev Narayan. Painted and varnished terracotta plaque in hollow relief; 75 cm x 55 cm. Molela, Rajasthan. Contemporary. VCD.

Once upon a time [1] a blind potter in village Molela, Rajasthan, dreamt of the local deity Dev Narayan, also known as Dharamraj, who instructed him to construct his image as a horse rider in clay. The next morning the potter's vision was restored and he found a hand impression on a brick in his courtyard left by the lord himself. Having been promised his livelihood by the deity, the potter was to continue making these idols or *murtis* for the rest of the village. One day he came home drunk and did not find the money that used to appear by the brick. All his descendants, therefore, continue to make terracotta plaques of Dev Narayan which, made only in Molela, are bought by people coming from as far away as Gujarat.

The long snake, found in all such plaques of Dev Narayan, is symbolic of the deity, who is an incarnation of Lord Vishnu. The cowherd on his right is Nepha Gwala and the man on his bottom left, Chhocha Bhat or one who keeps records of his clan history. Dev Narayan is shown riding his mare Bavli, and, as is characteristic of all Rajput warriors, he holds a *bhala* or javelin and

dhal or shield. He is said to have taken birth from a lotus flower. His mother, Sadhu mata, was the only woman left in the kingdom devastated by war since the other women had committed *sati* after the death of their husbands.

[1] In conversation with potter, Mohan Lal Kumar, from Molela

Kamadhenu, goddess of boons and mother of all cattle. Polychromed terracotta; 58 cm x 38 cm x 18 cm. Puddukottai, Tamilnadu c. mid 20th century. 7/4570.

Usually not found in the temple of Aiyanar, Kamadhenu, the half-cow half-female deity, was believed to have been sent by lord Devendra, lord of all *devas*, for the benefit of the Dikpalas[1]. "She is a goddess with marvellous powers and attainments who gives milk whenever needed by gods and sages. The Puranas declare that all the cattle in the world today are descended from Kamadhenu." [2]

Executed in the coil technique and polychromed in natural pigments the icon is depicted with a crescent moon and circular medallion on either side of her head.

[1] Courtesy: Potter Arumugha Velar from Puddukottai

[2] Mani, 1984, p.379

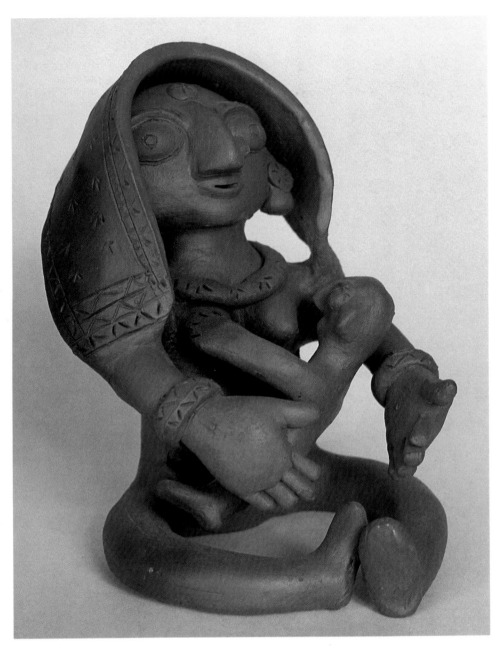

Mother and child. Terracotta; 18 cm x 12 cm. Madhubani, Bihar. Contemporary. 88/3/D.

On the day of the new moon, in the Hindu month of Kartik (October-November), young girls and women of Madhubani prepare delightful unbaked clay figures of the goddess Shyama [1], believed to be the daughter of Krishna, and her husband [2] Chakaiva, *satbhaiyan*, or "seven brothers", *malin* or "flower-girl", *jhanji kutta*, a dog and *dholia* or drummer, for the benefit of their brothers' well-being in whose honour the 10 day long festival Chhathi is celebrated. On the full moon day the brothers in the family ritually send Shyama back to her in-laws' home by causing the symbolic disintegration of her image. The clay figures carried in baskets, are ultimately "returned to earth" in the fields.

This terracotta mother with her child is an offshoot of this tradition which subsequently developed its own vocabulary of forms and symbols. The head cloth, worn by rural women all over India, gracefully falling across the shoulders, the somewhat unabashed yet virtuous position of the legs and the possessive arm around the child epitomise the instincts of maternal love so well known to Nirmala Devi, the creator-craftswoman of this folk terracotta.

[1] In conversation with Ganga Devi from Madhubani

[2] A majority of women in Mithila report that Chakaiva is Shyama's brother but Ganga Devi's version seems more plausible.

clientele of the early 19th century, are figures of the Bauls or itinerant minstrels singing songs in praise of lord Krishna and wearing the characteristic saffron robes, men and women engaged in various activities, scenes from the market place and so on.

Frolicking monkey, temple brick. Carved terracotta; 23 cm. x 19 cm. West Bengal. c. 18th century. 4/456(3).

In the Bankura, Burdwan and Birbhum districts of West Bengal there exist entire temples made from terracotta bricks, built during the 17th to 19th centuries. The unusual aspect of these temples are the terracotta bricks which, unlike most terracotta objects that are moulded or modelled, are "carved" in relief, piece by piece, according to the depictions of the narrative panel of myths and legends, both religious and secular. Thus the Pancharatna temple at Vishnupur is dedicated to lord Krishna while the Char Bangla temple at Baranagar is dedicated to Shiva.[1]

This temple brick, about an inch and a half thick and obviously part of a wider narrative panel, depicts a monkey frolicking amidst thick foliage of a jungle. The subject's gleaming smile, long upturned tail and limbs in an almost-human posture are rendered with extreme sensitivity in a style that is typical of the region and period.

[1] Dasgupta, 1971, p.49 and 59

Opposite page
Jar. "Black pottery" with designs in silver; 31 cm x 25 cm. Azamgarh, Uttar Pradesh. Contemporary. MC/460.

Nizamabad, in Azamgarh, is known for its "black" pottery where double glazing and double firing in a totally sealed container lends the pottery a wonderful lustrous black color. The beauty of the technique, however, lies in the engraving, or *nakkashi*, usually in floral patterns, which is executed on the semi-dry pot with a fine bamboo twig. After firing, a powdered mixture of lead, mercury and tin or *bukani* is filled in by hand onto the etched grooves of the design, washed with water, and finally burnished to highlight the starry sparkle of the design against the black ground of the terracotta.

Top
Goru-gadi-chalok, bullock-cart and rider. Terracotta, wood, twigs, hair and cotton cloth; 22 cm x 28 cm. Krishnanagar, West Bengal. c. early or mid 20th century. 4/16.

Krishnanagar in West Bengal is famous for the sensitive simulation of scenes from daily life in miniature models of terracotta, the almost-live human figures complete with accessories of clothing and occupation.

The photographic realism of this terracotta bullock-cart-rider is extremely impressive. It has been separately and precisely hand-modelled and subsequently assembled with various accoutrements to form an amazingly authentic ensemble.

Other items produced by the *kumhars* or potters of the region, in response to the rapidly increasing European

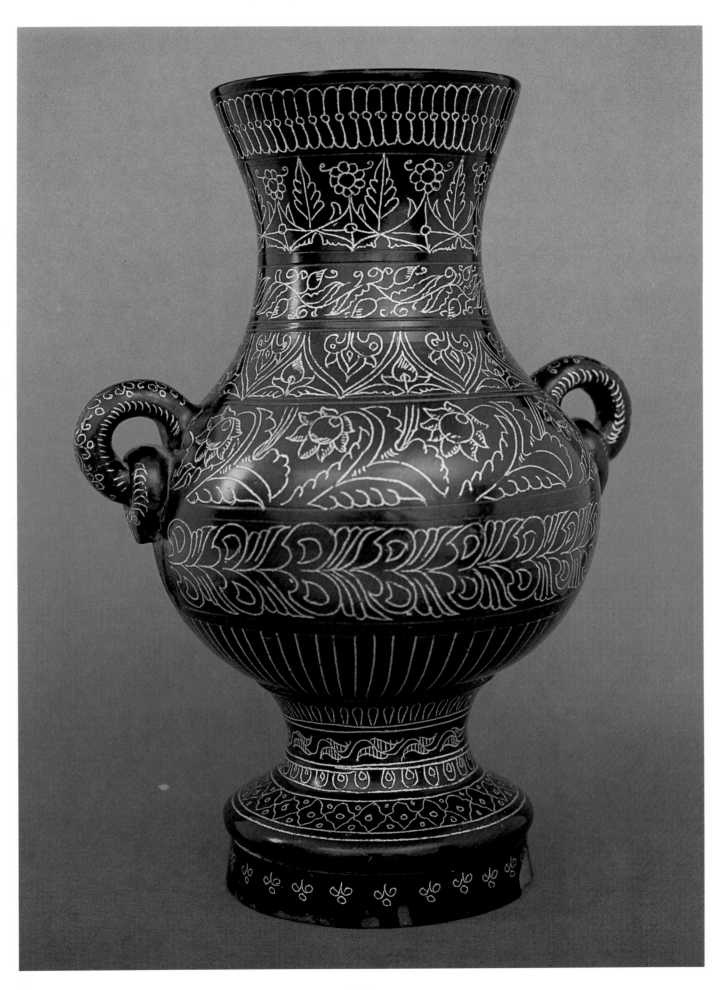

189

Felicitous Playthings:
Dolls, Toys, Puppets and Masks

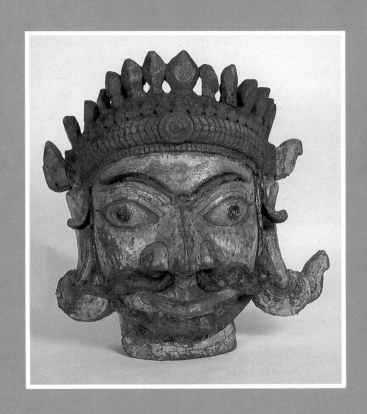

The Sanskrit words for amusement, entertainment, pastime, toy, game, play, sport and dalliance, are all derived from the root *krid*, meaning "to play". Accordingly, the word for toy is *kridanaka*, literally "a plaything". In fact, the *Varaha Purana* refers to a toy called *kridanaka* presented to the son of Shiva, Skanda.[1] The Sanskrit words *puttala* or *puttika*, meaning, "a doll" or "a puppet" are of equally interesting origin. Derived from *putra*, meaning "a son", the words *puttala* or *puttika* therefore literally mean "a little son." *Puttala* or *puttika* also denote "an effigy" or "a replica".

All traditional Indian dolls and toys, like those in other countries, are replicas of things in the real world. To the microcosm of the child's world, these toys bring a tangible recognition of the life around it in the form of miniature temples, icons, utensils and other objects from the household and community. Thus, toys are not only sources of delight, but are also educative and act as bridges between the worlds of fantasy and reality from which children journey back and forth with great ease.

Fairs, festivals and weekly markets have been an important feature of the everyday life of rural India. Creative playthings, made in materials ranging from ivory, silver and metal to terracotta, wood, fibres and rags were all sold at these gatherings. Imaginative yet simple and inexpensive, these dolls and toys provided children's first lessons in form and texture, colour and design, light and sound, thought and feeling. Weekly markets and fairs were thus important in a child's learning experience of the adult world and its complex relationships.

The earliest and most exceptional collection of Indian toys dates back 5000 years and was found at the sites of the Indus Valley Civilisation. Apart from the extremely naturalistic terracotta figurines of human beings and animals, the people of this early civilisation made highly animated toys such as bulls with moveable heads, monkeys sliding down a string, carts with rotating wheels and birds and animals with built-in whistles, the latter being still used in Indian villages today. As Professor Fairservis writes: "Games and toys other than dolls seem to have been widely used in Harappan times. We have such things as the ball and spiral-mountain toy, pottery rattles, throw-sticks in bone or ivory, dice, miniature vases, and possibly the enigmatic terracotta 'cakes', which may have been counters...."[2] Archaeological and literary sources of Indian history of subsequent periods amply prove that a variety of amusing toys, dolls and puppets were popular all over India.

There has rarely been a sharp dividing line between the religious and the secular in Indian culture. As with human beings, the gods of the Hindu pantheon also passed through the various *samskaras* or stages in life, including childhood. Hindu mythology describes in detail the childhood of Krishna and Rama and the various games and sports which they engaged in. Even today, in most parts of India, a large number of toys are displayed in temples during the celebration of Krishna's birthday or *Janmashtami*. It is probably due to their significance in both myth and secular entertainment that dolls and toys are ritually offered to deities in West Bengal at the annual Durga Puja festival and in South India, during the Dussehra festival on a makeshift staircase or *golu-padi* decorating the *navaratri* dolls. In addition to rattles, toy-carts, birds and animals, miniature figures of gods and goddesses, mythological characters and celestial dancers and musicians form an integral part of this ritualistic display of toys.

Almost every region of India is renowned for its distinctive tradition of toys. One of the oldest and most popular media for toys has been that of painted and lacquered wood. In the bazaars of Varanasi, Lucknow, Mathura and Vrindavan,

Previous page

***Mukha* or mask of Vibhishana.**
Pigment painting on wood. 57 cm x 57 cm. Orissa. c. early or mid-20th century. 7/5235.

Vibhishana, the younger brother of king Ravana of Lanka and son of Vishravas and Malini, was granted the boon of living as a righteous man.[1] He advised his villainous brother Ravana to return Sita, who had been kidnapped by Ravana, to her husband Rama. Ravana, angry with Vibhishana, expelled him from Lanka. Vibhishana joined Rama's side and in the battle that followed Ravana was killed and Vibhishana made king of Lanka.

Such wooden *mukhas* or masks were originally made from extremely light wood locally known as *paldua* and *simli*. The village of Khandpara, district Cuttack, is famed for such masks used for the annual Krishnalila and Ramlila performances.

[1] Mani, 1984, p.846

hand-carved and brightly-painted figures of Hindu deities, a variety of animal figures, miniature temples and scenes from everyday life — such as drawing water from wells and bullock carts — are commonly sold. A type of extremely light wood, locally known as *bhurkul* or *gular*, is used to make toys which are, then, painted in vibrant reds, yellows and greens, heightened by coats of varnish.

Perhaps the richest tradition of painted wooden toys exists in Rajasthan. In addition to miniature animals, birds and figures of band players and mythological characters, especially those of Ganagaur and her consort Isar, Rajasthani dolls, including figures of mother and child and pitcher-maids, eloquently depict scenes from daily life. Animated toys such as the snake-in-the-box and rams that charge at each other by a simple mechanical push, are only a few of the delightful painted wooden toys today solely made in the towns of Bassi, near Chittorgarh and Raghurajpur near Puri.

Other centres of painted wooden toys are Shantipur and Nutangram in West Bengal, which are known for the standing owl with a brightly-painted chest of feathers.[3] Raghurajpur in Puri, Orissa is famous for its playing cards and toys and masks depicting mythological characters. In the South, Trichur and Trivandrum in Kerala are known for Kathakali dolls of teak and jack wood. Nirmal, in the Adilabad district of Andhra Pradesh, produces a variety of painted wooden toys using a wood locally known as *tella puniki* (*Glotia rattle formis*). Kondapalli in Krishna district, where the same wood is used, is famous for its finely-painted models of human beings and scenes from rural every day life, temples, huts, birds, animals, vegetables, deities especially the *dashavatara* set, and *ambari* or caparisoned elephants.[4]

The town of Savantvadi in Maharashtra is traditionally renowned for its brilliantly shining imitation fruit and vegetables in nearly 200 varieties made from a soft light wood locally known as *pangara* (*Erythrina indica*). The *chitaris* or painters of this region also produce a variety of lac-turned toy sets packed in palm leaf baskets: miniature kitchen utensils and other accessories such as the grinding mill or *chakki*, *belan* or rolling pin, cups, glasses and jars for girls and different types of spinning tops — including those that whirr like aeroplanes, the *gulli danda*, "mallet and ball" and other games for boys. The *chitaris* of Savantvadi also paint a particular wooden doll called *bahulya*, usually for girls, made by craftsmen from nearby regions, especially Kunkeri village.[5] Other important centres of lac-painted wooden toys, with their characteristic graded coloured ring designs formed by the application of coloured lac on a rotating object, are Uttar Pradesh, Rajasthan, Gujarat, Andhra Pradesh, Sheopurkalan in Moraina district, Madhya Pradesh, Salem in Tamilnadu and Channapatana in Karnataka.

Special carved red wood toys are made at the pilgrimage centre of Tirupati in Andhra Pradesh. The chief production centres of these "Tirupati dolls", as they are called, are Tiruchanur and Madhavamala in Chittoor district. The wood used is red sanders (*Pterocarpus santalinus Linn*). Figures of deities, mythological characters and the famous married couple or *dampatti* are only a few of the carvings executed in bulky forms and somewhat simplified and shallow-cut surface ornamentation. There are special chisels for carving different features of the image or doll. Thus, the *valu uli* is used to carve out the eye region, the *gubba uli* for the breasts, the *konlu uli* for the vesture and garlands and so on.[6]

In almost the length and breadth of the country terracotta has traditionally been the most popular medium for making toys. The tribal regions of Madhya Pradesh, especially Bastar district, produce a breathtaking range of toy animals, both miniature and life-size. The "shocked monkey" with its wide-open eyes and hand on cheek as if startled, is extremely popular. The slightly elongated legs with holes for the wheel attachment is a particular style of the area. In Bundelkhand and Malwa districts terracotta toys, of which the elephant Airavat is very popular among children, are sold during the Dipavali festival.

The village of Barpali in Sambalpur, Orissa is famous for its highly ornate toys, which usually display the elaborate use of the pellet and include animal and bird figures, palanquins carrying the newly-weds and the long-snouted, floppy-eared Ganesha.

Goalpara in Assam and Birbhum and Bankura districts in West Bengal are known for their characteristic pinched facial renderings of the mother and child, equestrian figures and, most recently, bicycle riders.

Guleria Bazaar, in the Gorakhpur district of Uttar Pradesh, is known for its terracotta elephants and horses highly embellished with danglers and decorative incisions.

Krishnanagar in West Bengal is the centre for highly realistic miniature models of human beings which usually depict typical life in Bengal. These dolls, generally called "costume dolls"" are meticulously costumed and a mendicant, for instance, will be depicted complete with his begging bowl and saffron robes. Even the facial features are highly natural, almost to the point of photographic realism.

In Madhubani, Bihar, the women create extremely perceptive terracotta figures of females whose saris cover their heads and fall gracefully.

All over Rajasthan, and especially in Nagaur, there exists a tradition of unbaked clay toys made in elementary forms, usually painted white and animated with lively brisk strokes of colour. Among the popular themes are maidens with pitchers, mother and child, horse and elephant riders, and scooter riders. In Sarguja, Madhya Pradesh, a variety of unbaked clay and straw figures, usually of archers, women and children and animals standing in stiff postures are painted in lime, red ochre and lamp black and are used by the Rajwar community as household decorations in addition to toys for children.

In Durgabazaar, in Cuttack and Baleshwar in Orissa, highly simplified bird, animal and human terracotta forms are produced which are lac-painted and varnished in a bold spectrum of colours. In Darbhanga, Bihar, on the other hand, there is a tradition of making terracotta toys which include birds, animals and figures of women carrying fish, pitchers and children and painting them in water colours. Also popular is the *babua* (the town-bred) maiden and the *pari* or winged female in European clothes.[8]

Cherial in Warangal district, Andhra Pradesh, has the unique distinction of making beautiful ingenious toys and dolls out of *puniki* wood, (*Glotia rattle formis*) cow dung, sawdust and clay. These dolls, painted with lustrous pigments, usually represent mythological characters such as Renuka Devi, (Parashurama's mother), Ganga Bhavani, Gauri Bhavani, and Parashurama while lions, dogs, goats, cows, and parrots are also made. Like the scroll paintings of the region, the dolls and toys also serve as aids to narration of myths and legends.

In Assam and West Bengal, *shola-pith* (*Aeschynomene aspera*), an extremely light marshy reed is used to make the traditional *mukuts* or crowns worn by the bride and groom. The reed is easily sliced by a knife into paper-thin, ivory-white layers which are skilfully joined with an adhesive to make garlands, figures of deities, toys such as bird mobiles, elephants, crocodiles, soldiers, and masks. The *malakars*, or garland makers, use water-based pigments to enliven their creations. Tiruchirapalli, in Tamilnadu, is also noted for its remarkable structural models of entire temples in *pith*.

In Madhubani, Bihar, *sikki* grass is employed in making toys using twining, coiling, matting and basketry techniques. The golden yellow of the straw-like grass is dyed in bright colours before the toys — usually dolls, elephants, hanging mobiles, miniature trees, and boxes — are made.

Metal has been a very durable medium in recreating the adult world for children. Little girls learnt their roles as future women with miniature cooking utensils

usually made by beating flat sheets of brass or copper to the required shape. A variety of toys are produced in India, especially in the central and eastern "wax-thread" complex, by the cire perdue method of casting. In this process, unlike modern mass-production, each object is cast using a new mould, so that no two toys are identical. The toy metal figures of the tribal Khondhs of Orissa are exemplars of this tradition, regarding which E. Thurston, as early as 1909, wrote: "Reference has been made above to certain brass playthings, which are carried in the bridal procession. The figures include peacocks, chameleons, cobras, crabs, horses, deer, tigers, cocks, elephants, human beings, musicians, etc."[9] Dr. Stella Kramrisch quotes from the information provided by the Victoria and Albert Museum, London: "the figurines are playthings for the use of the bridegroom (generally about ten years old)."[10]

India has a variety of puppetry traditions.[11] Employed in both religious ritual as well as in mass entertainment, they endeavour to create and recreate for their audience, the mythical, the tragic, the humorous and the unknown.

The *sutradhara* or "puller of strings," in Vedanta philosophy, is likened to the supreme manipulator, Brahma, who performs backstage, so to speak, from the cosmic world.[12] This world is thus a stage in which humans, as puppets, experience the agonies and joys of life, while being governed by a predetermined destiny in the hands of the manipulator.

The *kathputalis* or string-puppets of Rajasthan, with their wooden heads, large painted eyes and dazzling trailing skirts, enact the heroic deeds of Rajput warrior kings, especially Amar Singh Rathor and Dhola and Maru, a tale of unrequited love, the puppeteers, usually of the Bhat community are itinerants who originally came from Jodhpur.

The string and rod puppets of Thanjavur in Tamilnadu, called *bommalattam* weigh nearly ten kilos and are realistically rendered. The strong strings of each puppet are attached to a cloth-covered iron ring that is placed over the puppeteer's head like a coronet, leaving his hands free to operate the long rods attached to the puppets.

Stories from the great epic *Mahabharata* and that of snake goddess Manasa Devi are depicted in the *Putul Nautch* of West Bengal. The puppets are modelled from a mixture of clay and rice husk over bamboo rods. The dolls are rather stiff and it is the puppeteer himself who produces the dramatic effect by performing vigorous dance movements.

The rare glove-puppets of Orissa and Kerala, carried around by wandering mendicants, depict the tales of Lord Subramanya, brother of Ganesha.

The unusual, two-dimensional shadow puppets of the Deccan and South India are made of goat, cow or deer skin with stark outlines and numerous ornamental perforations. The silhouetted figures of these leather puppets, presented from behind a lamp-lit cloth screen, represent "other worldly" forces to their audiences. Known as *Ravana Chhaya* in Orissa, *Thol Pava Koothu* in Kerala and *Tholu Bomalatta* in Andhra Pradesh, shadow theatre in India was originally a mode of worship of local temple deities. Themes from the epic Ramayana are enacted by highly-skilled puppeteers through manipulating bamboo sticks attached to the puppets. The extremely animated performance, along with the drum beat and loud narration of stories in rhetoric, is highly effective in transporting the spectators into the world beyond.

In India masks of numerous materials such as metal, wood, matting, clay, gourd, papier maché, pith, cloth and facial painting, are employed in ceremonies related to fertility, family and community well-being, theatrical play, initiation, marriage, festivals, propitiation and invocation of spirits and deities.

In the tribal belt of middle India as well as in many areas in the South, masks are essential preparations for the temporary inhabitation of the spirit or deity into the disguised human receptacle. The deity is said to "possess" the wearer of the

mask who loses his own personal identity and attains — even if temporarily — the identity of a vehicle of communication for the spirit. "The mask, *mohara,* through which the deity speaks is made of brass in the Kulu valley of the Western Himalayas"[13] Metal masks of Panjurli or the pig deity, of Huli devaru or tiger bhuta and of Jumadi bhuta, are commonly used and sold in coastal Karnataka where they are integral to the propitiation of *bhutas,* the spirit deities of a regional ancestoral cult.[14]

In many areas of Orissa and Bihar, dancers wear the *chhau* mask in the spring festival in honor of Nata Bhairava, the fearful dancing form of Shiva,[15] while in others it is dedicated to Ardhanarishvara, the composite form of male Shiva and female Shakti.[16] These clay masks, covered with gauze and paper and painted in pastel colours in highly stylized features, depict various human emotions in addition to representing animals, birds, celestial beings, demons, ascetics, warriors, court dancers, etc. and are important adjuncts of the Chhau dancer's costume.

In tribal India, masks are "found among the Gonds, Pardhans and Baigas of the Central Provinces, ... are decidedly rare in Orissa except among the Konds and Bhuiyas and ... are fairly common among the Murias"[17]

The Bhuiya masks are intended for divination before the annual hunt while the Khond masks are connected with their past practice of human sacrifice. The Muria masks are worn by young boys enacting short themes from daily life, while the Gond masks are worn for dancing during weddings. The Baiga mask is worn by young men during the Chherta festival, after the harvest and the beginning of the new year. Begging from house to house for grain and dancing outside the Mahadeva temple with these masks at night is an important feature of the festival.[18]

1. Census 1961m, p.3
2. Fairservis, 1975, p.287
3. Mookerjee, 1968, plates 24,25
4. AIHB, n.d
5. Census, 1961m, p.4-5
6. Census, 1961b, p.27
7. Mookerjee, 1968, p.14
8. Census 1971b, p.40-1
9. Thurston, 1909, Vol. III, p.391-2
10. Kramrisch, 1968, fn.42, p.77
11. See for instance, Pani, 1986 and *Marg* XXI, 1968
12. *Marg* Vol. XXI, No.3, 1968, p.3
13. Kramrisch, 1968, p.62
14. Thurston, 1909, Vol. V, p.145
15. Kramrisch, 1968, p.62
16. *Marg* XXII, 1968, p.26
17. Elwin, 1951, p.136
18. Information regarding tribal masks is taken mainly from Elwin op.cit

Bendri, **monkey on wheels.**
White-lime dabbed terracotta, twigs and string; 15 cm x 14 cm. Bastar, Madhya Pradesh. Contemporary. 7/5496.

Among the Parja, Gadba and Dhurva tribes of the non-hilly regions of Bastar, the *bendri*[1] is commonly offered to the Mardhiya Devi or deity of the home, installed inside the hut for the general well-being of the family. The *bendri* may also be used as a votive offering to the deities of the village in the local

devalla and *devgudi*, or village shrines of male and female deities respectively, or even to the spirits of the jungle, at the *sarna* or jungle shrine. The *bendri,* according to local informants, represents the ordinary red-faced monkey and not the "black-faced" langur.

No potter in the village will ever have anything readymade and votive animal figures are invariably commissioned in advance, before major festivals and ritual occasions. The white spots — a traditional decorative element on the animal — may also signify the particular potter's identity. Other votive animals such as the *pola baila,* or bullock on wheels, is offered at the village *devalla* during the Pola festival in large numbers, sometimes over five per family, for the general propitiation of the deities and well-being of the village. Once offered, these votive figures become playful toys for children and are willingly dragged along on wheels by their new masters.

[1] In conversation with Mushtak Khan

Locomotive engine with driver. Slip washed terracotta; 18 cm x 10 cm. Guleria Bazaar, Gorakhpur, Uttar Pradesh. Contemporary. VCD.

From bullock-carts to locomotives, Indian children have obviously learnt to play with toys that reflect the changing environment. This extremely perceptive locomotive on moveable wheels is the creation of Gulab Chand, a potter from Gorakhpur. Unlike the traditional, highly ornate, elephants and horses characteristic of the Guleria Bazaar potters, this simple plaything is a refreshing innovation. The pinched face of the driver is reminiscent of the work of potters from West Bengal and Assam, although the *kabeez* or slip, giving the toy its lustrous finish, is typical of Gorakhpur.

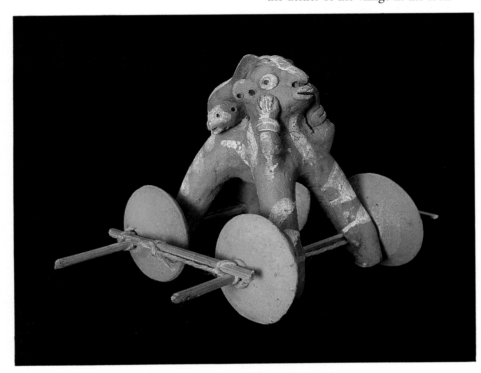

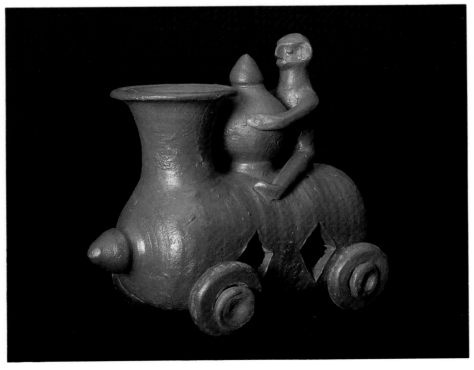

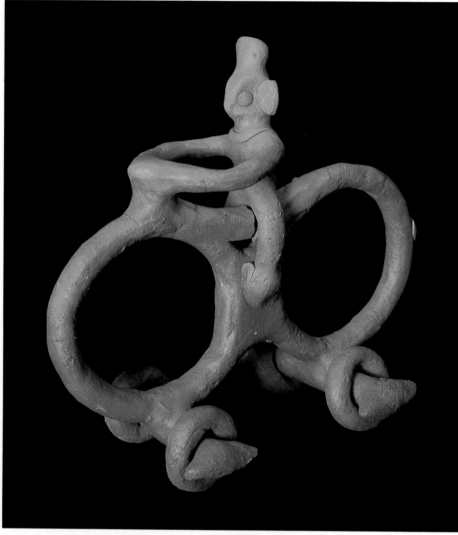

Top
Cyclist. Terracotta; 18 cm x 9 cm. Goalpara, Assam. Contemporary. VCD.

Cyclewallas or cyclists are a common sight all over India. However, this cyclist with immoveable tyres though animated by superficial wheels, is the creation of potter Dhirendra Nath Pal in response to the changing tastes of his clientele. During fairs and festivals the cycle, among other toys, is sold in huge numbers and dragged along a string by enthusiastic little boys and girls.

The pinched facial rendering and elephant-like floppy ears are characteristic of Assam terracottas of which Shashtimai, or goddess Shashti with a child, and Hathimai, a female figure with *hathi* or elephant ears, are most popular.

Below
Scooterist, mother and child. Painted clay; 23 cm x 20 cm. Nagaur, Rajasthan. c. mid-20th century. VC.

The unbaked clay toys of Nagaur are characteristically white-washed upon which lively and decisive black line brush strokes define the eyes and other decorative details. Olive green, blue and yellow ochre are the other colours used in the somewhat chaste ornamentation of the figures. Simplistic human forms, the shoulders merging with the curvilinear arms, the heads invariably elongated with elaborate hairdo, coupled with the goggle-like rendering of the eyes, give the figures an almost comical appearance.

The stern mother with her bird-faced baby, and the highly amused *scooterwalla* or scooterist are eloquent reminders of innocent childhood.

Opposite page, top
Dolls and toys, votive figures for ritual display. Lac-painted terracotta; 10 cm x 14 cm; 12 cm x 8 cm; 13 cm x 9 cm; 15 cm x 9 cm. c. mid-20th century. Baleshwar, Orissa. 7/5291; 7/5290; 7/3169 (6); 7/3169(7).

In Baleshwar, Orissa, as well as adjoining areas in Bengal, the *Shankhare* caste of lac bangle makers produce a heartening variety of lively terracotta dolls and toys, lac-painted in bright, spirited colours. Birds, horses, animals, *raja-rani* or king and queen, *ladka-ladki* or boy and girl, are only a few such toys.[1]

Essentially used as votive offerings to deities, the human figures are wishes made by childless couples desperately praying for a child. The terracotta toys are also employed for ritual display in temples during important festivals such as Holi, Shivaratri, Durga puja,

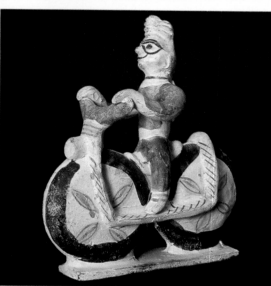

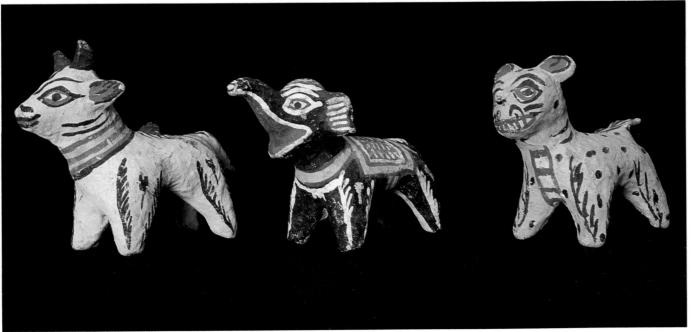

Rathayatra and Baliyatra.

Strange, although appropriate, the human forms resemble the armless images of lord Jaggannath, the foremost deity in Orissa. According to popular belief, Lord Jagannath, literally, "Lord of all creatures in this world", is said to have arms that reach infinity in all directions and therefore may not be represented with arms or legs in the manner of his humble human devotees.

[1] In conversation with craftsman Shankharasan Nandi from Baleshwar

Toy animals. Pigment painting on paper and cow dung models; 10 cm x 15 cm; 12 cm x 14 cm; 11 cm x 12 cm. Orissa, c. mid-20th century. VC.

In Puri, and to some extent in Raghurajpur, there exists a tradition of making wonderful light weight figures, also known as *gobar kandhayi*, or "toys made from cow dung". Unlike the papier maché technique, the toys are created by covering a clay model of the envisaged toy with layers of old paper moistened with water and gum. A string placed beneath these layers, along the central horizontal axis of the model, is then gently jerked out, effectively causing the paper model to be cut in half. The inner clay mould is removed and the hollow paper image put back together with the help of gum and cow dung. The surface is then smoothened and painted, initially in base white, upon which the bright colours of facial and other details are added. Often such toy animals, with moveable heads, are also made in very large sizes.

Toy animals on wheels. Lac-painted wood; 17 cm x 9 cm; 34 cm x 6 cm. Channapatna, Karnataka. c. mid-20th century. 7/3405(1), 7/3405(2).

The town of Channapatna, in Bangalore district, is known for its lac-painted wooden toy industry. Using a soft, fine-grained light wood, locally known as *hale* or *doodhi*, and sometimes yellow teak, a variety of toys such as miniature tea sets, dolls, wind mills, engines, aeroplanes, birds and animals on wheels, rattles, yo-yos, skipping rope handles, counters, tops and a whole range of utilitarian and decorative items are produced on the hand lathe or *pati*, in a dazzling spectrum of coloured lac.

The craft is generally practised by Muslims and certain Hindu communities and is largely confined to Makan, Diara, Khilla mohalla and Yelakeri [1] areas of the town.

[1] Courtesy: craftsman Sayyid Yadullah from Channapatna

Talli bidda, Mother and child.

Pigment painting on wood, saw-dust and cow dung models; 15 cm x 14 cm. Andhra Pradesh. c. mid-20th century. 7/3887.

An extremely light wood, locally known as *puniki*, (*Glotia rattle formis*) sawdust and cowdung, are used to create beautiful figures such as this mother and child. Essentially play toys for children, these *kundanapu bommas*, literally "beautiful figures," are also votive offerings to deities. Especially significant is the model of the child Krishna offered by childless couples. On weekly markets and important festivals such toys including animals and horse riders are locally sold on the streets for very meagre prices.

In this figure the baby, depicted as an extension of the mother's body, is obviously an attachment in sawdust and cow dung to the main three-dimensional wooden axis of the seated female figure. The extremely simplified toy, painted rather chastely, is nevertheless silently persuasive.

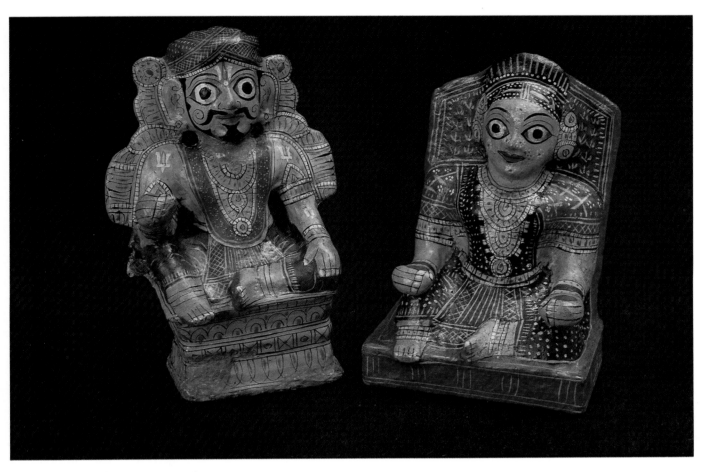

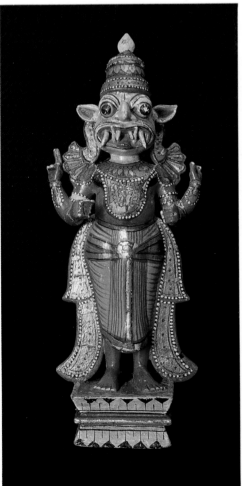

Top
Velamma Naidu and Pedamma Devi, toys for ritual display and narration. Pigment painting and lacquer on models of wood, sawdust, cloth and tamarind seed powder; 22 cm x 14 cm; 25 cm x 9 cm. Cherial, Warangal, Andhra Pradesh. c. early 20th century. 7/3059(1), 7/3060(2).

In addition to narrating stories depicted on cloth panels, the itinerant "picture-showmen" of Andhra Pradesh also use such painted models [1] representing various deities, birds and animals as aids to narration. These toys, created by the Nakkash community of scroll painters, are essentially models or *puttalas* of wood, sawdust and tamarind seed powder covered with a thin layer of cloth which is subsequently prepared for painting in bright colours, the black outlines and eyes being filled in last.

The male figure, Velamma Naidu, with a typical turban or *patka*, is that of a socially prominent man, while the female, Pedamma devi, typically painted yellow, is the wife of Pedi Raja, a king. The two are part of a set of figures employed in the narration of local myths and legends for the benefit of the Yadavs or Dhangars, a community which is generally pastoral. The itinerant performers who use these toys for narrative display are the Mandhets who go around singing tales to the clients sometimes for over 15 to 20 days for a nominal fee, usually paid in kind.

[1] In conversation with painter-craftsman D. Chandriah Nakkash from Cherial

Left
***Narasimha avatara,* man-lion incarnation of god Vishnu.** Pigment painting and lacquer on models of wood and saw-dust. 30 cm x 11 cm. Kondapalli, Andhra Pradesh. c. early 20th century. 7/4610.

Also popular among the clientele of the itinerant "picture showmen" is the *dashavatara* series or figures representing the ten incarnations of lord Vishnu. Traditionally such figures, usually much larger in size, were kept in temples as idols for worship.

The distinctive style of painting on wood with meticulous ornamentation using gold on red and the enchanting zoomorphic head with protruding ears are an asset to the deity's regal character.

201

Dolls. Painted wood, sawdust and cotton cloth; 20 cm x 10 cm; 20 cm x 11 cm. Kondapalli, Andhra Pradesh. c. early 20th century. 7/2684(5); 7/2684 (6).

Tella puniki, (*Glotia rattle formis*), a very light, white colored wood, is used to create the most delightful painted toys such as these dolls — one of a women carrying a handbag and a parrot on top of her head and the other wearing a shawl across her shoulders. Other figures made at the famous centre, Kondapalli in Krishna district, are the *dashavatara* or ten incarnations of Vishnu in a set of ten birds or animals, including the *ambari-hathi* or caparisoned elephant with seat, temples, huts, scenes depicting religious, legends or *harikatha*, as well as secular scenes of toddy-tapping and even that of an administrative office complete with miniature models of officers!

Rama, Sita, Lakshmana and Hanuman, toys for ritual display. Painted and varnished wood; 31 cm x 12 cm; 31 cm x 12 cm; 26 cm x 21 cm; 26 cm x 21 cm. Varanasi, Uttar Pradesh. c. early 20th century. 23/48, 23/50, 23/49, 23/57.

Varanasi, in Uttar Pradesh, is famous for its folk tradition of annual performances of Rama Lila or plays enacting the life history of Shri Rama, the seventh incarnation of Vishnu and son of king Dashratha of the Solar dynasty. The painted and varnished wooden toys are made from a kind of soft, light wood locally known as *bhurkul* or *gular*.

The figures reveal the spirit of the Rama Lila both in artistic expression, particularly in the mode of attire and adornments, as well as in the iconic representation of the mythological characters of the epic *Ramayana*. Shri Rama is accompanied by his half-brother, Lakshmana, his faithful monkey devotee, Hanuman, and Sita his beloved wife. The four are depicted together for they are said to have spent more than 10 years together in the forest following Rama's banishment from the kingdom, on the wishes of his step-mother Kaikeyi, who wanted her son Bharat to be crown prince of Ayodhya instead of Rama, the rightful heir.

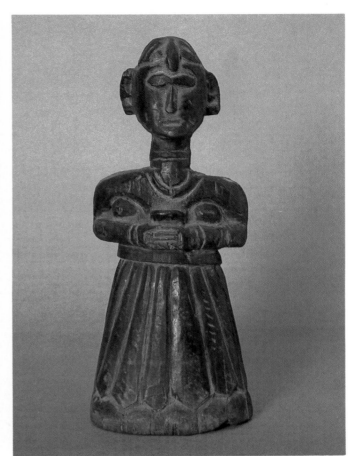

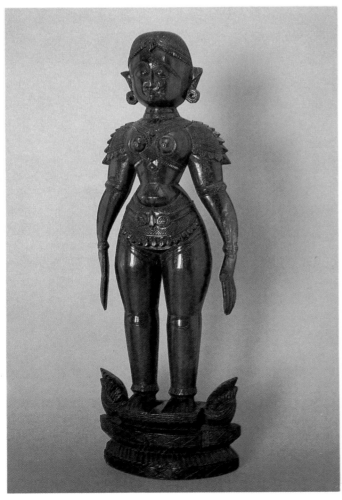

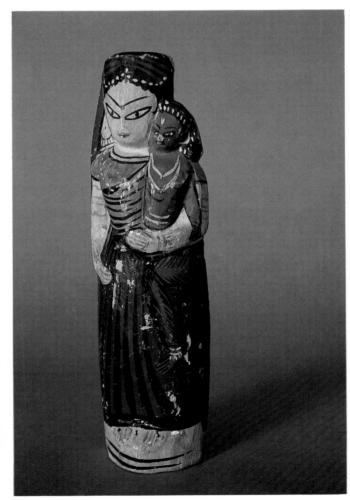

Doll, woman operating a hand mill.
Painted wood; 19.5 cm x 12.5 cm.
Bassi, Rajasthan. c. mid-20th century.
7/4261(1).

In Rajasthan, as elsewhere in India,
girls are initiated into various
household chores at an early age when
they are given dolls and toys depicting
scences from daily life. This doll,
grinding grain on a hand-operated mill,
usually of heavy solid slabs of stone in
real life, is a representation of a woman
engaged in domestic activities in rural
Rajasthan. So true to life is the scene
that even the doll's outstretched leg
supporting the mill was held in the
minds' eye of the perceptive
painter-craftsman.

Also famous among the painted
wooden toys of Bassi, in Chittorgarh,
are the mobile shrines known as *kavads*,
carried from village to village by bards.
These shrines are hung across the chest
and the multi-folded shutters open out
sideways displaying the deity's sanctum,
as well as the narrative legend painted
on the door panels.

Previous page, top right
Doll with folded hands. Carved
wood; 30 cm x 6 cm. Gujarat. c. early
to mid-20th century. 7/3800(3).

The most exquisite carved wooden
furniture is made in Gujarat where the
wood carvers also fashion wooden
pillars, window panels and brackets in
addition to dolls and toys for children.
The doll motif is sometimes found on
brackets and furniture.

This doll, holding a cup in her hands,
is carved in the particular stolid style of
the region. The austerity of the facial
rendering and the folded hands of the
doll give it a devotional air.

Previous page, bottom left
Doll. Carved red sanders wood; 45 cm
x 15 cm. Tirupati, Andhra Pradesh.
c. mid-20th century. 13/232(2).

"Tirupati wooden dolls" or *Tirupati
koyya bommalu* as they are popularly
known, are not in fact manufactured in
the pilgrim town of Tirupati, but in
neighbouring villages, mainly
Tiruchanur in Chandragiri taluk and
Madhavmala in Kalahasti taluk.
According to the Imperial Gazetteer of
India (1908), the craft was originally
practised by persons belonging to the
Visvabrahma community who produced
extremely simplistic dolls with little or
no ornamentation. Later the carvings
on the dolls became more elaborate and
stylised.

The dolls are temple souvenirs for the
millions of pilgrims who visit the shrine
of lord Venkateshwara at Tirumala.

Usually the figures are those of deities
such as Vishnu, Krishna, Rama,
Lakshmana, Sita, Hanuman, Sarasvati
and Ganesha. Also popular are the male
and female pairs known as *dampattalu*,
pindlikoothuru and *pindli kuduku* or
bride and groom.

The wood employed is locally known as
raktchandan or red sanders, a deep
burgundy brown wood that darkens
with time. In the past the wood was
used for the extraction of a red dye
known as *santallin*. In West Bengal it is
used in funeral pyres due to its affinity
with *chandan* or sandalwood.[1]

[1] A.I.H.B., 1963

Previous page, bottom right
Mother and child. Painted and
varnished wood, 24 cm x 7 cm. West
Bengal. c. mid-20th century. 7/4882(1).

In Bengal, whether it is painting on
wood, *sholapith* or paper, Durga — and
consequently all other female figures —
are invariably depicted with highly
stylised eyes executed in a swift black
brush stroke tending to almost reach
the temples. This doll is recognisably a
Bengali painter's rendition of a mother
with her child.

Following page, top
Elephant. Pigment painted and glued
marshy reed or sholapith; 20 cm x
13 cm. Assam. Contemporary. VCD.

Sholapith (*Aeschynomene aspera*), a
marshy reed, is used to create the
all-important wedding crowns or
mukuts worn by the bride and groom
in Bengal and Assam. The paper-light
ivory-coloured stem of the reed is easily
sliced with a sharp knife and glued
together with a locally produced gum
known as *aatha*, to fashion garlands,
masks, figures of deities, especially
Durga, and a delightful range of toys
for children such as this pigment
painted miniature elephant.

According to a legend,[1] Sholabati, a
deva nartiki or celestial dancer, fell in
love with Banasura, an *asura* or demon
in the court of Indra. Indra, displeased
with her public display of affection,
cursed her giving her the form of the
shola reed. Distressed by the curse,
Sholabati fell at Indra's feet, pleading
for mercy. Indra altered the curse in
that only in the hands of the *malakars*
or garland makers would she ever be
purified and of any use to others. Till
today, before beginning their work, all
malakars prepare a garland of *sholapith*
and throw it in flowing water around a
stick dug into the sand to make
Sholabati frolic in the water with her
beloved Banasura believed to be the
creator of floods.

[1] In conversation with craftsman Anil Chandra
Malakar

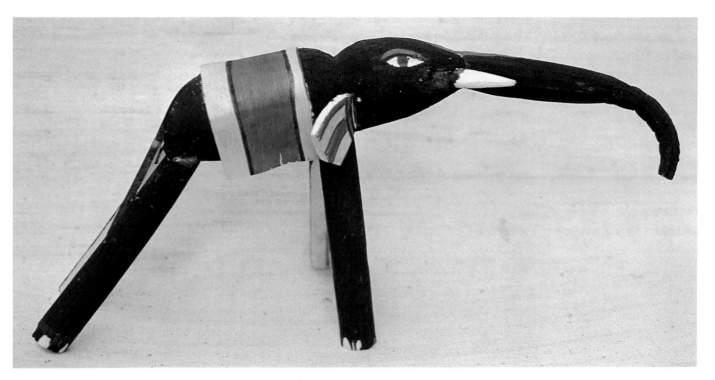

Snake-in the box, animated toy.
Painted wood and string; 15 cm x
3.5 cm. Orissa. c. early 20th century.
13/67(2).

The snake inside this animated box is
designed to spring up suddenly when
the box is opened providing an element
of surprise so crucial in playthings for
the young. Such toys are also extremely
beneficial in the treatment of the
physically and mentally handicapped as
well as aphasic patients, where the
sudden shock of seeing something
totally unexpected acts as a therapeutic
device in startling the patient out of his
or her inertia.

Masks of mythological characters.
Pigment painted wood; 65 cm x 48 cm;
61 cm x 49 cm. Maharashtra or
Gujarat. c. early 20th century. 7/6212,
7/6204.

In the adjoining border areas of
Maharashtra and Gujarat folk and
regional versions of the *Ramayana* and
Mahabharata epics are regularly
enacted. These theatrical performances
which are made up of much music,
song and dance make use of such masks
of mythological characters.

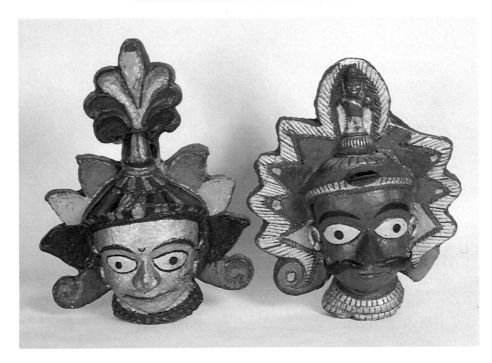

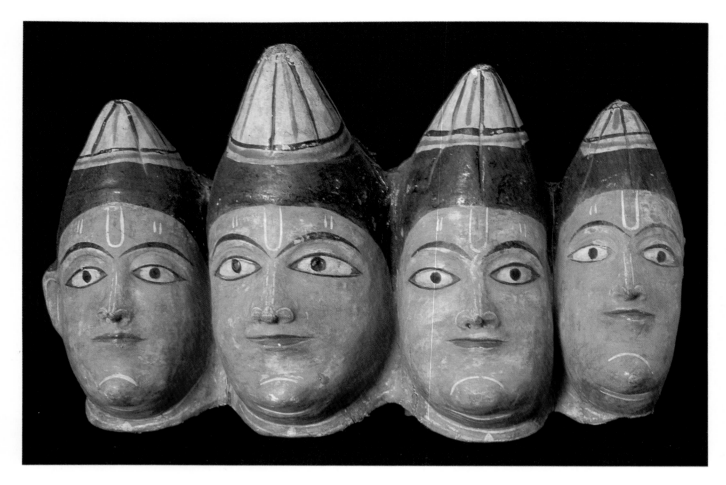

Four-headed mask for *Chhau* dance.
Pigment painting on papier maché and
gauze; 51 cm x 26 cm. West Bengal or
Bihar. c. early 20th century. 7/2359.

Chhau, an extremely energetic and
forceful dance, is a unique combination
of a pure dance recital and a
pantomime. Generally, Chhau dances
symbolise the victory of good over evil
in mythical, religious and secular
themes and the mask unleashes in the
dancer the vital qualities of the
personified character, be it a bird,
animal, demon or deity.

[1] For more details see Cat. No. IX/21

Opposite page
***Hamsa* or swan mask for Chhau
dance.** Pigment painting on papier
maché and gauze; 26 cm x 16 cm. West
Bengal or Bihar. c. mid-20th century.
7/2368.

The Chhau dance, a ritual dance-drama
enacting themes from the epics, is
essentially "of Bengali origin and it has
ultimately spread upto the districts of
Bihar namely Ranchi, Singhbhum
(which includes Seraikella) and of
Orissa, namely, Mayurbhanja.[1]

This *hamsa* or swan mask, made from
papier maché and gauze, strikingly
conforms to the pantomime of a swan.
The highly stylised eyebrows, lips and
nose are reminiscent of exaggerated
features in a theatrically vigorous

performance that necessarily "mask" the
Chhau dancer's individual feelings.

[1] Bhattacharya, 1972, p.31

206

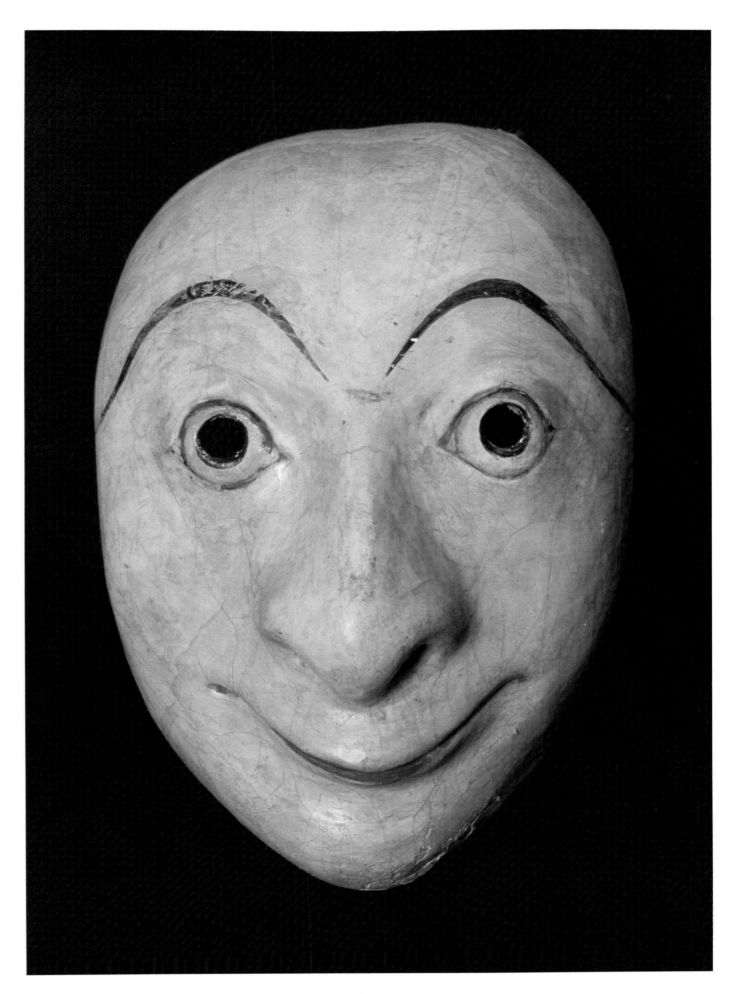

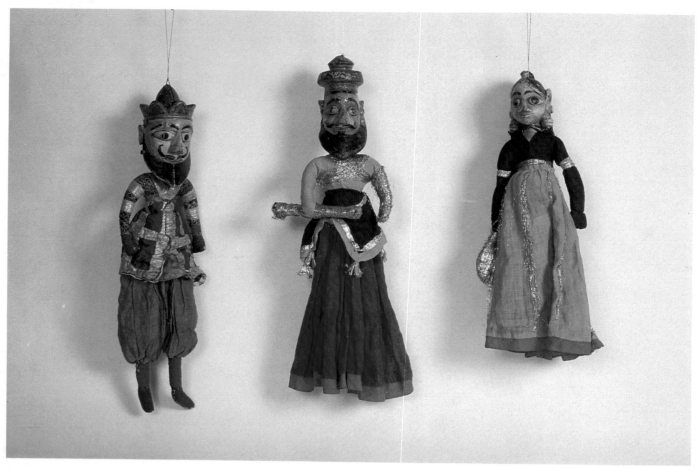

Above

Kathputlis, string puppets. Pigment painted wood and rag cotton cloth; 60 cm x 24 cm; 49 cm x 24 cm; 57 cm x 19 cm. Rajasthan. c. early to mid-20th century. 19/83, 19/84, 7/2127(25).

In many parts of Rajasthan the Bhat community of itinerant bards move with their mobile puppet theatre enacting the heroic deeds of Rajput warrior kings such as Amar Singh Rathore and the unrequited love story of Dhola and Maru.

The *kathputlis*, literally "wooden images", typically have wooden heads with large painted eyes and torsos adorned with dazzling, trailing skirts.

Sage, shadow puppet. Vegetable pigment stained goat skin; 113 cm x 60 cm. Andhra Pradesh. c. early 20th century. 7/4260(12).

In Andhra Pradesh the *Tholu Bomalatta* tradition of travelling shadow puppet theatre typically enacts the voluminous epics, *Ramayana* and *Mahabharata*. Made from goat, cow or buffalo skin, the Andhra Pradesh puppets are sometimes more than five feet high. They are transluscent, stained in vegetable dyes and are extremely stylised in facial and garment rendering.

Viewed as shadows from behind a lamp-lit cloth screen, the puppets are manipulated with the help of bamboo sticks attached at certain points, usually at joints on the shoulders, knees, elbows and head. The highly animated performance, along with the drum beat and loud narration of stories is highly effective in mesmerising the spectators transporting them into another world.

This figure of a hermit with his characteristic knotted hair and beard is depicted with the large angry eyes of one who has been rudely disturbed in meditation.

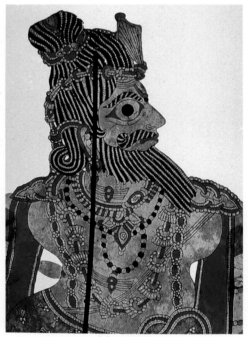

Appendix

An Overview of the Museum's Collection

Serial	Crafts Description		No. of Objects
I	Basketry, bamboo, cane, etc.		551
II	Clay and terracotta		2183
III	Floor coverings		164
IV	Glass, beads, etc.		65
V	Ivory, shell, bone, etc.		322
VI	Jewellery and ornaments		539
VII	Leather		356
VIII	Metal:	bidriware	151
		figures	1001
		iron	38
		precious metals	624
		utensils	1016
		miscellaneous	312
IX	Masks:	papier maché, wood, etc.	90
X		Musical instruments — drums, etc.	9
XI	Painting:	on cloth	327
		on glass	29
		on ivory	150
		illustrations	12
		on paper	3884
		miscellaneous	103
XII	Papier maché		60
XIII	Stone:	carvings	114
		objects/utensils	57
		miscellaneous	76
XIV	Textile:	applique	90
		brocade	363
		embroidery	962
		knotting, knitting, etc.	33
		printed, painted, etc.	393
		tie-and-dye	86
		costumes	363
		woven	688
		miscellaneous	602
XV		Wood: architectural	79
		carts	4
		furniture	121
		sculptures	615
		miscellaneous	1490
XVI	Other miscellaneous objects		103
	Total		18225

Compiled by Smt. J. Chauhan, Assistant Curator, National Museum of Handlooms & Handicrafts.

Glossary

aatha : a local gum in Assam and West Bengal

abharanam petti : lac-turned wooden casket with brass locks, hinges and beadings

abho : women's upper garment in Kutch, Gujarat

abrawan : mixed brocade fabric of Uttar Pradesh

achari : community of twice-born or high caste artisans of the South

adhunik patas : paintings of Bengal depicting modern themes

Adi Gaud : Brahmin community of stone sculptors of Gujarat and Rajasthan working in the Hindu and Jain tradition of temple architecture and sculpture

adi kurma : mythical tortoise

adyana : waistbelt in Kannada

aftaba : spouted vessel generally used for wine

agar : brownish-red natural substance

agin : basket used by men of the Adi Gallong tribe to carry rice in Arunachal Pradesh

ajrakh : block-printed fabrics of Kutch

alpona : auspicious symbols or diagrams outlined on the floor by the women of Bengal

ambari hathi : ceremonial elephant in Andhra Pradesh with a seat and canopy on its back for the rider

ambi : mango motifs

amjori : type of cane in Garo

amli : embroidered shawl of Kashmir

amli-pipli : game played between the Pandavas and Kauravas in the *Mahabharata*

amrita : nectar of the gods

amru : mixed brocade fabric from Varanasi, Uttar Pradesh

anchal : end-piece *(pallav)*

anjali : offering usually made by cupping the palms together

anjali mudra : stance wherein both hands are cupped together for offering

ankh : brocaded border design of the Maheshwari sari from Madhya Pradesh

apna : auspicious symbols or diagrams outlined on the floor by women in the western Himalayas

aragu kulishan : summit of a temple in South India

Aradhanarishwara : male-female figure of Shiva and Parvati

ari bharat : hook embroidery of the Thar desert

aripona : auspicious symbols or diagrams outlined on the floor by women of Bihar

arundee : local term for the castor plant in Assam

asura : demon

atiz : rice paste used as an adhesive to bind pulped paper to make papier maché in Kashmir

atlas : term for *mashru* fabric

attardan : rose water sprinkler

ayas : term for bronze and/or copper in the *Rigveda*, which later came to mean iron

Ayurveda : books of Indian medical science

babua : 'town bred' doll popular in Darbhanga, Bihar

badva : human receptacle for the spirit of the deity i.e. spirit medium among the Rathwa and Bhilala tribes of Chhota Udaipur in Gujarat and adjoining areas of Jhabua in Madhya Pradesh

bagh : embroidery of Punjab that covers the entire surface of the fabric such that only the floss silk is visible

bagida : tie-dyed shoulder cloth traditionally worn by Harijan women of Gujarat and Rajasthan

bahulya : type of doll made in Sawantwadi, Maharashtra

bajuband : armband worn on the upper arm; from *baju*, meaning upper arm and *bandh*, meaning to tie around

Balakrishna : child Krishna

bandhana : to tie

bandhani : women who do the tying

bandhej : technique of tye-dyeing designs on cloth in minute dots, distinctive of the Thar desert region

bansphor : worker in cane and bamboo in North India

basava savaras : bullock attendants and riders of the *bhuta* cult of spirit worship in coastal Karnataka

bashing : wedding head-dress among the Warli tribals of Maharashtra

basor : worker in cane and bamboo in North India

batti : cubes of coloured lac prepared by mixing shellac or purified lac with mineral colours

baul : itinerant minstrals of Bengal

baul kadi : spindle-shaped motif in Orissan sari

beejboni : bamboo basket for carrying seeds in Sarguja, Madhya Pradesh

belan : rolling pin, in Northern India

bendri : votive terracotta figure of a monkey on wheels in Bastar, Madhya Pradesh

Bhadra : Hindu month between August and September

bhagat : priest of the Dushadh community of Bihar

bhala : javelin in Northern India

bhang : *Cannabis sattvica*

bhatti : kiln

bhinanta : loose warp at edges

bhitti chitra : paintings or drawings executed on a wall

bhopa : itinerant narrator priests of the painted scrolls of Rajasthan

bhumi shobha : paintings or drawings executed on the floor to enhance its beauty

bhurkul (or gular) : light wood used in Varanasi to make toys

bhuta aradhana : invocation of the *bhuta* spirits that involves, in addition to daily worship, a periodic propitiation in the form of possession rituals.

bhutas : deities of coastal Karnataka

bhuta ganas : attendants of Shiva

bhutasthana : shrine of *bhuta* deities of coastal Karnataka, usually near a *peepal (ficus religiosa)* or banyan tree

bichhwas : toe rings worn by married women in Bundelkhand, Madhya Pradesh

bidri : inlay of gold and silver wire on the blackened surface of an alloy of zinc and copper named after Bidar, a town in Karnataka

bielan : grid pattern on the *sheetalpati*, in Assam

bigha : land measure

birhors : a caste which slices bamboo in Northern India

bommalattam : string and rod puppets of Tamil Nadu

bora : waistband of tiny silver beads that resemble smallpox postules and are meant to ward off the disease

bottu : traditional danglers on silver necklets worn by Lambadi tribal women of Andhra Pradesh

brahmasthanas : shrines visited by the Brahmin castes in Darbhanga, Bihar

bugdi : local term for reversible border of the Maheshwari sari

bukani : silvery mixture used to fill in etched patterns on pre-fired pots of Azamgarh, Uttar Pradesh

burchot : pulped paper used by Kashmiri craftsman to make papier maché items

buta : big floral motif

butadar aath phulia : type of Orissan *ikat* sari

butadar : saris with *butis* or tiny floral motifs

buti : small floral motif

chadar : veil cloth

Chaitra : Hindu month of spring between March and April

chaitya : Hindu, Buddhist or Jaina shrine

chak : potter's wheel in Northern India

chakki : grinding mill in Northern India

chakra : wheel

chakraiyas : potters who use the wheel in Bundelkhand, Madhya Pradesh

Chakshudana pat : Literally, the "eye bestowal painting" is one carried by the *jadu patuas* of Bengal to the family of a recently deceased individual wherein all but the eyes are painted, signifying the unincorporated wandering spirit of the dead. It is only after the *patua* has filled in the eyes that the spirit finds a permanent abode

chalani : round tray-like fish traps of Assam

chameli : jasmine

champa : magnolia

champakali : magnolia bud

chandan : sandalwood

chandra bimba : image of the moon

channalavattam : lamp in Kerala

chanvaradharini yakshi : female *chauri* bearer

chappat-kalam : blunt edged chisel in North India

charakku : cauldron for cooking *payasam,* a ritual meal. Made by the cire-perdue method of metal casting by the Moosaris of Kerala.

charan chitra : painting carried by itinerant picture showman

char pa ek : "four will make one", a design motif in *ajrakh* print of Kutch, Gujarat

charpoy : literally, one with four legs, a bed

chatai : brocaded border design of Maheshwari sari

chatera : ornament engraver in Northern India.

Chatia : festival celebrated in Orissa

chaukhat : grid motif in the painted pottery of Kutch, Gujarat

chaupat : traditional game of cross board dice

cheelne ki kalam : chisel for engraving and chasing the design in North India

chek : square or rectangular pattern on the *sheetal pati* of Assam and West Bengal

chhapna : to print, in Northern India

chhau : spring festival in Bengal, Bihar and Orissa involving elaborate dances in honour of Nata Bhairava, the fearful dancing form of Shiva

chhau dance : ritual dance drama in Bengal, Bihar and Orissa enacting themes from the epics using highly stylised masks.

chherta : harvest festival celebrated in Madhya Pradesh

Chhipa : printer caste in Northern India

chickan : embroidery executed in white thread on white muslin in Lucknow, Uttar Pradesh

chinar : autumn maple leaf, a floral motif employed by Kashmiri papier maché painters

chini : term for the most refined variety of silk i.e. mulberry, probably introduced into India from China and hence the term.

chirai chun mun : endearment referring to birds

chitaris : hereditary painters of Sawantwadi, Maharashtra

chitrakar : painter

chitrakatha : narrative paintings

chitrakathi : narrative paintings of Maharashtra pasted back-to-back and held up for the audience by means of a bamboo stick. Also used for itinerant disseminators of folklore who narrate the stories to the accompaniment of music.

chitti rumals : handkerchiefs of Andhra Pradesh; *chitti* in Telugu means small

chokha : refers to pure gold, in North India

choot jabra jamdani : design on *sheetalpatti,* in Assam and West Bengal

choria : cylindrical trap used in Madhya Pradesh for catching fish in flowing water

chowk : sacred enclosure within an auspicious square whose four corners face the four cardinal directions

chowka purne : auspicious symbols or diagram outlined on the floor by women in Uttar Pradesh

chudamani : forehead ornament, given to Sita by her father Janaka in the *Ramayana*

cikiststam : selected

cyclewallah : cyclist

daivasthana : shrine of the *daiva* or deity in South India

dakinis : demonesses

dalia : double-layered split bamboo basket for storing fine grain in Madhya Pradesh

dalia : North Indian salver

damaru : hour-glass shaped hand drum associated with Shaivite deities

dampattalu : male and female pair in Andhra Pradesh

dampatti : married couple

danalila : Krishna playfully demanding butter as toll from cowherdesses

danti : tooth-like motif in Orissan sari

dao : bill hook in North Eastern India

darbha : plant fibre

dargah : Muslim tomb

darshan : ritual viewing of the deity by devotees for seeking blessings

dasa : tassels

dashavatara : ten incarnations of Lord Vishnu

dauli : temple motif in Orissan sari

Dayabhaga : school of law

deh : Oriya term for the main ground of a sari

deoli : temple pinnacle motif in Orissan sari

devdasi : literally, devoted caretaker of the deity; temple dancers symbolically wedded to the deity

devalla : village shrine of the male deity in Madhya Pradesh

deva nartiki : celestial dancer

devgudi : village shrine of female deity in tribal Madhya Pradesh and Orissa

dhabu : dome-shaped lamp receptacle for deity in Gujarat

dhadi : Oriya term for sari border

dhakia : barrel-shaped grain storage basket with lid in Bihar

dhal : shield in Northern India

dhaniya ki bel : coriander creeper in Northern India

dheli : split-bamboo basket for grain storage in Madhya Pradesh

dholia : drummer in Northern India

dhuli chitra : painting or drawing executed on the floor

dhuna : black tar-like substance that becomes pliant and elastic upon the application of heat. It is extracted from the secretion of a particular tree.

dhurries : woven floor coverings

dhuvan : see *dhuna*

Dipalakshmi : Goddess of light

Dipavali : Hindu festival of lights

diyala : holder of the lamp in the Dev Narayan ritual in Rajasthan

dohrus : woollen twill weave blankets in geometric patterns, Himachal Pradesh

doyo : ladle made of gourd in Gujarat

draksh : grape

duku : Rabha fish basket, Assam

dupatta : shoulder cloth worn by women, Northern India

Durga Puja : festival where Goddess Durga is worshipped, mainly in West Bengal

dusa : rows of horizontal lines on *sheetal pati,* Assam and West Bengal

Dusshera : Hindu festival, in October, celebrated in honour of Rama and Durga

Eka Shringi Nandi : single-horned bull deity of the *bhuta* cult of spirit worship in coastal Karnataka

eri : silkworm that feeds on the leaves of the castor plant producing glossy raw silk

ezar : loose trousers worn by women in Gujarat

gadi : toy cart

gainda buti : marigold flower motif in North Indian textiles

gajabandh : elephant motif in the *ikat* saris of Orissa

Gajalakshmi : form of Goddess Lakshmi lustrated by elephants

gaji : precious silken cloth mainly in Gujarat

gamacha : towel fabric

Ganga-Jamuna : the confluence of the two sacred rivers used as metaphor for the confluence of gold and silver

Gangour ka guna : a particular type of floor painting in Rajasthan

ganjifa : playing cards

garbha griha : inner sanctum, literally abode or place of residence

Garuda : mythical eagle and vehicle of Vishnu

gaura : fair, white

Gauri : the white one — an appellation of Parvati, Shiva's consort

gavanti : stitch in *kasuti* embroidery of Karnataka

geru : red earthen substance used as a pigment

ghadai : in handcrafting precious ornaments in North India, process of shaping by hammering, soldering or casting the metal into the required size and shape

ghatta : mixed brocade fabric of Uttar Pradesh

ghora kalasha : votive painted terracotta horse riders of Darbhanga, Bihar

ghotana : pestle

ghumat : dome-shaped lamp receptacle for deity in Gujarat

gobar kandhayi : Orissan toys made from cowdung

gobi : cauliflower or cabbage

godna : tattoo designs executed on the skin

gol patti : brocaded border design of Maheshwari sari, Madhya Pradesh

golupadi : make-shift staircase made during Dussehra in South India

gophan : catapult

gopis : cowherdesses

goru gadi-chalak : bullock-cart rider in West Bengal

gosauni ka ghar : room of the family deity in Bihar

Govardhan puja : Vaishnava worship mainly in Northern India of the mythical mount Govardhan

Gouramma : female *bhuta* deity of coastal Karnataka

gram devata : village deity

gubba uli : type of chisel used by craftsment of Tirupati, Andhra Pradesh

guchch : wall plaster used with glue applied on the surface of papier maché object to create a smooth surface for painting

gudano patas : scroll paintings of Bengal that depict a single story

gudigar : sandalwood carvers of Mysore

gujuri : heavy pendant worn on the temples by the women of the Lambadi or Sugali tribe. An essential sign of marriage, its absence is a sign of widowhood

gulab : rose

gulabdan : mixed brocade fabric woven all over Northern India

gular : same as *bhurkul*

guli : flower motif in the painted pottery of Kutch, Gujarat

gule hazara : literally thousand-petalled flower, term used for a particular floral pattern employed by the papier maché painters of Kashmir

gulli danda : traditional North Indian game played with two small sticks

gurukul : teacher's or guru's residence, a school

hamsa : swan

hansli : North-Indian rigid neck band or choker that falls heavily on the collarbone

Hari : another name for Krishna

Harikatha : Krishna legends

harkalai : silvery pigment used by craftsmen of Sankheda, Gujarat, for painting on wooden furniture

hashiya : narrow patterned border of Kashmiri shawl

hatadi : stone spice container with various compartments common in Gujarat and Rajasthan

hath ari : hand-operated awl for embroidery

hathi : elephant

hathraiyas : potters who do not use the wheel

haveli : aristocratic residential building in Gujarat and Rajasthan

heer bharat : floss silk embroidery of the Thar desert

himru : mixed fabric of silk and cotton in which the extra silk weft used for brocading is thrown over the surface only where the actual pattern appears and the rest of the patterning thread is left hanging beneath the surface of the fabric

Holi : Hindu festival of colours

hukka : contraption for smoking tobacco. It consists of a bowl, a long flexible tube and a base containing water that cools and filters the smoke.

Hulidevaru : tiger deity of the *bhuta* cult of spirit worship in coastal Karnataka

hutusilli : pipe of the Nishi tribe from Arunachal Pradesh

ikat : pre-loom technique of resist dyeing wherein the warp or/and weft yarn is tie-dyed in such a way that the programmed pattern transfers in the process of weaving onto the finished fabrics. *Ikat* may be single *ikat*, i.e. warp *ikat* or weft *ikat*, or double *ikat* as in *patola*

irkal : brocaded border design of Maheshwari sari

ittal : wall paintings the Saora tribals of Orissa execute for the installation of spirits of the dead

ittalan : same as *ittal*

jada billies : circular medallions worn on the hair by dancers in Tamil Nadu

jadanagah : hair braid ornament composed of *nagas* or serpents in Tiruchirapalli, Tamil Nadu

jadu patuas : Literally 'magic' painters, itinerant painters of Bengal

jali : lattice

jamdani : figured or brocaded muslin, traditionally woven in Dhaka now in Bangladesh, West Bengal and Tanda in Uttar Pradesh

jamevar : a kashmiri shawl

Janamashtami : Krishna's birthday

janeu : sacred thread

jangla : mesh motif in Benaras brocade

jautuk pedi : dowry chest of Orissa

jhakoi : fish trap of Tripura and parts of Assam

Jhanji kutta : dog

jhanpi : cane and bamboo dowry casket in Madhya Pradesh

jharoka : window-facade-cum balcony of Rajasthan and Gujarat

jhop diya : hanging lamp in Bastar, Madhya Pradesh

jhumkas : ear ornaments with danglers, mainly in Northern India

joda patti : pairs of stripes; a traditional motif in the *mashru* fabric of Gujarat

jyonti : painting of three female deities with Ganesh, distinctive of Kumaon region of Uttar Pradesh

kabeez : slip used for glazing pots in Uttar Pradesh

kal-tac' chan : stone cutters belonging to the Kammalan community of artisans of the South

kalabattun : gold wire used in brocade weaving and embroidery in Kashmir

kala laher : black wave, a traditional motif in *mashru* fabric of Gujarat

kalam : pen, stylus

kalam : needle-sharp implement in Northern India

kalaura : container in the shape of a bitter gourd, a local term used by the nomadic Ghantrar community of metalsmiths of Orissa

kalamkaris : hand-painted fabrics of Andhra Pradesh

kalasha : pitcher

Kali : 'The black one', a Hindu Goddess

Kaliyadamana : quelling of the snake king Kaliya by Krishna

Kalki : tenth incarnation of Vishnu

kalpavriksha : wish fulfilling tree

kalu kadaga : anklets in South India

kamandalu : mendicant's bowl

kamkhi : a blouse specially made of the *mashru* fabric of Gujarat

kandarpa ratha : chariot of Kandarpa, the God of love

kangkhil : red seed of a wild creeper used by Manipuri potters to shine the surface of the clay pot before firing

kani : particular type of loom-woven shawl of Kashmir

kantha : patched cloth embroideries of Bengal using old saris stitched together in running stitch

karawal : a type of alloyed silver

kardhua jangla : a particular brocaded pattern technique of Varanasi

Karma : festival celebrated by tribal Gonds in the Chhatisgarh regions of Madhya Pradesh

karmakar : artisan community of Orissa usually engaged in stone carving

karpasam : cotton

karteyur : spun

Kartik : Hindu month between October and November

kartitam : spun

kashida : embroidery of Bihar

Kasumala : traditional coin necklace of Kerala

Kasuti : embroidery of Karnataka

kathputlis : string puppets of Rajasthan

kauna : a type of reed from Manipur

kavachh : receptable for the image of a deity worn as a pendant on a necklace. The Virashaivas or Lingayat community of the South.

kavad : painted wooden mobile shrine carried by mendicants in Rajasthan

keri : mango motif

khadi : handspun and handwoven fabric

khadi : white clay

khajur : date palm

khanjari bhat : a design in *mashru* fabric of Gujarat

kharad : hand-turned lathe

kharadi : occupational title given to lathe turners who are usually wood workers by caste in North India

kharal : mortar for grinding spices and medicines

kharek : date, in North India

khari : a particular type of raised printing with tinsel

khatis : wood carvers/carpenters of Rajasthan

khatva : an applique technique of Bihar where an entire piece of fabric is cut out in such a way that the cutout is attached to a background cloth of another colour without foregoing the contours of the original pieces.

khut diya : lamp with a pointed end that is dug into the ground in North India

kinkhab : brocaded fabric using dense gold wire in weaving

Kisan turi : traditional basket makers-cum-cultivators in tribal Central India

kitta : thick paste prepared from rags, sawdust and tamarind seed powder, used to coat wooden sculptures by the craftsmen of Kinnal in Raichinur district of Karnataka

koftgari : a variation of damascening technique

kohbar : women's ritual wall and paper paintings connected with marriage ceremonies of the Kayastha and other communities of Mithila, Bihar

kohbar ghar : nuptial chamber, Mithila, Bihar

kolam : auspicious floor paintings made with rice-paste in Southern India

kom : Oriya term for tie dyed or *ikat* designs in a sari

kondikar : ivory carvers of Bengal

konia : corner motif

konlu uli : type of chisel used by craftsmen of Tirupati

kophi : a double-walled basket given to a daughter as dowry

kora : a type of grass

kothi kothala : barrel-shaped clay grain containers with narrow bases from Gujarat

kovara : same as *kumbara*

krid : to play, Sanskrit root

kridanaka : Sanskrit word for plaything

Krishnalila : series of 'plays' depicting the life history of Krishna

kshauma : a type of linen

kubha : one who makes earthen pots

kuchaali : needle-like implement used for weaving *kera* mats

kudo : grain measure used in Madhya Pradesh

kuhsa : a plant fibre

kula devata : clan deity

kumni : trap for catching fish in stagnant water in Madhya Pradesh

kumar : one who makes earthen pots, mainly in Northern India

kumbara : potter in Kanarese

kumbha : earthen pot

kumbhakara : one who makes earthen pots

kumbhara : one who makes earthen pots

kumisyng : a type of a wood found in North Eastern India

kumhar : one who makes earthen pots

kum-kum : vermilion, a red substance used by Indian women or their foreheads or hair parting as a sign of marriage. Also considered auspicious for the propitiation of deities.

kummara : potter in Telugu

kumrulu : same as *kummara*

kundan : the setting of precious and semi-precious stones within bands of highly purified gold leaf or *kundan* in the space between the stone and its gold frame in order that the stone remains firmly set.

kundanapu bommas : literally beautiful figures in Telugu

kundansaz : one who sets the ornament with precious stones within bands of gold i.e. using the *kundan* technique

kuppi : gunpowder case of Rajasthan

kurkut : rounded stone used by Kashmiri craftsmen to smoothen the surface of a papier maché object before painting

kusavan or kulalan : potter in Tamil

kusavan or kuyarun : potter in Malayalam

kushornah : a type of linen

kyayong : seed basket of Arunachal Pradesh

laddoo : brocaded border design of Maheshwari sari

lodheyur : apportioned

ladka ladki : boy and girl

laher : wave motif in the painted pottery of Kutch, Gujarat

laheria : a technique of tie dyeing designs on cloth in patterns distinctive of Rajasthan

lamakakamma : low work

langota : loin cloth in North India

latifa : a pattern with horizontal rows

lehanga : ankle-length heavily pleated skirt in North India

lepshum : stool-like cylindrical platform used by Manipuri potter women for fashioning their pots

linga : phallic emblem of Shiva

lingam : same as *linga*

loha : iron

lohar : blacksmith

lota : the most versatile of all Indian metal pots which derives its basic shape from the gourd

lotadi : terracotta pot used for milk and curd in Gujarat

lungi : length of fabric worn from the waist downwards by men

maan : grain measure in Madhya Pradesh

machh : fish motif in an Orissan sari

Magh : Hindu month between January and February

Mahalakshmi : Hindu goddess of beauty and prosperity

mahua : *Madhuca indica;* mahua flowers are used for extracting alcohol

mala : garland

malakar : community of traditional *shola pith* toy makers in Assam and West Bengal

malin : flower girl in North India

maliphul : floral motif in Orissan sari

Manasa Jhard : shrine of the snake goddess Manasa in West Bengal

mandala : sacred diagram

mandana : auspicious diagrams executed on the floor by women of Rajasthan and Madhya Pradesh

mandir : temple

mandir pawnti : temple-shaped date palm leaf basket with lid, from Bihar

mangalsutram : literally auspicious thread, a necklace of black beads worn by married women, especially in Maharashtra

mangamalai : "mango necklace" in Tamil Nadu

manitham : Tamil word for man

martaban : North Indian storage jar

mashru : mixed fabric with a silk warp and cotton weft, mainly in Gujarat

matadiya : lamp for the *mata* or goddess in Bastar, Madhya Pradesh

matano candarvo : Hand-painted and block-printed temple hangings of Gujarat

matsya : fish or fish incarnation of Vishnu

matti : clay

Mayur phorua : Literally peacock casket, as it is called by the Ghantrar metalsmiths of Orissa

mazdalai : Tamil word for children

meenakar : enameller in North India

meenakari : enamelling on the surface of a metal

mehrab : arch

mehrabnuma buta : motif characterised by a flowering cane bound within an arch

mekka motiram : ring worn by women of Kerala in the upper part of the ear

memsahib : Indo-English word for woman of the upper class

methi : fenugreek

mettappaya : South Indian cushion mat made from two mats sewn together

mio : "spirit reservoir" among Naga tribes

mirchi : chilli

missar : triangular head cloth worn by some Muslim communities of Gujarat

Mitakshara : school of law

mochi embroidery : chain stitch embroidery done using a cobbler's awl in Rajasthan and Gujarat

mohara : deity mask in Himachal Pradesh

moonj : type of grass used for basketry work in Bihar

morung : young men's dormitory characteristic of the North-Eastern tribes of Nagaland

moti bharat : bead embroidery of Gujarat

mritakakarma : death rituals

muga : a silkworm reared mainly in Assam where it is fed on a species of laurel, producing a golden-hued silk

muhun : Oriya term for the endpiece of a sari

mukali : bamboo tripod in Tamil Nadu

mukha : face or mask

mukhalinga : anthropomorphic phallus, a Shaivite object of worship

mukhamandapa : main entrance hall of a temple

mukut : crown

murdah : low cane and bamboo stool from Tripura

murgi : name of a stitch in kasuti embroidery of Karnataka

murti : idol, image

mutra : type of cane used for making mats in Bengal

naga : serpent

nagakalla : votive stone tablet bearing carved images of serpent deities worshipped at wayside shrines in Karnataka and parts of Tamil Nadu

nagapatam : string of cobra hoods

naksha : design or model for brocade weaving

nakshi : design

namakarna : christening or naming ceremony

Nandi : derived from the Sanskrit root nand meaning to rejoice or to be pleased. It also means the happy one. Refers to the bull vehicle of Lord Shiva

Nandikeshvara : bull deity of the bhuta cult in coastal Karnataka and the chief deity of the shrine at Mekkekattu

Nandi Raja : horse-headed guardian deity of the bhuta cult of spirit worship of coastal Karnataka

Narasimha avatara : man-lion incarnation of Vishnu

Nataraja : dancing form of Shiva

nath : nose ring in North India

nauratnahar : necklace of nine gems that has the effect of negating the ill-effects of the planets associated with each gem

nayika : heroine

navaratri : literally 'nine nights' sacred to the goddess Durga

nayaka : hero

neel : indigo

neelgar : one who dyes in indigo

neem patti : leaf of neem tree (Azadirachta indica)

negi : name of a stitch in kasuti embroidery of Karnataka

netra mangalya : ritual opening of the eyes in a painting or sculpture so that the image may be imbued with 'life'

nettur petti : lac-turned wooden ornament casket from Kerala with brass locks, hinges and beadings

niarias : occupational group that separates the gold from the dust in a goldsmith's workshop

nishada : forest dwelling tribe

odhni : North Indian veil cloth covering the head

orkha : local term for ladle used by the tribal population of Bastar, Madhya Pradesh

osa : auspicious diagrams or symbols outlined on the floor by women in Orissa

paandan : container, often perforated, for betel leaves and other accessories

pachchikam : Gujarati technique of jewellery making wherein tiny claws cast together with the ornamental framework are used to hold the stone in place

padam : lotus motif in Orissan sari

padakkam : hanging pendant from Tamil Nadu that comes in various shapes including a serpent hood, swan, lotus, peacock and mango

pagdu bandhu : tie-dyeing in Telugu

paila : grain measure in Madhya Pradesh

paikawag : Mizo basket used by women for carrying firewood and cotton

palampores : bedspreads

palao : fish trap of Rabha tribe of Assam

pallav : the principal usually ornamented endpiece of a sari

panbatti : basket for betel in Bihar

panchadipa : lamp with five lamp bowls

panch patta : five stripes, a traditional motif in mashru fabric of Gujarat

pangar : Erythrina indica; wood used in Savantwadi, Maharashtra.

panna hazar : thousand emeralds, name of a brocade design

pantipaya : kora grass mat of Kerala

pari : fairy

parikrama : circumambulation of the deity

pata : scroll paintings

pata chitra : cloth board painting, distinctive of Orissa

patbane ki sari : sari made from untwisted silk

pati : lathe in Kannada

patikars : mat weavers of Bengal and Assam

patka : typical turban in Andhra Pradesh

pattakula : silk fabric

patti bent : type of cane used for making mats in Bengal

pattidue : type of cane in Assamese

patola : double ikat silk fabric of Gujarat. The term probably derives from the Sanskrit pattakula, meaning silk fabric

patolawallas : Salvi community of Gujarati weavers who weave the double ikat patola silks

patri : impersonator and vehicle of the deity in spirit possession rites among the bhuta deities of coastal Karnataka.

patta : paintings on cloth board

patta-patti : pairs of stripes, a design on the mashru fabric of Gujarat

pattus : woollen twill weave blankets in geometric designs from Himachal Pradesh

patuas : painters of Bengal

pawnti : basket

penmani : Tamil for woman

phad : large painted rectangular canvas panels rolled and carried around by the bhopas that depict the life story of the fighter hero Pabuji and the neo-Hindu incarnation of Vishnu, Dev Narayan of Rajasthan

phak : reed mat of Manipur

phala : end pieces of Kashmiri shawl

phika : gold alloyed with silver

phoda kumbh : steeple-shaped motif in Orissan sari

phuldalia : bamboo flower basket in North India

phulkari : "garden in bloom" embroidery of Punjab done in darn stitch using floss silk over counted threads on coarse homespun cotton fabric

phunanphadi : wet rag used by Manipuri women in hand modelling the pot

phuzei : stone anvil used by Manipur potter women

piari mitti : yellow earth in Uttar Pradesh

pichhvai : temple hanging of the Vaishnava Vallabacharya sect of Nathdwara in Udaipur, Rajasthan

pindlikoothuru : bride in Telugu

pindlikuduku : bridegroom in Telugu

pinjeyur : cleaned

pinjitam : cleaned

pinjra : fretsaw perforation style of wood carving typical of Kashmiri craftsmanship

pipal : *Ficus religiosa*

pitto : the soft stem of a marshy reed

po-tie : cotton brocade or cottonstuff, mentioned in the authoritative Chinese works as an Indian product which was exported to China

Pola : festival celebrated in Madhya Pradesh

pola baila : votive terracotta figure of a bullock on wheels, Madhya Pradesh

pollo : large conical fish trap from Tripura

pothi : a bundle of rectangular *chitrakathi* paintings of Maharashtra that together relate a single story

Prajapati : lord of the universe, also an appellation given to potters

prana-pratishtha : 'breathing in of life' in the image of a deity after its completion by the craftsman. It is believed that the deity descends into its image.

puja : worship

purdah : veil

putra : son

puttala : effigy or replica

puttala : model

puttika : effigy or replica

Putul Nautch : puppetry of Bengal

Rahu puja : ceremony to propitiate King Rahu performed by the Dushadh community of Bihar

rajarani : king and queen

rakt chandan : red sandalwood

Rama Lila : theatrical performance enacting incidents from the story of Rama

ranakakan diya : lamp depicting the sun and the moon in Bastar, Madhya Pradesh

rang : colour

rangoli : auspicious diagrams executed on the floor by women of Maharashtra

rangrez : dyer

rasa : circle dance

raslila : mythical love play of Krishna

rath diya : lamp shaped like a chariot in Madhya Pradesh

rathas : chariots

Rathayatra : chariot festival

raun pawnti : basket for betel in Bihar

Ravana Chhaya : shadow theatre of Orissa

rez : to pour

rishi : sage

roghan : an adhesive residue of safflower, castor or linseed oil heated for 12 hours and cast in cold water, to prepare a colour for painting textiles, in Kutch, Gujarat

rudraksha : fruits of the *Elacocarpus Canitrus* used as rosary beads

rumal : handkerchief

rupa : type of alloyed silver

sadhkar : one who handcrafts an entire ornament on his own (*sadh* in Persian means 100%)

safa : turban

sahib : Indo-English word for an upper class man

sahvasini : woman whose husband is alive

sailabchi : wash basin, term also used in the USSR

saj : necklace of charms and pendants of the Deccan. The word probably has it's origin in the Sanskrit word *sraj*

sajji mitti : crude carbonate of soda

salheshsthanas : shrines visited by the Dusadhs of Bihar

samskaras : important ritual occasions or rites of passage in the life of a Hindu

Sangam : literature of classical Tamil (*c* 150 B.C. - A.D. 250), literally an academy or fraternity

sangi : mixed brocade fabric from Azamgarh

sanjivani buti : mythical herb that Hanuman brought to save Lakshmana's life

san mukha : one with six faces, refers to Kartikeya, Shiva's son

santallin : a red dye extracted from wood, in Andhra Pradesh

sanyasi : ascetic

saras : type of glue

saresh : glue used along with wall plaster to coat the surface of moulded pulped paper while making papier maché objects in Kashmir

sarna : jungle shrine in Madhya Pradesh

sarong : woman's wrap-around, shorter than a sari and usually worn without a blouse

sarota : North Indian term for nutcracker. Made in a variety of shapes, from equestrian figures to couples

sarovaracitra : painting of the family pool which includes different kinds of fish, turtles, etc, executed on the walls of homes in Madhubani, Bihar

satbanteli : a tie-dyed shoulder cloth worn by a woman after her first child is born in Rajasthan

satbhaiyan : seven brothers in the legend of Shyama-Chakaiva in Bihar

sathiya : auspicious diagrams outlined on the floor by women of Gujarat

sati : a ritual wherein the woman commits suicide on her husband's funeral pyre

saudagiri : fabric exported to Islamic countries under this trade name since it was brought by 'saudagars', Arabic for merchant

scooterwalla : scooterist

seth : wealthy man

Shaivite : follower of Shiva, pertaining to Shaivism

shanaha : jute

shankha : conch shell, one of Vishnu's emblems

Sharad purnima : 'autumn full moon', a Hindu festival

shedoli : ceremony among the Korku tribals of Pachmadi in Madhya Pradesh

shedoli munda : flat, paddle-shaped wood or stone pillars erected at the *shedoli* ceremony by the Korku tribals of Madhya Pradesh

sheetal : cool and pleasant

sheetal pati : split cane mat of Assam, Bengal

shikargah : sari depicting hunting scenes, usually in Benares brocade

shilpa : literally refers to all forms of creative expression including skill, craft, work of art or architecture, design, ability, ritual and ingenuity.

Shilpashastras : Sanskrit treatises on art and architecture

shilpi : one engaged in *shilpa*

shilpakar : one engaged in *shilpa*, a craftsman

shiva patra : bull-headed ritual pot for lustrating the phallic symbol of Shiva

Shivaratri : festival in honour of Shiva

sholapith : *Aeschynomene aspera* a light marshy need used in Assam and West Bengal

shreni : guild of medieval India

Shri Krishna Bhupati : "Krishna, the Lord of the Earth", a title adopted by the kings of Mysore

shringara : women's body decoration

shvetambaras : "white clad ones" a Jaina sect whose monks wear white clothes

Shyama Chakaiva : festival celebrated by women of Bihar

sikas : fine slices of bamboo used in central tribal India

sikki : dried stems of a succulent plant found in Bihar

Silavats : community of stone carvers of Rajasthan

sindoor : vermilion

sindoordan : vermilion or *sindoor* container in North India

sinhasana : throne

situ : black stone used for making everyday utensils, in Bihar

sokha : shaman, in Uttar Pradesh

sompura : Shaivite community of stone sculptors and architects of Gujarat and Rajasthan

sona rakha : auspicious symbols or diagrams outlined on the floor by women in Uttar Pradesh

sooph bharat : embroidery that follows counted threads of the warp and weft in creating geometric patterns on homespun fabrics, mainly in the Thar desert area

sraj : Sanskrit work meaning garland or necklace

sthapana : installation

216

sthapati : traditional architect = craftsman

stridhana : moveable wealth a woman inherits from her parents at her wedding

stupa : dome-shaped Buddhist and Jaina funerary monument

subara : type of alloyed silver

sudarshan chakra : sacred discus of Vishnu

sudha : fish trap from Tripura and parts of Assam

sudhum : pipe of the Apa Tani tribe

suhagadi : tie-dyed shoulder cloth for women worn after marriage and before the first-born in Rajasthan

sujni : quilts made from old saris with lively figurative motifs in running stitch, distinctive of Bihar

sunar : goldsmith in North India

supali diya : lamp in the shape of a winnowing tray

supli : winnowing tray in Tamil Nadu

surahi : long slender-necked spouted vessel

surma : scented eyeliner

surya bimba : image of the sun

suthar : carpenter

sutra : string

sutradhara : wielder of strings, architect

suvarnakar : one who works in gold, gold-smith

svansa : gold alloyed with copper

svastika : brocaded border design of Maheshwari sari

svastika aripana : type of *aripana* done by the women of Madhubani, Bihar, consisting of 41 interlinked swastikas. It is usually drawn near the auspicious *tulsi* plant or holy basil

svayambhu : self-born, appellation of Shiva

svayamvara : ancient Indian marriage ceremony where the bride selected her own groom

taar pati : slab for drawing wires

Tacchan : carpenter belonging to the Kanmalan community of artisans in the South

takya : refined silver in Lucknow, Uttar Pradesh

talli bidda : mother and child in Telugu

tambula : betel leaf

tan : to stretch, also a verb for weaving in Sanskrit

tanjir : narrow horizontal borders in a Kashmiri shawl

tantra : warp

tantu : yarn

tantuvaya : weaver

tapeli : terracotta pan for cooking vegetables

tarang kati : long wooden rod with six horizontal divisions, each painted with mythological figures. An important ritual accessory in parts of Maharashtra

tarkashi : inlaying of gold or silver wire into previously engraved beads on a metal surface

tassar : type of wild silkworm producing raw silk. Tassar worms are fed on any tree in hilly tracts and produce a variety of silk that is stiff in texture.

teen gomi Maheshwari bugdi : type of brocaded border design of Maheshwari sari

teen kani : triangular pattern on the *sheetal pati* of Assam, Bengal

teh nishan : technique wherein gold or silver sheets are embedded onto a previously chased metal surface

telia rumals : telia means 'oily'. Refers to the *ikat* handkerchiefs of Andhra Pradesh where the yarn is dipped in oil.

tella puniki : *Glotia rattle formis*, wood used for making toys

thali : large eating plate with upturned edges in Andhra Pradesh

thali : an essential component of many South Indian weddings. It is a gold necklace consisting of numerous emblems of which the *thali*, usually a phallic symbol, hangs in the centre. In the coastal regions of Kerala and Karnataka, the cylindrical bars are of gold

thapa : literally imprint, probably a derivation from the word *sthapana*, meaning installation

then check : square or rectangular pattern on the *sheetal pati* of Assam Bengal

theva : Erroneously believed to be a form of enamelling, *theva* is a technique in which a fine sheet of silver or gold, upon which a pattern is punched out, is delicately slipped onto the surface of semi-fused coloured glass usually green or red. The technique is the sole inheritance of four goldsmith families still practising today in the erstwhile Rajput kingdom of Partabgarh in Chittorgarh district of South Rajasthan

Thol Pava Koothu : shadow puppetry of Kerala

Tholu Bomalatta : leather puppets of Andhra Pradesh

tipanu : picture scrolls of Gujarat, literally meaning "recording" or "remark", they depict many legends in a single scroll, unlike the narrative painting traditions of Bengal and Rajasthan

tirthankaras : enlightened teachers of Jainism

Tirupati koyya bommalu : Tirupati wooden dolls

toda : button-shaped gold-embossed ear ornaments of Kerala

toran : embroidered door-frame hanging of Gujarat

Tretayuga : "age of triads", the second age of Hindu mythology

tribhanga : posture wherein there is a tilt of the head, waist and knee

tuibur : pipe

tulsi : sweet basil considered to be the sacred plant of the Hindus

Turi : traditional basket makers cum cultivators, in central tribal India

tusa : woven border

uda : purple

ugaldan : spittoon in Urdu

umah : flax

Ummalti : a ferocious female deity of the *bhuta* cult of spirit worship in coastal Karnataka

upadhayyapurvaya : embroidery or patch-work

upanayana : initiation into the sacred Vedas by the investiture of the *yagnopavita*

uruli : an important vessel made by the Musaris in Kerala

vadhi : a semicircular arch-like halo around the icons of Bastar, Madhya Pradesh

vahana : vehicle

vaibel : Mizo bamboo pipe

Vaishnavas : followers of Vishnu

valu uli : type of chisel used by craftsmen of Tirupati

vanchi vilakke : lamp in Kerala

vastra : cloth

vastraharana : abduction of the clothes of the cowherdesses by Lord Krishna

vel : creeper motif in the painted pottery of Kutch, Gujarat

venu : bamboo or bamboo flute in Sanskrit

vichhi : scorpion motif in the painted pottery of Kutch, Gujarat

vidyarambha : rituals performed at the commencement of formal educatior

vihara : Buddhist monastery

vihatam : apportioning

vikaddheyur : combed

vilakku : lamp, in Southern India

vilopitam : spread

vimana : celestial vehicle

vira : hero

Vishwakarma : maker of the universe and architect of the gods

Vishwakarma Puja : annual propitiation of Vishwakarma on the tenth day of Dusshera by all craftsmen worshipping their tools and implements

vohra gaji : traditional motif of the *patola* sari

vratas : vows taken before the deity usually involving certain abstentions by the devotees.

yagna : fire sacrifice

yagnopavita : thread worn from the left shoulder across the chest to the right side by twice-born castes

yali : mythical lion

Yama pattika : picture showman of the panel of Yama, the god of death

Yamapata : painting of Yama, the lord of death

zari : gold and silver wire thread

zari patti bugdi : border of Maheshwari sari with some *zari* or gold threads

Bibliography

Agrawala, V.S. : *Ancient Indian Folk Cults*, Varanasi, Prithivi Prakashan, 1970.

Agrawala, P.K. : *Early Indian Bronzes*, Varanasi, Prithivi Prakashan, 1977.

A.I.H.B. : *An Economic Assessment of Kondapalli Toy Industry*, New Delhi, n.d.

—— *Imitation Fruits and Lacquerware Crafts,Sawantwadi*, New Delhi, 1962.

—— *Wood Carving Industry Trichanur, Madhavmala(Tirupati)*, New Delhi, 1963.

—— *Sitalpati Industry at Dibrugarh, Khowang Village and Khowang Colony (Assam)*, New Delhi, 1965.

—— *Survey Report on Tribal Crafts of Koraput District (Orissa)*, New Delhi,1969a.

—— *Report on Tribal Crafts of Bastar District*, New Delhi, 1969b.

Al-Talib, F : *"The Splendour of Indian Silk" (pamphlet)*, New Delhi, H.H.E.C., for Festival of India, n.d.

Ames, Frank : *The Kashmir Shawl*, Suffolk, Antique Collectors' Club, 1986.

Anand, Mulk Raj : *Madhubani Painting*, New Delhi, Publication Div., Ministry of Information & Broadcasting, 1984.

Anonymous : *Kult Und Alltag/The Sacred and the Profane, Gelbguss in der Volkskunst Indiens/ Bell metal Casting in the Folk Art of India*, Ex. cat., Heidelberg, 1984. (In German and English).

—— *The Kashmir Shawl*, Ex. cat., Yale University Art Gallery, 1975.

Appasamy, Jaya : *Indian Paintings on Glass*, New Delhi, I.C.C.R., 1980.

Archer, Mildred : *Indian Popular Painting in the India Office Library*, London, UBS, 1977.

Archer, W.G. : *Bazar Paintings of Calcutta*, London, Her Majesty's Stationery Office, 1953.

Archer, W.G. : *Kalighat Paintings*, London, Her Majesty's Stationery Service, 1971.

Barbier, J.P. : *Kunst aus Nagaland*, Geneva, Barbier-Mueller Museum, 1986.

Basham, A.L. : *History and Doctrine of the Ajivikas, A Vanished Indian Religion*, Delhi, Motilal Banarsidass, 1957.

Bhattacharyya, A.K. : *Chamba Rumal*, Indian Museum, Calcutta, 1968.

Bhattacharya, A. : *Chhau Dance of Purulia*, Calcutta, Rabindra Bharati University, 1972.

Bhushan, J.B. : *Indian Jewellery, Ornaments and Decorative Designs*, Bombay, Taraporevala, n.d.

Buhler, A., E. Fischer : *The Patola of Gujarat.* 2 vols. Switzerland, Krebs AG, Basle, 1979.

Buhler, A., E. Fischer and Nabholz, M.L. : *Indian Tie-dyed Fabrics*, Ahmedabad, Calico Museum, 1980.

Census of India 1961a : *Selected Crafts of Kerala*, Vol.VII, Part VII-A, New Delhi, 1964.

1961b : *Selected Crafts of Andhra Pradesh*, Vol. II, Part VII-A(3), New Delhi, 1964.

1961c : Vol. II, Part VII-A(1), New Delhi, 1964.

1961d : *Fine Mats of Pattamadai*, Handicrafts and Artisans of Madras State, Vol. IX, Part VII-A-IV, Madras, 1964.

1961e : *Palm Leaf Products*, Handicrafts and Artisans of Madras State, Vol.IX, Part VII-A, Madras, 1964.

1961h : *Handloom Sari Industry of Maheshwar*, Vol.VIII, Part VII-A, Handicraft Survey Monograph No.2, Delhi, 1965.

1961i : *The Laws Governing Craftsmen and Their Crafts from Ancient Days till today in India*, Monograph series No. 2, Vol.I, Part VII-A, New Delhi, 1965.

1961j : *Selected Handicrafts of Assam*, Vol. III, Part VII-A, Delhi, 1966.

1961k : *Lac Ornaments*, West Bengal and Sikkim, Vol.XVI, Part VII-A(ii), Handicrafts Survey Monograph, Delhi, 1967.

1961l : *The Art of Weaving*, Himachal Pradesh Rural Craft Survey, Vol.XX, Part VII-A, No.2, Delhi, 1968.

1961m : *Wooden Toys of Savantvadi and Coir Ropes of Achare*, Handicrafts in Maharashtra, Vol. X, Part VII-A (4&5), Bombay, 1968.

1961n : *Transparent Lacquer Work of Sankheda*, Selected Crafts of Gujarat, Vol.V, Part VII-A, Delhi, 1968.

1961o : *Dokra Artisans of Dariapur (Burdwan)*, West Bengal and Sikkim, Handicrafts Survey Monograph, Vol. XVI, Part VII-A(4), Calcutta, 1968.

1961p. : *Stoneware Craft of Patharkatti Village*, Vol.IV, Part VII-A, Patna, 1968.

1961q : *Folk Art of Kumaon*, Vol. I, Part VII-A, Monograph series No.5, New Delhi, 1969.

1961r : *Basketry and Mat-weaving in India*, Series No.1, Paper No.2, New Delhi, 1970.

Census of India, 1971a : *Tribal Wood-Carving in India*, Series 1, Paper 1, New Delhi, 1973.

1971b : *Ritual Terracotta and Terracotta Toys of Darbhanga*, Series 1, Miscellaneous studies, Monograph No. 1, New Delhi,1973.

1971c : *Special Study Report on Bhuta Cult in South Kanara District*, Mysore, series 14, Bangalore, 1976.

Chandra, L. and Jyotindra Jain (eds.) : *Dimensions of Indian Art*, 2 Vols., New Delhi, Agam Prakashan, 1986.

Chandra, Moti : *Costumes, Textiles, Cosmetics and Coiffure in Ancient and Mediaeval India*, Delhi, Oriental, 1973.

—— *Indian Ivories*, Marg Publications, New Delhi, Arnold-Heinemann, 1977.

Chattopadhyay, K. : *Handicrafts of India*, New Delhj, I.C.C.R., 1975.

—— *Indian Embroidery*, New Delhi, Wiley Eastern, 1977.

Coomaraswamy, A.K. : *The Indian Craftsman*, London, Probsthain and Co., 1909.

—— *The Dance of Shiva*, Bombay, Asia Publishing House, 1948.

—— *Christian and Oriental Philosophy of Art*, New York, Dover Publications, 1956.

—— *History of Indian and Indonesian Art*, New York, Dover Publications, 1965.

—— *"An Early Passage on Indian Painting"*, in *Figures of Speech or Figures of Thought*, New Delhi, Munshiram Manoharlal, 1981.

Crooke, W. : *The Popular Religion and Folk-Lore of Northern India*, 2 Vols. Westminister, Archibald Constable & Co., 1896.

Crooke, W. and R.E. Enthoven : *Religion and Folk-Lore of Northern India*, New Delhi, S. Chand & Co., 1925.

Dalmia, Yashodhara : *"The Warli Chawk: A World View"*, in I.I.C. Quarterly, *Design Tradition and Change*, Vol.11, No.4, Dec. 1984.

Dar, S.N. : *Costumes of India and Pakistan*, Bombay, Taraporewala, 1969.

Das, J.P. : *Puri Paintings, The Chitrakara and his Work*, New Delhi, Arnold-Heinemann, 1982.

—— *Chitra-Pothi; Illustrated Palm-Leaf Manuscripts from Orissa*, New Delhi, Arnold-Heinemann, 1985.

Dasgupta, Prodosh : *Temple Terracotta of Bengal*, New Delhi, Crafts Museum, 1971.

Dhamija, Jasleen : *"Sikki and Moonj Work"*, in *Bihar Handicrafts*, in Marg Vol.XX, No.1, Dec. 1966.

(ed.) : *Crafts of Gujarat*, Ahmedabad, Mapin, 1985.

Doctor, G. and S. Subbiah,(eds.) : *A Celebration of Kerala*, Ex. Cat. Madras, The Madras Crafts Foundation & D.C.(H), 1987.

Dongerkery, K.S. : *Jewellery and Personal Adornment in India*, New Delhi, I.C.C.R., 1970.

Doshi, Saryu : *Masterpieces of Jain Painting*, Marg Publications, Bombay, 1985.

Dumont, Louis : "A Structural Definition of a Folk Deity of Tamilnadu: Aiyanar, the Lord" in *Religion, Politics and History in India*, Paris, Mouton, 1970.

Dwivedi, V.P. : *Indian Ivories*, Agam Prakashan, Delhi, 1976.

Eck, Diana : *Darsan: Seeing the Divine Image in India*, Pennsylvania, ANIMA, 1981.

Elwin, Verrier : *The Muria and Their Ghotul*, Bombay, Oxford University Press, 1947.

—— *The Tribal Art of Middle India*, Bombay, Oxford University Press, 1951.

—— *The Religion of an Indian Tribe*, Bombay, Oxford University Press, 1955.

Eschmann A.H. Kulke and G.C. Tripathi (eds.) : *The Cult of Jagannath and the Regional Tradition of Orissa*, South Asia Institute, Delhi, Munshiram Manoharlal, 1976.

Fairservis Jr., W.A. : *The Roots of Ancient India: The Archaeology of Early Indian Civilization*, London, University of Chicago Press, 1975.

Fischer, E.J. Jain and H. Shah : "Matano Candarvo" in *Homage to Kalamkari*, Marg Publications, Bombay, 1978.

—— *Tempeltuecher für die Muttergoettinnen in Indien*, Zurich, Museum Rietberg Zurich, 1982.

Ghosh, Prodyot : *Kalighat Pats: Annals and Appraisal*, Calcutta, Chaitra Samkranti, Shilpayan, Artists Society, n.d.

Gill, H.S. : *A Phulkari from Bhatinda*, Patiala, Punjabi Univ., 1977.

Goudriaan, T. : *Kasyapa's Book of Wisdom*, (transl.) The Hague, Mouton & Co., 1965.

Handa, D.C. : *Pahari Folk Art*, Bombay, Taraporevala, 1975.

Hendley, T.H. : *Indian Jewellery*, 2 Vols. Delhi, Cultural Publishing House, 1984, First published, 1909.

Herskovits, M.J. : *Cultural Anthropology*, New Delhi, Oxford and I.B.H., 1955.

Hitkari, S.S. : *Phulkari: The Folk Art of Punjab*, Delhi, Phulkari Publications, New Delhi, 1980.

Hivale, S. and V. Elwin : *Songs of the Forest, The Folk Poetry of the Gonds*, London, Allen and Unwin, 1935.

Inglis, Stephen : "Possession and Pottery: Serving the Divine in a South Indian Community", in Waghorne, et.al. (eds.) *Gods of Stone, Gods of Flesh*, Pennsylvania, ANIMA, 1985.

Irwin, John : *Shawls*, London, Victoria and Albert Museum, 1955.

Irwin, John : "Indian Textile Trade in the 17th Century", in *Journal of Indian Textile History*, Nos.II and III, 1957.

Irwin, J. and M. Hall, : *Indian Painted and Printed Fabrics*, Ahmedabad, Calico Museum, 1971.

—— *Indian Embroideries*, Vol. II, Ahmedabad, Calico Museum, 1973.

Jain, Jyotindra : "The Culture of Tambula: Betel Boxes, Lime Containers and Nutcrackers" in Marg Vol. XXXI, No.3, June 1978.

—— "The Painted Scrolls of the Garoda Picture-Showmen of Gujarat",*National Centre for the Performing Arts*, Journal Vol. IX, No. 3, Sept. 1980.

—— *Folk Art and Culture of Gujarat*, Ahmedabad, Shreyas Folk Museum of Gujarat, 1981a.

—— *Utensils*, An introduction to the Utensils Museum, Ahmedabad, Ahmedabad, 1981b.

—— *Master Weavers*, Bombay, Subrata Bhowmick, 1982a.

—— "Ethnic Background of some Herostones of Gujarat" in S. Settar and G.D Sontheimer (eds.) *Memorial Stones: A study of their origin, significance and variety,* New Delhi, Karnataka Univ. and S.A.I. Univ. of Heidelberg, 1982b.

—— "Rajasthan aur Gujarat Ke Chitrakatha pat", in *Samkaleen Kala*, Lalit Kala Academy, Nov. 1983, No. 1. (Hindi).

—— *Painted Myths of Creation — Art and Ritual of an Indian Tribe*, New Delhi, Lalit Kala Academy, 1984a.

—— *Introduction to Everyday Art of India*, Sanskriti Museum of Everyday Art, New Delhi, O.P. Jain, 1984b.

—— "Metal Casters of Madhya Pradesh", Unpublished manuscript.

—— *The Jayakar Volumes*, Vol.I, New Delhi, The Development Commissioner for Handlooms and The Handicrafts and Handlooms Export Corporation, n.d.

—— "Parallel Structures: Ritual Dimensions of some Tribal Dwellings", in *Vistara, The Architecture of India*, (ed.) Carmen Kagal, Bombay, Festival of India, 1986a.

—— "Survival of 'Yama-Pattika' tradition in Gujarat" in Chandra, L. and J. Jain, in *Dimensions of Indian Art*, 2 vols., Agam Prakashan, Delhi 1986b.

—— "Using Wood" in *India Magazine*, Bombay, A.H. Advani, Vol. 7, Dec. 1986c.

—— "Metalwork", *in Arts and Crafts of Rajasthan*, Ahmedabad, Mapin, 1987a.

—— "Metalwork", in *Crafts of Gujarat*, Ahmedabad, Mapin, 1987b.

—— "The Absent Form: Tribal Bronzes of India," in *The Art of the Adivasi (Indian Tribal Art)*, Tokyo, Festival of India, 1988.

Jain, Jyotindra and E. Fischer : *Jaina Iconography*, Part 1 and 2, Netherlands, Leiden, Brill, 1978.

Jain - Neubauer, Jutta : "Stonework", in *Crafts of Gujarat*, Ahmedabad, Mapin, 1985.

—— "Gold Filigree on Glass", in *India Magazine*, Bombay, A.H. Advani, Vol.7, Dec. 1986.

—— "Stonework", in *Arts and Crafts of Rajasthan*, Ahmedabad, Mapin, 1987.

Jayakar, P., and J. Irwin : *Textiles and Ornaments of India*, New York, Museum of Modern Art, 1956.

Jayakar, Pupul : *Indian Printed Textiles,* New Delhi, All India Handicrafts Board, Govt. of India, 1954.

"Naksha bandhas of Banaras", in *Journal of Indian Textile History*, No.7, Ahmedabad, Calico Museum, 1967.

—— *The Earthen Drum: An introduction to the ritual arts of rural India*, New Delhi, National Museum, 1981.

Joshi, O.P. : *Painted Folklore and Folklore Painters of India*, Delhi, Concept, 1976.

Louise, M., and N. Kartaschoff : *Golden Sprays and Scarlet Flowers — Traditional Indian Textiles from the Museum of Ethnography Basel*, Switzerland, Shikosha, 1986.

Khan, Mushtak : "Sarguja Ke Rajwar", *Chaumasa*, July-Nov 1984a, Bhopal, (Hindi).

—— "Sarguja Ke Kumhar", *Nai Duniya*, 16th Nov. 1984b, Indore, (Hindi).

—— "Adivasi Kathmuhen", *Jansatta*, 16th Jan., 1985a, New Delhi, (Hindi).

—— "Raigarh Ke Dhatu-Shilpi, Jhara Adivasi" 19th April, 1985b, *Nai Duniya*, Indore (Hindi).

—— "Bastar Ke Kumhar", *Nai Duniya*, 25th Oct. 1985c, Indore, (Hindi).

—— "Sheopur Ka Kasthshilpa", *Nai Duniya*, 20th Dec. 1985d, Indore, (Hindi).

—— "Sarguja Ke Basor", *Nai Duniya*, 18th Jan. 1986a, Indore, (Hindi)

—— "Bastar Ke Ghadwa", *Nai Duniya*, 28th March, 1986b, Indore, (Hindi).

—— "Sheopur Ka Kasthshilpa", *Nav Bharat Times*, 6th April, 1986c, New Delhi, (Hindi).

—— "Gwalior Ke Kumhar" *Nai Duniya*, 2nd May, 1986d, Indore, (Hindi).

—— "Korku Smritistambh", *Jansatta*, 22nd May, 1986e, New Delhi (Hindi).

—— "Jhabua Ke Mranshilpa", *Nav Bharat Times*, 29th June, 1986f, New Delhi (Hindi).

Kinsley, David : *Hindu Goddesses, Visions of the Divine Feminine in the Hindu Religious Tradition*, Delhi, Motilal Banarsidass, 1987.

Kosambi, D.D. : *The Culture & Civilization of Ancient India in Historical Outline*, New Delhi, Vikas, 1972.

Kramrisch, Stella : "Traditions of the Indian Craftsman", in *Traditional India*(ed.) Singer M., University of Texas Press, American Folklore Society, 1959.

—— *Unknown India: Ritual Art in Tribe and Village*, Philadelphia, Philadelphia Museum of Art, 1968.

—— *Manifestations of Shiva*. Ex. Cat., Philadelphia, Philadelphia Museum of Art, 1981.

Krishna, A. and V. Krishna : *Banaras Brocades*, New Delhi, Crafts Museum, 1966.

Krishnan, M.V. : *Cire Perdue Casting in India*, New Delhi, Kanak, 1976.

Lannoy, Richard : *The Speaking Tree*, Oxford Univ.Press, 1971.

von Leyden, Rudolf : "Ganjifa, the Playing Cards of India", in *Marg*, Vol. XXXV, No. 4, n.d.

Lipsey, Roger (ed.) : *Coomaraswamy*, 3 Vols. Princeton, New Jersey, Bollingen series LXXXIX, 1977.

Lohia, Bajranglal : *Rajasthan Ki Jatiyan*, Calcutta, Bajranglal Lohia, 1954, (Hindi).

Mahapatra, Sitakant : "Art and Ritual": A Study of Saora Pictograms" in *Dimensions of Indian Art*, (eds.) Chandra L. and J. Jain, 2 Vols, New Delhi, Agam, 1986.

Mahapatra, S. and N. Patnaik : *Patterns of Tribal Housing*, Harijan and Tribal Welfare Dept., Govt. of Orissa, Bhuvaneshwar, 1986.

Majumdar, R.C. : *Corporate Life in Ancient India*, Calcutta, Firma K.L. Mukhopadhyay, 1969.

Majumdar, R.C., and A.D. Pusalkar : *History and Culture of the Indian People*, Vol.III, Bombay, Bhartiya Vidya Bhawan, 1953.

Mani, Vettam : *Puranic Encyclopaedia*, New Delhi, Motilal Banarsidas, 1984.

Marg Publications, : *Handlooms*, Vol.XV, No. 4, Bombay, Sept. 1962.

—— *Embroideries of India*, Vol. XVII, No. 2, March, 1964.

—— *Bihar Handicrafts*, Vol. XX, No. 1, Dec. 1966.

—— *Puppets of India*, Special Vol.XXI, No. 3, June, 1968.

—— *Chhau Dances of India*, Vol. XXII, No.1, Dec., 1968.

—— *Treasures of Everyday Art — Raja Dinker Kelkar Museum*, Vol. XXXI, No.3, June, 1978.

—— *Warp and Woof-Historical Textiles*, Calico Museum, Ahmedabad, Vol.XXXIII, No. 1, 1980.

—— *Symbols and Manifestation of Indian Art*, Bombay, 1984.

Marglin, F.A. : *Wives of the God-King: Ritual of the Devadasis of Puri*, Delhi, Oxford University Press, 1985.

Marshal, Sir John,(et.al) : *The Bagh Caves in the Gwalior State*, Delhi, Printers Prakashan, 1978, First published, 1927.

Mehta, R.J. : *Handicrafts and Industrial Arts of India*, Bombay, Taraporevala, 1960.

Miller, Barbara Stoller : *Exploring India's Sacred Art: Selected writings of Stella Kramrisch*, Philadelphia, Univ. of Pennsylvania Press, 1983.

(transl.) : *The Gitagovinda of Jayadeva: Love Song of the Dark Lord*. Delhi, Motilal Banarsidass, 1984.

Misrà, P.K. : *The Nomadic Gadulia Lohar of Eastern Rajasthan*, Calcutta, Anthropological Survey of 1977.

Mittal, Jagdish : Telia Rumals of Pochampalli and Chirala" in *Marg*, Vol.XV, No.4, 1962.

—— *Andhra Paintings of the Ramayana*, Hyderabad, Lalit Kala Academy, 1969.

—— "Bidri, Silver Inlaid Metal", in *India Magazine*, Bombay, A.H. Advani, Vol.7, Dec. 1986.

Mode, H., and S. Chandra. : *Indian Folk Art*, Bombay, Taraporevala, 1985.

Mohanty, B.C. : *Appliqué Crafts of Orissa*, Ahmedabad, Calico Museum, 1980.

Monier-Williams M. : *Sanskrit-English Dictionary*, Delhi, Motilal Banarsidass, 1976, first published, 1899.

Mookerjee, Ajit : *Indian Dolls and Toys*, Crafts Museum, New Delhi, 1968.

Mukherji, Meera : *Folk Metal Craft of Eastern India*, New Delhi, All India Handicraft Board, A.I.H.B., 1977.

—— *Metal Craftsmen of India*, Calcutta, Anthropological Survey of India, A.S.I., 1978.

Nabholz-Kastascoff, M.L. : *Golden Sprays and Scarlet Flowers — Traditional Indian Textiles from the Museum of Ethnography*. Basel, Switzerland, Shikosha, 1986.

Nath, Aman : "Blue Ceramics", in *India Magazine*, Bombay, A.H. Advani, Vol. 7, Dec. 1986.

Nath, A., and F. Wacziarg (eds.) : *Arts and Crafts of Rajasthan*, Ahmedabad, Mapin, 1987.

Pal, P. : *Bronzes of Kashmir*, Graz, Austria,1975.

Pani, Jiwan : *Indian Puppets*, New Delhi, Publications Div., Ministry of Information and Broadcasting, 1986.

Pant, G.N. : "Damascening Weapons" in *India Magazine*, Bombay, A.H. Advani, Vol. 7, Dec. 1986.

Pathak, J. (ed.,transl.) : *Harshacharitam*, Benaras, 1958.

Ramanujan, A.K. (transl.) : *Poems of Love and War*, New Delhi, Oxford University Press, 1985.

Ranjan, M.P., N. Iyer and G. Pandya : *Bamboo and Cane Crafts of North-East India*, New Delhi, The Development Commissioner for Handicrafts, 1986.

Rau, Wilhelm : "Weben and Flechten im Vedischen Indien", Akademie eler Wissenschafteh und der Literatur, *Mainz*, 1971.

Rawson Philip : *The Art of Tantra*, London, 1973.

Reeves, Ruth : *Cire Perdue Casting in India*, New Delhi, Crafts Museum, 1962.

Risley, H. : *The Tribes and Castes of Bengal*, 2 Vols, Calcutta, 1891.

—— *The People of India*, Delhi, Oriental, 1969, first published, 1915.

Robinson, Stuart : *A History of Printed Textiles*, Cambridge, M.I.T. Press, 1969.

Russell R.V., and R.B. Hiralal : *The Tribes and Castes of the Central Provinces of India*, 4 Vols, Delhi, Cosmo, 1975, first published, 1916.

Saksena, Jogendra : *Mandana, A Folk Art of Rajasthan*, New Delhi, Crafts Museum, 1985.

Saraf, D.N. : *Indian Crafts and Development Potential*, New Delhi, Vikas, 1982.

Saraswati, Baidyanath : *Pottery-Making Cultures and Indian Civilization*, New Delhi, Abhinav, 1978.

Schoff, W.H. (transl.) : *The Periplus of the Erythrean Sea, Travels and Trade in the Indian Ocean by a Merchant of the First Century*, New York, Longmans, Green, and Co., 1912.

Sen Gupta, Shankar(ed.) : *The Patas and the Patuas of Bengal*, Calcutta, Indian Publications, 1973.

Sethna, N.H. : *Kalamkari*, Ahmedabad, Mapin, 1985.

Shah, Haku : *Form and Many Forms of Mother Clay; Contemporary Indian pottery and terracotta*, Ex. cat. New Delhi, Crafts Museum, 1985a.

—— *Votive Terracottas of Gujarat*, Ahmedabad, Mapin, 1985b.

Sherring, Rev. M.A. : *Hindu Tribes and Castes*, 3 Vols. Delhi, Cosmo, 1974 first published, 1881.

Shirali, Aditi : *Textile and Bamboo Crafts of the North-eastern Region*. Ahmedabad, N.I.D., 1983.

Singer, Milton (ed.) : *Traditional India*, Univ. of Texas Press, American Folklore Society, 1959.

Sivaramamurti, C. : *Indian Bronzes*, Marg Publications, Bombay, 1962.

—— *South Indian Bronzes*, New Delhi, Lalit Kala Academy, 1963.

Sontheimer, G.D. : "The Mallari/Khandoba Myth as Reflected in Folk Art and Ritual," in *India and the West*, Deppert J.(ed.), New Delhi, Manohar, 1983.

Swaminathan, J : *The Perceiving Fingers*, Bhopal, Bharat Bhawan, 1987.

Talwar, K., and K. Krishna : *Indian Pigment Paintings on Cloth*, Ahmedabad, Calico Museum, 1979.

Thakur, Upendra : *Madhubani Paintings*, New Delhi, Abhinav, n.d.

Thurston, Edgar : *Castes and Tribes of Southern India*. Vol.I-VII, Madras, Government Press, 1909.

Thurston, E. et.al : *Illustrations of Metal Works in Brass and Copper*, Madras, 1913.

Tod, James : *Annals and Antiquities of Rajasthan*, 2 Vols. London, Routledge and Kegan Paul Ltd., 1957, first published Vol. I in 1829 and Vol. II in 1832.

Upadhyaya, U.P. and S.P. Upadhyaya : *Bhuta Worship, Aspects of a Ritualistic Theatre*, Udipi, Karnataka, National Centre for Performing Arts, 1984.

Varadarajan, Lotika & Jyotindra Jain : *Traditions of Textiles Printing in Kutch : Ajrakh and related techniques, Report for the Gujarat State Handicrafts Development Corporation*, (unpublished) n.d.

Venu, G. : "Tolpava Koothu: The Traditional Shadow Puppet Play of Kerala", in *National Centre for the Performing Arts* journal Vol. X, No.4, Dec. 1981.

Vequaud, Yves : *The Art of Mithila — Ceremonial Paintings from an Ancient Kingdom,* London, Thames and Hudson, 1977.

Wacziarg, F. and A. Nath : *Rajasthan: The Painted Walls of Shekhavati,* New Delhi, Vikas, 1982.

Walker, A.R. : *The Toda of South India — A New Look.* Delhi, Hindustan Publishing Corp., 1986.

Watts G. and P. Brown : *Arts and Crafts of India — A Descriptive Study,* New Delhi, Cosmo, 1979, first published, 1904 (First author's name corrected)

Welch, S.C. : *India, Art and Culture, 1300-1900,* New York, The Metropolitan Museum of Art, Holt Rienhart and Winston, 1985.

Whitehead, Henry : *The Village Gods of South India,* Calcutta, Oxfort University Press, 1921.

Woodroffe, John : *Hymns to the Goddess,* Madras, Ganesh & Co., 1973.

Zimmer, H. : *The Art of Indian Asia, 2 Vols.* New York, Bollingen series XXXIX, 1955.

Acknowledgements

We would like to thank the following staff members of the National Handicrafts and Handlooms Museum without whose help this project would not have been possible: J. Chauhan and Puran Singh of the Museum Store; Bachi Ram and Lila Dey of the Village Complex Store; Mushtak Khan and S. Nagalakshmi in the Research and Documentation Section; Charu Smita Gupta, Sneh Grover and Leela Sharma in the Library; V.P. Ranjit, R.K. Kaushik, R.D. Bhowmick, Chambel Singh, Jeet Singh and M. Ali in the Laboratory; Anil Bhardwaj of the Photo Unit, and Anil Aggarwal and Panjo Jaiswal for their general assistance.

Our special thanks to Mushtak Khan, Deputy Director, and J. Chauhan Assistant Curator of the Museum for their invaluable help; to Aman Nath, C.L. Bharany and Pria Devi for their assistance; to Raj K. Aggarwala and Sulekha Menon for help in the preparation of the manuscript, and finally to Jutta and Manish for their patience and continuous support.